# Ann Lowe
## American Couturier

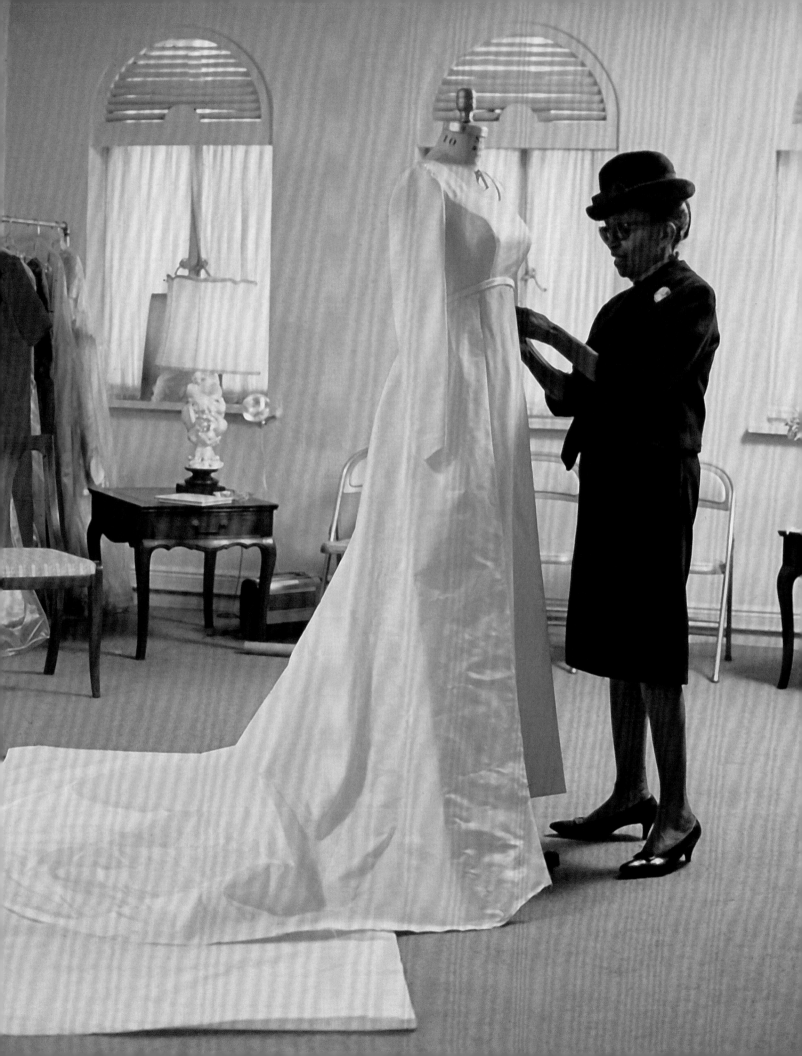

# Ann Lowe
## American Couturier

Elizabeth Way *with contributions by*
Heather Hodge, Laura Mina, Margaret Powell,
Katya Roelse, and Katherine Sahmel

WINTERTHUR
MUSEUM, GARDEN & LIBRARY

*Rizzoli* **Electa**

Published on the occasion of the exhibition *Ann Lowe: American Couturier*, organized by Winterthur Museum, Garden & Library, Winterthur, Delaware

Exhibition Itinerary
Winterthur Museum, Garden & Library, Winterthur,
Delaware: September 9, 2023–January 7, 2024

**Generous support for this exhibition and catalogue was provided by the Terra Foundation for American Art.**

# TERRA
FOUNDATION FOR AMERICAN ART

First published in the United States of America in 2023 by
Rizzoli Electa
A Division of Rizzoli International Publications, Inc.
300 Park Avenue South
New York, NY 10010
www.rizzoliusa.com

in association with
Winterthur Museum, Garden & Library
5105 Kennett Pike
Winterthur, DE 19735

For Winterthur Museum, Garden & Library:
Publications Manager: Teresa Vivolo

For Rizzoli Electa:
Publisher: Charles Miers
Associate Publisher: Margaret Rennolds Chace
Editor: Sarah Scheffel
Designer: Su Barber
Production Manager: Alyn Evans
Managing Editor: Lynn Scrabis

Library of Congress Control Number: 2023931673
ISBN: 978-0-8478-7314-2

2024 2025 2026 2027 / 10 9 8 7 6 5 4 3

Printed in China

ON THE FRONT COVER: Ann Lowe (foreground) with model Judith Guile photographed for *Ebony*, December 1966. Johnson Publishing Company Archive. Courtesy Ford Foundation, J. Paul Getty Trust, John D. and Catherine T. MacArthur Foundation, Andrew W. Mellon Foundation, and Smithsonian Institution.

ON THE BACK COVER: Ak-Sar-Ben countess gown by Ann Lowe for Saks Fifth Avenue, 1961. Collection of the Durham Museum, Gift of Ann Lallman Jessop.

FRONTISPIECE: Ann Lowe fitting wedding dress on mannequin, photographed for *Ebony*, 1966. Johnson Publishing Company Archive. Courtesy Ford Foundation, J. Paul Getty Trust, John D. and Catherine T. MacArthur Foundation, Andrew W. Mellon Foundation, and Smithsonian Institution.

FSC
www.fsc.org
MIX
Paper | Supporting
responsible forestry
FSC® C008047

# Contents

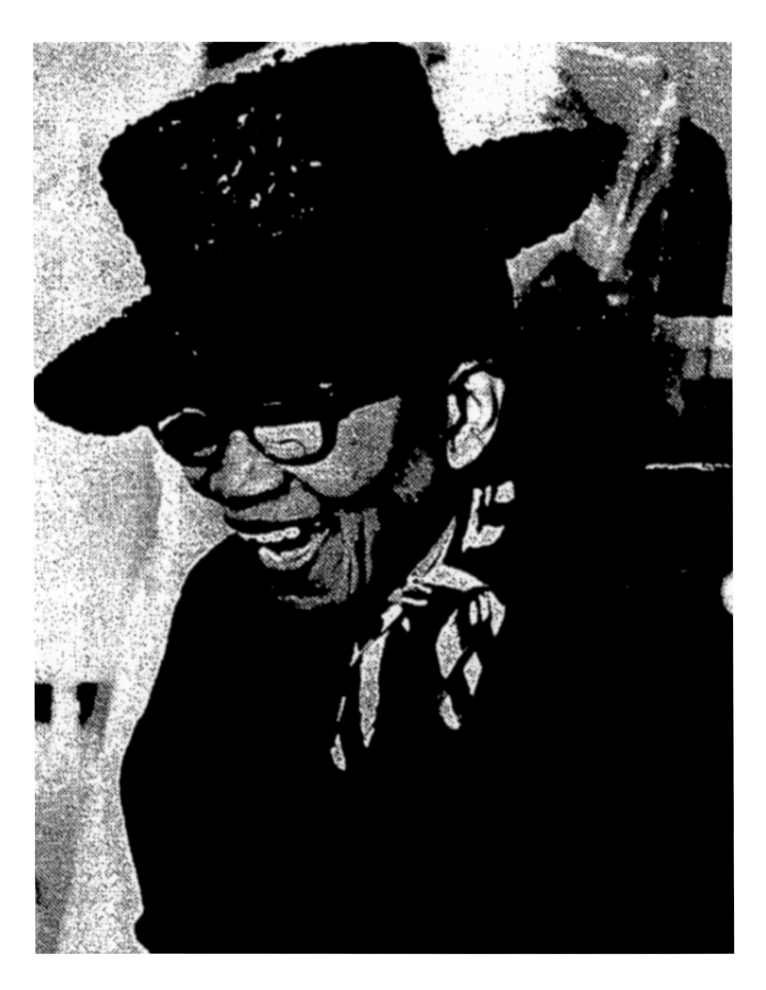

# Preface

ALEXANDRA DEUTSCH
JOHN L. AND MARJORIE P. MCGRAW DIRECTOR OF COLLECTIONS
WINTERTHUR MUSEUM, GARDEN & LIBRARY

This book, like the exhibition on which it is based, is both a tribute and a memorial. It is a tribute to the life and legacy of Ann Lowe as an American couturier, marked by Winterthur with the largest exhibition of Lowe's work to date. It is also a tribute to Margaret Powell, whose three-year tenure at Winterthur from 2013 to 2016 as a cataloguing assistant for a grant-funded project with the Institute of Museum and Library Services (IMLS) coincided with the early stages of her research into Lowe's life and legacy. Encouraged by Winterthur's curatorial staff, who recognized her unique talent for tireless research, she continued to investigate and write about Lowe, whose history she had first discovered at the Hillwood Museum in Washington, D.C. Recalling Powell, Ann Wagner, Winterthur's curator of decorative arts, wrote that "her commitment to working here meant taking the regional rail from the suburbs into Philadelphia, then catching Amtrak to the Wilmington train station, and then taking a thirty-minute bus ride from there to Winterthur's gate. . . . She read and did research on those long commutes."

Drawing on Powell's in-depth work, Elizabeth Way's curation of the exhibition, *Ann Lowe: American Couturier*, brought to life in Winterthur's galleries, is documented in these pages. This project is also a memorial to two women, Lowe and Powell, whose legacies, one to the field of fashion and the other to the scholarship of Black dressmakers and designers, have, until now, received acknowledgment, but lacked extensive attention. This show came at the right moment in Winterthur's history. Institutionally, recognizing, uncovering, and representing formerly untold or under-acknowledged histories sits at the forefront of Winterthur's work.

Winterthur is an institution dedicated to interpreting the history of material life, and fashion is one of culture's most powerful and relatable material manifestations of history. As one of the seminal homes of American material culture studies, Winterthur and its degree-granting program, the Winterthur Program in American Material Culture, affiliated with the University of Delaware, have been a hub of interdisciplinary efforts using material culture to uncover the stories of the past. By pioneering the concept of close visual analysis combined with scholarly investigation and standard-setting conservation, Winterthur has shaped the field of material culture studies for more than seven decades. With this project, Winterthur has not only advanced the scholarship of Lowe, but also innovated conservation techniques that will benefit future projects and the study of material culture.

It is exactly this kind of close-looking and deep-reaching academic investigation that led Powell, during her all-too-brief career, to reveal the depth of Lowe's contributions to the history of fashion. Mentored closely by Linda Eaton, the former John L. and Marjorie P. McGraw Director of Collections at Winterthur, Powell found consistent encouragement to pursue her interest in Lowe's work. In Powell, Eaton and others at Winterthur recognized a great scholar whose unrelenting energy and curiosity fueled her tenacious research. After Powell's untimely passing in 2019, her name and contributions remained a reference point for many who worked with her. "I loved hearing Margaret's stories about her Lowe research. Margaret had an unforgettable smile, and the joy that she found in her work was palpable and contagious," remarked Kim Collison, Winterthur's curator of exhibitions. Shortly after, Winterthur undertook plans for a multiyear exhibition schedule, and the idea of a show based on Powell's work and the history of Lowe was among the first shows discussed. It is with gratitude that one of Powell's later mentors and supporters, Rachel Delphia, the Allan G. and Jane A. Lehman Curator of Decorative Arts and Design at Carnegie Museum of Art, remained in contact with Winterthur about a possible Lowe exhibition. It is Delphia who led Winterthur to Elizabeth Way, who had briefly known Powell and who was the optimal fashion historian to continue Powell's research and guest curate a future exhibition.

Building on Powell's previously unpublished thesis, Way centers her analysis on Lowe's extant work and corroborates details of her life history through surviving garments, primary sources, and oral histories. Way traces the evolution of Lowe's long career, persuasively building a history of a

Ann Lowe. From Eleanor Coleman,
"Deb's Fairy Godmother," *The
Milwaukee Journal*, June 27, 1965.

remarkable and influential American designer who deserves a firmly established place in the canon of American fashion. Through systematically detailing Lowe's meticulous construction techniques, brought vividly to life in the photographs of James Schneck, a portrait of Lowe as an innovator and a couturier emerges. By deftly charting the pivots in Lowe's evolution as a designer from the 1910s to the end of the 1960s, Way demonstrates Lowe's ongoing engagement with fashion trends and shifting cultural moments. In doing so, Lowe serves as more than just a fashion designer. She becomes a window into the lived experience of a Black designer navigating a career from the Jim Crow South and to the metropolis of New York City during the pinnacle of her success in the 1950s and 1960s. Way persuasively illuminates how Lowe moved with the times and stayed relevant for more than five decades.

Lowe's story, uncovered by Powell and expanded by Way, is represented in these pages with an honesty that fills in realities of Lowe's career and acknowledges that racism imposed consistent challenges to the designer's success. As Way deftly notes, Lowe rarely expressed her "bitterness," but it was there. When speaking of widely celebrated gowns designed by her but left unacknowledged by the wearers and the press, Lowe remained measured publicly, but she did not shrink from claiming recognition. When the *Saturday Evening Post* described Lowe as "Society's Best-Kept Secret" in 1964, the ironies within that title are there to be seen.

This exhibition and catalogue are also a testament to the unparalleled resources Winterthur's conservation department and the University of Delaware brought to the creation, treatment, and display of Lowe's work. From the re-creation of Jacqueline Bouvier Kennedy's wedding dress to the innovative conservation techniques undertaken on Lowe pieces from both institutional and private collections, the multipronged nature of this project is illustrated in these pages.

As Winterthur confronts previously unacknowledged stories of the past, Lowe's history and Way's telling of it capture the essence of Winterthur's commitment to documenting complete histories. In the designs of the

Amsale brand, Bishme Cromartie, B Michael, Dapper Dan, Anifa Mvuemba, and Tracy Reese—whose voices and work are included in this project—Lowe's legacy is more fully contextualized within the continuum of American fashion. These designers link past with present, that intersection where relevance is found. This project stands as a memorial and tribute to two women, Ann Lowe and Margaret Powell, whose contributions to American material culture history merit continued attention. It is Winterthur's privilege to celebrate the overdue recognition of their legacies.

**Detail of rosette from the Ann Lowe–
designed Jacqueline Kennedy wedding
dress re-created by Katya Roelse.**

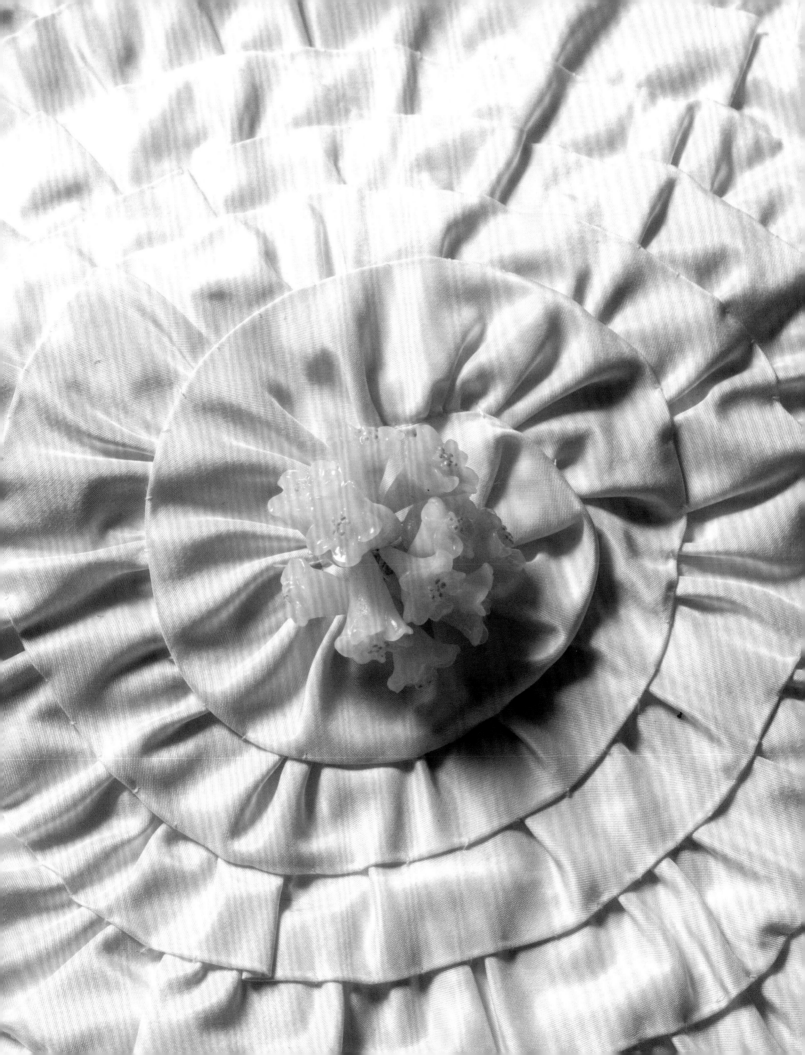

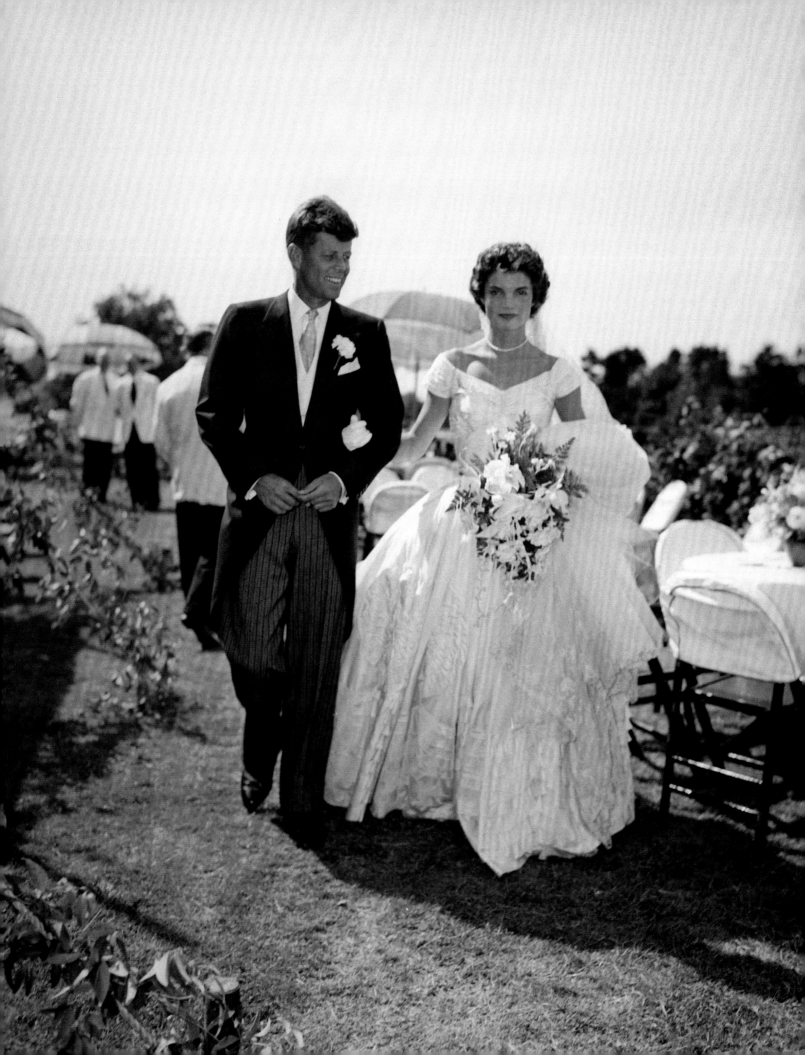

# The Life and Work of Ann Lowe:

## Rediscovering "Society's Best-Kept Secret"

MARGARET POWELL

**Note about the Author:**
*Margaret Powell (1975–2019) was the first scholar to take a rigorous academic interest in Ann Lowe and her work. Margaret first came across Lowe's work in 2011 while interning at the Hillwood Estate, Museum & Gardens in Washington, D.C., and she pursued her exploration at the suggestion of the chief curator, Liana Paredes. Intrigued by her initial research, Margaret went on to complete a meticulous study of Lowe's life and work for her 2012 master's thesis in the history of decorative arts at the Smithsonian Associates and the Corcoran College of Art and Design (now Corcoran School of the Arts and Design). Margaret carried on her Lowe research well after completing her graduate degree, tirelessly piecing together documents, personal accounts, and material culture to fill in the details of Lowe's life and design work. Margaret was lost much too early, and the field of fashion studies, as well as a larger public fascinated by Lowe's story, feels this tremendous loss. The following is an abridged version of Margaret's master's thesis, which remains a vital resource for anyone interested in Ann Lowe.*
*—Elizabeth Way*

## Introduction

On September 13, 1953, the *New York Times* covered society's wedding of the year on its front page, that of Senator John F. Kennedy and Jacqueline Bouvier. For the dress designer, this type of international exposure should have represented a major turning point in her career. Detailed photographs of the gown in newspapers and magazines should have brought priceless name recognition and waves of profitable business opportunities that could never be matched through an advertising campaign. Yet, in all of the Kennedy wedding coverage, including international newspapers, newsreels, and magazines, the designer, Ann Lowe of New York City, was not identified. The *Boston Daily Globe* acknowledged that the event's gowns came from "a New York dressmaker who has been her [Jacqueline's] mother's dressmaker for several years,"[1] but aside from that brief note, the artist behind the work remained a mystery. Even today, as the Kennedy wedding gown resides in the permanent collection of the John F. Kennedy Presidential Library and Museum in Boston, Massachusetts, most people remain unaware of the historical significance of its designer. Very few people realize that this dress is the work of an African American dressmaker and that it is just one example of the countless dresses she designed for members of the Social Register, an elite segment of the American upper class.

Ann Lowe's story is remarkable. With little more than an inadequate elementary education in rural Alabama, sewing lessons from her family, and encouragement from her early clients, Lowe became a designing powerhouse. Her custom dresses in the field of bridal and debut gowns were preferred by an elite group of clients for more than sixty years, and she became one of the first African American women to operate a couture dress salon on Madison Avenue. Stylistically, Lowe's work reflects a French influence. Her gowns were heavily structured and heavily adorned with a presence that Gerri Stutz, the president of the American department store Henri Bendel between 1957 and 1986, described as "a fairy princess look." Her style set the perfect tone for the debutantes and brides she served. "That is why these clothes are

John F. Kennedy and Jacqueline
Bouvier Kennedy at their wedding
reception, 1953. Newport, R.I.

so right for these young women," Stutz explained, "because this is a fairy tale moment in their lives."[2] Ann Lowe's fairy-tale-like gowns appeared in *Vogue, Vanity Fair,* and *Town & Country* magazines during the late 1960s. One gown also appeared at the Nineteenth Academy Awards in 1947, worn by Olivia de Havilland, that year's winner for Best Actress. There are ten Ann Lowe dresses in the permanent collection in The Costume Institute at The Metropolitan Museum of Art and a number in the collection of the Smithsonian Institution. With a résumé like that, it would be unheard-of for a designer of this caliber to remain in the shadows, but in the case of Ann Lowe, that is exactly what happened. She obtained a small amount of recognition during the 1960s, when nostalgia about anything related to the Kennedy family found an audience, but this attention was mostly grounded in Lowe's status as a novelty instead of a talented artist. To the press, Lowe was an elderly "Negro" seamstress with one eye and a sophisticated list of long-term clients that was difficult to believe. An article in the *Saturday Evening Post* dubbed Lowe "Society's Best-Kept Secret" because she was responsible for so many of the gowns worn by many of the country's wealthiest women but remained virtually unknown outside of that circle. Attention from this article led to a few other interviews in newspapers and magazines throughout the decade and an appearance on *The Mike Douglas Show,* one of the most popular television interview programs of the time, but Lowe was never able to turn this attention to her professional advantage.

In the *Mike Douglas* interview, Lowe explained that the driving force behind her work was "to prove that a Negro can become a major dress designer,"[3] and in fact, the predominant theory behind Lowe's exclusion from the story of popular American fashion is simply that the American public was not ready to accept her argument. As a result of producing special-occasion gowns for an almost exclusively white clientele during a time of institutionalized racism in the United States, the theme of racial identity has framed the reception and interpretation of her work. However, this almost single-minded focus on race may have actually limited the analysis of Lowe as a designer and her body of work. Existing scholarship about Lowe's designs focuses on her wrongful exclusion from fashion history and argues that any African American designer working for white customers in the middle of the twentieth century would not have been taken seriously by the predominantly white fashion industry. However, the reasons behind Lowe's muted historical status as a curiosity instead of an accomplished fashion designer are more than simply a matter of her race. It was a combination of racial attitudes, social conditions, missed educational opportunities, outdated business models, and health problems that contributed to the loss of Lowe's rightful place in the story of American history.

## Southern Style

The rural Alabama town where Ann Lowe (ca. 1898–1981) was born was a world away from the glamorous New York fashion district where she would work for forty years. Clayton, Alabama, of the late 1890s was a lush section of Barbour County, a predominantly African American part of Alabama's "Cotton Belt."[4] Lowe moved to the city of Montgomery as a small child and remained in the area until 1916, although many of the details of her childhood are not clear.[5] Throughout her life, Lowe gave a number of inconsistent statements about the dates and circumstances of her childhood. These varied accounts may have been the result of an aging memory—she was in her late sixties at the time of these interviews—or perhaps it was an attempt to avoid revealing either a very early marriage (the first of two to end in divorce) or an earlier birth date than Lowe's self-reported birth date of 1898. The date of Lowe's first marriage is unknown, but census records indicate that she lived in Dothan, Alabama, with her husband, Lee Cone, in 1910.[6] If Lowe's self-reported 1898 birth date is correct, she would have been eleven years old on the date of the 1910 census. Her birth date was listed in that census as 1889. In a 1966 interview with the *Oakland Tribune,* Lowe stated that she left school at age fourteen to get married. Very little family information is available in Alabama's archive of vital records,

Ann Lowe, ca. 1966. From Sally Holabird,
"Ask Her About Jackie's Bridal Gown,"
*Oakland Tribune,* August 7, 1966.

grandmother, a
was the daughter
tion owner and a
n, made gowns for
the house and her

nn's grandmother
were dressmakers
oveliest Southern
ir native Alabama.

MBER m a k i n g
ss," says Ann. "It
ico with black pol-
was a little long
shed it, but I wore
that Sunday any-

n was 14 she ran
school to get mar-
time she was 16
mother and a wi-
y after her hus-
eath, her mother,
m she had been
ied leaving unfi-
elaborate gowns
all. Ann completed
herself and after-
there was nothing
o when it came to

Ann was seen in a
store by a weal-
n matron who ex-
had "never seen
d girl so well
and who, after
that Ann made all
othes, invited the
smaker to go to
make her daugh-
g dress and trous-

hen Ann was 18,
New York to at-
mall dressmaking

**DESIGNER ANN LOWE**
... she was born to the art of dressmaking

isher in a small shop for a
short time and then returned
to Tampa with her little son.
There she had all the work
she could handle, and by the
time she was 21 she was run-
ning the city's leading dress
establishment.

By 1927 she had saved $20-

dresses were my life I guess
he gave up."

While she soon enjoyed suc-
cess as a designer in New
York, there is undeniable evi-
dence that she was somewhat
less than successful as a busi-
nesswoman

ding, which was to
five days later

What had taken tw
to make was redor
days. The dresses
ished the Wednesdy
fore the wedding, i
packed on Thursda
Friday Miss Lowe
train to Newport
ered the dresses
Not one alteration w
sary.

The accident w
mentioned to Mrs.
chincloss, Jacquelir
er. What would ha
$700 profit became
loss.

But Ann was
when she walked t
receiving line follo
wedding and Senato
took her hand
"Thank you for m
bride so lovely."

THE NATION'S t
ment stores began
from her, but her
tinued to build. So s
to work for Saks
nue. The store hop
society by hiring so
signer. It opened a
voted to Ann's dr
she bought all her
terials and paid
while the store b
output.

"I was getting pa
dresses I was pu
into," she recalls.
realize until too lat

and it is likely that state birth and wedding records for the family during this period never existed.[7] Nothing, for instance, is known about Lowe's father, Jack Lowe. It is also not known whether Sallie Mathis, introduced publicly as Lowe's sister in a 1966 article in *Ebony*, was her only sibling. The sisters remained close throughout their lives, working and living together until Sallie's death in 1967.[8] They spoke in detail with *Ebony* about their everyday lives in New York but did not mention their early experiences in Alabama. Their extended family (on their mother's side) remained in Alabama, in the same area settled by the family's patriarch, a freeman carpenter named General Cole.

General Cole was Lowe's maternal grandfather. He was born in Alabama and moved to Clayton during the late 1850s to work on the new Clayton courthouse. He married Georgia Thompkins, an enslaved woman at the time, and he purchased her freedom along with the freedom of her daughter Janie in 1860.[9] Georgia was a seamstress during her enslavement, and in freedom she used these skills to build a business as a professional dressmaker. Janie became her assistant and a proficient dressmaker as well. Together, the two women sewed for elite white families throughout Montgomery. One of their most affluent clients was Elizabeth Kirkman O'Neal, a popular society matron who became the First Lady of Alabama in 1911.[10] Mrs. O'Neal was described by the *Montgomery Advertiser* as being a fashionable woman, "of marked grace and charm of manner,"[11] and Lowe's family proudly sewed gowns for the O'Neals for years. Lowe often referred to the designs of "old-fashioned ball gown[s] like one her mother had made for a Montgomery belle" when she worked on especially grand assignments.[12]

Lowe developed her sewing skills as she played at the side of her mother and grandmother. She described this early training in a 1964 television interview on *The Mike Douglas Show* as her family's way of making sure that there was "enough for you to do."[13] Georgia and Janie were wise to pass along a trade that could help the girls to support their family. Dressmaking was clean and steady work. It was relatively easy on the body (when compared to the work of

a laundress or a housekeeper), and it was the type of occupation that could be pursued comfortably within the home. Dressmaking was also a common path for African American women who needed to find ways of contributing to their family income.[14] The precision and patience required to become a seamstress made it a challenging skill for children to master, but Lowe and her older sister Sallie were well suited to the work. At ten years old, Lowe could make her own patterns.[15] A story retold in her funeral program recounts the growth of Lowe's skill with great admiration, stating that by the time she was five years old, "little Ann took up the needle and never put it down again. She became famous for the exquisite flowers that adorned her spectacular creations. She had learned to make them at this early age using scraps that her mother and grandmother had thrown away."[16] Lowe used her signature fabric flowers as a recurring theme throughout her career on her couture and wholesale dresses. She also later taught the technique to her staff. These decorations were so realistic that in one case a dress was returned to her salon after a debutante ball to repair damage caused when the debutante's date "snipped a beautiful silk carnation from the dress as a memento."[17]

The vocational training that Lowe's family provided to their children was a helpful and necessary supplement to their formal education. While Lowe's enrollment in the Alabama public school system cannot be verified, her mention of leaving school at fourteen to be married indicates that she was enrolled.[18] The quality of the Lowe children's formal education depended upon the quality of the Alabama public schools. In 1911, forty-nine percent of eligible African American children were enrolled in the Alabama public school system compared to seventy-eight percent of eligible white students.[19] All public schools in the state were segregated, and African American schools were kept in exceptionally poor condition. The curriculum was very basic, and even if Lowe attended school every day that it was offered, she would not have been provided with the basic math instruction required to successfully navigate the financial side of her future business.[20] Lowe left school during her

OPPOSITE: Ann Lowe in her late twenties or thirties, pictured in Dorothy Dodd, "Ancient Wedding Formulae Ignored by Modern Bride," *Tampa Daily Times*, March 27, 1926. FOLLOWING SPREAD: Pink satin dress by Ann Lowe, 1962, The Metropolitan Museum of Art, Gift of Mrs. J. Winston Fowlkes and Mrs. Will R. Gregg, 1979 (1979.11.1).

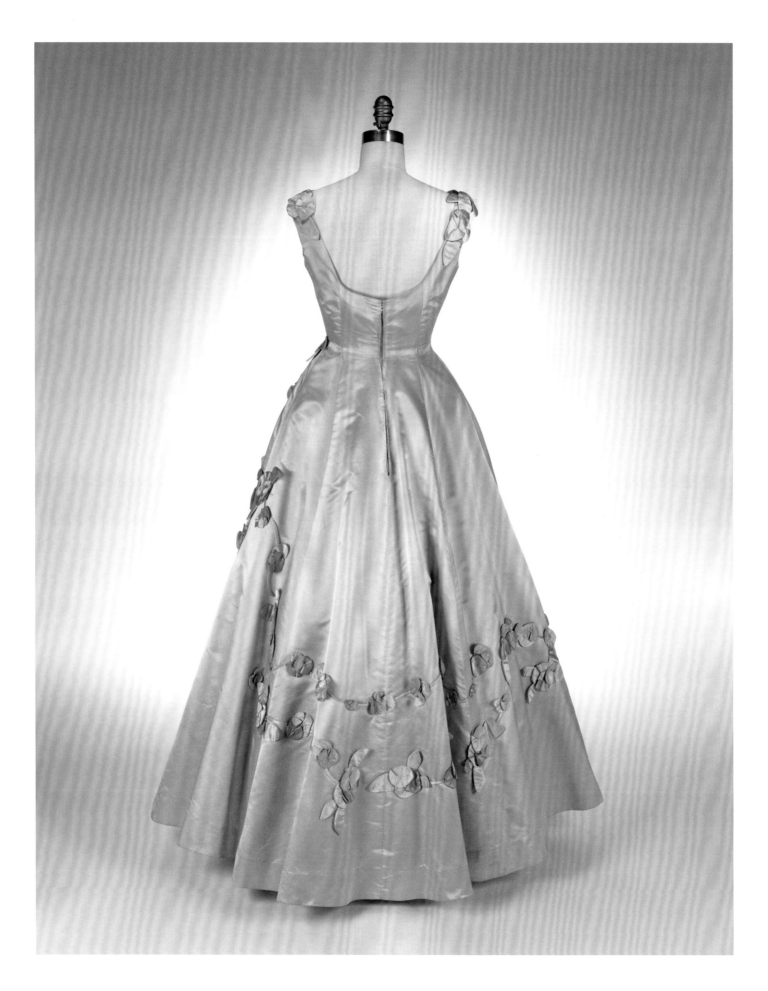

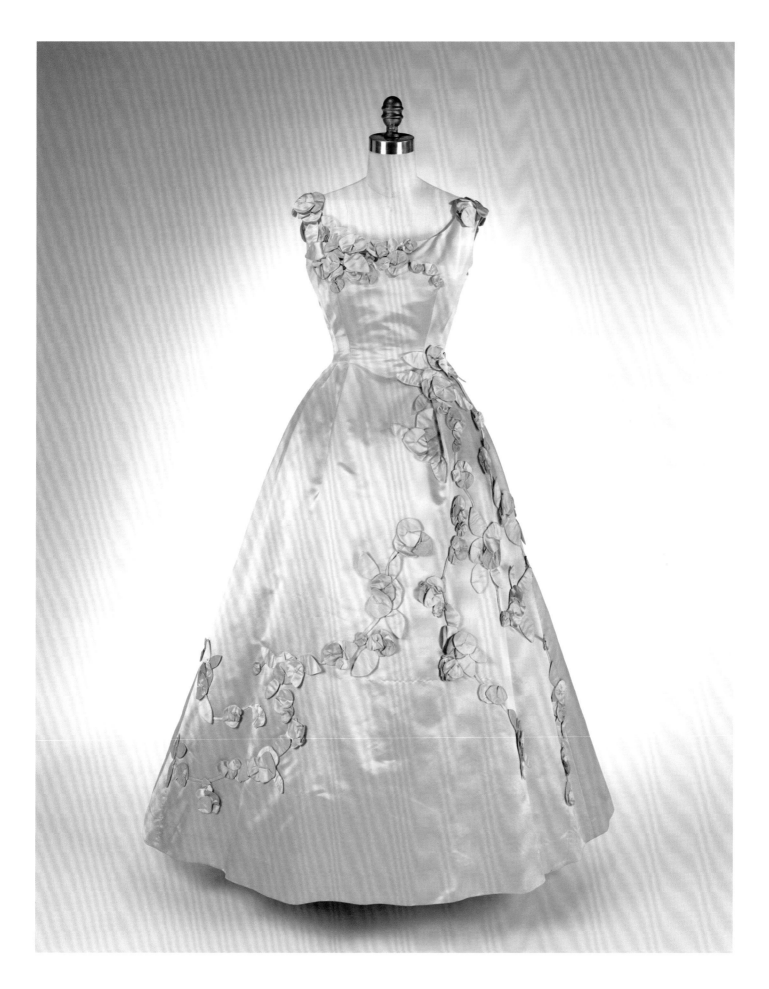

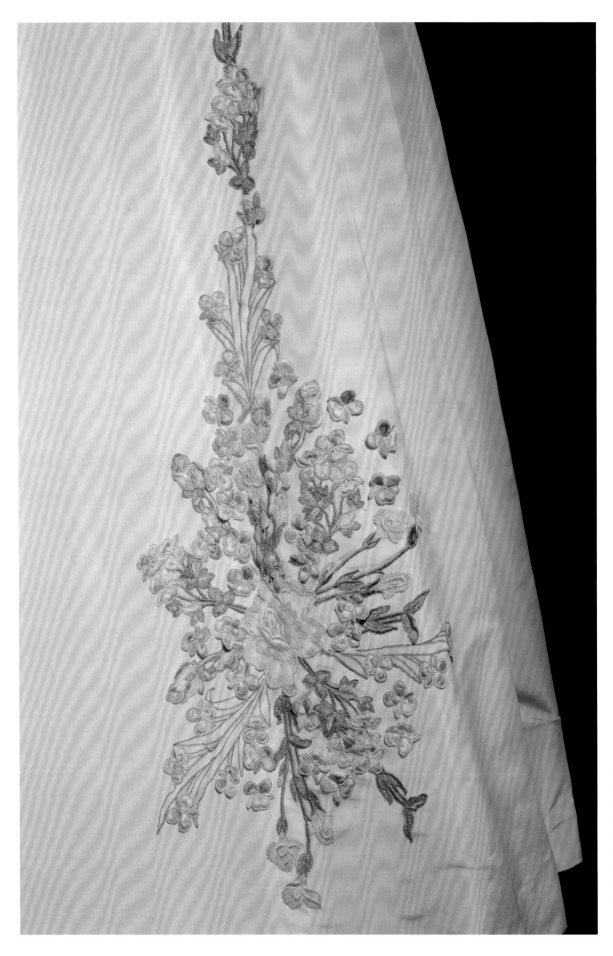

PAGES 18–21: Silk faille dress by Ann Lowe, 1958. Collection of the Smithsonian National Museum of African American History and Culture, Gift of the Black Fashion Museum, founded by Lois K. Alexander-Lane.

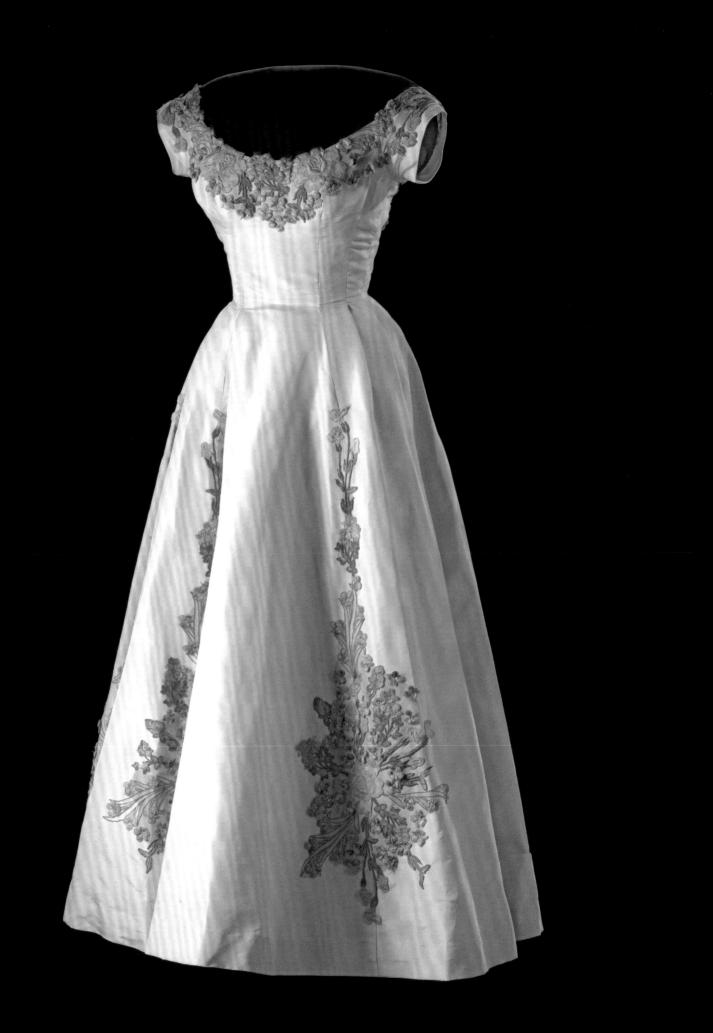

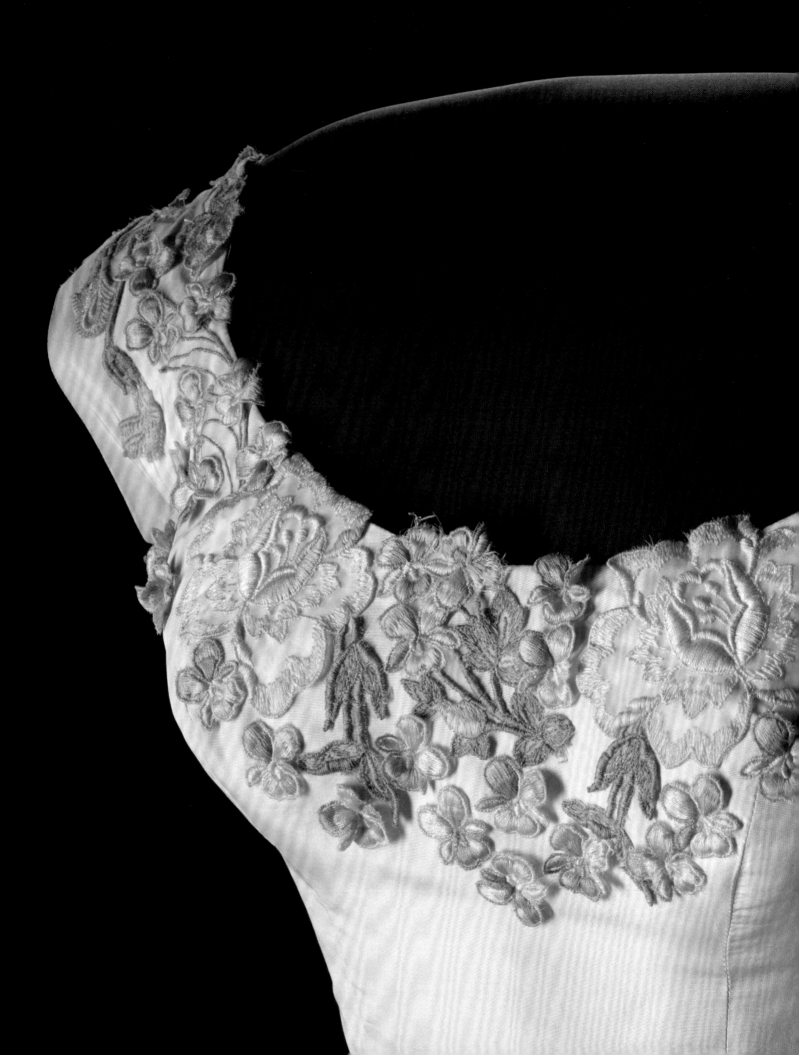

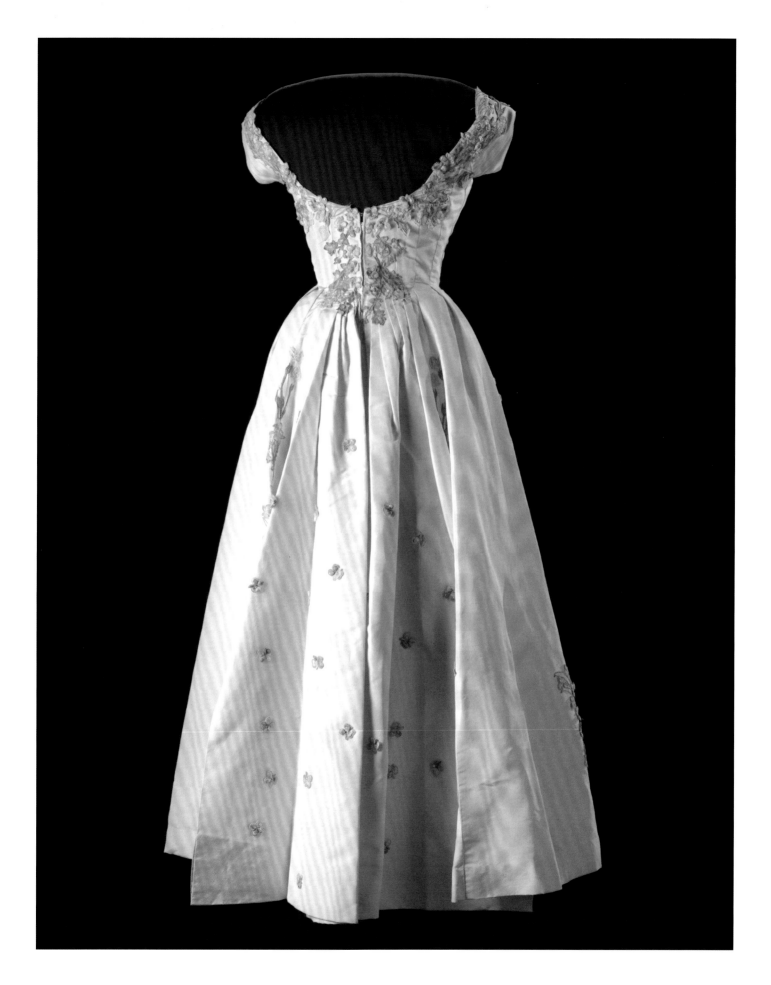

early teenage years and became an official part of the family business. When Janie died during the winter of 1914, several unfinished gown commissions for an upcoming ball became Lowe's responsibility.[21] "It was my first big test in life," she recalled in 1966. "I remember it was Christmas time and there were a number of unfinished gowns in our house. There was a big affair coming up, the Governor's Ball on New Year's Eve, and the ladies were in a terrible panic that their dresses wouldn't be ready on time." Lowe completed the dresses on a tight deadline and delivered the finished dresses successfully. "After the ball, they told me that they were very happy with what I did and that my work matched my mother's."[22] This first professional accomplishment gave her the feeling that "there was nothing I couldn't do when it came to sewing."[23]

## Annie Cone West of Tampa
If she had been able to continue with the family sewing business, Lowe's modest success as a dressmaker throughout Montgomery would have been secure. Unfortunately, Lowe's husband was against her new career. Lee Cone was a tailor, and while the combination of a husband/wife, tailor/dress-maker sounds like an attractive business arrangement, the *Saturday Evening Post* reported that Cone "did not want [Lowe] to sew, and for a time, she didn't."[24] She did, how-ever, continue to sew her own wardrobe, and this practice would be indirectly responsible for Lowe's return to profes-sional dressmaking in 1916. The story of Lowe's "discovery" in her hometown of Dothan, Alabama, suggests that her outfits were so fashion-forward and professionally executed that they caught the eye of fashionable women through-out the city. One of these women, a society matron named Josephine Edwards Lee, was the wife of a successful Tampa businessman. The Lees were originally from Dothan but moved away during the early 1900s to explore business opportunities in the growing citrus industry.[25] Their family enjoyed an affluent lifestyle in Florida, although Mrs. Lee was unable to find a quality seamstress who could keep up with the needs of her four active daughters. When Lee

noticed Lowe in the middle of a Dothan department store, where Lowe was likely working, she asked a salesgirl where she could find similar clothing.[26] She was deeply impressed when she learned that the outfit Lowe was wearing was of her own design.[27] Lowe recalled that Mrs. Lee "said she had never seen a colored girl so well dressed" and invited her to Tampa, Florida, to work as a seamstress for her family.[28] "I'm from Tampa," Lee told her, "and there isn't anyone there who can sew like that."[29]

For Lowe, the move to Tampa was a bridge leading back to the career that she loved and missed. A position as live-in seamstress for an upper-class southern family hundreds of miles away from home may have sounded like an unconven-tional offer, but the Lee family had more than enough work to keep a live-in seamstress busy. The eldest Lee daughters, Rosemary and Louise, were twenty-one-year-old identical twins who preferred to dress alike. Their twin preferences turned out to be a challenge for the local dressmakers, and with the girls preparing for marriage in an upcoming joint ceremony, Lowe's expertise arrived at just the right time.[30] She looked forward to the new challenge. "I could hardly believe it!" Lowe explained fifty years later to the *Saturday Evening Post*. "It was a chance to make all the lovely gowns I'd always dreamed of." She believed that it was too good an opportunity to decline, and although her husband disagreed, Lowe followed her own judgment and moved to Tampa. She would later recall, "When I told my husband, he told me to stay home. But I picked up my baby and got on that Tampa train."[31] This decision would have grave consequences for her family. "A while later," Lowe explained, "he divorced me."[32] In spite of this, Lowe continued to use her married name, Annie Cone, while in Tampa. Lowe arrived in Lake Thonotosassa, Florida, with her son Arthur in late 1916.

Lake Thonotosassa was a vacation community that was connected by rail to Tampa, the closest major city, fourteen miles away.[33] Mother and son moved into the Lee family's large Victorian estate on the shores of the lake with Josephine, her husband Dempsey Cowan Lee, their six children, and other members of the live-in staff. The Lees were an active

Detail of Fleur de Lis ball gown
designed by Ann Lowe for Saks Fifth

Avenue, 1963. Courtesy of the Missouri
Historical Society, St. Louis, Mo.

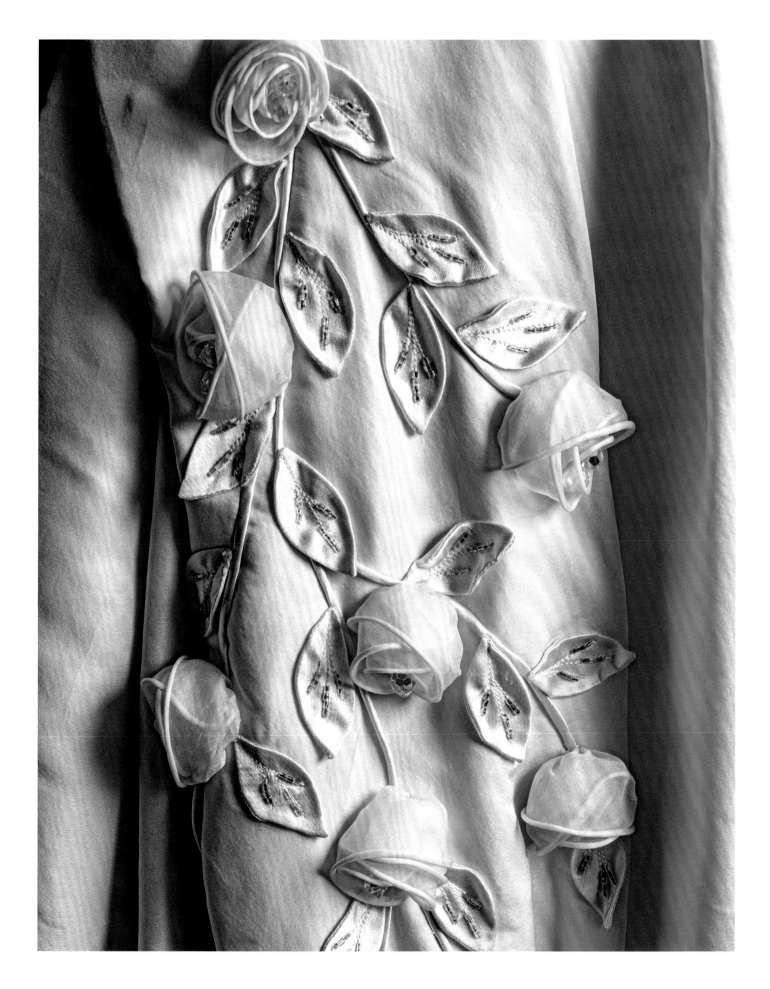

and social family, appearing regularly on the society pages of the *Tampa Tribune* and *Tampa Daily Times*. The four Lee daughters ranged in age from twelve to twenty-one, and along with Josephine, the girls often required elaborate new dresses in the latest styles.[34] Although Lowe lacked the formal training of other dressmakers around Tampa, she was able to put her years of experience creating those dramatic Alabama ball gowns to good use. Lowe's account of her time with the Lees suggests that the financial details of the arrangement were respectful and profitable for the young seamstress.[35] The family purchased all materials necessary, provided room and board for Lowe and Arthur, and paid her a salary. They permitted her to take in work from neighbors, and a number of friends in the Lee family circle were soon wearing dresses by Annie Cone.

The dresses for the upcoming wedding of twin daughters Rosemary and Louise were Lowe's first responsibility. The Lee twins married brothers from another prominent Tampa family, the Johnstons, in a dual ceremony on December 30, 1916. Lowe designed the dresses for the entire wedding party including the brides, bridesmaids, ribbon bearers, and flower girls. She also designed each bride's trousseau. The twins dressed alike throughout their lives, and it was not surprising to family members when they requested identical trousseaux. While the Lee wedding gowns no longer exist, and it is not known if they were identical, this description from the January 1, 1917, *Tampa Daily Times* indicates that they coordinated well. "The brides wore beautiful wedding gowns of white satin, embroidered in silver and pearls, and trimmed with exquisite lace also. They were fashioned with long trains, and they wore tulle veils caught [*sic*] orange blossom wreaths." Twelve-year-old Nell, one of the two ribbon bearers at the ceremony, wore a dress of "gold cloth and tulle trimmed with lace," and the two bridesmaids, including seventeen-year-old Grace, wore "very becoming creations of golden tint, with which they wore golden picture hats.[36]

As a live-in seamstress, Lowe created special-occasion dresses and daywear for Josephine and the girls during this period. A set of costumes with Swiss waists and puffed sleeves sewn for the twins and a white day suit for Grace, a young coed at the time, are typical examples of her work. One Lee daughter, twelve-year-old Nell, was a bit too young to enjoy all of the benefits of a full-time dressmaker, but Lowe found a kind way to make her feel included. In 1965, Nell recalled that Lowe dressed her dolls when she first arrived in Lake Thonotosassa, "when I was still too young to wear her clothes."[37]

At the beginning of 1917, Lowe worked for the Lees under the same financial arrangement while she accepted a growing number of commissions in the neighborhood, sewing for the Lee family's neighbors and friends. This allowed Lowe to save some of her earnings for use later in the year toward tuition at a dressmaking school in Manhattan. Magazines were her primary source of design education at this point, and she hoped that this advanced education in the country's fashion capital would help her to open her own shop.[38] Josephine and Dempsey encouraged Lowe to attend the school and assisted with their financial support.[39] Lowe took the train to New York City in April 1917, and settled temporarily in Manhattan.[40] The Lee family expected "Annie" (as they called her) to return to Tampa after a brief New York adventure. This would be Lowe's first experience in an area with relaxed segregation laws, and there is no doubt that this young woman raised in rural Alabama found excitement in her first visit to a large city.

The challenges Lowe discovered in 1917 Manhattan transcended her coursework. "Not that there was 'segregation' or something," Lowe would joke in an interview in 1966:

> Oh no. The whole idea to admit a Negro girl to a high-class fashion school was absurd and even ridiculous. The director of the famous school, a Frenchman, didn't believe I had the $1,500 for the course—he just laughed. When I showed him my bankbook, he stopped laughing, but he still didn't believe that I could learn what he was teaching there. . . . He almost didn't take me when he found out I was a Negro.[41]

(Research has shown that the statement of this fee was likely overexaggerated.) The director agreed to accept a "Negro" student if she agreed to work in a segregated classroom. "The other girls said that they wouldn't work in the same room with me, so he set me off in a room by myself."[42] In time, the quality of Lowe's work, grounded in the complicated dressmaking techniques she learned from Janie and Georgia, such as her careful finishing techniques and handmade fabric flowers, impressed the instructor and other students. Lowe remarked later, "After a while, when he saw the work I was doing, he began taking samples in to show the others. Before you knew it they were coming in to watch me."[43] At the director's request, Lowe finished the one-year curriculum in six months, recalling years later that the director explained his offer for early completion by telling her, "There is nothing more that we can teach you. You are *very* good" (emphasis original).[44]

Lowe's next steps during late 1917 and early 1918 are difficult to confirm. In 1966, Lowe told the *Oakland Tribune* that she worked briefly as a finisher in a Manhattan dress shop for several months, sewing together garments from precut pieces, before returning to the Lee household.[45] That same year, however, *Sepia* magazine wrote that Lowe "opened her own fashion shop in New York" after dressmaking school and became "probably the youngest independent dressmaker of all times. . . . Her creations became the talk of the town, practically overnight. But businesswise her venture was a disaster. She returned to her hometown where her artistry was still well remembered."[46] It is possible that the author confused details of Lowe's 1917 trip to New York with a later move to the city during the late 1920s, when Lowe opened a small shop on West Forty-Sixth Street and attempted to operate her first independent dressmaking business. That venture survived for a year.[47] In 1918, however, Lowe was not prepared for such a bold move, and neither was the New York fashion district along Seventh Avenue. Paris remained the world's fashion capital, even with the ongoing devastation of World War I, and many fashionable New Yorkers continued to bypass American designers if they were presenting anything other

than French copies. This atmosphere meant that New York was probably not the best choice for Lowe's next professional endeavor. She wanted to open a shop and continue to sell evening clothes. It would also have been exceptionally difficult for an African American woman to rent a work space in 1917. With few business connections, any space that she might be able to find on her own would have been prohibitively expensive. Tampa, on the other hand, was growing. In 1917, the city was described as being in "boom times . . . when money and aspirations walked hand-in-hand."[48] The cigar and citrus industries were growing, individual income tax laws were still not in place, and members of Tampa society kept themselves busy with a number of dances and other events. The Lee family account of this time in Lowe's life confirms that Lowe returned to Lake Thonotosassa shortly after completing her coursework and lived with the Lee family until her second marriage, to a hotel bellman named Caleb West, around 1920. Lowe then moved to Tampa with her own family and settled in a rented house on Pierce Street (they would later move to 1514 Jefferson Street) in the African American residential area.[49]

Lowe continued to sew for the Lees throughout the 1920s, as her business outside of the Lee family circle continued to grow. She became known for her exquisite bridal work, and in the small social circle of Tampa's elite, the appearance of every "elaborate and truly beautiful" wedding party worked as advertising for the next.[50] Bridesmaids would possibly become brides in the near future, and they certainly remembered the quality of Lowe's work. Lowe's wedding gowns provided dramatic moments at each ceremony as guests became "really almost breathless at their marvelous beauty."[51] The success she found through her wedding work allowed her to put plans into place to grow her business, and within a few years, she had grown into the most popular dressmaker in the area. "There have been very few if any of the big weddings in the last half dozen years," claimed a Tampa society magazine called *The Social Mirror* in 1927, "that Annie did not have the responsibility of the gowns worn by the bride and her attendants."[52] Lowe's designs followed traditional

couture methods and were extremely labor-intensive. Creating multiple dresses for each wedding party required a number of well-trained helpers, and Lowe had very particular skill requirements. The *Tampa Tribune* noted that the designer worked without patterns and that much of Lowe's work "required hand stitching literally thousands of beads and sequins into intricate forms."[53] To accomplish Lowe's vision of high quality and innovative design, she needed a staff with special training.

The only way for Lowe to obtain a highly trained staff in a small southern town like Tampa was to hire promising novices and train them. At the Jefferson Street house, Lowe set up a workroom behind her home and offered dressmaking classes to a small group of neighborhood women. One of these students, an African American woman named Martha Ravannah, would eventually work as a seamstress at "Annie Cone." Ravannah was not a professional seamstress when she arrived at Lowe's workroom, but Ravannah's daughter recalled that her mother learned all of the skills needed to become a skilled dressmaker:

> She took this course in sewing from this lady. The lady came down to Tampa from New York, opened up this school, and taught these people to sew. I think she had a very small class and as a seamstress, she did a lot of work on dresses and gowns and all that kind of thing. And then she went on back to New York and that same lady made some of Jacqueline Kennedy's wedding clothes.[54]

Ravannah sewed for Lowe until 1928 and continued to work as an independent dressmaker for the rest of her career.[55] In a 1965 *Tampa Tribune* article, Ravannah described the working environment at "Annie Cone." Her memories provide detailed information about the shop that would otherwise be lost. Lowe worked with her small staff in a workroom behind her house on Jefferson Street. The studio had "three dress forms, a long cutting table, a cabinet for accessories . . . and a few sewing machines."[56] "Annie Cone" may have been the launching pad for a number of Tampa's

African American seamstresses. Lowe claimed to employ at least eighteen women during the shop's lifetime.[57] It is not known if they were all African American, although the women who have been identified as employees by the 1965 *Tampa Tribune* article and a woman named Gussie Sheffield, who placed an advertisement noting her connection to Lowe, were African American. Sheffield's advertisement on the "Society" page of the *Tampa Morning Tribune* describes her as a "Dressmaker and designer of original frocks—for years associated with Annie Cone West."[58] By the time Ms. Sheffield placed her ad, Lowe was living in New York City. Sheffield's ad is definitely an attempt to claim some of Lowe's previous Tampa customers for herself. The ad's placement as the only dressmaker's advertisement on the "Society" page that day demonstrates Sheffield's hope of being noticed by the circle of women for whom she worked during her employment with Lowe. Sheffield also used an entire line of text to mention her connection to Lowe, at a time when newspaper advertisements were priced by the line. Being affiliated with Annie Cone West was clearly helpful in the world of Tampa's society dressmakers.

Clients brought their fabric to the shop, and although Lowe did not appear to work from patterns, she did maintain a client record "of their sizes, as well as any physical peculiarities—such as minute differences of shoulder height—on file."[59] As a rule, Lowe did not repeat designs. This tradition began in Tampa and continued throughout her career. In a 1976 interview with the *Tampa Tribune*, she proudly recalled, "You know, I never made two dresses alike, except for bridesmaids. After I made a debutante or wedding dress, I filed the sketch away with swatches of the material and it was never used again."[60] Former customers recalled that they would go to Lowe's shop the evening of their events and slip into their gowns right there: "they would dress on the spot . . . and sail into the night. There was never any question of fit and there never were any complications about it."[61]

Between 1924 and 1929, Lowe was an integral part of Tampa's most elite tradition, the annual Gasparilla festival.[62] Gasparilla was a series of balls and parades with the young

A rare photo of Lowe's Tampa workshop in 1926 appeared in Dorothy Dodd, "Ancient Wedding Formulae Ignored by Modern Bride," *Tampa Daily Times*, March 27, 1926.

members of Tampa society taking roles as members of royalty for the length of the festival. As the most celebrated part of Gasparilla, a king and queen were selected each year, along with a full court of attendants to watch over the proceedings at the annual coronation ball and parade. Lowe's role as dressmaker for the court involved the creation of a number of fine gowns for the coronation ball and other dances. She was also in high demand to create dresses for attendees of the ball. "If you didn't have a Gasparilla gown by Annie," a Tampa resident recalled in 1965, "you might as well stay home."[63]

In 1926, Lowe created the dresses for Nell Lee's wedding.[64] This commission demonstrates that the Lees remained a part of Lowe's circle while she found greater professional success with her own sewing business in Tampa. Nell was a popular young woman, and as the Queen of Gasparilla that year, her ceremony received attention from the Tampa newspapers. Lowe created all of the gowns for the ceremony, including the gowns for the bride, bridesmaids, flower girls, and mother of the bride. The gowns of the bride's six attendants were

> fashioned alike from apple-green taffeta. They were made robe-de-style with full skirts shirred on to tight bodices. The necks were finished with deep georgette bertha collars, edged with tiny ruffles, hanging to the waist in the back and tied at the neck with a bow of taffeta. The skirts were in scallops, finished at the hem with four tiny picoted ruffles. They wore large yellow horsehair braid hats, trimmed with wide apple-green velvet ribbon and carried graceful arm bouquets of daisies.[65]

Nell's gown was white silk satin, "entirely untrimmed except for an exquisite duchess Bertha [wide, flat collar highlighting the shoulders] of rose point lace. The waist was tight fitting with a full skirt and a long princess train extending from the shoulders."[66] The skirt was finished with an asymmetrical hemline that was popular with wedding gowns of the period. From the coverage of Lowe's work in *The Social Mirror*, it can be determined that Lowe owned one of the most popular dressmaking establishments in Tampa.

Interestingly, she managed to achieve this success without any kind of advertising. In ten editions of the *Tampa City Directory*, no mention of Annie Cone's dress shop can be found. Lowe is listed in a residential listing with her husband, Caleb West, in multiple editions of the directory, but she is not included in any edition's listing of independent dressmakers (both white and African American) or clothing shops. It is possible that the *Tampa City Directory* only listed paying clients in their business section. If that were the case, Lowe may have decided not to spend money for a listing. Additionally, Lowe's business probably looked very similar to the dressmaking businesses run by Georgia Cole and Janie Lowe and other African American dressmakers at the turn of the twentieth century. Her customers were an exclusive, and an exclusively white, group of women from Tampa's high society. It is possible that this type of customer avoided city directories and hired dressmakers based on word of mouth alone.

Lowe's strong customer base brought her great success in Tampa, but the support of the Lee family and their friends would not be enough to shield Lowe from the serious business challenges posed by the social conditions of the time. Like all southern communities in the early twentieth century, Tampa was racially segregated. Public transportation and facilities were officially segregated in 1905, but the people of Tampa lived in divided communities long before official laws were established. This division presented challenges for an African American business owner who maintained an exclusively white clientele. Lowe's white dressmaking competitors maintained a significant advantage because there were no legal or social reasons to physically separate them from their customer base. A white seamstress could rent a work space in the middle of Tampa's main business district and easily set up shop in view of her affluent audience. White landlords would rent to her, although it is possible that during the 1920s, her husband or father would need to be officially involved in financial papers. Supply vendors would take her business and possibly offer the credit needed to purchase the high-quality and expensive materials that couture gowns

Ann Lowe created these costumes for the Gasparilla royal court, made up of Tampa's young elite.

OPPOSITE, TOP: 1924 Gasparilla court. Courtesy, Tampa-Hillsborough County Public Library System.

OPPOSITE, BOTTOM: 1928 Gasparilla court. Courtesy, Collection of Henry B. Plant Museum Society, Inc., Tampa, Fla.

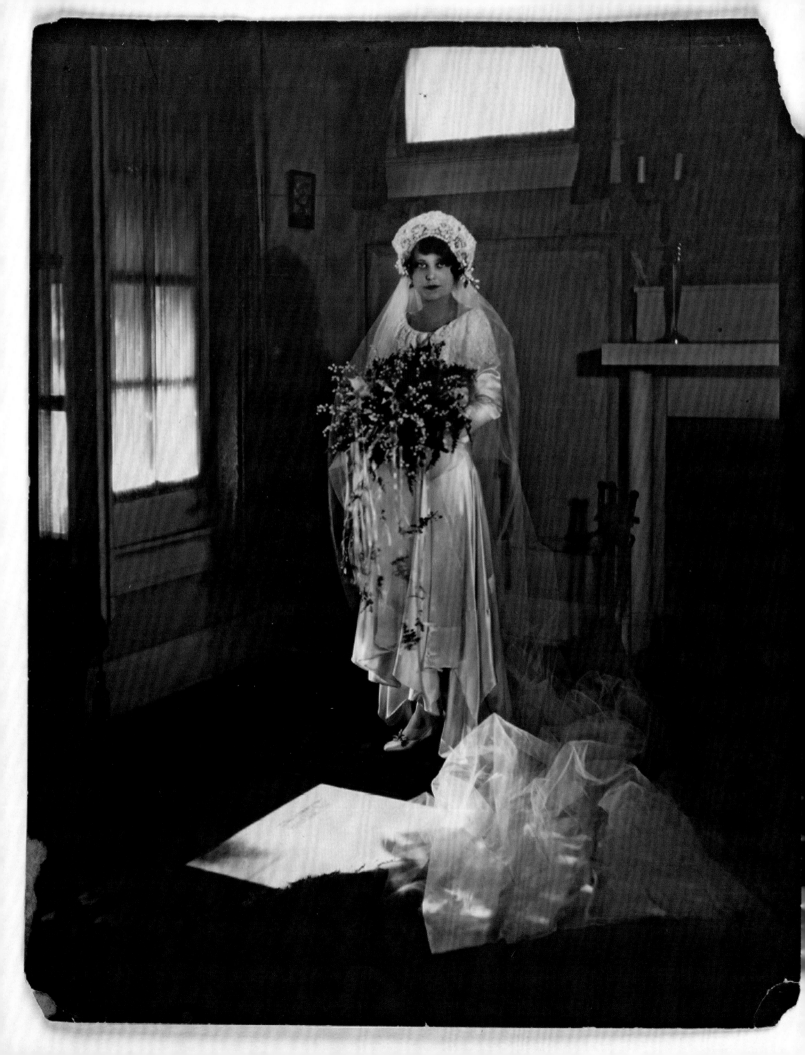

required. These doors were closed to an African American seamstress. An average of ten African Americans were listed each year as dressmakers in the *Tampa City Directory* between 1919 and 1924, but they each operated within the African American business district.[67] Lowe found success in her home workshop, but if she had hopes of expanding and opening up a true dress shop, it is not surprising that it did not happen in Tampa.

The business closed in 1928, when Lowe moved to New York City. She held fond memories of her twelve years in Tampa, even though it would only represent a small portion of her successful career. Writing to Rosemary Lee Johnston in 1965, Lowe suggested that her connections in Tampa were extremely precious: "Knowing the Top Society people in New York has not been like knowing the Lees and others in Tampa. I have always felt you were sincere."[68] Lowe also explained the importance of her time in Tampa to a reporter from the *Tampa Tribune* in 1976, from her New York City hospital bed:

> Take a message to the women of Tampa who might remember me. Tell them I love each and every one. In my mind, they are young, beautiful, excited about a wedding, Gasparilla, or a party. Those were the happiest days of my life and I will always feel that Tampa is my real home. People were so kind and so good to me there. I find myself reliving those days, and those memories bring me great happiness.[69]

**Preparing for New York**
When Lowe was ready to move to New York in early 1928, she reportedly brought $20,000 with her as seed money for her new shop. Multiple interviews explained that this money was saved from Lowe's work, but this is a staggering amount of money to earn from a business that did not have a physical storefront and did not place newspaper advertising or city directory listings. Along with the question of how one woman could earn such a large amount of money from nine years in her made-to-order dress business, there is a question of

how Lowe's husband would have regarded and handled this money. Caleb West's occupations during the period of 1919 to 1928 ranged from laborer to hotel bellman.[70] The probability that he would have allowed Lowe to keep her earnings separate from the expenses of the household, when they represented many times the average African American family's income (and even the income of white families in 1928 Tampa), is astounding and highly unlikely. Lowe did have a history of making independent decisions about her career and marriage, so it is not out of the realm of possibility that she insisted that her earnings remain separate from the household finances. The Lee family describes Josephine and Dempsey's efforts to help financially with the move to New York by pooling their resources with those of two other affluent Tampa families and giving Lowe money for her New York venture.[71] Lowe's account of the seed money changed from interview to interview. *Sepia* magazine stated that Lowe opened her business "after accumulating $20,000."[72] The use of the word "accumulated" could suggest a combination of Lowe's savings and the contributions of her former clients. The *Saturday Evening Post* article states that she saved the money but also describes Josephine Lee as Lowe's "friend and patron," so it is possible that Lowe mentioned the Lee family's financial contributions to the reporter, who then neglected to mention it in his article.[73] A 1976 *Tampa Tribune* interview quoted from a citation Lowe received from the Alpha Phi Alpha International Fraternity in New York City stating that Lowe "opened her first salon with a borrowed $20,000."[74] Lowe probably did save a considerable amount of money, but several generous clients in Tampa are likely to have contributed to the fund as well.

The state of the "American fashion designer" in 1928 was still very much a developing one. Lowe was walking into a challenging environment where she would need to convince future clients that her work could match the high-quality dresses they ordered in France. Paris was the home of couture fashion. Work in the New York ready-to-wear market was plentiful, but the couture business was in its infancy. Elizabeth Hawes, another fashion designer who was returning

Nell Lee in her wedding dress by Ann Lowe.
Ann Lowe / Madeleine Couture Archives,

1962–67. Courtesy of Sharman S. Peddy in
memory of Ione and Benjamin M. Stoddard.

to New York from France to begin her own couture house in 1928, described the New York fashion scene that both women would enter in her autobiography *Fashion Is Spinach*:

> To my knowledge there were no couturieres in existence with the possible exception of Jessie Franklin Turner. She made tea gowns of her own design to order. Everyone else sold copies of French models. . . . Many women here who could afford to have clothes made-to-order buy very expensive ready-made clothes. This is largely due, I believe, to the absence of real couturieres.[75]

Josephine Lee was in full support of Lowe's decision to leave for New York because she felt that Lowe "was too good to waste herself where she was."[76] The dream of New York City began to become a reality after a Tampa guest arrived at a Manhattan party in a hand-painted Lowe original with a floral motif. A group of New York socialites at the event appeared to agree with Mrs. Lee. "The charming wearer was besieged with questions as to who had fashioned this unusual frock, and the explanation resulted in a group of New York society women insisting that Annie be brought to their midst, so that she might conveniently create similar smart things for their own wardrobes."[77] Lowe arrived in Manhattan with money, initiative, and experience, but her endeavor was missing an important element: professional connections. Any contacts she may have established during her brief stay in 1917 would have been out-of-date by 1928. From the *Saturday Evening Post* account of her first year in business, however, it does not appear that the group of New York society matrons who encouraged Lowe to come to New York in the first place followed her arrival with much attention. Fashion moves quickly, and it is possible that many of the women who admired the "unusual frock" by Annie Cone at a party the previous fall had found other designers to admire.[78] Every customer, fabric vendor, and professional relationship needed to be cultivated from scratch, and the designer who had completed hundreds of professional garments for elite members of Tampa society was essentially starting over.

## Ann Lowe of New York City

Although Lowe would not leave for New York City until February 1928, preliminary arrangements for the move were announced in a five-hundred-word article in *The Social Mirror* during the previous November:

> There is much "weeping and wailing and maybe gnashing of teeth" to use the old expression, among Tampa society maids over the fact that Annie Cone is going to New York City in February to make her future home. Annie has designed and made all the exquisite gowns worn at all the big weddings, Gasparilla and other social events for the past several years, and feminine society is wondering just how it will be able to survive the future social seasons without her assistance.[79]

The bond Lowe established with her customers made them feel that they were losing an important social partner as a result of her New York City aspirations. At the same time, they were excited to see Lowe's career grow. Nell Lee's daughter, Nell Lee Greening, who was born in 1928 and lived on the Lee family estate in Thonotosassa during her childhood, first knew Ann Lowe through her family's vibrant stories. As a little girl, she would get to know "Annie" in person as the family continued regular contact and patronage of Lowe's shop through the years. Greening recalled the relationship between Lowe and the Lee family with great warmth:

> She was wonderful! My parents just loved her dearly—as a person, not just as a wonderful sewer. They helped her as much as they were able to, to go up there [New York], and they thought it was wonderful that she went and had the courage to go up there and be on her own. . . . We were very proud of her. We loved her. She was a good friend of the family, we [the family] felt that way about her and we [the family] had been friends in Alabama.[80]

Lowe never spoke publicly about the emotional impact of her transition from life in the Deep South to the relative

Ann Lowe fitting debutante dress on model, photographed for *Ebony*, 1966. Johnson Publishing Company Archive. Courtesy Ford Foundation, J. Paul Getty Trust, John D. and Catherine T. MacArthur Foundation, Andrew W. Mellon Foundation, and Smithsonian Institution.

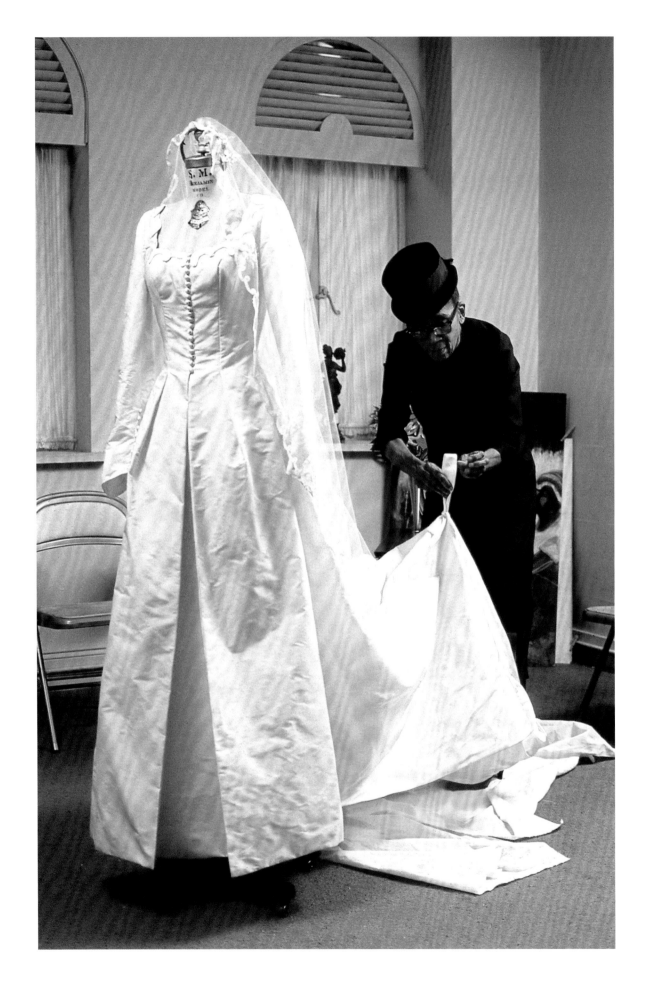

equality of New York City, but leaving a lifetime of discriminatory laws behind her was most likely a welcome change. Lowe may have outgrown Tampa by the late 1920s, having achieved the greatest amount of professional success available to her within the social constraints of the time. Her first taste of the city in 1917 fueled her dreams of becoming a Manhattan dressmaker, and she was excited to try "to see one of those lovely New York society girls" in a Lowe creation.[81] Aside from the glamour of the city, reestablishing her business in New York City made a great deal of financial sense. In Tampa, it is likely that a business like Lowe's, run by an African American but serving an all-white clientele, even when funded by a white partner, would have run into significant challenges in setting up a physical location within the white area of Tampa as late as the early 1970s. The climate of New York City was different. New York was home to a wide variety of races and cultures, and that diversity provided Lowe with business opportunities that would never have been available to her in Florida. Lowe dropped her married names upon moving to New York and adopted her professional name: Ann Lowe.

It is not clear if arrangements in New York went exactly as planned. Originally, the New York clients were put in charge of securing "a suitable location . . . for a modiste shop" that Lowe would "have entire charge of."[82] The reality of the situation, as described by the *Saturday Evening Post* article, may have been less than ideal. "Miss Lowe rented a third-floor workroom on West Forty-Sixth Street and limped along for a year, making few dresses. Then her money ran out."[83] The spring of 1928 was an unfortunate time to begin a new business, especially one that would rely upon an affluent clientele's desire for luxury goods. The *Post*'s account suggests that Lowe's "money ran out" not long before the crash of 1929.

The Great Depression affected Lowe's New York client base immediately, but a number of her Tampa clients were not dramatically affected by early events around the crash. Descendants of these citrus executives believe that the nature of the citrus industry insulated grove owners like the Lee family from the worst of the financial downturn at

first.[84] Gasparilla continued with a few adjustments, and a number of Lowe's Tampa clients held on to their way of life. Members of the Lee family came to her throughout the 1930s and 1940s when they needed an important dress, and Lowe kept her promise to "make their choicest frocks just as of old, even if it is not quite so convenient for them as if she were in Tampa."[85] Lowe probably felt very fortunate to have their business, but scattered business from Tampa would not be enough to support an independent Manhattan dress shop. The cost of running her business in New York was high, and Lowe was not accustomed to the expenses her new business required. *Sepia* magazine reported that she didn't realize that her business was losing money until the end of that first year. Looking back on the situation, Lowe admitted that she "devoted too little attention to economic matters and concentrated on the work itself."[86] This would prove to be an ongoing problem for Lowe throughout her career.

The major houses like Hattie Carnegie and department stores like Saks Fifth Avenue were not immune to the financial distress of the period, but they also had the capital and established clientele to remain in business. Smaller business had smaller financial cushions. Lowe and a number of the smallest and least-established designers in New York had the most to lose. Their clients, the wives and daughters of bankers and business owners, were no longer in the market for couture wardrobes. Some designers, like Elizabeth Hawes, stayed afloat in their own shops by reducing staff salaries dramatically and offering clothing to existing clients for whatever they could pay.[87] Designers gave up their own showrooms and work spaces and sought any work they could find through the large fashion houses in the Garment District. Lowe recalled that she went to numerous shops during a long job search and asked for "a place to work and some fabric." She offered to "make the dresses for nothing. You pay me only if they sell."[88] An unnamed shop owner accepted her offer, and Lowe was back to creating a number of elaborate gowns of her own design, although the owner of each design house would receive the credit. Lowe recalled that her first gown sold immediately, and many others

Ann Lowe fitting wedding dress on mannequin photographed for *Ebony*, 1966. Johnson Publishing Company Archive. Courtesy Ford Foundation, J. Paul Getty Trust, John D. and Catherine T. MacArthur Foundation, Andrew W. Mellon Foundation, and Smithsonian Institution.

followed.[89] The success of this arrangement allowed Lowe to create similar working relationships with a number of established design houses throughout the Depression years. She would work a great deal during this period for established houses such as Hattie Carnegie, Chez Sonia (owned by Sonia Levienne), and Sonia Gowns (owned by Sonia Rosenberg). This work allowed her to stay busy when many other independent dressmakers were without work.

Lowe's income was probably not comparable to the money she earned during her years in Florida, but at least she was working. Her profit on each gown was nothing like the margin she enjoyed on the Gasparilla gowns she sold without the involvement of a third party, and although her income may not have been substantial during these years, it was enough to keep her apartment in a fashionable section of Harlem. The success or failure of Lowe's business affected not just her own life, but the lives of her family members including two other women, Ruth Williams, considered by Lowe to be an unofficially adopted daughter, and Tommie Mae Cole, a cousin from Alabama who had traveled to New York from Tampa to assist her. Their success relied upon steady work in the only field they knew.[90] Lowe's independent career was on hold, but the dressmakers of the household continued to work, and the women remained in New York. Her freelance work was also enough to keep her customers familiar with her presence in the city. To earn substantial profit, however, Lowe would need to find an equivalent to the plentiful annual business she experienced in Tampa. Gasparilla provided her with dozens of steady commissions each winter, and that kind of steady, seasonal work would be needed once again if Lowe had a chance of maintaining her own dress shop.

In Tampa, word of mouth was the only advertising she needed. Word of mouth was also becoming a powerful tool in the growth of Lowe's New York career as her special-occasion dresses were noticed by her customer's friends, and she was beginning to make helpful connections such as Polly Bush, a local socialite. Bush was a customer at Lowe's first New York shop. She thought that Lowe "was too good to be hidden away here," and she promised to introduce Lowe "to the right people."[91] Under Bush's wing, Lowe began to work for the most socially prominent families of the city. Her interviews would mention her long working relationships with the "Dupont, Auchincloss, Vander Poel, Lodge and Hamilton" families, and soon she would design exclusively for the families of the New York Social Register and reestablish herself as a leader in extraordinary wedding gowns, while adding a new specialty to her business: the debut gown.[92]

The young ladies of the Social Register had an annual calendar of social commitments related to their work as members of the Junior League of New York and other charitable organizations. The wardrobe needs of each debutante provided a lucrative stream of income to her dressmaker. Even the most bare-boned wardrobe requirements for a debutante's season added up to a large custom order. The required pieces, outside of the presentation gown, were described by the *New York Times* as "a grand ball gown, a simple ball gown, a good all-day suit and coat, and two cocktail or tea-dance dresses."[93] Lowe's clients set the social tone of each season, leading the pack in the latest fashions. They ordered much more than the basics to get them through the two- or three-month party season described as the "Debutante Whirl."[94] These multiple dress orders added up quickly, and the debut season would become an exceptionally profitable and reliable part of Lowe's business.

As Lowe's professional accomplishments in the city increased, problems in her personal life began to appear. Caleb West was more supportive of his wife's career than Lee Cone had been. By the time the couple married, Lowe had already established herself as a leading dressmaker in Tampa. Lowe set up a workroom behind their home, which suggests that West was sensitive to the logistical needs of her career. He also moved to New York with Lowe, a show of cooperation that was in sharp contrast to Lee Cone's response when Lowe told him about her chance to move to Florida and sew for the Lees. Lowe would later describe the toll the demands of her work began to take on the family, saying that Caleb told her "he wanted a real wife. Not one

OPPOSITE: *Park Avenue Social Review*, January 1966. Collection of Ms. Margaret E. Powell.

FOLLOWING SPREAD: Silk organza and taffeta debutante dress by Ann Lowe, 1956. Ann Lowe (1898–1981). Museum of the City of New York, 2009.2.1.

Park Avenue Social Review

JANUARY
1966
OUR FORTY-FIRST YEAR

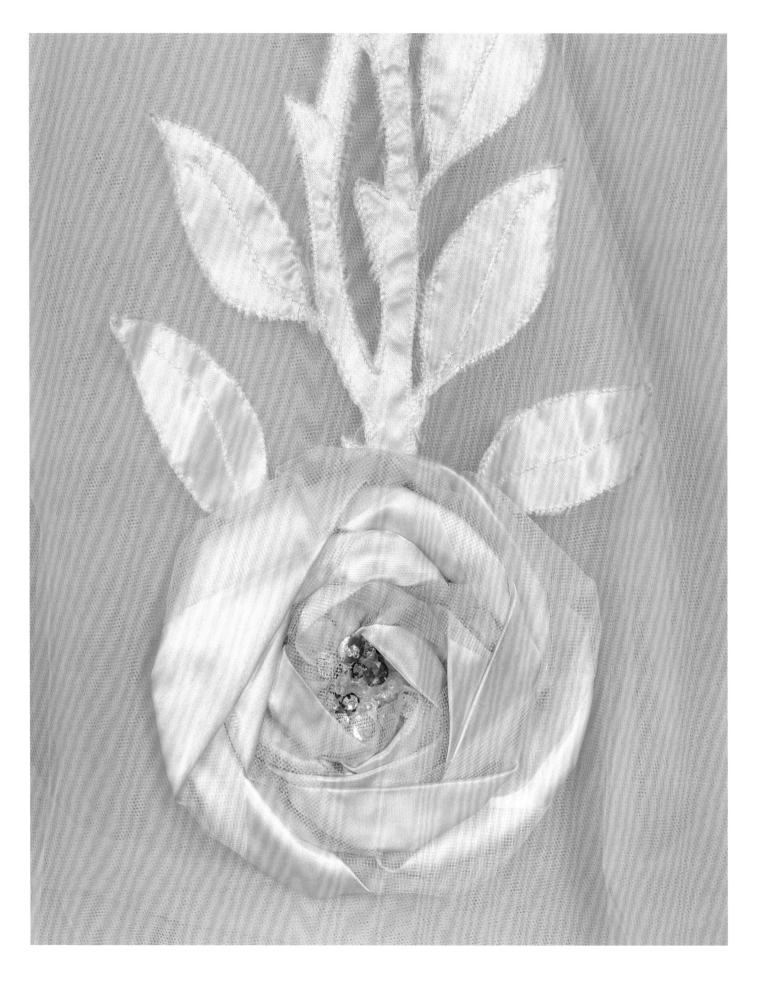

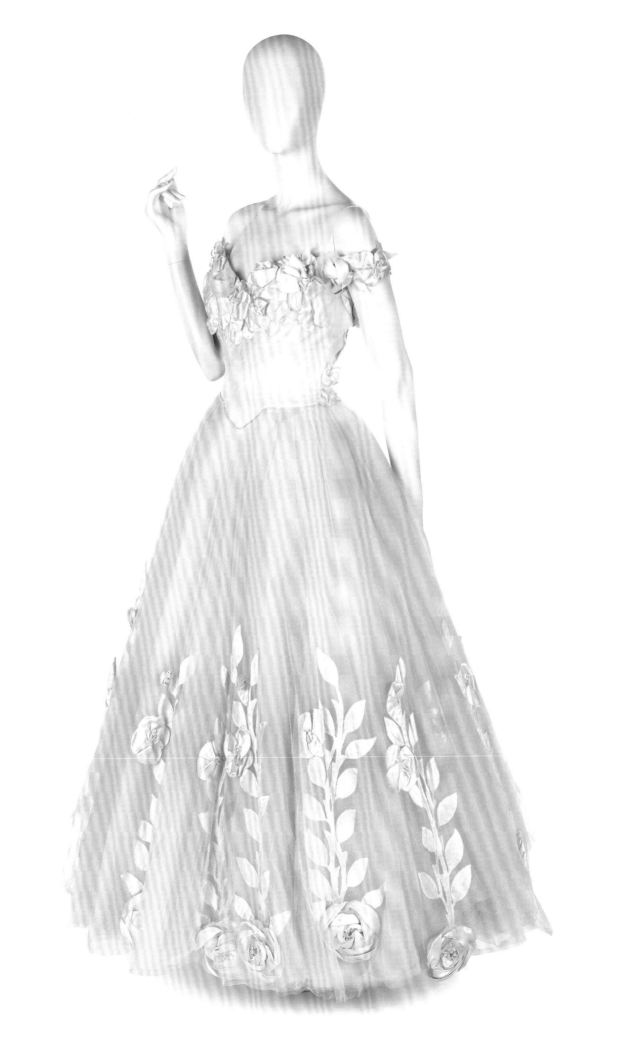

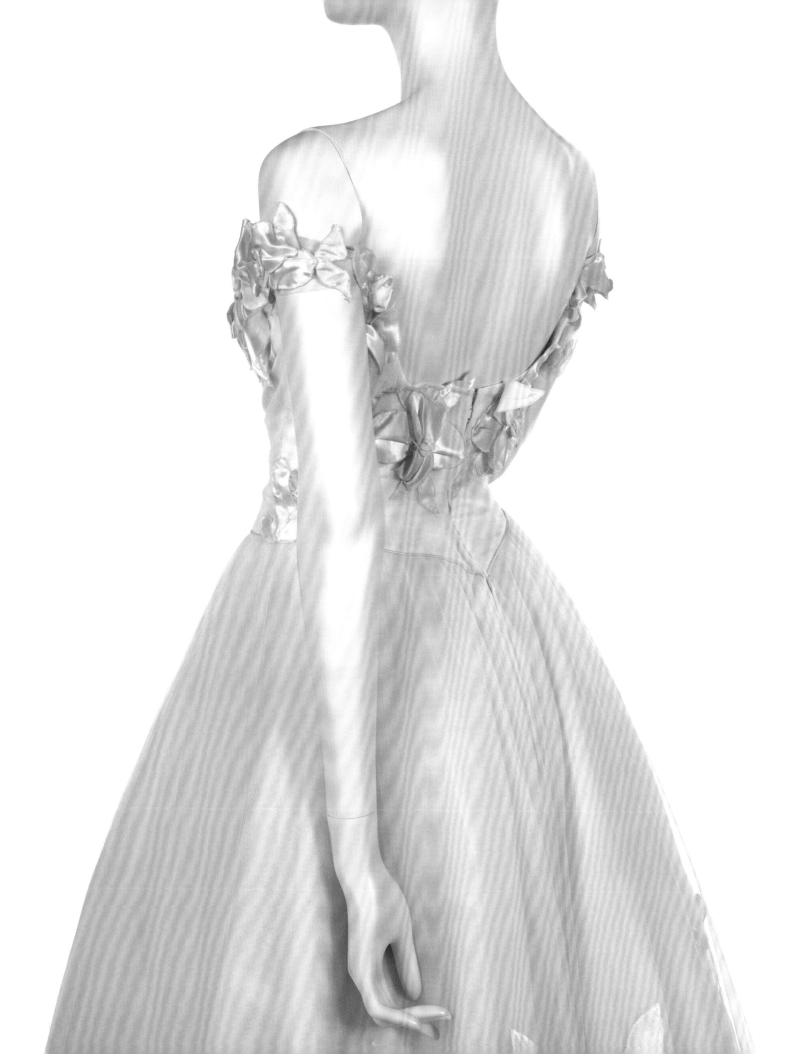

who was forever jumping out of bed to sketch dresses."[95] She explained that although West was supportive, "he never did want me to sew. When he saw that dresses were my life I guess he gave up."[96] A series of legal notices placed in the *New York Post* between September 1941 and January 1942 indicate that West was seeking information about Lowe's whereabouts in order to serve her with a lawsuit. Caleb West sued for divorce in Hartford, Connecticut, on grounds of desertion. The divorce was granted on January 31, 1942. Lowe never spoke publicly about this situation.

By the mid-1940s, Lowe continued to work for other design houses but also maintained a steady list of independent clients that included Jacqueline and Lee Bouvier and their mother, Janet Auchincloss, along with the wife and daughters of a prominent political figure of the day, C. Douglass Dillon.[97] Joan Dillon recalled that Lowe made the dresses she wore to New York parties during her teenage years.[98] For the Bouvier sisters, Lowe designed party dresses as well as their 1947 debut gowns. Later that year, while working as a designer for Sonia Gowns, Inc., Lowe was given a prestigious assignment for a Hollywood actress. Olivia de Havilland ordered a gown to wear to the Academy Awards, where she was nominated as Best Actress for her role in the 1946 motion picture *To Each His Own*. Lowe was in charge of the design and created a strapless tulle gown with a vibrant hand-painted and sequined floral motif. The completed gown was officially credited to the head of Sonia Gowns, Sonia Rosenberg, and when de Havilland won the Academy Award, her dress appeared in countless newspapers and movie theaters throughout the country (see photo, page 42). Promotional trailers for de Havilland's next film, *The Snake Pit*, also featured the actress receiving her Academy Award in this gown. The de Havilland gown was the most famous Ann Lowe original to date, but it was also a lost opportunity because the gown was created for and credited to another designer's house. This would certainly be a disappointment to an up-and-coming dressmaker. Eight years later, however, Lowe's work would make its way back into the pages of *Vogue*, this time in a full-page photograph of Nina Auchincloss's debut gown with a proper credit line (see photo, pages 44–45).[99]

By the end of the forties, Lowe's business had weathered the financial challenges of the Great Depression, and the supply shortages of World War II. She had not become a prosperous business owner during this time by any stretch of the imagination, but the ability to stay solvent during these two difficult periods was an accomplishment of which any business owner could be proud. Young women who wore Ann Lowe originals for their debuts at nineteen were returning to Lowe a few years later for her help as they became engaged to be married, and this kind of growth put her in the position to open another shop. She partnered with Grace Stehli, a former customer and the wife of the owner of Stehli Silks, to open Ann Lowe, Inc., at 667 Madison Avenue.[100] Ruth Williams, one of the young assistants who moved with Lowe from Tampa, joined Lowe as a dressmaker. Other positions were filled through classified ads in the *New York Times*. The shop advertised for dressmakers and finishers throughout October 1950. "DRESSMAKER," read one of the earliest known ads, "for fine custom dresses. Apply Ann Lowe, Inc. 667 Madison Ave. Room 301."[101]

Grace Stehli, a society matron with an interest in fashion design, had a role in the business management of Ann Lowe, Inc., and hosted a fashion show for the shop at her estate in Mill Neck, Long Island, in May 1951.[102] It is likely that the Stehli family's business connections gave Lowe the ability to rent a space and begin a business. The Stehli family's connections in the textile industry may have also been helpful in the acquisition of fabric and supplies, and possibly in bookkeeping. Lowe's formal education ended somewhere around the eighth grade, and a partner with formal business experience and the advantage of a quality education would be necessary if the shop had a true opportunity to succeed. She discussed the partnership in one article, suggesting that it dissolved shortly after the commission of gowns for Jacqueline Bouvier's fall 1953 wedding to John F. Kennedy because of tension between the partners. Lowe told the *Saturday Evening Post* that there were two partners in the shop; although neither is identified in the article, it is probable that this additional partner

Silk organza and taffeta debutante dress (back view) by Ann Lowe, 1956.

Ann Lowe (1898–1981). Museum of the City of New York, 2009.2.1.

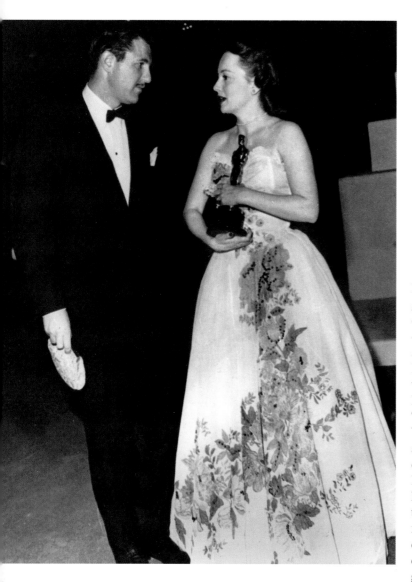

Lowe's dresses were selling to a growing group of elite (white) women throughout the country. Along with her label on Madison Avenue, Lowe was also selling her custom gowns through several exclusive department stores throughout the United States.[106] Department stores served local client bases during the 1950s and 1960s. These arrangements allowed her to expand the reach of her gowns away from the East Coast, and along with the New York stores, her designs were available in I. Magnin, Neiman Marcus, and Montaldo's. Neiman Marcus was the best way to reach her client base in Texas, and I. Magnin expanded Lowe's work to California. When a Lowe debutante gown appeared in an editorial article in *Town & Country* in 1966, Lowe was credited as the designer, but the dress was said to be available through Henri Bendel and Montaldo's.[107] Lowe was associated with high-quality couture work for a select group of clients, and throughout the decade, she would create debutante gowns for hundreds of attendees of the top balls in New York—all dressed, as one *New York Times* fashion writer of the period described after visiting Lowe's studio, "in one-of-a-kind gowns that look like kissing cousins at a distance."[108] A popular quote about Lowe's career originated from Lowe herself when she explained to *Ebony* that she was "an awful snob. I love my clothes and I'm particular about who wears them. I am not interested in sewing for café society or social climbers. I do not cater to Mary and Sue. I sew for the families of the Social Register."[109] This bold statement was not an exaggeration. The bulk of Lowe's customers really did come from the Social Register, and Lowe was even listed in the National Social Directory, an annual business directory used by its members.

Along with her custom work, wholesale designs became a part of her overall business plan by the middle of the 1950s. She advertised for dressmakers who were "capable of draping and making an expensive line of custom and wholesale gowns" in 1957, although more precise information about the details of this early wholesale work is not known.[110] Lowe was best known for her bridal and debutante work, but she also designed special-occasion gowns for high-profile

was another member of the Stehli family. One of Lowe's partners "had been kind, the other shrill," and with this being the case, Lowe decided to "set out on her own, and this time she was joined by her son Arthur, who kept her books and ordered her materials."[103]

The pieces of Lowe's career were beginning to align during the early 1950s, and she was able to enjoy this success in her typically modest fashion. The happiness that her career provided for her was more important to Lowe than any material displays of wealth it could provide. Dressmaking was her life's work. "I feel so happy when I am making clothes," she told a reporter in 1966, "that I could just jump up and down with joy."[104] During this period, she proudly reported to have "turned out an average of one thousand gowns a year, had a staff of 35 and grossed $300,000 annually," although she continued to live without frills, wearing her own designs and focusing on her work in the same apartment on Manhattan Avenue.[105]

ABOVE: **Best Actress Olivia de Havilland in Ann Lowe gown for Sonia Designs, with publicist Henry C. Rogers at the Nineteenth** Academy Awards in 1947. Margaret Herrick Library, Academy of Motion Picture Arts and Sciences. OPPOSITE: **Jacqueline and Lee Bouvier in Ann Lowe debutante dresses, 1947. FOLLOWING SPREAD: Nina Auchincloss debuts in an Ann Lowe gown,** *Vogue,* **August 1955.**

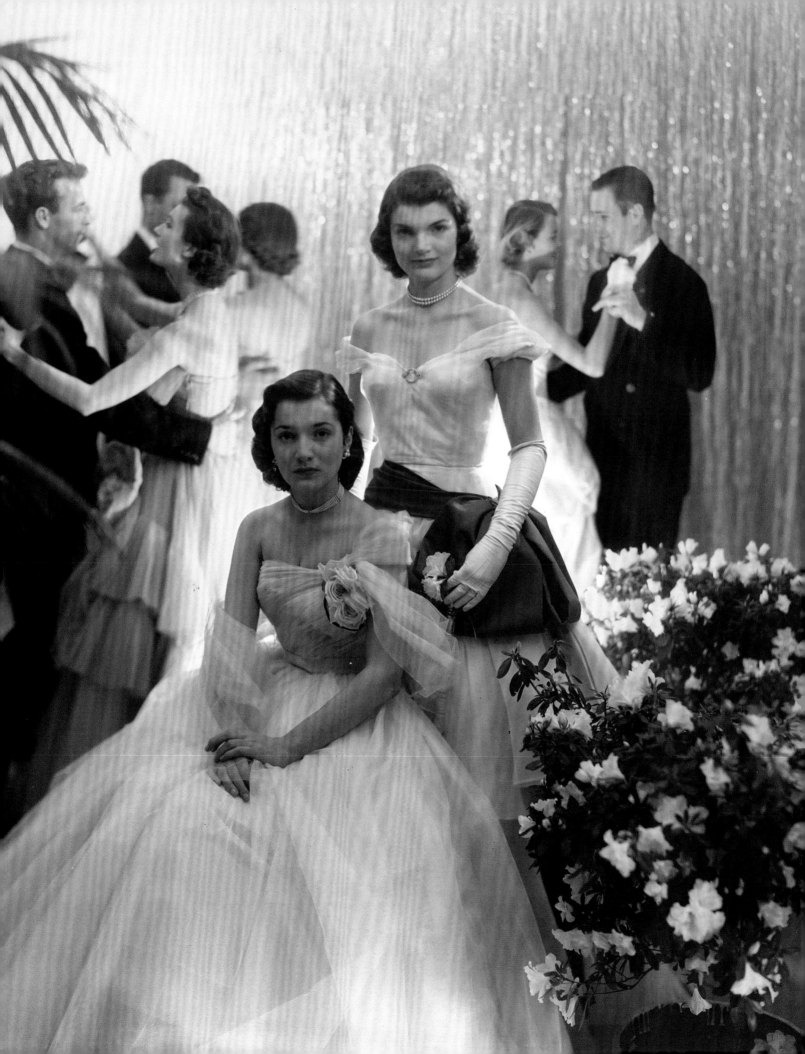

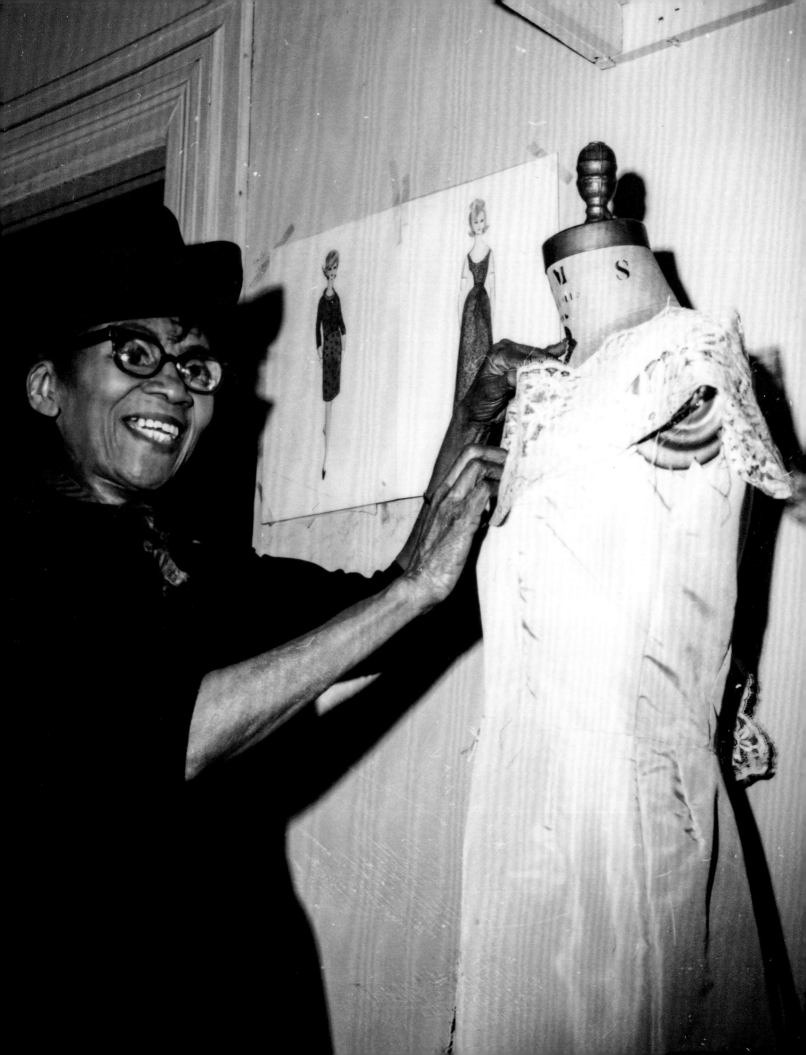

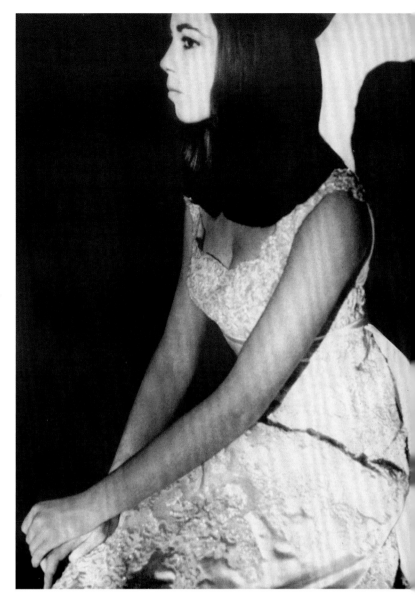

clients like Marjorie Merriweather Post, sole heiress to the Post cereal fortune. Lowe proudly recalled an incident that occurred in Paris, when she and Mrs. Post attended the same fashion show. Lowe was visiting Paris on a trip as a reporter for the *New York Age* in 1949. Upon running into Mrs. Post at one of these shows, she was deeply surprised to watch her client introduce her to acquaintances around the room as "Miss Lowe, head of the American House of Ann Lowe."[111] It is notable that someone of Mrs. Post's social status would feel comfortable introducing her African American dress designer around a fashion house in Paris with a manner that suggested that Lowe's work was of the same quality as French designers'. Lowe recounted this story in several interviews and was clearly amused by the encounter. Mrs. Post had many occasions to wear formal clothes, and while she purchased gowns from a wide range of high-quality stores and designers, such as Saks Fifth Avenue and Hattie Carnegie, her patronage of Lowe's work is representative of the interest that socialites of all ages had in Lowe originals throughout the major metropolitan centers of the East Coast. This incident also suggests a warm working relationship between the two women.

### "A Major Fashion Designer"

The years between 1955 and 1958 may have been the peak of Lowe's independent career. She was occasionally quoted in the *New York Times* as an expert on debutante style, and her business continued to grow. By 1955 Lowe moved her business to 973 Lexington Avenue and renamed the shop Ann Lowe Gowns. Classified ads provide an intriguing look into the growth of Lowe's business and suggest that the number and types of commissions had increased dramatically by this time. She sought drapers who were "experienced only, high priced evening gowns, must be fast: high salary."[112] Her dresses were in demand throughout New York, and hundreds of young women were making their social debut each year in an Ann Lowe original. Her business was thriving, even without the advantages of a partnership with the Stehli family. When Arthur Cone died in a car accident in

1958, however, Lowe's luck changed dramatically. Arthur had maintained a watchful eye over the financial aspects of his mother's business immediately after the partnership with the Stehli family dissolved at the beginning of the decade, and at the time of his death, Ann Lowe Gowns began to have severe financial problems. It appears that Lowe did not hire a financial advisor or bookkeeper after Arthur's death.[113] Maintaining her own business quickly became too much for Lowe; glaucoma was advancing in her right eye, and she was quickly losing track of her bills and taxes. By 1960, Lowe owed thousands of dollars in supplies and back taxes, forcing her to close.[114]

A dressmaker of Lowe's status would not be able to operate without a workroom. Fortunately, the quality of Lowe's professional reputation within New York meant that Lowe would not be without a professional salon space for long.

OPPOSITE: Ann Lowe with mannequin, 1960s. Ann Lowe / Madeleine Couture Archives,

1962–67. Courtesy of Sharman S. Peddy in memory of Ione and Benjamin M. Stoddard.

ABOVE: Justina Seeburg in Ann Lowe gown, *Town & Country* magazine, June 1966.

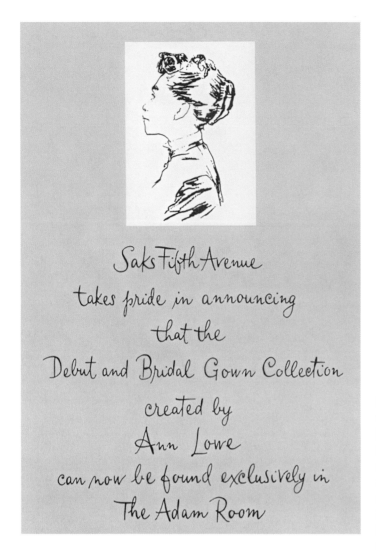

*Saks Fifth Avenue
takes pride in announcing
that the
Debut and Bridal Gown Collection
created by
Ann Lowe
can now be found exclusively in
The Adam Room*

Her financial affairs prevented her from reopening her own salon, but as word spread that one of New York society's most prolific designers was out of business, a prestigious opportunity soon appeared. Saks Fifth Avenue presented an offer for a partnership in its exclusive boutique, the Adam Room, and Lowe agreed to become its head designer. The Adam Room was an established department on the fifth floor of the flagship store. It specialized in custom and ready-to-wear debutante and bridal gowns. Promotional materials featuring a pen-and-ink portrait of Lowe in profile were produced to announce the arrival of New York society's beloved designer: "Saks Fifth Avenue takes pride in announcing that the Debut and Bridal Gown Collection created by Ann Lowe can now be found exclusively in The Adam Room."[115] This was a prestigious step forward, with many possibilities for Lowe's growth. But the details of the arrangement, described in the *Saturday Evening Post* a few years later, highlight Lowe's inexperience with financial matters. Her position at Saks was based upon a contract that was heavily weighted in the department store's favor:

Saks provided the workroom, *and Lowe bought her own materials and paid her own staff*; in turn, Saks bought Miss Lowe's output. Most of her customers did follow her, but the arrangement was doomed. "Not counting the dollars going into a dress but just the beauty that came out of it," Miss Lowe says, "I didn't realize until too late that on dresses I was getting $300 for, I had put about $450 into it."[116]

Lowe's pattern of undercharging was not exclusive to her work with Saks; one client from her private salon revealed happily to the *Saturday Evening Post* that Lowe "charged seventy dollars apiece for bridesmaid dresses that should have cost at least two hundred, but that's how she is."[117] In the same way that Lowe looked only at the beauty going into her designs, instead of the cost, she was unable to predict the additional financial burden represented by the Saks offer. She was released from the burden of managing the rent for a showroom and work space. However, in exchange for that freedom, she was introducing a third party into established relationships with her most lucrative clients and lowering the amount of profit she received for each gown. From the outside, the arrangement may have looked like a golden partnership, but it became a precarious arrangement for an independent designer. This partnership made excellent financial sense for the department store. For the small cost of maintaining a work space in the building on Fifth Avenue and probably providing credit backing for Lowe, it received high-quality couture work with a Saks Fifth Avenue label, in addition to a coveted list of young women from the Social Register who would be perfect customers for future services. Investing in an elderly designer who was become increasingly frail may appear to be an unsteady arrangement, but realistically, Saks had very little risk in the partnership.

Lowe's 1963 bankruptcy file provides a rare look at the details of her financial situation. There were ten claimants listed in the file. Five of these claimants were companies that sold fabric and other dressmaking supplies. Three claimants were related to taxes and unemployment. These suggest that

ABOVE: Line drawing of Lowe, Saks Fifth Avenue promotional materials for the Adam Room, *Alabama Heritage*, 1999.

Collection of Esther Provenzano.
OPPOSITE: Ann Lowe's son, Arthur Cone. Collection of Esther Provenzano.

PAGES 50-53: Debutante gown by Ann Lowe, 1956. Chicago History Museum, ICHi-175969.

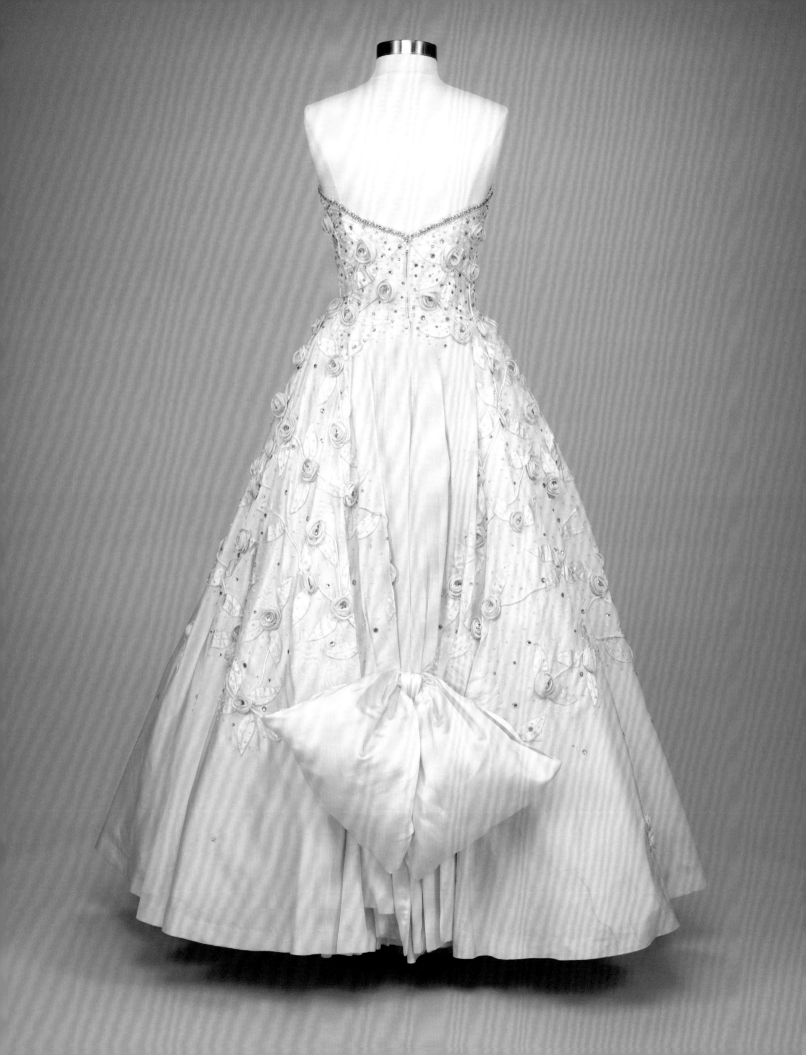

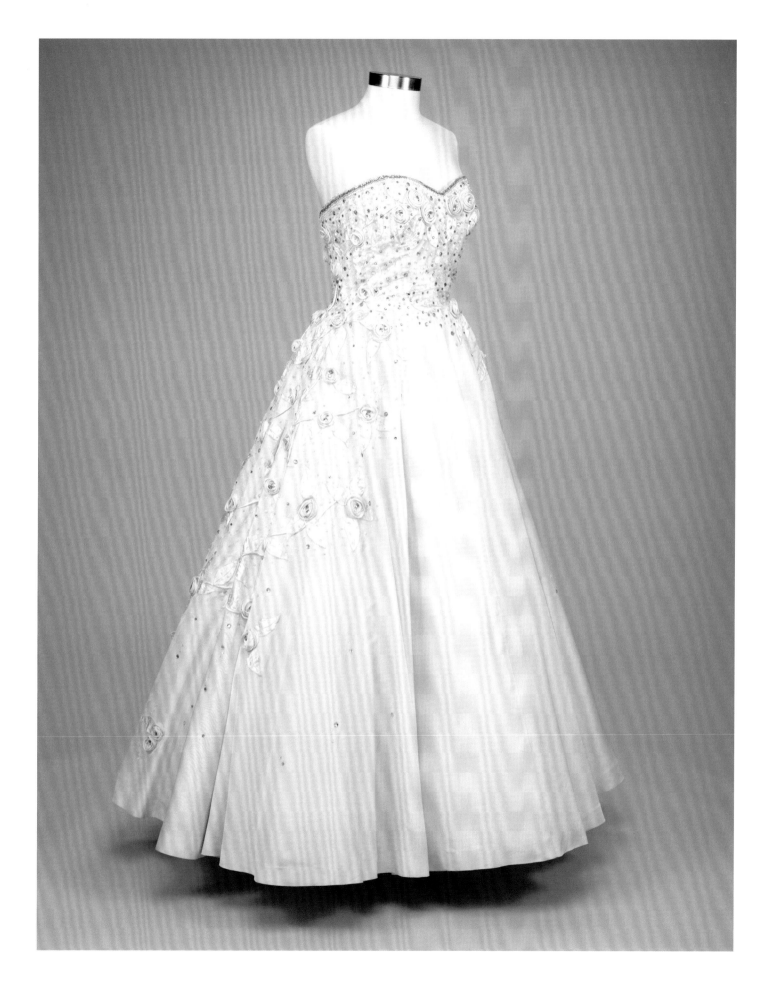

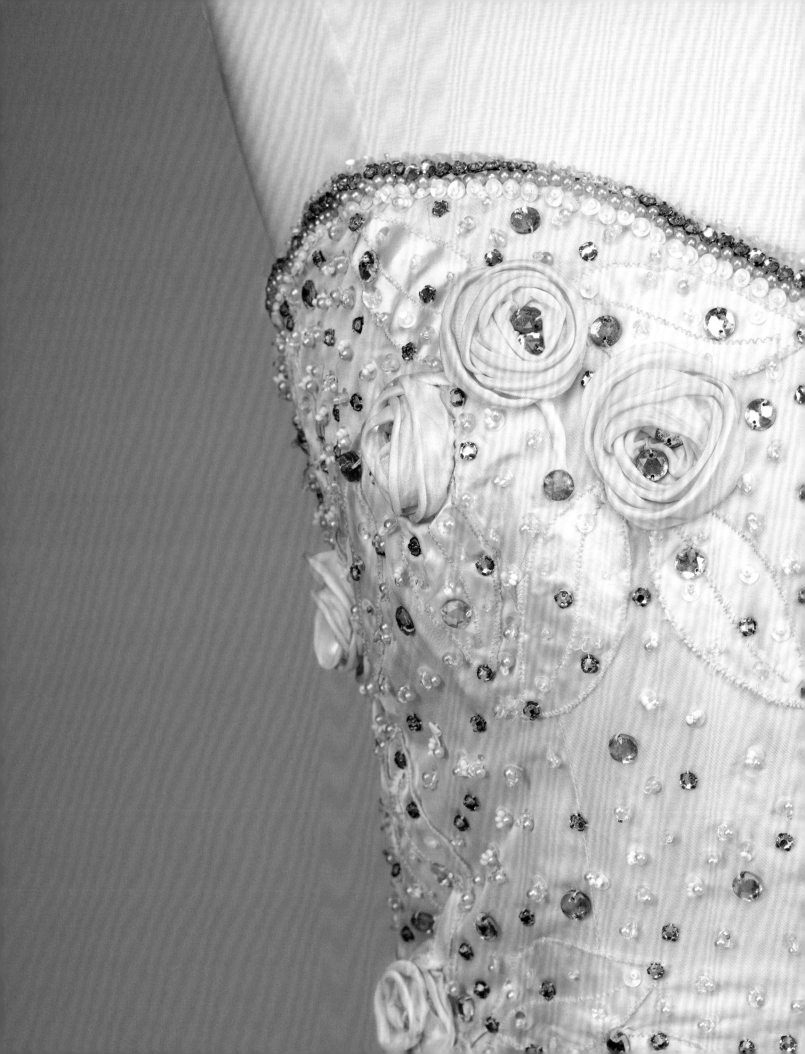

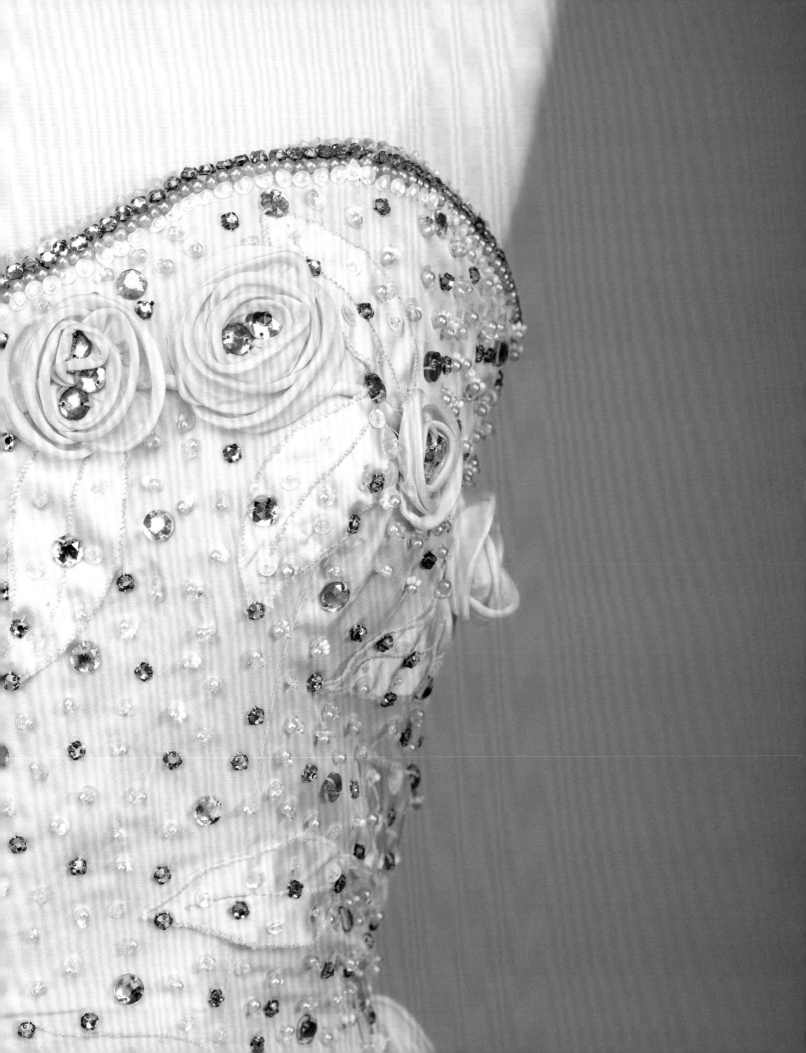

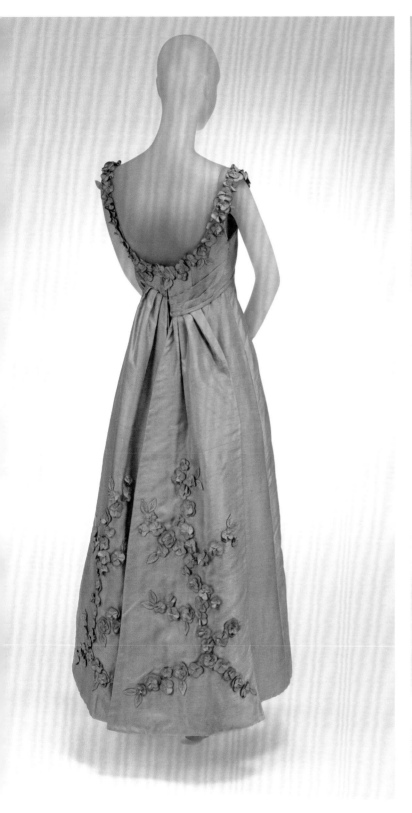

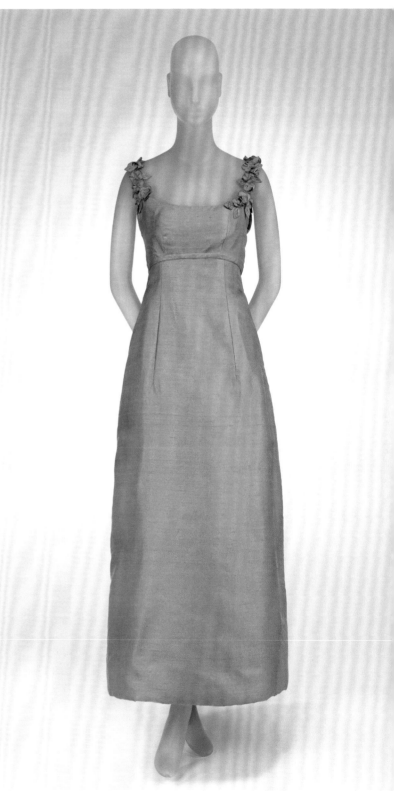

OPPOSITE: Label inside Saks Fifth Avenue Ann Lowe dress, 1962–64.

ABOVE: Orange silk dress by Ann Lowe for Saks Fifth Avenue, 1962–64 (back and front).

The Metropolitan Museum of Art, Gift of Mrs. Carli Tucker Jr., 1979 (1979.260.2).

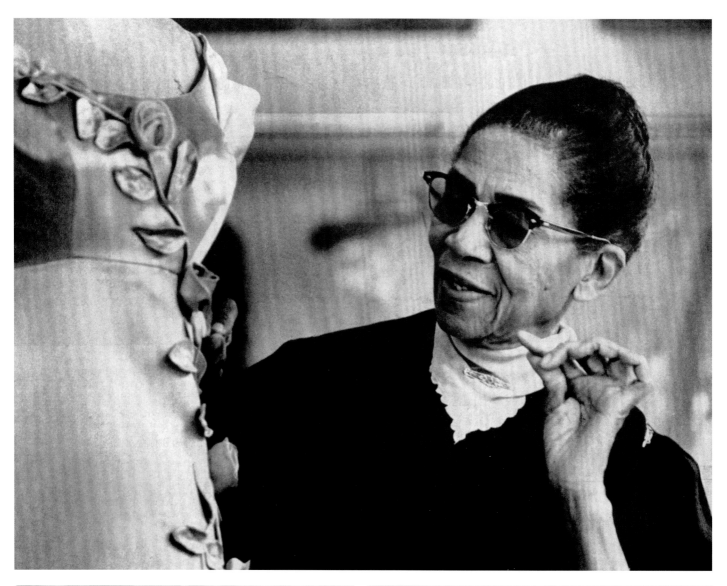

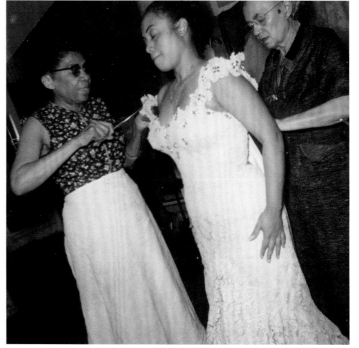

Lowe was still attempting to care for the financial details of the business herself. One claimant filed for $150 of missed salary. Saks Fifth Avenue (listed as doing business as Saks & Co.) was the largest claimant at $9,275.06. The size of its claim suggests that Saks may have advanced money to Lowe to pay staff salaries, material costs, or her own living expenses.[118] If she lost money with each dress order, it is difficult to see how she was covering her own living expenses, let alone the operating costs of her Adam Room salon.

The financial problems of 1962 were just the beginning of Lowe's troubles. Lowe left Saks at some point during that year and reopened in a small work space farther down Fifty-Third Street. Unfortunately, the majority of Lowe's employees chose to continue with Saks because it could pay more than Lowe was able to offer.[119] A few employees attempted to move with Lowe but returned to Saks when Lowe's financial problems affected the reliability of their salaries. Only her sister, Sallie, stayed by her side.[120]

A strong staff was an absolute necessity for Lowe at this point. Although she began her career sketching dress after dress, her increasingly poor eyesight made drawing impossible and severely limited her sewing capability. "I've had to work by feel," she admitted, "but people tell me I've done better feeling than others do seeing."[121] Without a staff to sketch and take up the bulk of the sewing, running a shop would be impossible. Lowe's sketcher and chief assistant remained at Saks, and Lowe was unable to hire new and highly trained workers who could meet the challenge of a high-volume couture shop. "I couldn't fill my orders," she admitted. "Things went from bad to worse." When this shop closed, Lowe "ran sobbing into the street. . . . The tears wouldn't stop."[122] Shortly after this, Lowe's right eye, which had been heavily damaged by glaucoma, was removed. Lowe had to stop working completely.[123]

After a period of rehabilitation, Lowe became a designer for Madeleine Couture, a dress shop in New York City. At Madeleine Couture, Lowe was able to have a fashion show where former customers did the modeling. Shortly after the show, Lowe began to have problems with her other

OPPOSITE, CLOCKWISE FROM TOP: Lowe in Thomas B. Congdon Jr., "Ann Lowe: Society's Best-Kept Secret," *Saturday Evening Post*. Lowe fitting dress with her sister Sallie Mathis. Lowe with Esther Provenzano (foreground) and another staff member. Both: Collection of Esther Provenzano. ABOVE: Floating Cloud debut dress, 1964. Ann Lowe (1898–1981). Museum of the City of New York, 94.38AB.

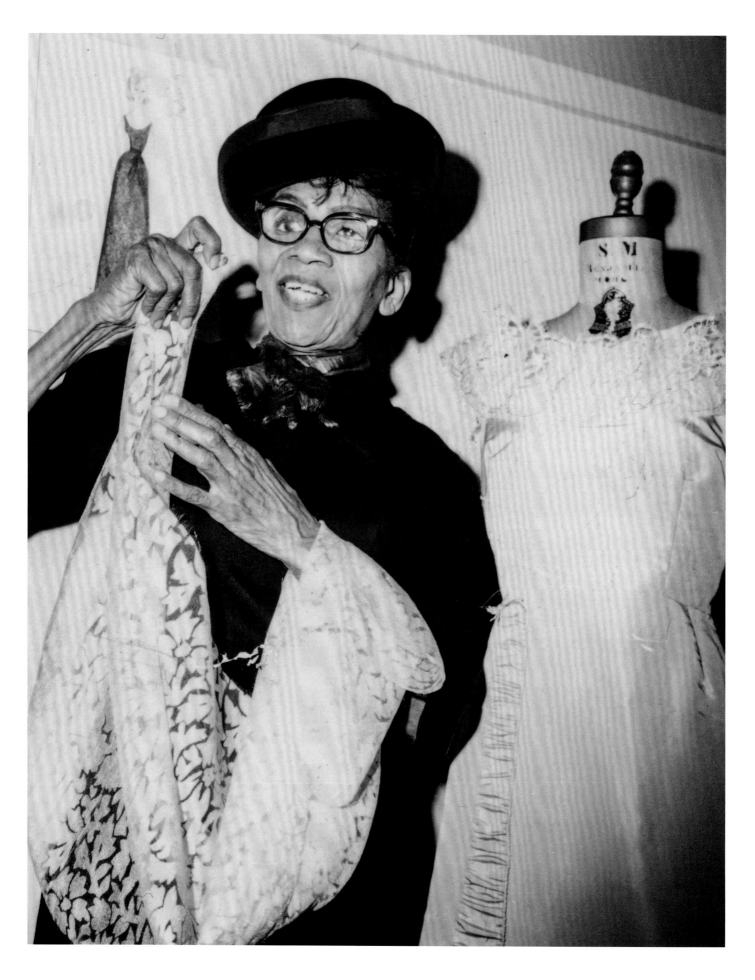

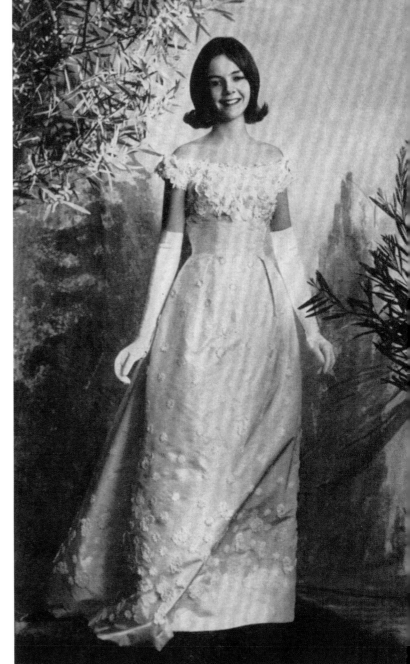

eye. Her attempts to continue working with a severe cata-
ract in her only eye led to embarrassing attempts to cover
up her problems:

> Terrified of losing her job, she tried to bluff. "Now here's
> a design I think you'll like," she would say to a customer,
> picking up a sketch and bringing it close to her eyes. "Oh,
> my goodness," she would add brightly, "isn't that ridic-
> ulous! I'm holding this sketch upside down!" The bluff
> worked through this past spring. She gave up her job at
> the shop in March.[124]

Lowe was completely unprepared for retirement. She had
no savings and no way of paying her living expenses without
working. The surgery she needed to restore sight to her only
eye was high risk. It could possibly destroy whatever sight
she still had in her left eye, and a number of surgeons refused
to take the chance. With the help of her previous clients, she
eventually found a surgeon who would attempt to remove the
cataract. "If I can't design dresses," she told him, "I'd rather
fly off the Empire State Building." The doctor donated his
services and covered the costs of the operating room.[125] The
August 1964 operation restored sight to Lowe's left eye, and,
amazingly, she prepared her business again. She contacted
her previous customers through postcards—five hundred
handwritten postcards, according to the *Saturday Evening
Post*. The campaign worked, and Lowe was back to sewing for
a number of her previous customers. She continued to create
wholesale designs, and she maintained her close and person-
alized working style with her couture clients.

### No Longer a Secret
In 1967, Lowe's studio, with the help of her staff of five seam-
stresses, made eighty-five dresses for the largest debut balls
in the city. Lowe had begun working with a new partner in
1965, a designer named Florence Cowell, under the label
A. F. Chantilly.[126] Lowe was no longer sketching or sewing
at this time. Finishing such a high number of custom gowns
at the same time was an impressive accomplishment for a

five-person staff. Lowe mentioned that she was finally able
to price her dresses appropriately. In 1957, during a period
when she was not always comfortable with her pricing struc-
ture, Lowe charged "up to $500" for her gowns.[127] By 1967,
however, the gowns were priced between $200 and $995,
with the average price for a debutante gown being between
$395 and $495."[128] Gowns could even be purchased on a

OPPOSITE: Ann Lowe with bolt of
fabric. Ann Lowe / Madeleine Couture
Archives, 1962–67. Courtesy of

Sharman S. Peddy in memory of
Ione and Benjamin M. Stoddard.
ABOVE: Madeleine Couture,

New York, gown. From "First
Appearances on the Social Scene,"
*Town & Country*, June 1963.

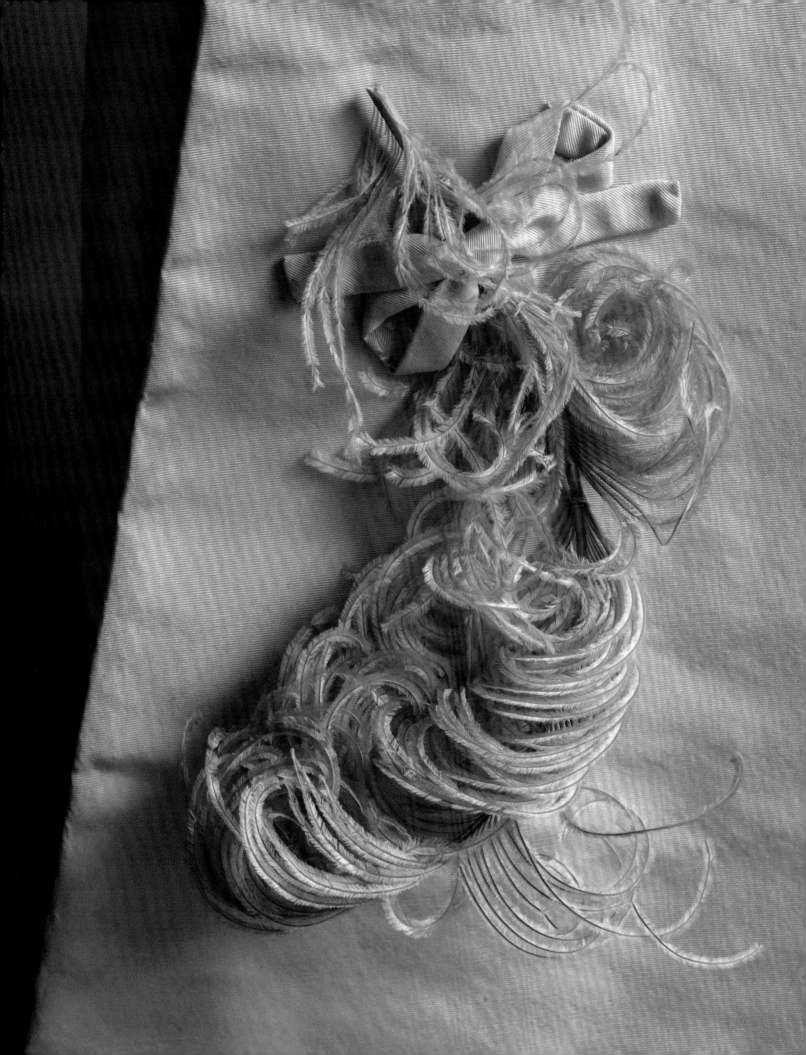

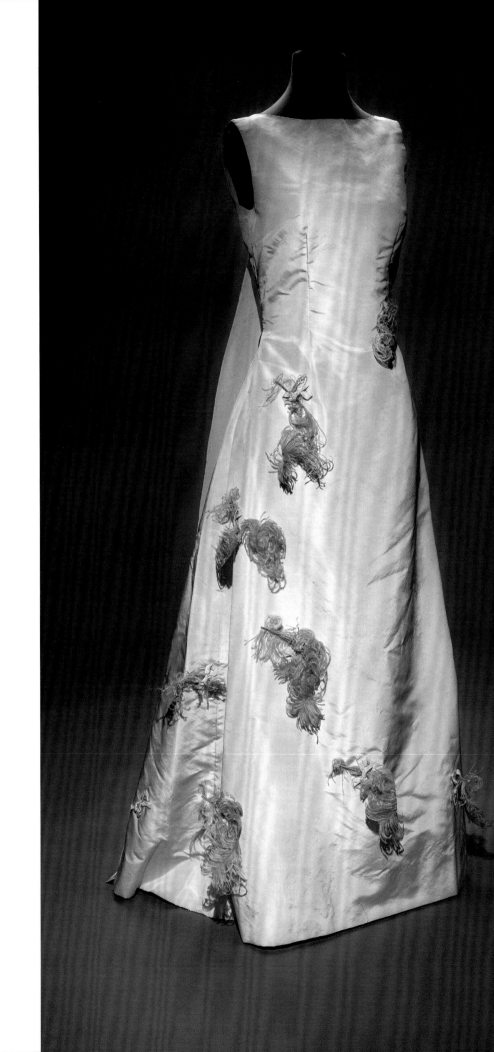

RIGHT: Pink dress with ostrich feathers
by Ann Lowe for Madeleine Couture,
New York, 1964. OPPOSITE: Detail. Private
collection of Sharman Stoddard Peddy.

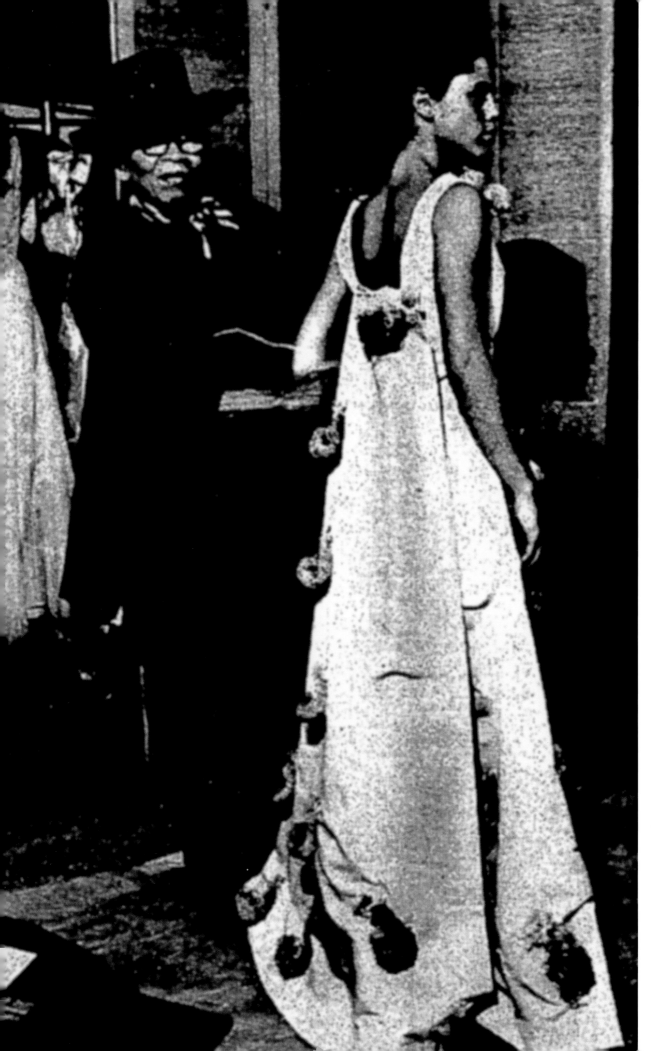

LEFT: Lowe fitting Madeleine Couture dress. From Eleanor Coleman, "Deb's Fairy Godmother," *The Milwaukee Journal*, June 27, 1966. OPPOSITE: Pink dress with ostrich feathers (back view) by Ann Lowe for Madeleine Couture, New York, 1964. Private collection of Sharman Stoddard Peddy.

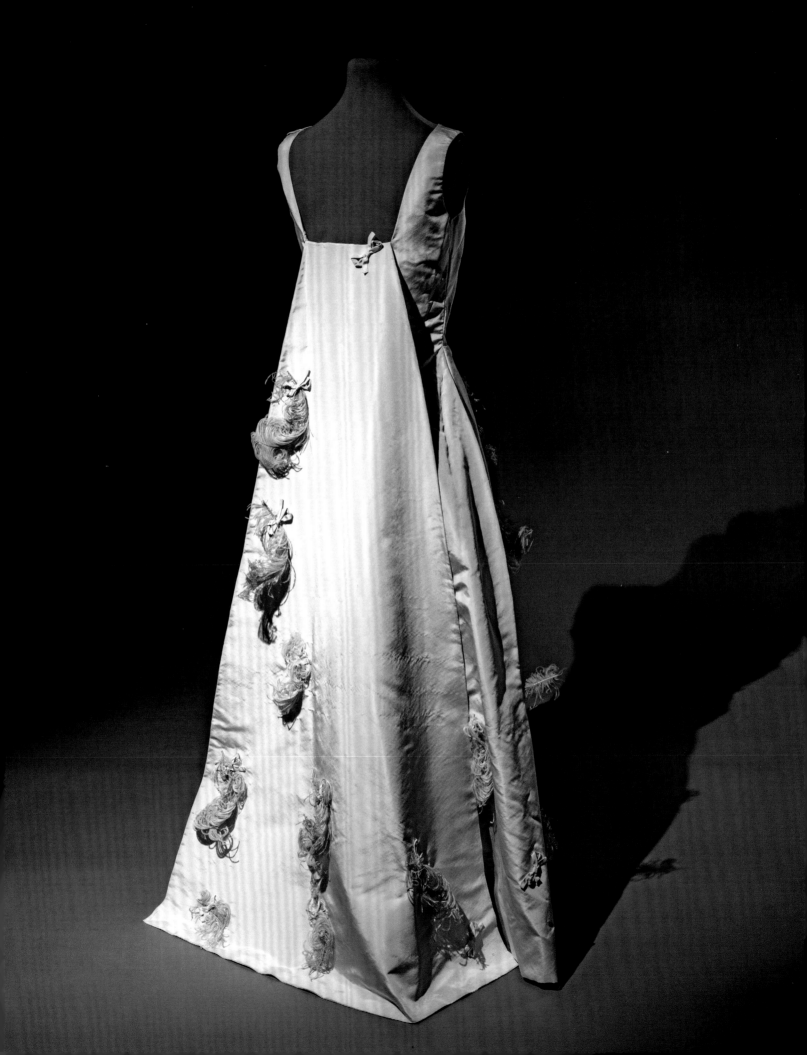

*Original* **DEBUTANTE GOWNS** BY ANN LOWE

and 1968, Lowe gave three national magazine interviews, one television interview on *The Mike Douglas Show*, and a number of newspaper interviews. One of her debutante gowns was featured in *Town & Country*, and she was slowly pulling away from her position as "Society's Best-Kept Secret" and into public view.

Lowe's tone in March 1965 in a letter to Rosemary Lee Johnston was upbeat. She acknowledged that she had experienced "lots of good luck, but twice as much bad" and also that she "knew how to make money for others to spend because I had bad management," but she was hopeful for new opportunities.[129] Lowe would not create any more high-profile gowns during her career, but she was still selling a number of debutante gowns through high-end department stores around the country, along with the business from her Manhattan shop. She donated a hot pink gown with inserted lace detail to the Tampa Junior League in 1967 in response to a request from Nell Lee Greening, the daughter of Nell Lee. The Junior League was still one of the leading society organizations in Tampa, and the Lee family was active in work for the League. "I contacted her in August," Nell Lee Greening told a staff writer for the *Tampa Daily Times*, "and Ann agreed to send one of her gowns here to help us publicize the Ball. It's a copy of a gown that originally sold in St. Louis for $750.00 and it's truly a work of art."[130] The Lees celebrated Lowe's success proudly. Rosemary, Louise, Grace, and Nell passed down stories about her to the following generations and carefully saved newspaper and magazine articles about her exciting career. "We were just delighted with all of the things she did," Nell Lee Greening recalled in January 2012. "It made us feel so good for her. It was wonderful what she did because it was not easy at that time!" When the details about the Junior League gala gown were being discussed, Lowe mentioned how much she would like to finally see what a large Tampa ball was like. Lowe had designed hundreds of dresses for Tampa dances, but each event was segregated so she had no way of seeing her gowns on the dance floor. Nell Lee Greening was excited to be able to make that happen. Lowe came to Tampa to visit

walk-in basis, and a custom gown could be ordered in 1966 for as low as $150. With a revised pricing structure, a strong and highly skilled staff, and a new modern outlook on her dress designs, Lowe was in a position to build upon her success and continue to bring Ann Lowe gowns into a new period of growth and success. In the period between 1964

the Lees and attend the Junior League gala. The Lee family escorted Lowe to the event, and although a few attendees were angered by the presence of an African American at a historically white event, the Lee family felt that Lowe had every right to attend. Ann Lowe was a celebrity in the eyes of the Lee family, and not just any celebrity, but one whom they had personally helped along the way. After fifty years of contributing her talents to the formal events of Tampa, Lowe was finally able to attend a Tampa ball as a guest of honor.[131]

By the time of the Junior League gala, Lowe's health was continuing to fade, and her career was coming to an end. The quality of Lowe's eyesight continued to decrease, and Lowe entered full retirement by 1972. Her shop closed, and Lowe moved to the home of Ruth Alexander, née Williams, in Long Island.[132] She received a number of local honors in New York City during the 1970s. In 1976, she was to be honored with a luncheon and fashion show held in her honor by an African American fraternity, Alpha Phi Alpha. This final show dedicated exclusively to Ann Lowe's work showcased a number of dresses Lowe created in the 1940s and 1950s. The citation read at the event highlighted her accomplishments:

> An American and international designer whose life has been filled with sagas of patience, sadness and happiness, she has dressed First Ladies of the nation. . . . There is no resentment of the illnesses, tragedies and financial problems that have beset her. . . . She opened her first salon with a borrowed $20,000 and soon her name became synonymous with elegance and beauty. She has provided clothing for the grand entrances of some of the most celebrated ladies of our land.[133]

Lowe was unable to attend the event, but a number of her family members were in attendance, and her granddaughter, an aspiring fashion designer named Audrey Hassell, accepted a plaque on Lowe's behalf. It seems very fitting that Lowe's final interview was given to the *Tampa Tribune* for the benefit of the Tampa residents who had been such an important part of Lowe's early career. Betty Phipps,

the *Tribune* reporter, met Lowe in her New York hospital room to discuss the Alpha Phi Alpha luncheon. Lowe was completely blind at this point, and when she was presented with the plaque from the banquet to honor her life achievements, Phipps noted that, that "she ran her fingers over the plaque, the heavy wood frame, the brass plate set on velvet, her fingers outlined the engraving, 'There are still a thousand ideas for dresses in my mind,'" Lowe told the reporter, "dresses which I see in great detail."[134]

## A Place in History

Ann Lowe was a talented woman with a truly remarkable career. She worked in a period in American history when social and political conditions created an oppressive environment for African Americans. Many had few resources, inadequate educational opportunities, and very little chance of reaching the height of their chosen fields. In this climate,

OPPOSITE: "Original Debutante Gowns by Ann Lowe" flyer. Collection of Ms. Margaret E. Powell.

ABOVE: *Park Avenue Social Review*, November 1965 Debutante Issue. Collection of Ms. Margaret E. Powell.

*Miss Ann Lowe Announces*
*her exclusive association with*
*A. F. Chantilly, Inc.*

*Ann Lowe*
*Debutante Gowns*
*Wedding and Ball Gowns*

FLORENCE COWELL
Couture Suits - Coats

*558 Madison Avenue*
*New York, New York 10022*

*Code 212*
421-8795-6

Lowe went from a childhood in a dilapidated rural Alabama schoolhouse at the turn of the twentieth century to selling thousand-dollar ball gowns on Madison Avenue. She created dresses of a lifetime for women from the most financially prosperous families of the United States. She designed thousands of gowns during a career that spanned nearly seventy years, but in the early twenty-first century, her work (with the exception of Jackie Kennedy's wedding dress) and name are virtually unknown.

During the 1980s and 1990s, a shift began to take place in the study of Lowe's career. African American historians began to discover her, and fashion historians hurried to spotlight her work. When Lowe died in 1981, her obituary was published in papers throughout the country. The head of the Black Fashion Museum, Lois Alexander, took on a daunting task when she made public calls for donations of work by African American designers for her small museum in Harlem, New York City. A number of Lowe's gowns from her New York years were donated and preserved through this heroic effort. Historians began to write about Lowe and other African American designers who disappeared from view. Although there was not a lot of information available at the time, the work of Lois Alexander and her book *Blacks in the History of Fashion* and Rosemary Reed Miller and her book *Threads of Time: The Fabric of History; Profiles of African American Dressmakers and Designers, 1850–2002* opened doors and began a discussion about these talented men and women.

Lowe was not necessarily concerned about being commemorated. Designing dresses brought her joy, and the rest of it just didn't seem to bother her. She didn't talk about her work the way that some people do when they are interested in immortality. "I like for my dresses to be admired," she told the *Saturday Evening Post* in 1964. "I like to hear about it—the oohs and ahs as they come into the ballroom. Like when someone tells me, 'The Ann Lowe dresses were doing all of the dancing at the cotillion last night. That's what I like to hear.'"[135]

ABOVE: Announcement of Ann Lowe's new association with A. F. Chantilly. Collection of Ms. Margaret E. Powell. OPPOSITE: Ann Lowe with Florence Cowell. Johnson Publishing Company Archive. Courtesy J. Paul Getty Trust and Smithsonian National Museum of African American History and Culture. Made possible by the Ford Foundation, J. Paul Getty Trust, John D. and Catherine T. MacArthur Foundation, Andrew W. Mellon Foundation, and Smithsonian Institution.

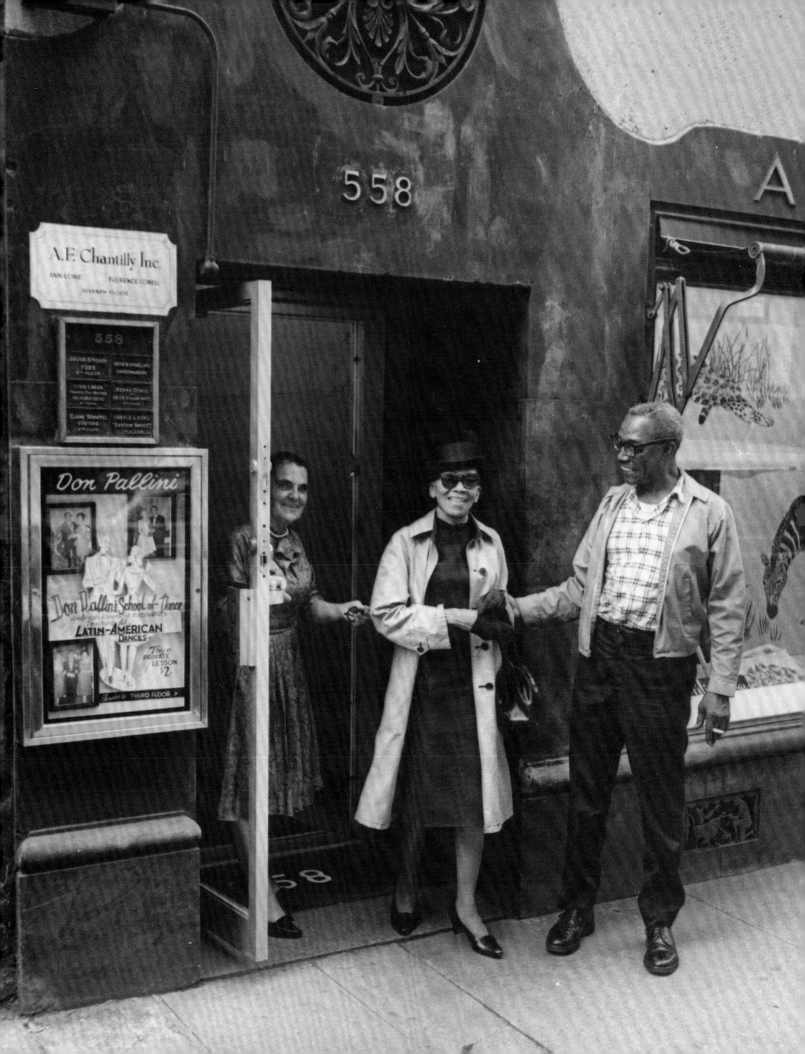

1. Elizabeth Watts, "Guests from All Over U.S. in Newport for Wedding," *Boston Daily Globe*, September 11, 1953, 10.

2. "New York Negro Designer Fashions Debutant Gowns," *Calgary Herald*, November 20, 1967, 31.

3. Anita Polk, "Anne [*sic*] Lowe . . . Designs 'One of a Kind,'" *Call and Post*, February 20, 1965.

4. Barbour County's population in 1890: 13,454 white residents and 21,444 African American residents. Benjamin Franklin Riley, *Alabama As It Is* (Montgomery: Brown Printing Co., 1893,) 190–93.

5. Thomas B. Congdon Jr., "Ann Lowe: Society's Best-Kept Secret," *Saturday Evening Post*, December 12, 1964, 75.

6. U.S. Department of the Interior, Thirteenth Census, 1910, Dothan Ward 3, Alabama, s.v. "Lee Cone," www.ancestry.com.

7. Vital records in the state of Alabama were not required until the late 1930s. Alabama birth certificates were not issued before 1908. Some counties kept birth ledgers. Barbour County (Lowe's birthplace) did not. See www.vitalrec.com/al.html#State, accessed January 12, 2012.

8. "Deaths," *New York Times*, September 3, 1967, 53.

9. Melissa Sones, "Fashioned Exclusively at Ann Lowe's Gowns," *American Legacy* 4 (1999): 32.

10. Sally Holabird, "Ask Her About Jackie's Bridal Gown," *Oakland Tribune*, August 7, 1966, 87; Ann Smith, "Ann Lowe Couturier to the Rich and Famous," *Alabama Heritage* 53 (Summer 1999): 8.

11. Marie Bankhead Owen, "Inaugural Ball Was a Brilliant Success," *Montgomery Advertiser*, January 17, 1911, 10.

12. Congdon, "Ann Lowe: Society's Best-Kept Secret," 75.

13. Polk, "Anne [*sic*] Lowe . . . Designs 'One of a Kind.'"

14. Wilma King, *The Essence of Liberty: Free Black Women During the Slave Era* (Columbia: University of Missouri Press, 2006), 71.

15. "Fashion Designer for the Elite," *Sepia*, August 1966, 33.

16. Lois K. Alexander, "Funeral Program Obituary," February 1981.

17. Geri Major, "Dean of American Designers," *Ebony*, December 1966, 138.

18. Major, 138.

19. State of Alabama Department of Education, *Annual Report of the Department of Education of the State of Alabama for the Scholastic Year Ending September 30, 1911*, 1911, 5.

20. U.S. Bureau of Education, *An Educational Study of Alabama*, 178–82.

21. The 1914 death of Janie Lowe is confirmed by her gravestone, documented in "Jane Cole Lowe, 1860–1914, Mother of Ann Lowe, Fashion Designer," *Alabama Heritage* magazine.

22. "Fashion Designer for the Elite," 33.

23. Holabird, "Ask Her About Jackie's Bridal Gown," 87.

24. Congdon, "Ann Lowe: Society's Best-Kept Secret," 75.

25. The Lee and Edwards Citrus Packing Company opened with Josephine's brother, Lamarcus Edwards, as a partner in 1910. "Florida Citrus Hall of Fame – Lamarcus C. Edwards, St (1870–1948) – Inducted 1970 – Welcome to the Citrus Hall of Fame," accessed September 25, 2011, http://floridacitrushalloffame.com/inductees/1970-1979/1970/lamarcus_edwards_sr.

26. Margaret Culbreth Hall, a lifelong white resident of Dothan, believes that Lowe was probably not shopping in the department store when she was discovered as "there were only two department stores during that time—the most notable being named Bloombergs where people would go in, sit down and be shown different articles of clothing." Hall's family believes that Lowe "was most likely a seamstress or one of the employees who showed the shoppers items for sale." It is not completely inconceivable to think that Lowe may have been shopping in the store, but they believe that although Lowe would not "necessarily have been prevented from entering a department store as a shopper . . . she would not have been encouraged." Elizabeth Hall interview of Margaret Culbreth Hall, email message to author, April 1, 2012.

27. Joan Apthorp, interview with author, August 18, 2011.

28. Holabird, "Ask Her About Jackie's Bridal Gown," 87.

29. Congdon, "Ann Lowe: Society's Best-Kept Secret," 75.

30. Apthorp, interview with author, September 2, 2011.

31. Congdon, "Ann Lowe: Society's Best-Kept Secret," 75.

32. This story would be repeated by Lowe in *Sepia* and other interviews; however, in a 1966 interview for the *Oakland Tribune*, Lowe would tell the reporter that she was a widow with a child by the age of fourteen and that this happened before the death of her mother. Janie died in 1914. This would have been at least two years before this incident in the Dothan store. An Alabama death certificate dated April 7, 1920, shows that Lee Cone, a forty-five-year-old tailor, died in Dothan, Alabama, on April 7, 1920. Holabird, "Ask Her About Jackie's Bridal Gown," 87.

33. Hillsborough County Planning & Growth Management, *Hillsborough County Historic Resources Survey Report Excerpt: Thonotosassa: Tampa*, 1998, 3.

34. Apthorp, interview with author, August 18, 2011.

35. A letter written from Lowe to Rosemary Lee Johnston spoke warmly about Lowe's experience in Tampa. This suggests that the arrangements regarding her work were acceptable to Lowe. Ann Lowe to Rosemary Lee Johnston, March 1965.

36. "Beautiful Wedding," *Tampa Daily Times*, January 1, 1917, 8.

37. Nell Lee Greening, interview with author, January 18, 2011; Elinor Boushall, interview with author, January 19, 2012.

38. Congdon, "Ann Lowe: Society's Best-Kept Secret," 76.

39. Apthorp, interview with author, August 18, 2011.

40. Congdon, "Ann Lowe: Society's Best-Kept Secret," 76.

41. "Fashion Designer for the Elite," 33.

42. Holabird, "Ask Her About Jackie's Bridal Gown," 87.

43. Holabird, 87.

44. Congdon, "Ann Lowe: Society's Best-Kept Secret," 76.

45. Holabird, "Ask Her About Jackie's Bridal Gown," 87.

46. "Fashion Designer for the Elite," 33.

47. Congdon, "Ann Lowe: Society's Best-Kept Secret," 76.

48. Alexandra Frye, "Fairy Princess Gowns Created by Tampa Designer for Queens in Gasparilla's Golden Era," *Tampa Tribune*, February 7, 1965, 6-E.

49. U.S. Department of the Interior, Fourteenth Census, 1920, Tampa City, Hillsboro [*sic*] County, Florida, s.v. "Caleb West," www.ancestry.com.

50. "Will Go to New York," *The Social Mirror*, November 1927.

51. "Will Go to New York."

52. "Will Go to New York."

53. Frye, "Fairy Princess Gowns," 6-E.

54. The Hillsborough Public Library oral history project records interviews with African American residents of Hillsborough County. Dora Reeder, the daughter of Martha Ravannah, recorded her interview in 2001,

and it is available in audio and pdf versions. "Dora Reeder oral history interview by Marti Everitt, July 10, 2001 (Transcript)," Hillsborough Remembers Oral History Collection, Hillsborough Public Library, accessed December 17, 2021, https://digitalcollections.hcplc.org/digital/collection/p15391qs/id/373/rec/38. Accessed December 17, 2021.

55. Frye, "Fairy Princess Gowns," 6-E.
56. Frye, 6-E.
57. Congdon, "Ann Lowe: Society's Best-Kept Secret," 76.
58. "Advertisement," *Tampa Morning Tribune*, October 10, 1928, 12.
59. Frye, "Fairy Princess Gowns," 6-E.
60. Frye, 6-E.
61. Betty Phipps, "Ann Cone Lowe: A Tampa Legacy Is Honored in New York," *Tampa Tribune*, August 7, 1976, 1-D.
62. Phipps, 1-D.
63. Frye, "Fairy Princess Gowns," 6-E.
64. Elinor Boushall, interview with author, January 19, 2012.
65. "Reigning Queen of Gasparilla Becomes Bride," *Tampa Sunday Tribune*, April 25, 1926, 37.
66. "Reigning Queen of Gasparilla Becomes Bride."
67. Nancy A. Hewitt, *Southern Discomfort: Women's Activism in Tampa, Florida, 1880s–1920s* (Champaign: University of Illinois Press), 146.
68. Lowe to Rosemary Lee Johnston, March 1965.
69. Phipps, "Ann Cone Lowe: A Tampa Legacy is Honored in New York," 12-D.
70. Information from the Polk's City Directory and the 1920 Census.
71. Apthorp, interview with author, September 10, 1911.
72. "Fashion Designer for the Elite," 34.
73. Congdon, "Ann Lowe: Society's Best-Kept Secret," 76.
74. Phipps, "Ann Cone Lowe: A Tampa Legacy is Honored in New York," 1-D.
75. Elizabeth Hawes, *Fashion Is Spinach* (New York: Random House, 1938), 124.
76. Nell Lee Greening, interview with author, January 18, 2011.
77. "Will Go to New York."
78. "Will Go to New York."
79. "Will Go to New York."
80. Nell Lee Greening, interview with author, January 18, 2011.
81. Congdon, "Ann Lowe: Society's Best-Kept Secret," 76.
82. "Will Go to New York."
83. Congdon, "Ann Lowe: Society's Best-Kept Secret," 76.
84. Elinor Boushall and Jo Apthorp, interview with author, January 19, 2012.
85. "Will Go to New York."
86. "Fashion Designer for the Elite," 34.
87. Hawes, *Fashion Is Spinach*, 203–5.
88. Congdon, "Ann Lowe: Society's Best-Kept Secret," 76.
89. Congdon, 76.
90. U.S. Department of the Interior, Fifteenth Census, 1930, Manhattan Enumeration District 31-520, District 22, New York, NY, s.v. "Caleb West, Tommie Mae Cole," www.ancestry.com.
91. Congdon, "Ann Lowe: Society's Best-Kept Secret," 76.
92. Congdon, 75.
93. Nan Robertson, "A Debutante Assembles Herself with Care," *New York Times*, October 30, 1957, 22.
94. Congdon, "Ann Lowe: Society's Best-Kept Secret," 75.
95. Major, "Dean of American Designers," 139.
96. Holabird, "Ask Her About Jackie's Bridal Gown," 87.
97. Congdon, "Ann Lowe: Society's Best-Kept Secret," 76.
98. Duchess du Mouchy, née Joan Dillon, email message to author, November 7, 2011.
99. *Vogue*, August 1955.
100. Lynn Sands, "High Times," *Newsday*, May 14, 1951, 42.
101. "Advertisement," *New York Times*, October 17, 1950, 57.
102. Sands, "High Times," 42.
103. Congdon, "Ann Lowe: Society's Best-Kept Secret," 76.
104. Holabird, "Ask Her About Jackie's Bridal Gown," 87.
105. Major, "Dean of American Designers," 138.
106. Major, 138.
107. Ted Burke, "The Frantic Deb Scene," *Town & Country*, June 1966, 70–71.
108. Robertson, "A Debutante Assembles Herself with Care," 22.
109. Major, "Dean of American Designers," 139.
110. "Advertisement," *New York Times*, September 19, 1957, 53.
111. Major, "Dean of American Designers," 142.
112. "Drapers (classified ad)," *New York Times*, October 7, 1955, 46.
113. Congdon, "Ann Lowe: Society's Best-Kept Secret," 76.
114. Congdon, 76.
115. Smith, "Couturier to the Rich and Famous," 12.
116. Emphasis added. Congdon, "Ann Lowe: Society's Best-Kept Secret," 76.
117. Congdon, 75.
118. Bankruptcy docket, United States District Court, New York 63 B 105.
119. Congdon, "Ann Lowe: Society's Best-Kept Secret," 76.
120. Sones, "Fashioned Exclusively at Ann Lowe's Gowns," 39.
121. Congdon, "Ann Lowe: Society's Best-Kept Secret," 75.
122. Congdon, 76.
123. Congdon, 76.
124. Congdon, 76.
125. Congdon, 76.
126. "Wholesale-Retail Company Formed," *Women's Wear Daily*, July 27, 1965, 14; "Fashion Designer for the Elite," 35.
127. Robertson, "A Debutante Assembles Herself with Care," 22.
128. Virginia Lee Warren, "For Debutantes: Bare Backs," *New York Times*, November 17, 1967, 42.
129. Ann Lowe to Rosemary Lee Johnston, March 1965.
130. *Tampa Daily Times*, Undated clipping, 1967.
131. Elinor Boushall, interview with author, January 19, 2012; Elinor Boushall, email message to author, September 10, 2011.
132. Phipps, "Ann Cone Lowe: A Tampa Legacy is Honored in New York," 1-D.
133. Phipps.
134. Phipps.
135. Congdon, "Ann Lowe: Society's Best-Kept Secret," 75.

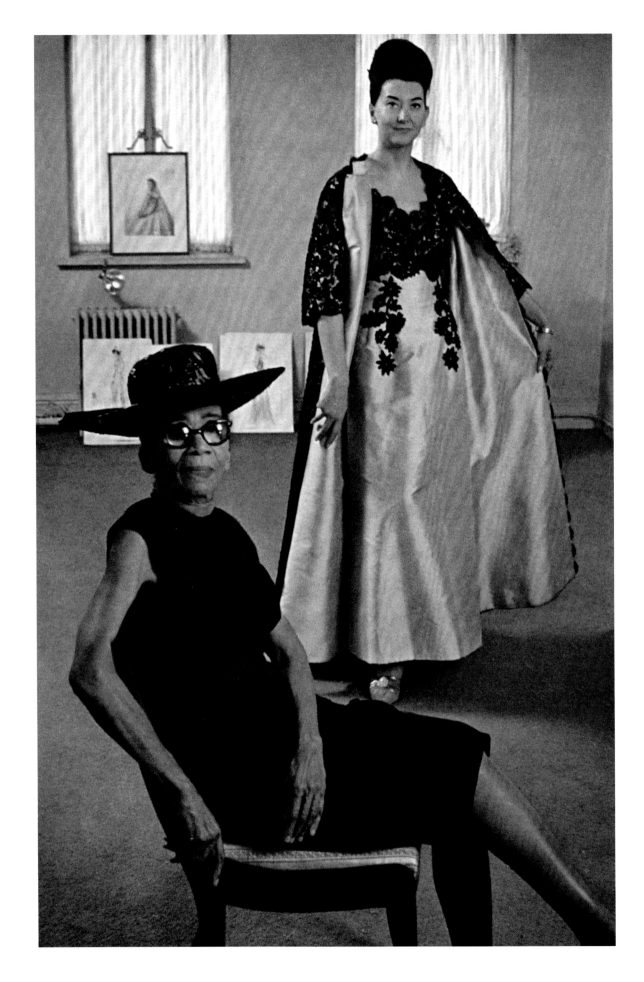

# Ann Lowe: American Couturier

ELIZABETH WAY

## Ann Lowe in Context

Margaret Powell's scholarship on Ann Lowe's extraordinary life and career has recovered Lowe as a major American fashion designer, one whose creative work was widely admired—and decimated—by the press, local and national, from the 1920s through the 1960s. That she has not been recognized previously as one of the most important American designers to create in an elite, custom fashion space does not diminish her impact or the breathtaking beauty of her gowns. The term *haute couturier* is technically reserved for members of the French fashion governing body, the Chambre syndicale de la haute couture. However, Ann Lowe's design creativity and the quality of her work place her on the level of a couturier, as her client, the powerful businesswoman, socialite, and philanthropist Marjorie Merriweather Post, recognized when she introduced Lowe to a couture fashion crowd as "head of the American House of Ann Lowe."[1]

As a Black woman in Jim Crow America, Lowe took a very different path to the status of elite fashion designer than her French and white American counterparts. She was part of an important legacy of Black American fashion makers, including forebears such as Elizabeth Keckly (1818–1907) and contemporaries like Zelda Wynn Valdes (1905–2001). Keckly was a highly respected dressmaker who used her fashion skills and ingenuity to buy her freedom from slavery, and she worked her way up to become the most sought-after mantua-maker (dressmaker) in 1860s Washington, D.C. Wynn Valdes, like Lowe, lived in Harlem, and she, too, created high-end custom gowns. Her work also garnered national attention, though she specialized in fashion and stage costumes for the leading Black performers of the twentieth century, including Josephine Baker, Dorothy Dandridge, and Ella Fitzgerald, as well as white performers like Mae West. These Black fashion makers, as well as countless others, known and unknown to history, contributed significantly to American fashion culture. Lowe, as an exemplary Black fashion designer working in the couture tradition—high-end, intricately constructed, and custom-made for individual clients—was not singular. A history of Black fashion makers from the antebellum period, and likely before, can be told through the story of Lowe's own family. Her grandmother Georgia Cole "was sewing before freedom,"[2] and she, with Lowe's mother, Janie Lowe, used dressmaking to support their family in Alabama during the Reconstruction and Jim Crow eras, when the vast majority of Black southern women were restricted to low-status, low-paying jobs in agriculture and domestic service. They instilled technical dressmaking skills in Lowe and nurtured her artistic creativity from early childhood—Lowe much later recalled, "The first thing I can remember is making flowers."[3] Georgia Cole and Janie Lowe's interactions with elite white women such as Elizabeth Kirkman O'Neal, the wife of Alabama's governor in 1911, were informed by generational experiences of how Black women could navigate relationships with wealthy white people to their benefit, and this too, was important knowledge that they passed to Ann Lowe.[4] These tools equipped her to practice freedom in an environment steeped in racism and sexism generally, but one that was also personally restrictive: she was a very young wife and mother with an unsupportive husband when she first set out for Florida in 1916, away from all that was familiar to her in Alabama. Historian Saidiya Hartman notes that for Black people in the Jim Crow South, "Locomotion was definitive of personal liberty."[5] When presented with an opportunity, Lowe exercised her personal liberty and moved, first to Tampa and then to New York City. Scholarship on Lowe's biography and examinations of her work are valuable in fashion studies for creating a more accurate and holistic picture of American fashion. But Lowe's personal history also illuminates an extraordinary account of a Black woman who navigated employment and relocation within the Jim Crow South, participated in the Great Migration, weathered the Great Depression and war years, and grew her business and her public profile during the civil rights era. Lowe herself would likely not consider her role so historically; however, her story humanizes Black American experiences during a tumultuous twentieth century, bringing these cultural shifts to the human level.

Ann Lowe (foreground) with model Judith Guile. From Gerri Major, "Dean of American Designers," *Ebony*, December 1966. Johnson Publishing Company Archive. Courtesy Ford Foundation, J. Paul Getty Trust, John D. and Catherine T. MacArthur Foundation, Andrew W. Mellon Foundation, and Smithsonian Institution.

Powell and journalist Judith Thurman note that Lowe's reportage of financial figures tended to be inflated—for example, Lowe stated that she paid $1,500 for fashion school tuition in a period when Harvard's tuition was $150.[6] However, it is clear that her financial position in New York was rarely, if ever, secure enough to allow her substantial wealth. Powell outlines the deficiency of education available to Black children in Lowe's childhood Alabama that perhaps accounts for her lack of business acumen, as well as Lowe's preference for the creative aspects of her work over the monetary. In this, however, Lowe is similar to countless designers who divorce themselves from the quotidian aspects of running a business. Thurman states, "Some of the greatest designers have been hopeless with money. Paul Poiret and Charles James both died destitute. Yves Saint Laurent was a financial imbecile."[7] And like other designers who lacked shrewd partners and backers (Yves Saint Laurent's business was guarded by the savvy Pierre Bergé, and, notably, the company survived both partners), Lowe did not find significant financial success, nor did her label outlive her. And yet, the value of her work is undeniable.

In most cases, a Lowe dress is recognizable, with hallmarks of design and construction that identify her as the creator (see "Identifying Lowe's Work," page 97). Her later work from the 1950s, and especially the 1960s, survives in greater numbers than her early work from the 1920s, 1930s, and 1940s, and this later work is dominated by wedding and debutante dresses. Gowns for these traditional, nostalgic events—deemed some of the most important occasions for elite white women in a period when advantageous marriage was their ultimate aim—were never meant to be vanguard fashions. Lowe created garments to enhance the beauty and confidence of women at important moments when they were expected to command attention and perform their ascribed societal roles. An "ex-debutante" related to the *Saturday Evening Post* in 1964, "I was no beauty when I was eighteen . . . but when I put on my Ann Lowe dress, I felt I owned the world."[8] Although Lowe's designs were not typically avant-garde, she did create cutting-edge fashions in certain contexts. Her work consistently reveals her as a highly sophisticated designer who was enmeshed in fashion culture and well aware of its changes and trends. This is easily apparent in her eveningwear designs but also in the evolving details of her traditional gowns. Lowe worked with women, one-on-one, to design dresses that embodied the designer's signature feminine beauty but also the clients' wants and needs. Historian and fashion scholar Tanisha Ford notes that during "the peak years of Jim Crow segregation, when black seamstresses were largely low-wage earning service industry workers, the title 'designer' or 'couturier' was typically reserved for esteemed white men. Seamstresses were deemed problem solvers, while couturiers were lauded as genius innovators."[9] Ann Lowe *was* a problem solver and a skilled seamstress. She was also an extraordinary and creative designer.

Lowe transformed the skills her mother and grandmother passed down to her into something bigger and more modern. She moved to New York City and established several design houses over the course of her career that collectively became a sought-after brand. She labeled her dresses with her own name, invoking the power of the label, described by theorists Pierre Bourdieu and Yvette Delsaut as "a simple word stuck on a product, [that] is without a doubt . . . one of the most economically and symbolically powerful words amongst those in use today."[10] Lowe claimed authority and expertise in fashion, as well as a deep and innate love for design. When she made statements to the press about the joy she experienced while designing, divine inspiration, the gowns she dreamed of making, and the countless ideas still in her head, Lowe positioned herself as a fount of fashion talent that could not be restrained by age or illness—a creative genius, a born couturier.

### Six Decades of Design

Lowe began sewing and designing garments at a very young age, and she developed her style over the decades that she was in business. Influences on her design aesthetic were likely wide-ranging, though she, like Christian Dior, had an affinity for nostalgic, nineteenth-century femininity and

Light teal and black lace evening ensemble by Ann Lowe, ca. 1966. The Metropolitan Museum of Art, Gift of Florence I. Cowell, 1980 (1980.433.2a, b).

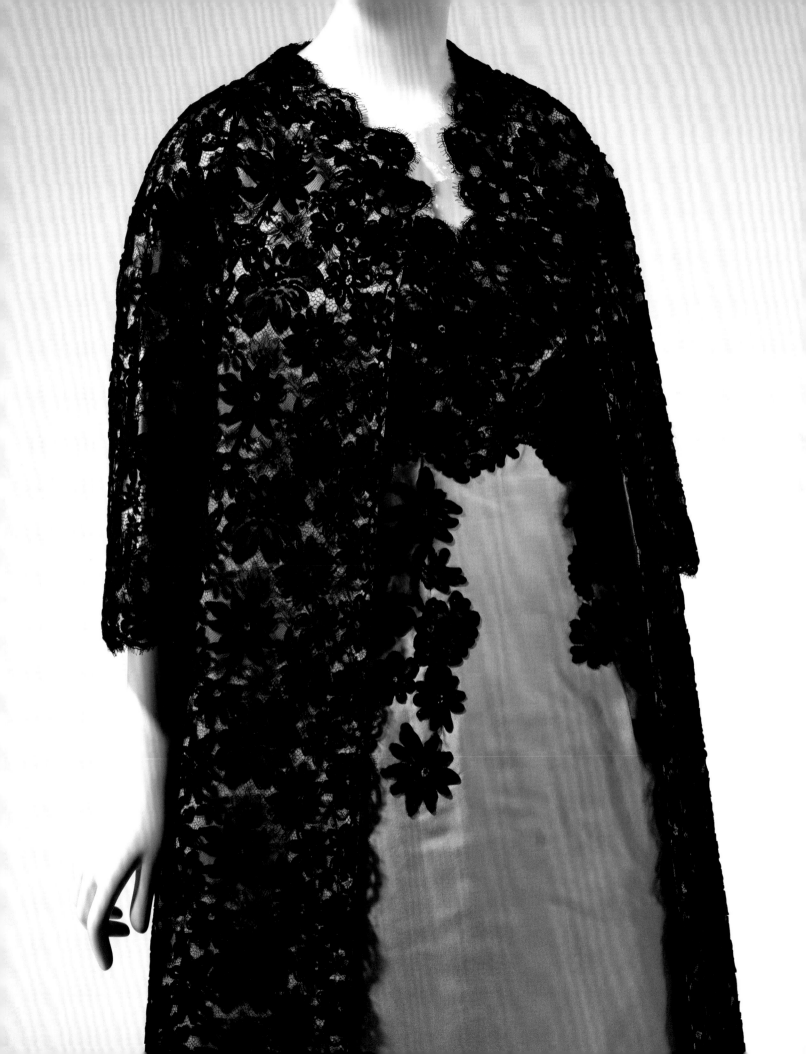

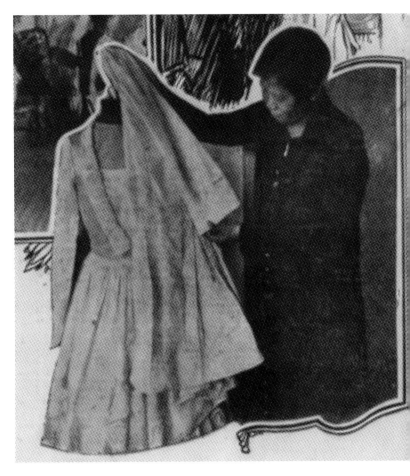

flowers. She referenced an "old-fashioned ball gown like one her mother had made for a Montgomery belle,"[11] when she sketched a design for Jacqueline Bouvier's 1953 wedding gown—her most famous work. And many of her surviving garments feature a tight-waisted, full-skirted silhouette (or an elongated, higher-waisted variation in line with 1960s styles) with her signature three-dimensional floral embellishments or similarly elaborate decoration. "Typical Ann Lowe,"[12] the gowns show a small stylistic sample in her range. These wedding and debut gowns were likely worn once or a handful of times, and, as they marked important events, they were saved and donated to museum collections. Lowe's work before the 1950s is less available to contemporary audiences, although some exist as extant garments and in photographs.

Powell's early research on Lowe led her to the Lee family archive, which shows photographic examples of Lowe's work for the family. A young and stylishly dressed Ann Lowe caught the eye of Josephine Lee in an Alabama department store in 1916, and Mrs. Lee, the wife of a wealthy citrus businessman, hired Lowe on the spot to work as a live-in dressmaker for herself and her four daughters outside of Tampa, Florida. Lowe remained close to the Lees throughout her life. Besides their 1917 wedding gowns, Lowe created chic daywear for the Lee twins, Rosemary and Louise, including blue broadcloth traveling suits for their trousseaux. These suits embody the fashionable and practical styles of the World War I era with narrow skirts and long jackets, while incorporating a luxurious touch through fur trim. Lowe also made a white day suit for younger sister Grace around the same time. Its full-length skirt and long jacket are again in line with the fashionable silhouette of the war years and a sensible choice for the college student. The white color may be a functional choice for the Tampa heat, or a preference for the styles made popular by women's suffrage advocates.[13] These examples show that Lowe could tailor garments as well as construct intricate ball gowns, though none of her suits seem to have survived.

As early as 1925, Lowe, under her married name, Annie Cone, drew press in Tampa for her wedding gowns. The

*Tampa Sunday Tribune* described her as "one of Tampa's dressmakers most in demand" for wedding gowns and trousseaux, as well as many of the wedding guests' gowns. The society correspondent notes "she executes lots of new styles and some original ones too,"[14] implying that Lowe copied styles from sources of new fashions, likely magazines, at the request of her clients, and she created her own designs. In 1926, the *Tampa Daily Times* featured an article on Lowe. She and her Jefferson Street dress shop were pictured in the paper (see "The Life and Work of Ann Lowe," page 26), which noted that she employed eight to twelve seamstresses but "does much of the finer work and always puts the finishing touches on her beloved wedding gowns and veils."[15] The article highlights her paradoxical position as a demanded Black dressmaker. The reporter notes Lowe's expertise in draping, cutting, and sewing, establishing her years of experience between Alabama and Tampa beginning with her first project, a quilt completed at the age of five, and totaling more than one hundred fifty wedding gowns. Lowe is also established as a style expert. She deems the *robe de style*, with its defined waist and full skirts, the most appropriate style for brides and states, "I enjoy sewing for anyone who can and will wear youthful clothes." She adds that she coaxes older women into the new styles, convincing them that they will

OPPOSITE: Lee twins in broadcloth suits, 1917. Apthorp Collection, Courtesy, Tampa Bay History Center. ABOVE: Ann Lowe with dress form. From Dorothy Dodd, "Ancient Wedding Formulae Ignored by Modern Bride," *Tampa Daily Times*, March 27, 1926.

clients clearly engaged in the fashionable influences of the period. The youngest Lee daughter, Nell, married in 1926, and her dress of white crepe romain, embellished with crystals and pearls, featured a handkerchief hem, full headpiece, and long-trained veil, all stylish elements for brides of the mid-1920s.[17] Photographs of the Gasparilla court between 1924 and 1928 show the festivals' various annual themes—Egyptian and Chinese themes play to fashionable, Western-imperialist trends of the decade—and Lowe incorporated costume versions of cultural dress elements into the gowns. Some years' dresses resemble more typical eveningwear fashions—1927 and 1928 Gasparilla court portraits show an arrangement of sleek, sequined "flapper" dresses and ruffled, tiered, and tulle *robe de style* gowns. The 1928 Gasparilla queen, Emala Parkhill, was photographed on her throne in a white velvet *robe de style* with a form-fitting bodice and a full skirt, appliquéd with three-dimensional flower buds and blooms. Lowe named this dress "My Rose Dream," and the embellishment is clearly recognizable as her work (see "The Life and Work of Ann Lowe," page 19 [flowers]). The Henry B. Plant Museum in Tampa holds two Gasparilla dresses from the 1920s: a 1924 gown worn by Gasparilla queen Sara Lykes Keller (the earliest known extant Lowe garment) and a 1926 court gown worn by Katherine Broaddus. The earlier dress is a sleeveless chemise style more in keeping with contemporary fashion than the Egyptian theme of Gasparilla that year—it was not Keller's presentation gown but was made for one of the festival's many dances. Powell has noted that the floral beading—applied in strings and not individually—was unusual for Lowe's craftsmanship, though the hemline beading is applied individually in Lowe's usual style. Keller's family attributed the design to Lowe, who also made Keller's wedding dress.[18] The 1926 lamé gauze dress has an asymmetrical bodice with a defined waistline and "an ornate starburst design decoration made of hand-sewn rhinestones, red sequin beads, and red jeweled stones,"[19] showing more fantastical design elements mingled with 1920s style.

Lowe and her assistants turned these "tremendous show pieces" out from her workroom in Tampa, located behind the

look good in the modern fashions. However, the article also sharply brings the environment of the Jim Crow South into focus, describing the "dainty white cap and apron of a lady's maid" that Lowe wears to attend her brides' weddings to make final adjustments on gowns before the ceremonies.[16] Both articles note that Lowe attended the Montgomery Industrial School for Black girls and that she studied dressmaking in Chicago with a Madame Seabrook. The *Tampa Daily Times* wrote that for nine years, she spent her summers designing for a manufacturer in New York, and the *Tampa Sunday Tribune* stated that she spent three years in New York before returning to Tampa. None of these details appear in her later press from the 1960s.

Most of the evidence of Lowe's 1920s designs are photographs of wedding dresses or of gowns for Tampa's Gasparilla festival. Both types of dresses followed their own stylistic codes with traditional or fantastical aspects that separated them from everyday fashion. Yet Lowe and her

ABOVE: Grace Lee in white suit by Ann Lowe, ca. 1918. Courtesy of Elinor Keen Boushall.
OPPOSITE: Sarah Lykes Keller, Gasparilla queen in Egyptian costume by Ann Lowe, 1924. PAGES 78–79, LEFT: Gasparilla gown worn by Queen Sarah Lykes Keller (Mrs. W. Frank Hobbs), 1924; RIGHT: Gasparilla court gown, 1926. Photos on pages 77–79 Courtesy, Collection of Henry B. Plant Museum Society, Inc., Tampa, Fla.

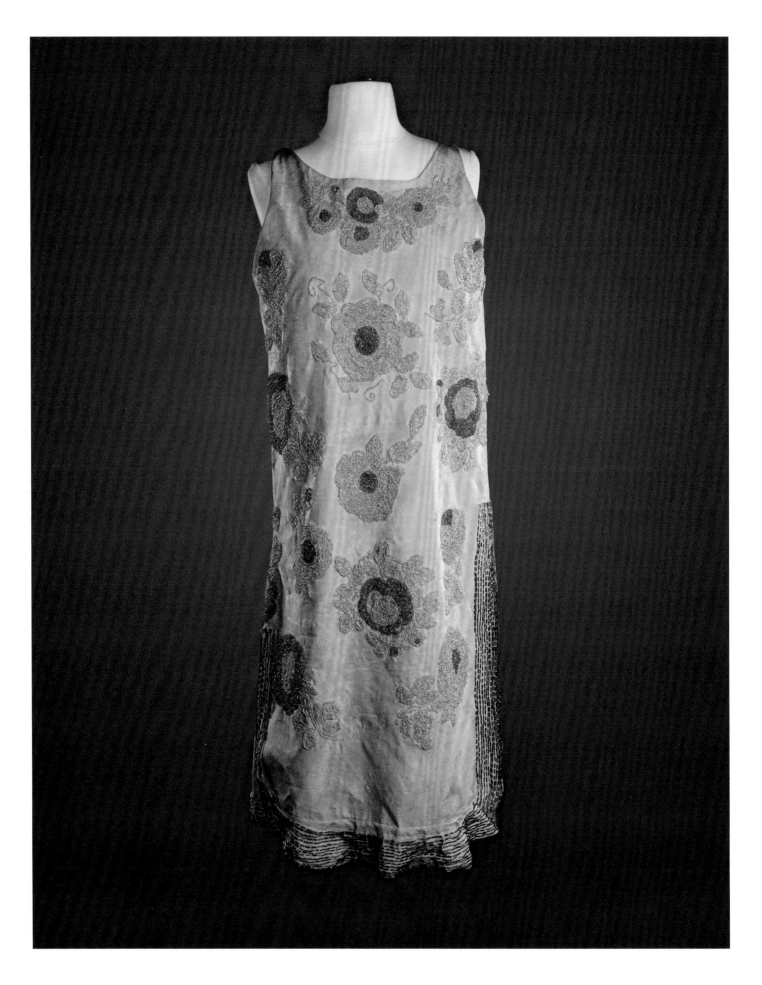

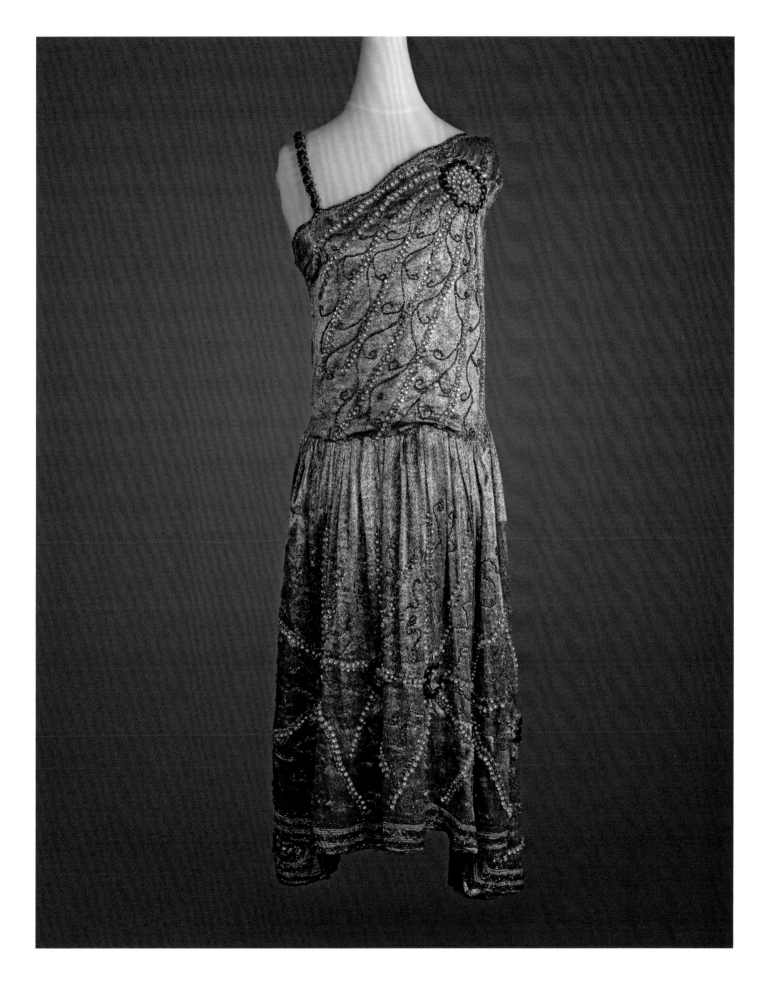

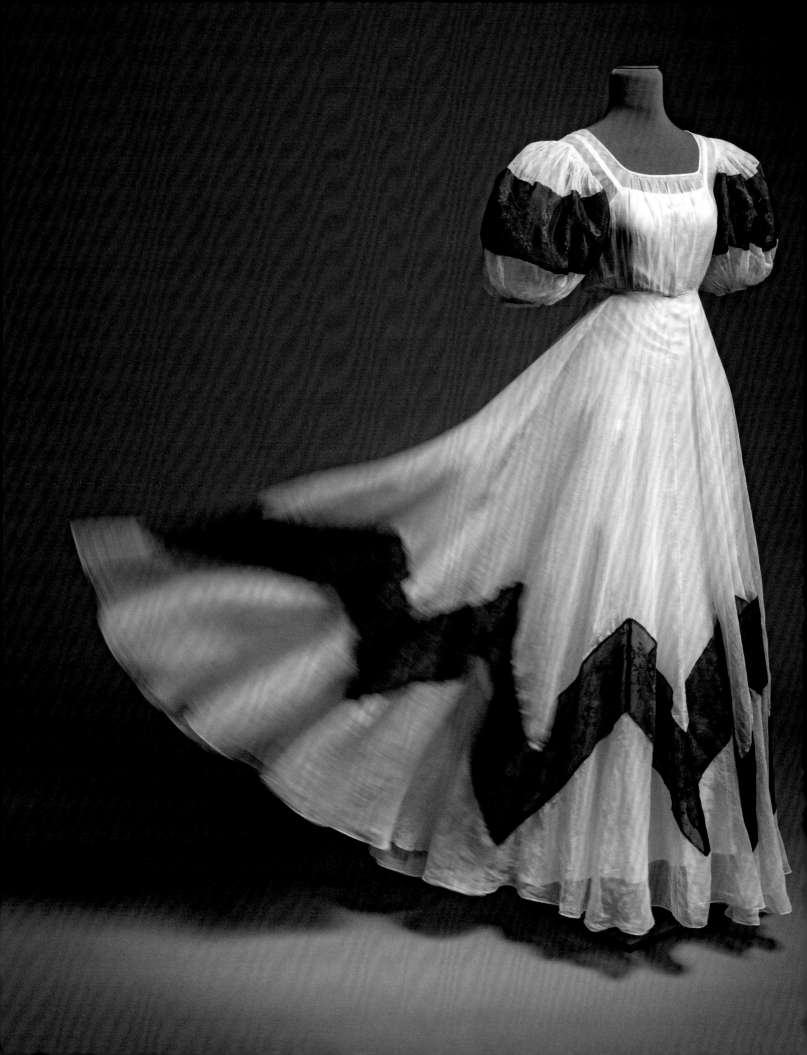

home she shared with her husband, Caleb West, and remarkably, her clients—socially prominent young white women—would stream in and out of the atelier to try on and pick up their orders.[20] Lowe fondly described their familiarity compared to the "cold way" of New York women: "I missed the friendly way the girls here [in Tampa] have of running in all excited and saying, 'Annie, you just must make this dress for me.'"[21] Much of the press written during the 1960s on Lowe's time in Tampa during the late 1910s and 1920s remembers her as a vital part of the socially elite community, a favorite and reliable dressmaker who brought an incredible creative talent to a relatively remote regional American city. Lowe was a big fish in a small pond and "felt compelled" to move to New York to truly test her potential.[22] However, she also remembered her time in Tampa fondly as a period in which she was appreciated and respected. Gasparilla gave her a unique opportunity to unleash her design fantasies, in addition to creating more typical fashionable attire for an eager clientele.[23]

One of Lowe's earliest existing fashion garments is an organdy afternoon dress made for Josephine Lee. The dress was in the private collection of the Lee family until the Tampa Bay History Center acquired it as an important example of early twentieth-century fashion and Lowe's work in the city. Although the dress has previously been dated to the mid-twenties, its features—graphic, contrasting black lace inset in bold zigzags; a waist seam positioned at or slightly above the natural waistline; and full, floor-length skirt—more likely place its creation in the first half of the 1930s or possibly later in the decade. The romantic reference to lingerie dresses of the 1910s might have appealed to the middle-aged Josephine Lee, yet the trimness of the silhouette and the puffed sleeves are more in line with 1930s silhouettes.[24] Lowe would have been living in New York by the 1930s, though Powell notes that she maintained her relationship and business with the Lees and others in Tampa.[25] This early dress is unlined, though an undergarment would have been originally worn with it, and like the Lee daughters' suits, it gives an example of Lowe's dressmaking range. The delicate organdy is handled expertly—tiny handstitched

gatherings, narrow hem finishes, and hook-and-eye-closures under covered buttons all accommodate the lightweight fabric. Hidden details such as lingerie straps to hold a slip in place and horsehair sleeve caps to add fullness to the puffed sleeves are high-quality finishes.[26]

Lowe struggled in 1928 during her transition to New York. Competition would have been stiff in America's fashion capital, especially for a dressmaker with few connections in the city. The Great Depression descended in 1929, forcing her to close her first shop. Lowe found work on commission for other dressmaking shops, but also managed to build up her own clientele. Three unlabeled 1930s gowns, for example, were given anonymously to the Cincinnati Art Museum in 1999. Chief Curator and Curator of Fashion Arts and Textiles Cynthia Amnéus notes that the donor gave his mother's dresses and attributed them to Ann Lowe. Later comparisons to a labeled dress confirmed Lowe as the maker. The wearer of the dresses likely commissioned them directly from Lowe and not a third-party dressmaking shop if the designer's name was remembered well enough (or documented) for over six decades to pass down to the son who later recognized their value and donated them to the art museum.[27]

These dresses illustrate the height of 1930s chic. Fabricated from printed silks and all featuring flowers, they

OPPOSITE: **Josephine Lee dress, ca. 1930.**
**Courtesy of Tampa Bay History Center.**
ABOVE: **Sleeve of Josephine Lee dress.**

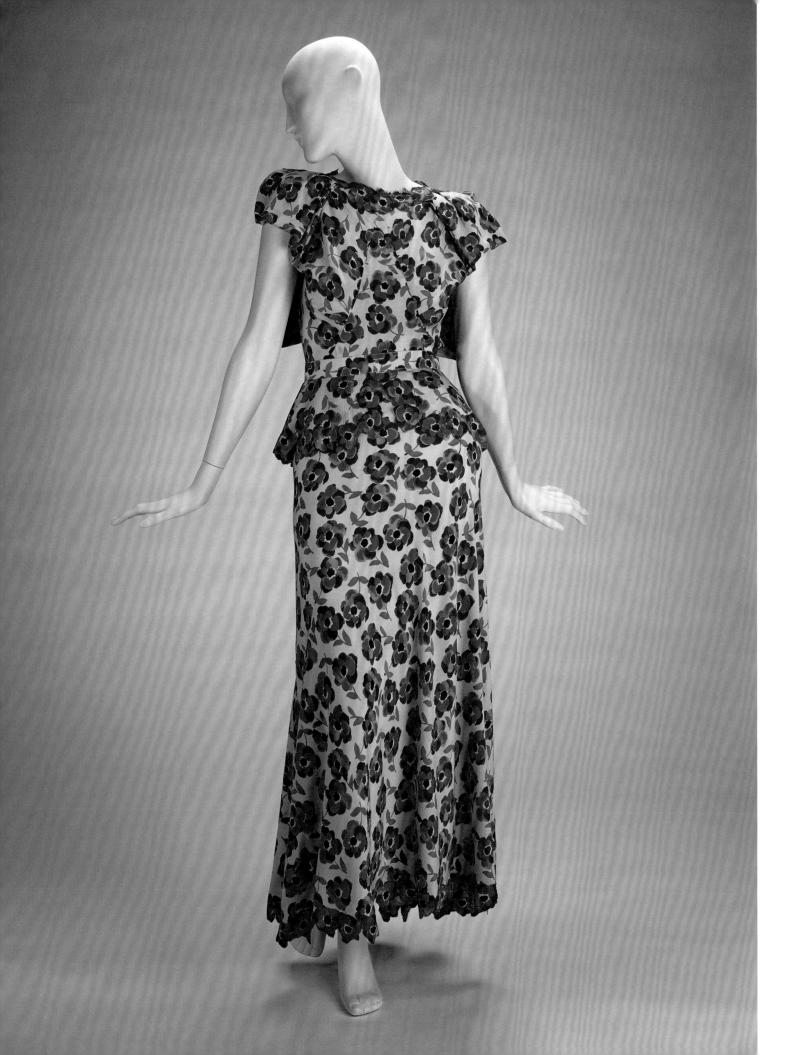

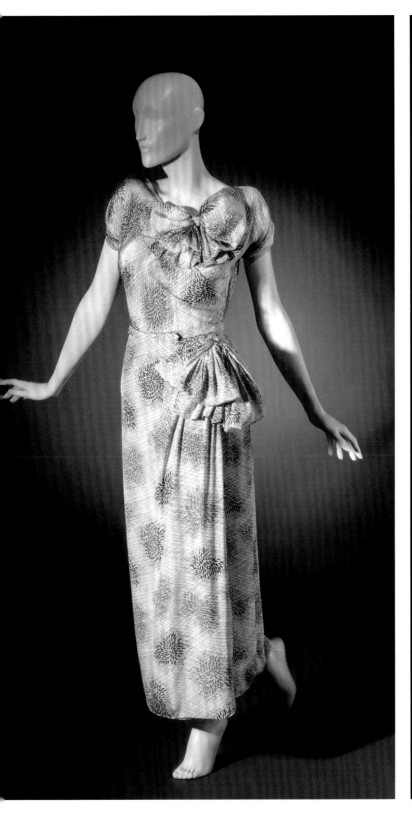

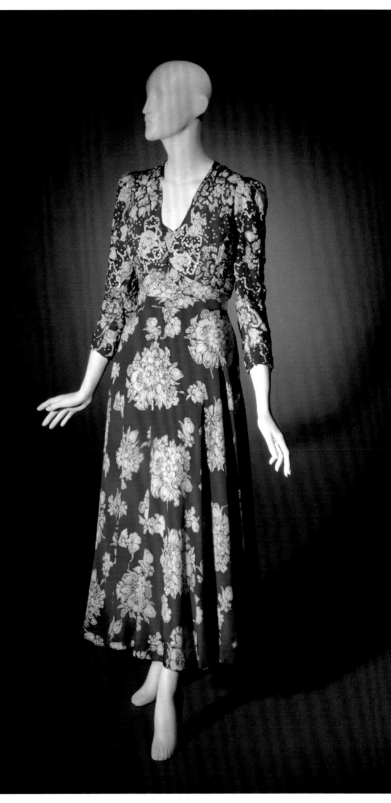

OPPOSITE: Red dress and belt by Ann Lowe, 1930s, Cincinnati Art Museum, Anonymous Gift, 1999.810a–b. ABOVE LEFT: White printed dress and belt by Ann Lowe, 1930s, Cincinnati Art Museum, Anonymous Gift, 1999.811a–b. ABOVE RIGHT: Blue printed jacket, dress, and belt by Ann Lowe, 1930s, Cincinnati Art Museum, Gift of Fashion Design Department, University of Cincinnati, 2016.83a–c.

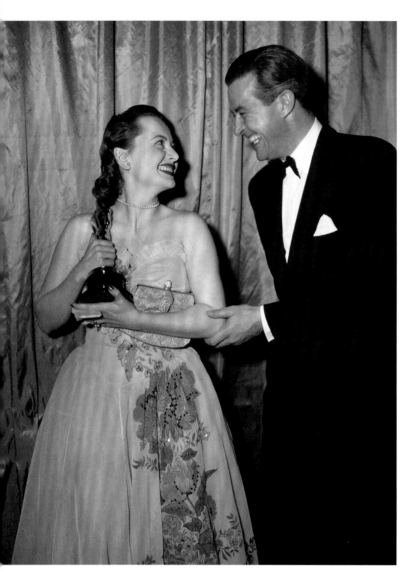

and extend into looped streamers at the back. The truly extraordinary element of the design is the couture detailing of the hems, neckline, and open T back. The red printed poppy flowers are cut out and finished to create a floral trim from the fabric (a technique called *fussy cutting*). Although these gowns are as stylistically different as dresses from the 1930s and 1950s would be—Lowe's design philosophies are present and recognizable in these and later works.

Dresses from the 1940s show Lowe's continuing design evolution in line with changing styles and cultural shifts. A 1941 wedding gown worn by Jane Tanner Trimingham in the collection of The Metropolitan Museum of Art is made from "art silk," or rayon, a fiber that rose to prominence for fashion as World War II placed restrictions on silk and other fibers.[30] The gown's Queen Anne neckline, long sleeves with volume at the shoulders, and silhouette that skims the body to the hipline show a style current for the early 1940s. There is little evidence of Lowe's early and mid-1940s designs apart from this wedding dress—for much of this period Lowe continued to work for other manufacturers, and her designs would bear their labels. Two designs that Lowe created in the late forties suggest that she quickly embraced the "New Look" styles with the complex construction and hourglass silhouettes that would have been familiar to her from her grandmother's training. Lowe was not immune to American fashion's reverence for French couture—many American designers and manufacturers, such as Lowe's one-time employer Hattie Carnegie, established their popularity on the ability to copy haute couture. When postwar collections in Paris revealed a major return to nineteenth-century femininity, most American designers followed suit. This change seemed to be exactly in line with Lowe's design sensibility. During the 1960s, Lowe claimed credit for a 1947 dress she created while working for Sonia Gowns. It was worn by Olivia de Havilland to that year's Academy Awards in March. Christian Dior's legendary New Look collection was shown in Paris in February 1947. While Lowe most definitely kept herself abreast of the changing fashion trends, Dior's singularity in reviving the

show a number of defining details for fashions of the period. Daniel Cole and Nancy Deihl summarize, "Embellishment was reduced during the early 1930s, with visual interest often provided by details," including asymmetry, self scarves (and belts), oversized bows, peplums, matching jackets.[28] Lowe deftly administered these design elements to infuse both the modernism and whimsy of 1930s fashion into these pieces. A white dress with matching belt (1935–38), printed with a "Japonesque version of the chrysanthemum,"[29] features a large bow at the neckline, mirroring a swag at the hip, also placed on the left side, and emphasizing the subtle drape of the bodice and skirt. A deep-blue 1930s dress with thin straps is paired with a matching cropped jacket on which the floral print is accentuated with matching lines of sequins. Both dresses illustrate Lowe's penchant for building up the fabric with three-dimensional elements in more or less overt ways. The third dress (1930–34) is cut with a peplum, set off with a matching belt. The sleeves are draped softly from the bodice

ABOVE: Best Actress Olivia de Havilland (*To Each His Own*, 1946) wearing a design by Ann Lowe for Sonia Gowns, with presenter Ray Milland at the Nineteenth Academy Awards ceremony in 1947. Margaret Herrick Library, Academy of Motion Picture Arts and Sciences. PAGES 85–87: Wedding dress by Ann Lowe, 1940s. The Metropolitan Museum of Art, Gift of Mrs. K. Fenton Trimingham Jr., 1975 (1975.349a, b).

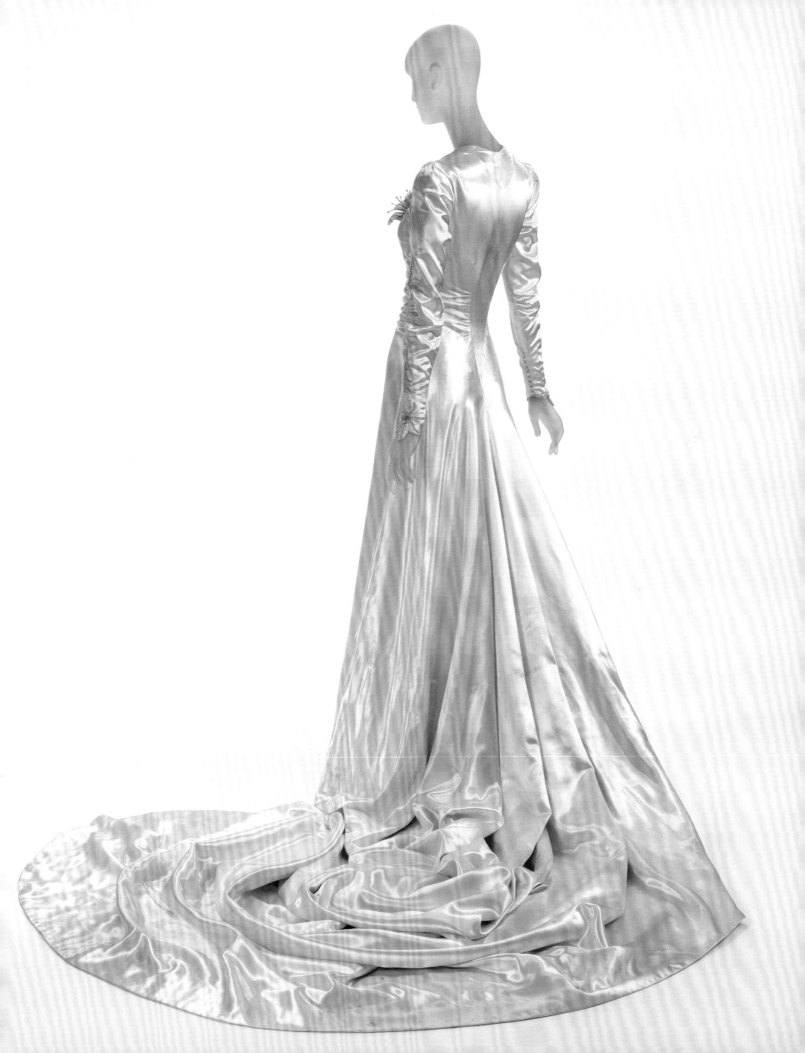

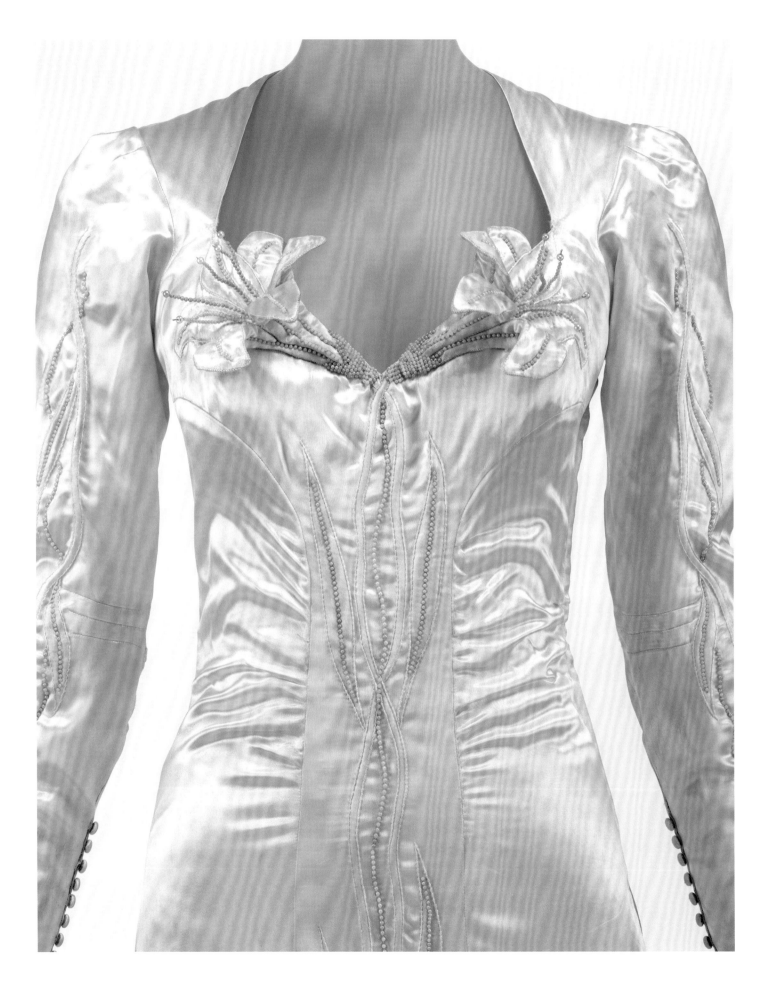

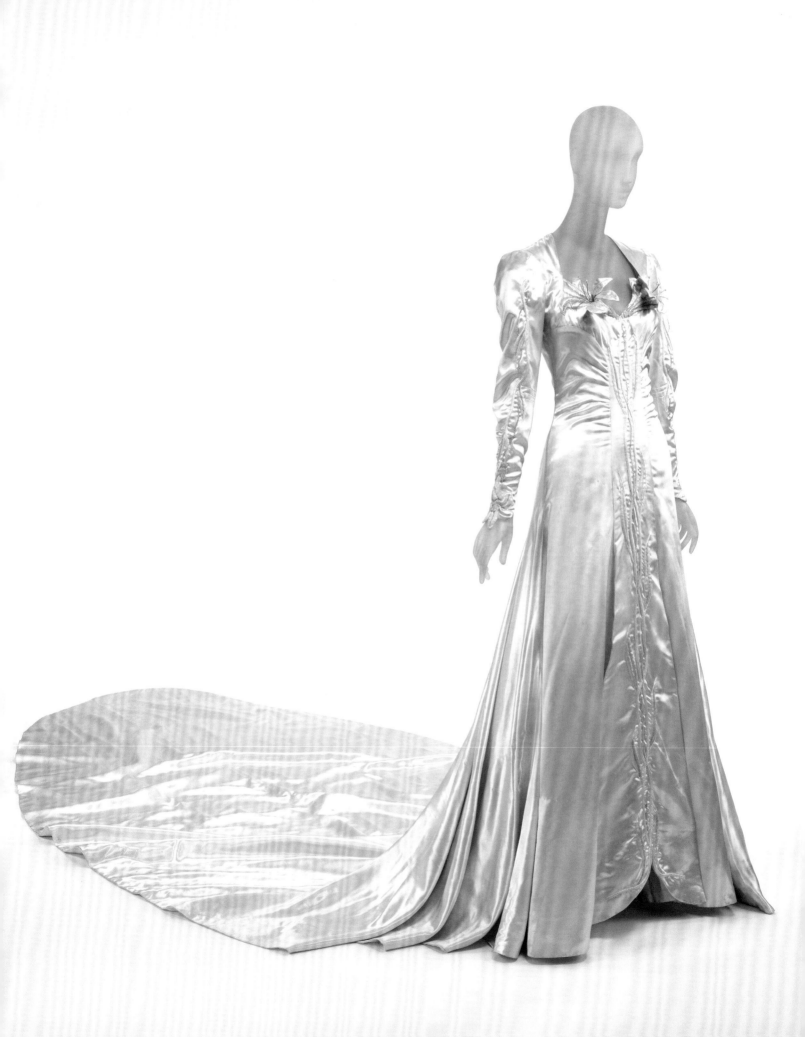

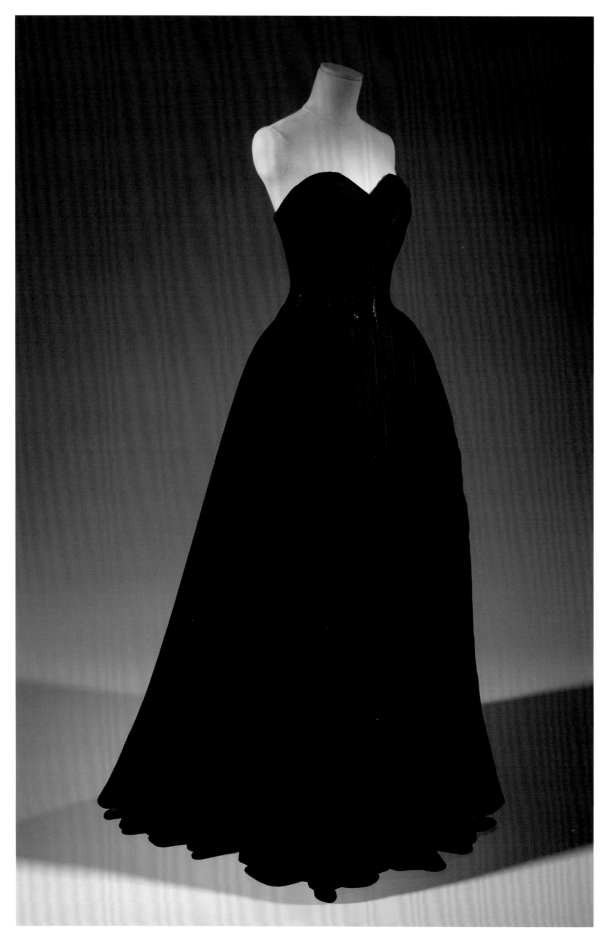

LEFT: Burgundy velvet
evening gown by
Ann Lowe, ca. 1955.
The Museum at the
Fashion Institute
of Technology,
Gift of Eleanor
Cates, 77.60.1.
OPPOSITE: Ball gown
in Chantilly lace
over silver-white
duchesse silk
satin, by Ann Lowe,
1957. Museum of
the City of New
York, 2009.2.2.

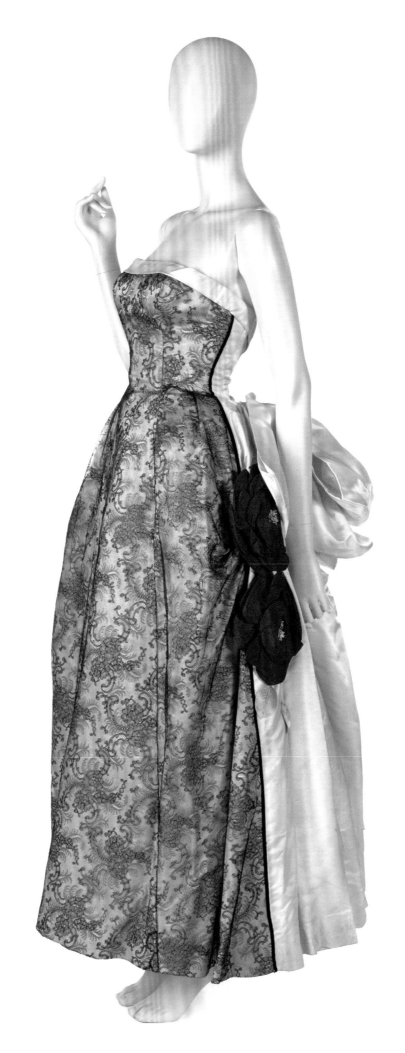

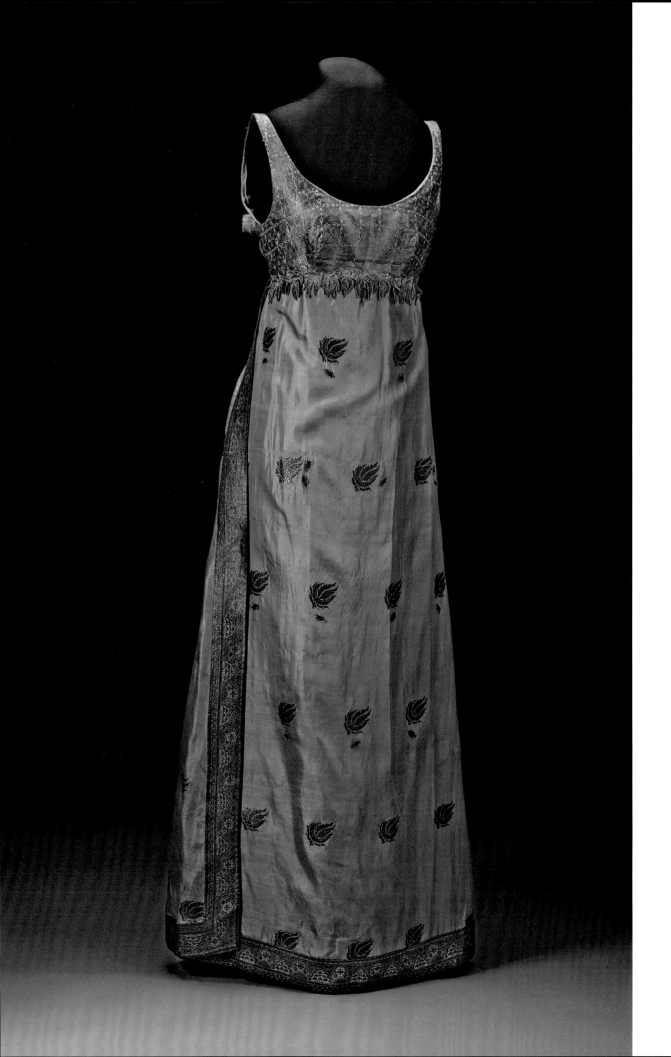

tight-waisted silhouette is overstated—hourglass silhouettes had toured the United States in the Théâtre de la Mode, an exhibition of doll-sized Parisian couture fashion in 1945 and 1946. Furthermore, these styles picked up where French fashion had left off in the late 1930s. Valerie Mendes and Amy de la Haye note that, "Designers understood the psychological need for change and were beginning to move away from the boxy wartime profile towards softer, longer lines."[31] It is likely that Lowe was considering her customers' needs and wants as much as Parisian designers, and this dress is evidence. It is an unapologetically sweet, feminine, and youthful gown, hand-painted with flowers from the ruffle-trimmed sweetheart neckline to the hem of the full skirt.[32]

The last 1940s design discussed here explicitly illustrates Lowe's connection to Parisian couture. The Black newspaper the *New York Age* sent Lowe to Paris as its couture correspondent in August 1949. She reported on the fall fashion presentations from the leading houses, including Christian Dior, Balenciaga, and Jacques Fath, and, inspired by the trends she observed, designed an exclusive look that was photographed and published for *Age* readers. The caption describes it as a black silk faille taffeta cocktail dress with an asymmetrically draped skirt appliquéd with dahlias and a standing wing collar accenting "a deep plunging neckline."[33] Compared to the girlish, strapless ball gown designed for de Havilland, this cocktail dress is mature and sophisticated, recalling the effortlessly elegant dresses she designed in the 1930s. Lowe could clearly create cutting-edge fashions when called upon to do so.

The 1950s and 1960s found Lowe at the height of her career in New York. She had established an exclusive list of clients through word-of-mouth connections, and she consistently found business within New York's tight circle of elite socialites. A small sample of her eveningwear designs from this period show both her consistency and the influence of fashionable trends of the period. One of the more dramatically understated and heavily structured gowns in her known repertoire is a strapless deep-burgundy velvet gown

in the collection of The Museum at the Fashion Institute of Technology (FIT). The weighty dress from the early to mid-1950s features a pronounced hourglass silhouette and a deep sweetheart neckline. Its interior construction follows Lowe's typical bodice assemblage (see page 95) and also contains additional interior support around the waist and deep reinforcements throughout the skirt and hem to maintain the structured shape. It is notably devoid of further embellishment. A ball gown in the collection of the Museum of the City of New York dates to 1957 and also features an hourglass silhouette and a strapless neckline, but this white duchesse satin gown boasts a front overlay of black Chantilly lace and an enormous bow falling from the back waist among the folds of satin, creating a bustle effect. Large red cabbage roses adorn the sides, creating striking pops of color. Both of these gowns show a distinctive sex appeal that is not often associated with Lowe's work, as well as the range of her embellishment style from the minimal to the highly adorned. The velvet dress is sensual and elegant in its sharp silhouette, while the graphic contrast of the black lace that ends cleanly at the side seams, the back drapery, and the bright roses, visible from virtually all angles, creates a surprisingly cohesive effect of three divergent elements. Both show Lowe's mastery of design.

Asian textiles and silhouettes have had an ongoing influence on Western fashion for centuries, and trends for adapting Asian silk fabrics and motifs consistently reoccur, as seen in Lowe's designs for the 1925 Gasparilla court inspired by imperial Qing court dress and much later examples of designs utilizing Asian textiles. These later dresses show another way in which Lowe engaged with fashions of the 1950s and 1960s and likely worked with her clients to create styles that captured their tastes and interests. Lowe designed a strapless evening gown with matching cropped jacket for Florance Colgate Rumbough Trevor during the 1950s. The neckline and waistline are defined by bands of fabric, and the waistband curves into narrow side panels accented with self-fabric bows. The volume of the skirt creates a columnar shape that lies smooth in front and gathers into pleats at the

OPPOSITE: Sari dress by Ann Lowe, 1966–67. PAGES 92–93: Teal brocade dress and cropped jacket designed by Ann Lowe and worn by Florance Trevor, 1950s. Both: Collection of the Smithsonian National Museum of African American History and Culture, Gift of the Black Fashion Museum founded by Lois K. Alexander-Lane.

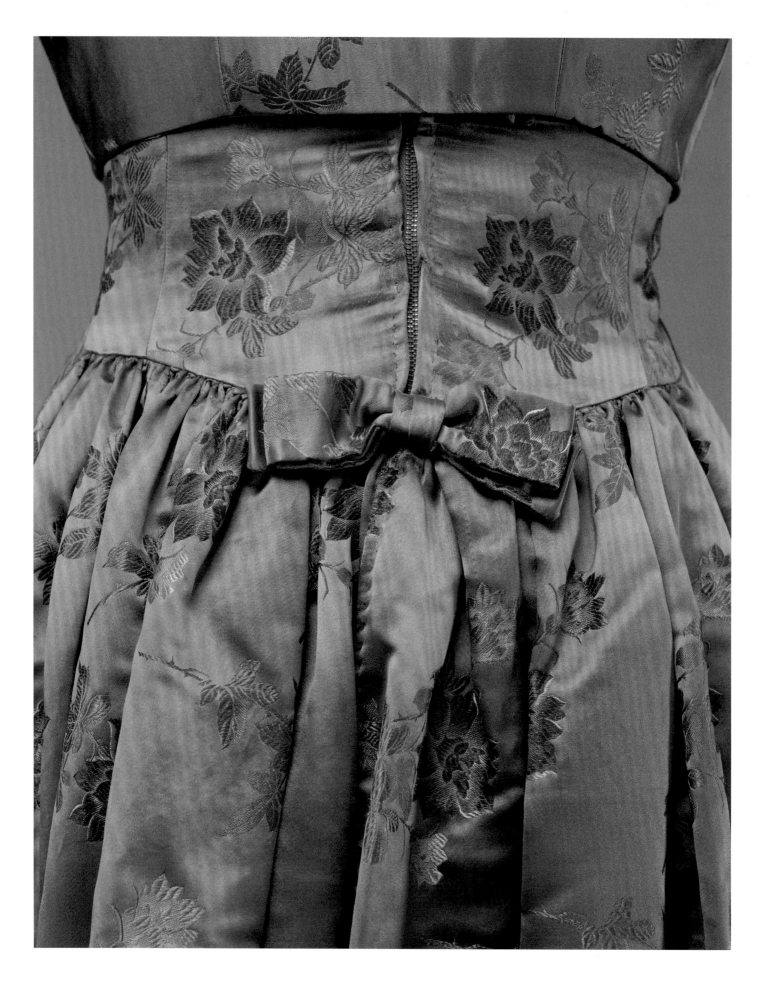

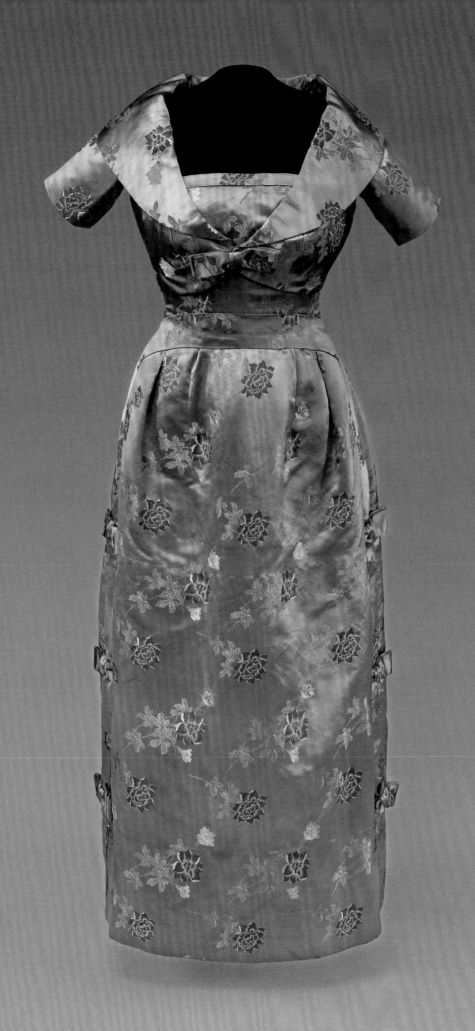

back. The short-sleeve jacket has a wide collar that creates a portrait neckline and closes with a bow at center front. This ensemble likely dates to mid-decade and was probably made after Lowe made Florance Rumbough's 1951 wedding gown (see photo, page 115, top left). The evening set is made from a teal silk brocade with a floral design. The fabric's selvedge edge remains intact, and a manufacturer's mark reading "Singchon H.K." is visible on a seam allowance. It is possible that Florance Trevor acquired this fabric as a souvenir while visiting Hong Kong or received it as a gift and took it to Lowe to have the ensemble made. This would have been a fashionable choice at the time that simultaneously displayed the wearer's worldly sophistication and ability to travel. The fabric could have also been simply imported. Many fashion articles from the 1950s confirm the popularity of Chinese brocade and Chinese-inspired fashions and accessories. The reporting on a consular ball in Chicago in 1955 points to many trends that this ensemble incorporates, including Chinese inspiration "in fabric rather than actual design," metallic elements in the textile, a silhouette of "restrained fullness," "sheath profiles . . . broken with . . . back treatments," and "fichu effects" covering "strapless decolletage."[34] The small details of this ensemble, including the intricate construction of the waistband falling to the sides, the gusset construction of the jacket sleeves, and interior details such as fabric-covered dress weights, along with the layers of petticoats and linings to hold the skirt shape, all show Lowe's thoughtfulness and attention to detail. Two other surviving Lowe designs also show Asian influence. A plum satin evening coat that was modeled on *The Mike Douglas Show* when Lowe was interviewed on December 31, 1964, shows a simple, but full, flared silhouette with sleeves just below elbow-length and a padded lining covered in contrasting cream satin. The coat's shape and the floral-and-leaf hand beading around the neckline and down both sides of the center-front opening recall Middle Eastern caftan designs. The coordinating dress mirrored the embroidery and beading in a wide waistband, but not the Asian influence. It featured a columnar silhouette with double spaghetti straps and a self-fabric band around the neckline.

A 1966–67 evening gown made from a blue-green and gold sari uses the original garment's rich metallic borders for the high-waisted bodice, which is edged in the fabric's fussy-cut leaf motifs. Lowe also incorporated a wrapped effect at the back referencing the original sari. Deihl notes, "In 1962, the fashion world experienced a brief infatuation with silk saris, inspired by Jacqueline Kennedy's trip to Pakistan and India where she purchased several to have made into dresses."[35] Continuing interest in Southeast Asia driven by countercultural movements and popular music also fed this trend. This dress was made for Barbara Brooke Baldwin during her debut season (see photo, page 90) under the brand A. F. Chantilly, Lowe's last company, a partnership with designer Florence Cowell. Thurman notes that "by the late nineteen-sixties society girls were interested in shacking up with rock stars and jetting off to ashrams. Coming out was a charade of purity that many endured to placate their mothers."[36] This dress and another made under the A. F. Chantilly label—a circa 1968 teal one-shouldered evening dress with a matching sheer overlay and two bands of silver floral embroidery—show Lowe adapting to the changing American culture. Her designs are pared down, less structured (at least on the outside), and more modern. They engage with styles and cultural influences that would have attracted younger women of the late 1960s. As Thurman indicated, the debutante tradition was fading as elite young white women expanded their education, interests, and options in line with the growing women's liberation movement. Lowe's specialties in extravagant and feminine couture eveningwear were in less demand as even the French haute couture market gave way to high-end ready-to-wear. Lowe's career seemed to align with the changing culture—by the late sixties, her failing eyesight was her major concern, and she retired in 1972.

**Lowe's Construction**
One of the most recognizable features of Lowe's work from the 1950s onward was the way she built the interior bodices of her gowns. These included layers of fabric, boning, elastic, and non-elastic bands to hold the dress and the body of

Interior details showing Lowe's bodice construction: CLOCKWISE FROM TOP LEFT: On loan from the Delaware Historical Society, 2003.028, Gift of Ann Bellah Copeland; Courtesy of the Missouri Historical Society, St. Louis, Mo. (top right and bottom right); Collection of the Durham Museum, Gift of Ann Lallman Jessop.

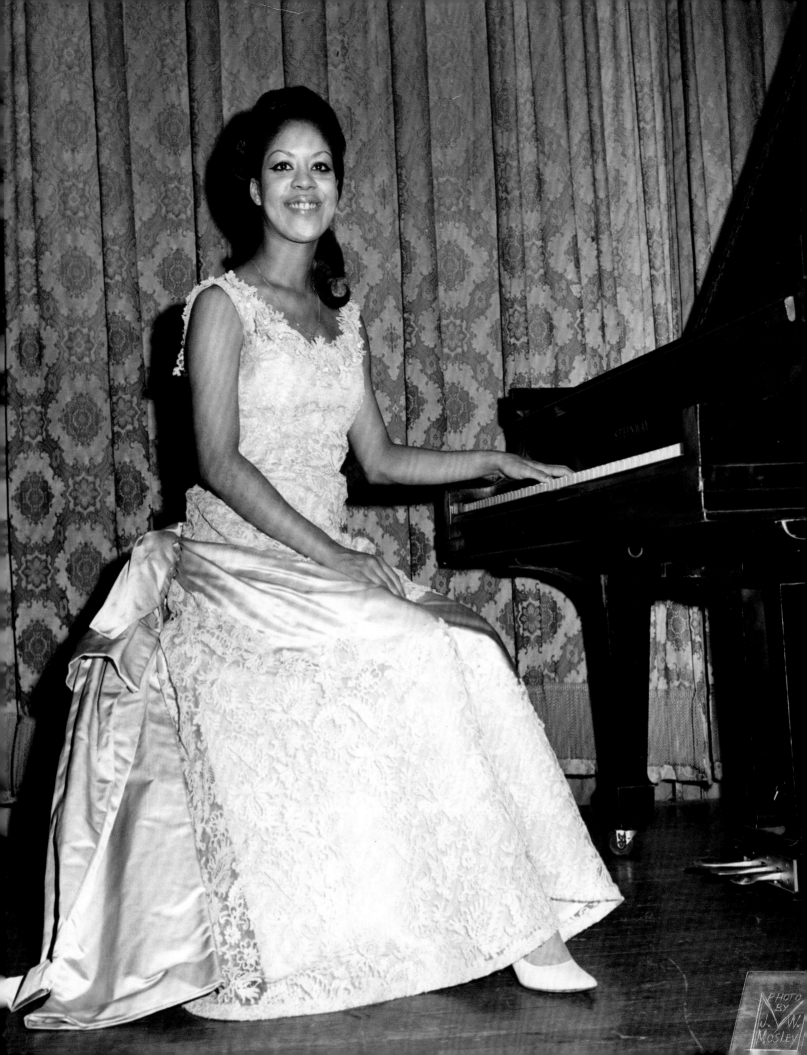

the wearer in place. She created this "built-in long-line bra, so that the wearer 'can just put on a panty girdle and slip into the dress.'"[37] This technique was likely learned in basic form from her grandmother and mother, who were used to creating interior bodices with boning and waist stays, though Lowe standardized the construction to become a hall-mark of her later garments. In other ways, she continued to experiment with construction techniques. For example, she cites "30-15" sleeves as her invention. These were "shoulder sleeves that permit the girl to move her arms around more without splitting the underarm material of the dress" and named for the thirty hours and fifteen minutes the first set consumed.[38] These dressmaking techniques as well as others, such as built-in petticoats, lace-finished seams, hems reinforced with gathered tulle, and perfect custom fits, mark Lowe's gowns as couture quality. A particular dress examined here illustrates this quality over ready-to-wear garments, showing the care Lowe took to create each gown to best fit the needs of the client.

Lowe made a blue satin-and-lace concert dress for pianist Elizabeth Mance around 1966 or 1967. Mance was one of Lowe's few documented Black clients, and Lowe also created her 1968 wedding dress (see photos, pages 116–21). A talented musician, Mance attended the Oberlin Conservatory of Music in Ohio and the Royal Conservatory of Music in Brussels and performed both in the United States and internationally.[39] Lowe created this performance gown to stun viewers both up close and from a distance. The satin base fabric is over-laid with a lace that is couched with cording to outline the floral design. Although the lace was likely manufactured with the corded embellishment, it was aptly chosen by Lowe, who used it to stabilize the flowers, fussy cut from the lace, to form decorative edges where it overlaid the satin and where the lace was cut to mold to the silhouette. She also cut flowers from the lace to trim the neckline and arm-holes. Translucent crystal-cut drop beads and seed beads were added to the lace at various points to catch the stage lights while Mance played. Slim darts to fit the lace to the satin base were placed on the diagonal to better hide them

from view. All of these techniques are typical of Lowe's high-quality construction. What is remarkable is that Lowe designed this gown especially for Mance to sit in and to be viewed from her right side as she played piano from a stage. The lace covers most of the dress except for a diagonal swath from under the right hip down to the left side of the skirt above the hem and a vertical swath to the right of the center back seam. The more flexible satin was left exposed to accommodate Mance as she sat at the piano. Lowe placed several deep pleats to the right of the center back to facili-tate the graceful drape of the skirt, and a large satin bow is also placed to the right of center back to be best seen by the audience. By the 1950s and 1960s, quality off-the-rack evening gowns were widely available, yet Lowe still attracted as many clients as she could handle because she created dresses to specifically fit the needs of her clients. Debutantes and brides came to her for one-of-a-kind gowns that would not be seen on others and for the fast-waning experience of having a custom gown made especially for them.

### Identifying Lowe's Work

Ann Lowe created literally thousands of garments through-out her long career, and although dozens are preserved in the collections of museums around the country, there are likely many more, unidentified in private collections. Certain markers such as Lowe's distinctive bodice construction and use of floral embellishment are good indicators of a Lowe attribution (though they are not always conclusive). A good example is a wedding dress (shown on pages 102–3) held in the private collection of designer and fashion scholar Adnan Ege Kutay that was made in the Adam Room, the custom salon at Saks Fifth Avenue, as indicated by the label. The style of the dress—an hourglass silhouette with a slightly raised waistline that dips down at the back, a relatively flat front skirt with more pleating at the back, and the struc-tured silk fabric with floral appliqué-covered sleeves and accents on the skirt—indicate an early 1960s design. The simple bow at the front waist and the wide bateau neckline are further indicators. This estimated date would align with

Elizabeth Mance wearing Ann Lowe
concert gown, 1960s. Elizabeth
Mance de Jonge Collection.

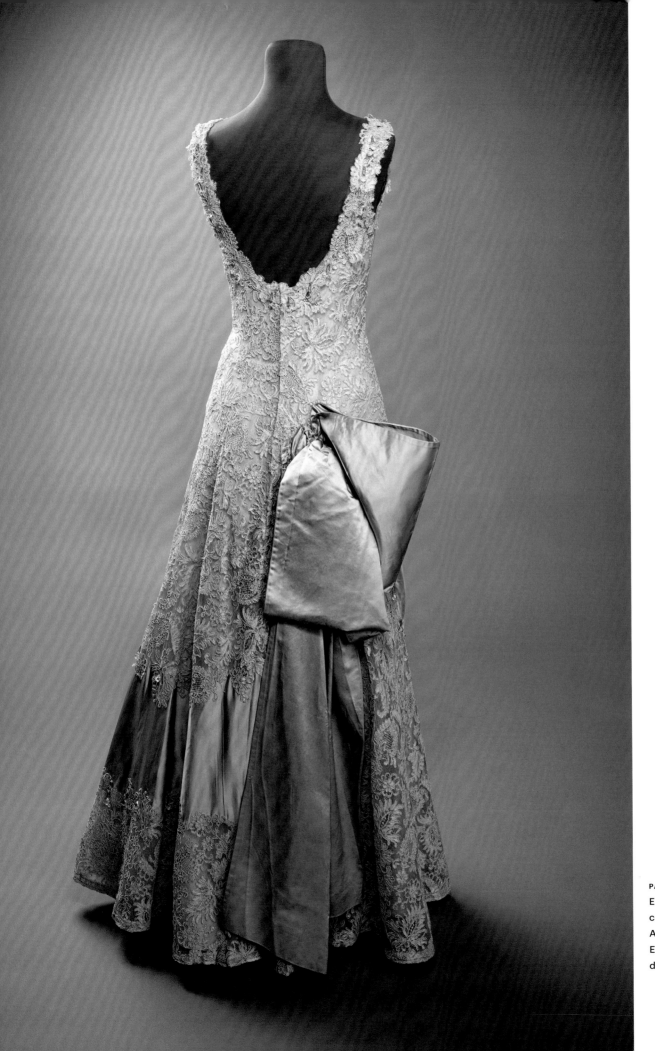

PAGES 98–101:
Elizabeth Mance
concert dress by
Ann Lowe, 1960s.
Elizabeth Mance
de Jonge Collection.

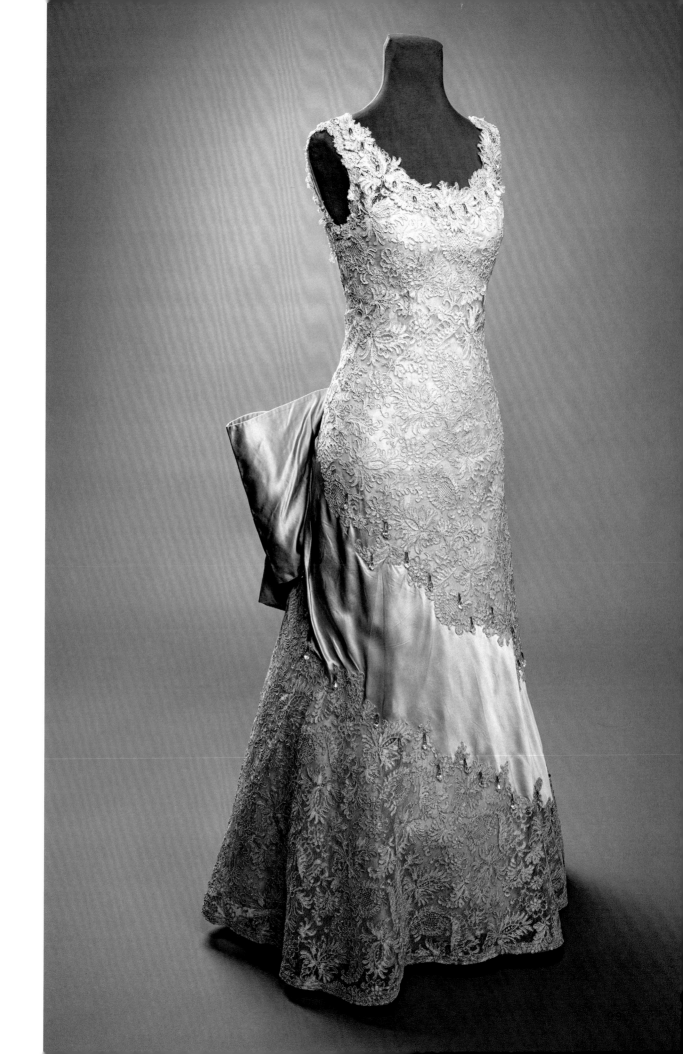

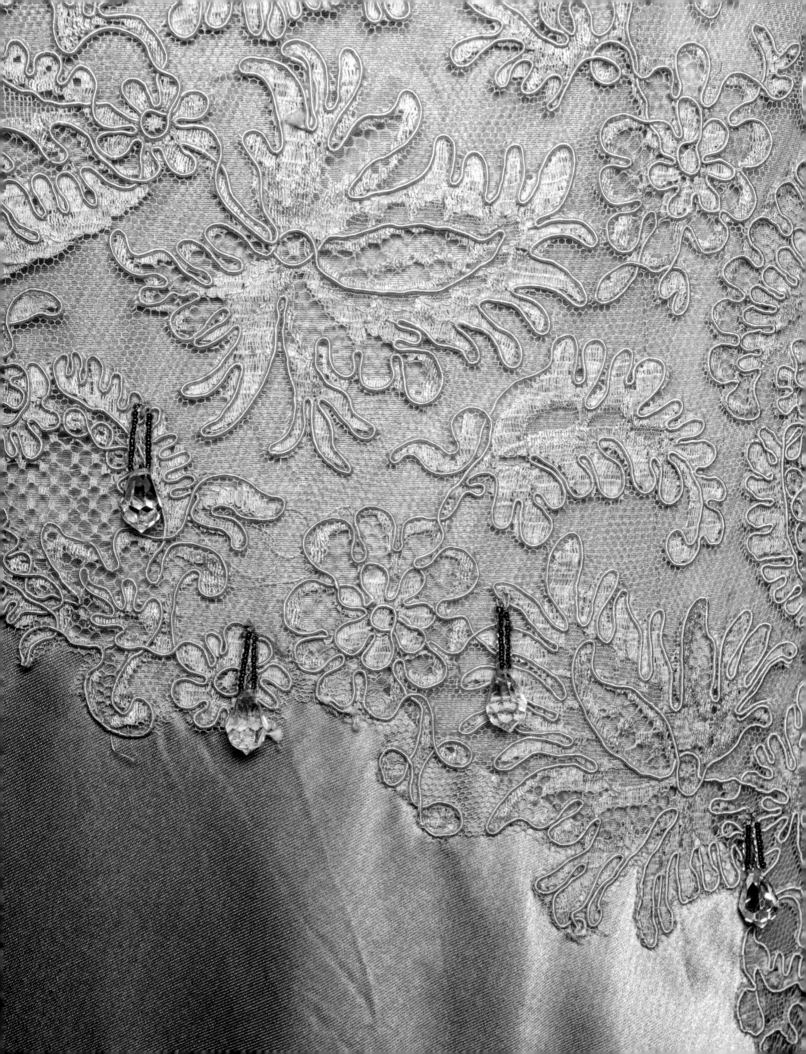

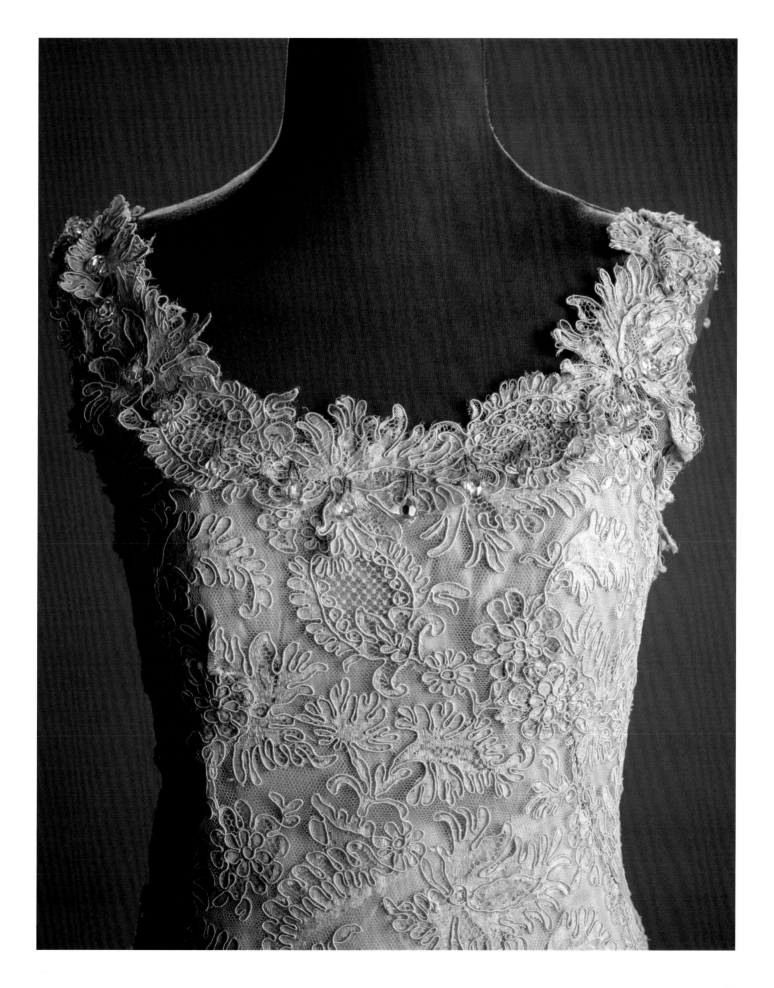

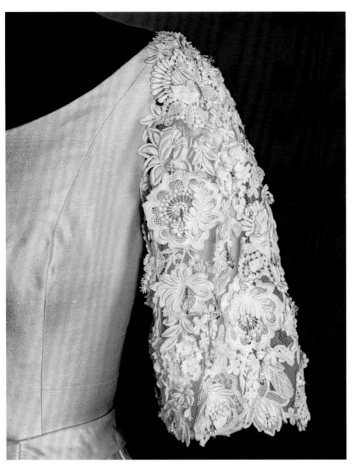

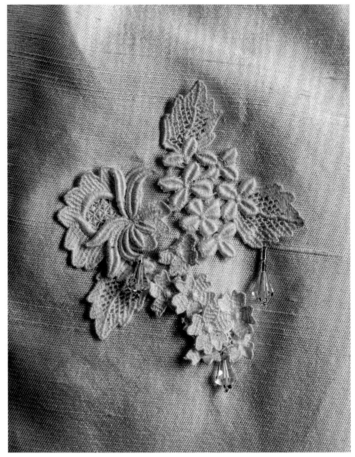

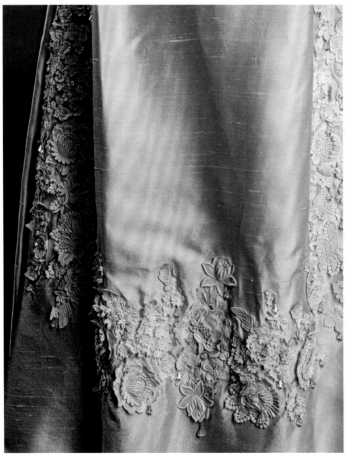

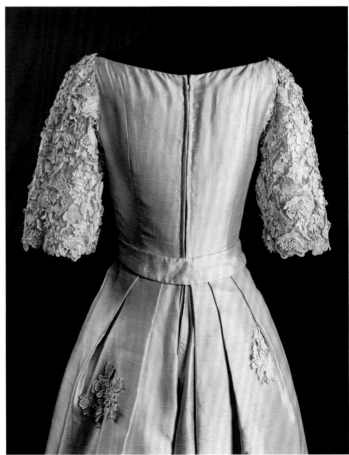

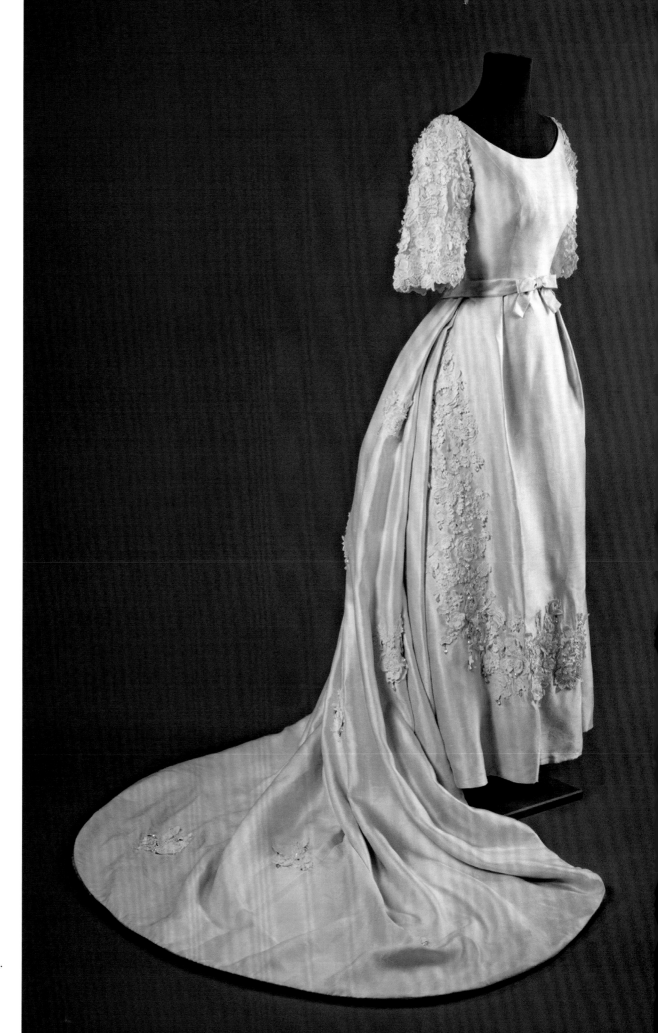

Wedding dress by
Ann Lowe for Saks
Fifth Avenue, early
1960s. Details,
opposite. Adnan
Ege Kutay Collection.

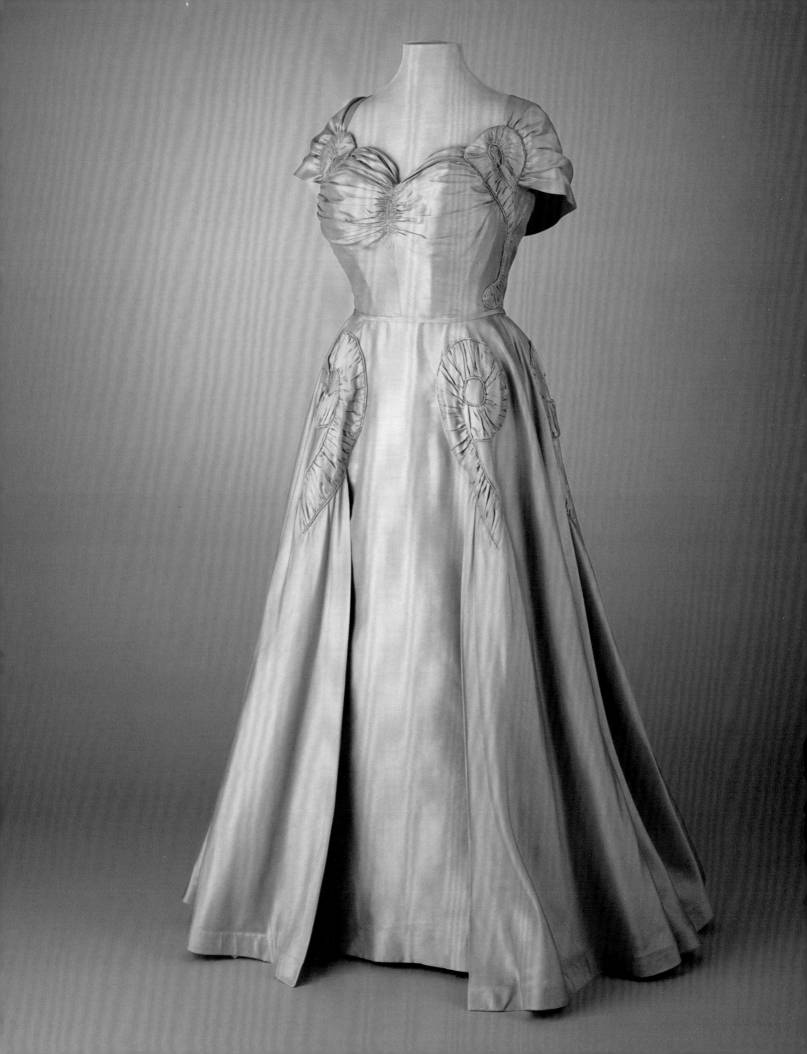

Lowe's time at the Adam Room (1960–62), and the interior details strongly indicate Lowe as the maker. Her signature bodice construction style, the gathered tulle at the interior petticoat's hemline, and lace-bound seam allowances are all features found on other Lowe gowns. The floral lace appliqué enhanced with drop crystal beads (similar to the Mance concert dress) is further proof, though, of course, these embellishments were not exclusive to Lowe. Thoughtful details, such as a small fabric butterfly on the interior petticoat and a long train from the waist that could be detached after the ceremony, may have been requested by the bride.

More of a mystery is Marjorie Merriweather Post's 1952 gray silk faille gown. Post was a known Lowe client, though the collection of her wardrobe held at the Hillwood Estate, Museum & Gardens does not contain any labeled Lowe garments. The gown in question is unlabeled and had been attributed by Hillwood as a possible Lowe design. The interior of the gown does not show typical Lowe craftsmanship; in fact, it appears to be hastily made, and the interior is largely rudimentarily finished. This may be because the gown was made specifically for a portrait of Post painted by Douglas Granvil Chandor. Post sat for the portrait in Texas, where Chandor was based because he was in ill health. The artist was only able to accept the commission in 1952, and he died in January 1953, leaving the portrait unfinished. Post had the portrait copied by artist Frank Salisbury in 1953 and again by artist David Swasey in 1966. A letter from Post to Swasey, dated June 30, 1965, indicates that Post sent props to Swasey to aid him in his copy—while Chandor finished Post's face, much of the other details, including the dress, were unfinished.[40] The multiple locations of the paintings' creators may account for the unusual construction of the dress. Both the skirt and bodice have been expanded and additional panels of the original fabric were added to the bodice. If Chandor was working on a tight timeline, the dress may have been made as quickly as possible and sent directly to Texas, where it was fit to Post (or perhaps another model acting as a stand-in) by another dressmaker—this might account for the rudimentary interior finishing as adjustments

were anticipated. The dress also could have been altered in Swasey's care to fit a stand-in model while he created his copy. The same method might also have been used by Salisbury. This dress was clearly created to be used only for the portrait sitting—it would have needed more interior finishing to stand up to more standard wear, yet the outside presents a beautiful, elegant gown fit for a painted portrait.

Powell notes features of the dress's design, including the portrait neckline and the intricate scrollwork, which may point to Lowe as designer: The gathered, sculptural embellishments on the sides of the bodice and the front and back of the skirt are created with "a sophisticated series of cuts, tucks and stitching to the original fabric of the overskirt [and may have] . . . developed out of a need to reduce the amount of fabric used." Powell hypothesizes that such techniques may have been used by Georgia Cole, who "worked as an

OPPOSITE AND FOLLOWING SPREAD: Evening dress worn by Marjorie Merriweather Post, 1952. Hillwood Estate, Museum & Gardens. ABOVE: Marjorie Merriweather Post portrait by Douglas Chandor, 1952. Hillwood Estate, Museum & Gardens.

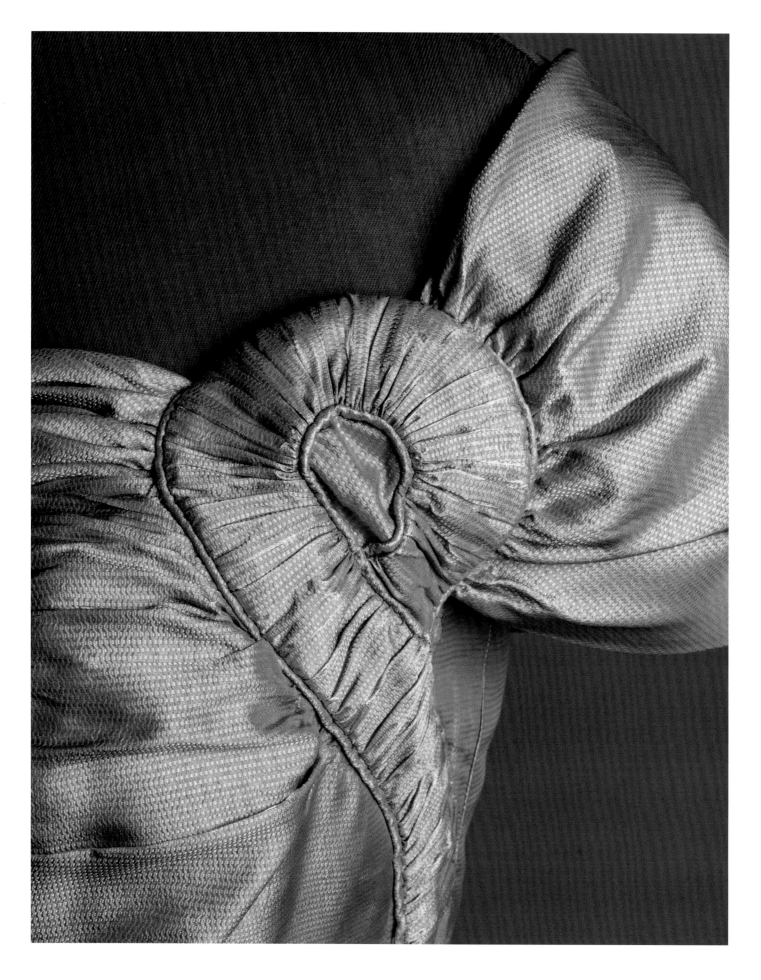

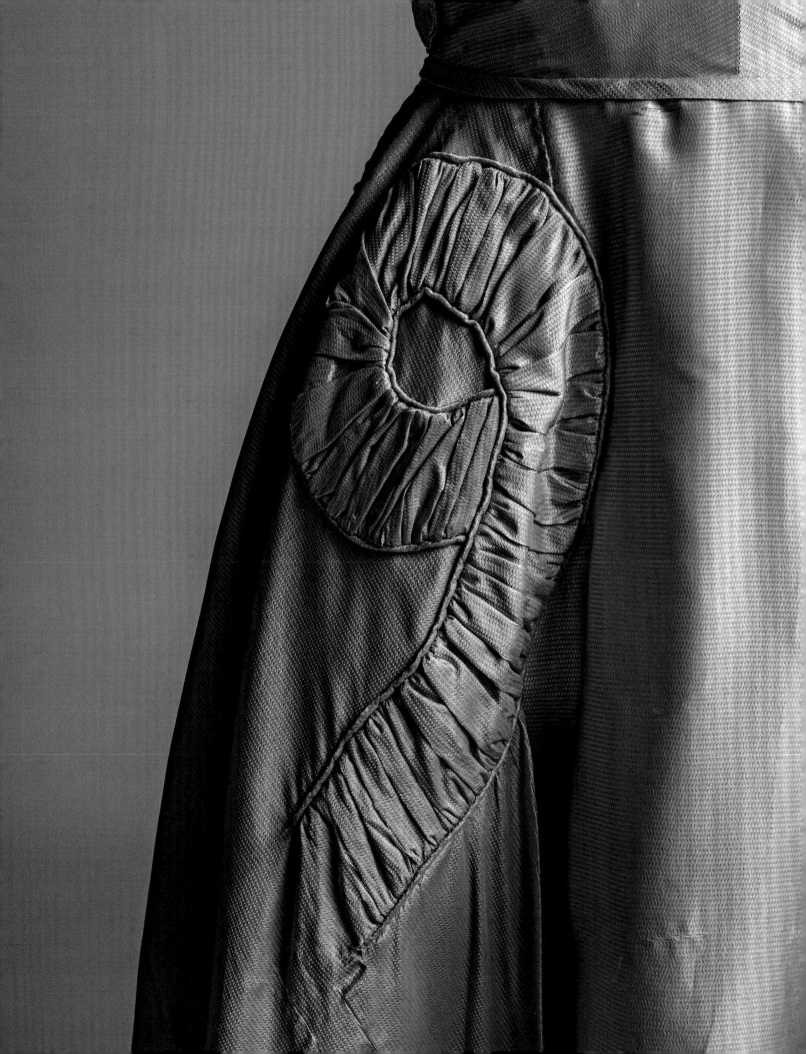

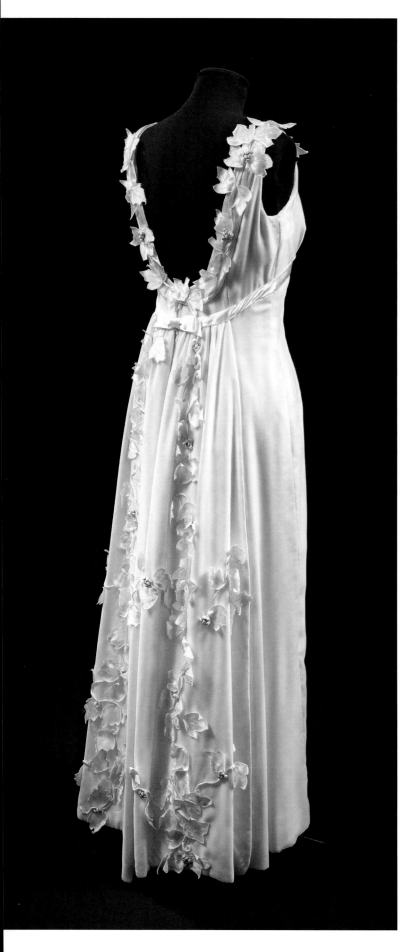

independent dressmaker during the Civil War, when luxury goods throughout the South were scarce," and passed to Lowe.[41] These details offer tantalizing connections to Lowe. Post obviously respected her work. Lowe's elegant historically inspired style may have been the perfect choice for a portrait painted in the Gilded Age tradition; however, the attribution is incomplete.

**Flower Embellishments on Debutante Gowns**

Lowe employed a number of embellishment techniques throughout her career, including intricate fabric manipulations, pleating, appliqué, embroidery, beading, fussy cutting, the use of lace, and countless others. Many of these incorporated flowers, which, more than any other element, are a signature of her style. She spoke of her first design experiences as replicating flowers with fabric, and by the time she designed her own gowns, her floral work showed confidence and a lush, luxurious sensibility. Previous gowns discussed here, including the 1928 "My Rose Dream" Gasparilla dress, the early 1930s red poppy–printed dress, and Olivia de Havilland's 1947 Oscar dress, all use floral embellishment in different ways and show Lowe's true artistic talent—on the de Havilland dress, Lowe handpainted the multicolored roses without a stencil.[42] Yet, the three-dimensional flower appliqués Lowe used to adorn certain gowns may be the most stunning examples of her work. The "American Beauty" dress from 1966–67 in the collection of the Smithsonian National Museum of African American History and Culture was made for Barbara Brooke Baldwin's debut and was first collected by the Black Fashion Museum's founder, Lois K. Alexander. The pink satin American Beauty roses that cling to green satin vines and leaves appear as buds and opening flowers at the shoulders and travel down the sides of the dress to the front hem. They seem to originate at the back waist, where full open blooms highlight the deep-scooped back neckline. The ivory dress has a high empire waistline that dips lower toward the back to accommodate the backless design. It was made for, and perfectly embodies, youthful beauty.

OPPOSITE: White velvet debutante dress
by Ann Lowe, 1965. The Museum at
the Fashion Institute of Technology,
Gift of Judith A. Tabler, 2009.70.1.
CLOCKWISE FROM TOP LEFT: Flower and leaf
samples from Ann Lowe's workshop.
FIRST FOUR: Ann Lowe / Madeleine
Couture Archives, 1962–67. Courtesy
of Sharman S. Peddy in memory of
Ione and Benjamin M. Stoddard; RIGHT:
Collection of Ms. Margaret E. Powell.

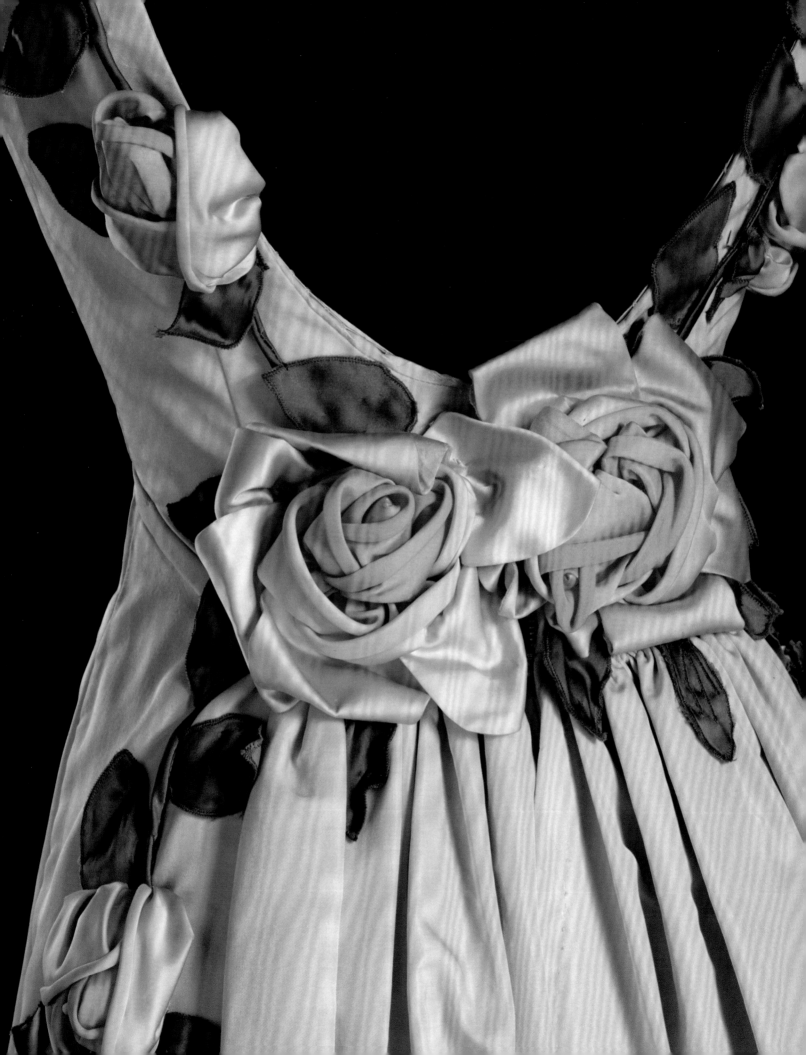

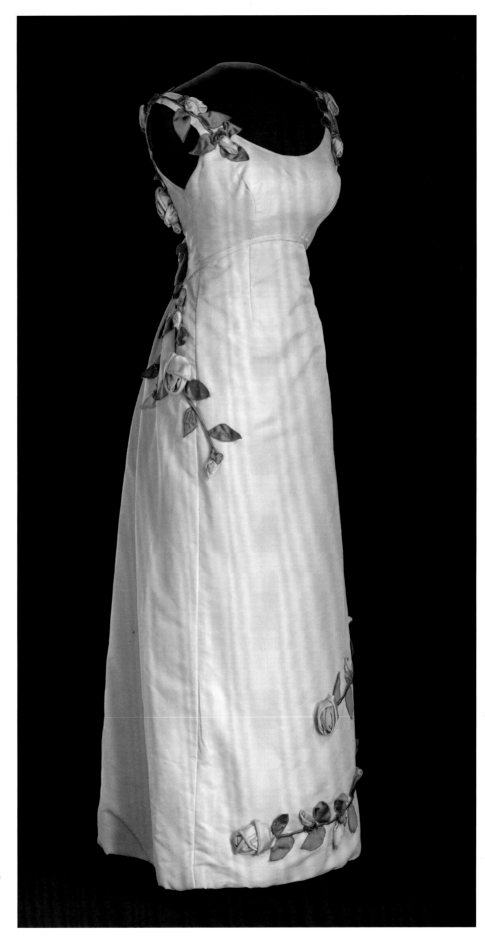

"American Beauty" designed by Ann Lowe and worn by Barbara Brooke Baldwin, 1966–67. Detail, opposite. Collection of the Smithsonian National Museum of African American History and Culture, Gift of the Black Fashion Museum founded by Lois K. Alexander-Lane.

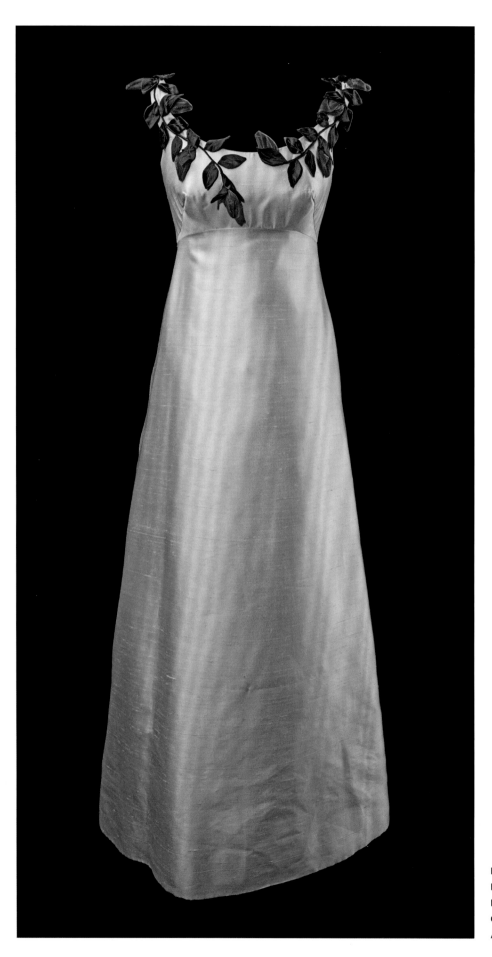

Debutante dress designed by Ann Lowe and worn by Pauline Carver, 1967. Detail, opposite. Division of Cultural and Community Life, National Museum of American History, Smithsonian Institution.

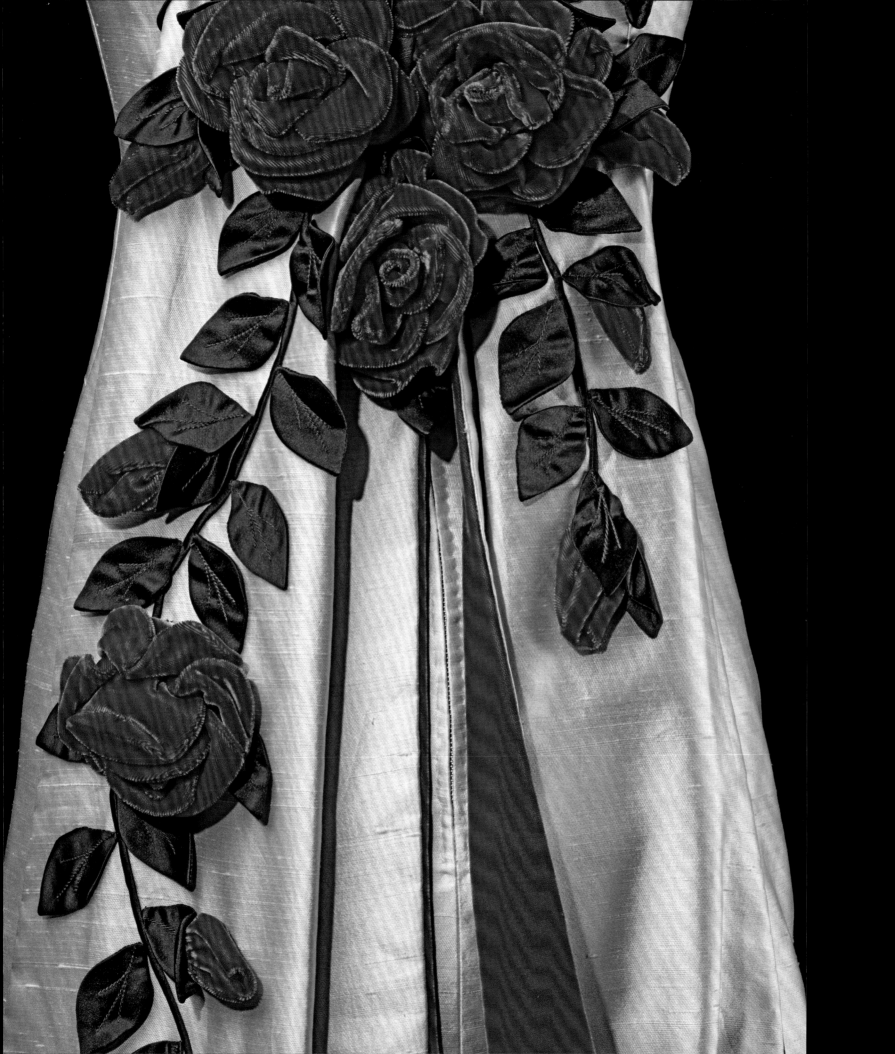

Pauline Carver's debutante dress from the same season seems simple from the front. The high-waisted white silk shantung dress features velvet rose buds in a vibrant fuchsia set off against deep green leaves and vines that drape about the neckline. Again, the roses reach full bloom at the back waist where they cluster atop deep pleats lined in the same fuchsia velvet. It is easy to see from these examples how a debutante's date might mistake these fabric sculptures for real flowers.[43] By the time Lowe was designing these dresses, she had been making flowers for decades. Sharman Peddy, whose parents employed Lowe during the early 1960s at Madeleine Couture, remembers watching Lowe roll fabric roses with one hand.[44] Lowe herself noted the trend she started, stating in 1965, "All the flowers in New York are copied from mine."[45] These dresses and others, such as Judith Tabler's 1965 debut dress in the collection of The Museum at the Fashion Institute of Technology, are demurely simple from the front with delicate details mostly at the necklines. These only hint at the explosion of floral embellishment at the back. Again, Lowe designed with her clients in mind. Debutantes traditionally wore white, and group photographs seem to depict identical women in identical dresses. By incorporating unique and eye-catching floral appliqués, Lowe helped debutantes stand out from the crowd. The young women would spend their night dancing. Facing a partner, extensive embellishment on the front of the dress would go unseen—back details, including the fullness Lowe added to each of these gowns, would create movement and visual interest, ensuring the gown was noticed. By the 1960s, debutante balls—events that advertised wealthy young women as open for marriage—were considered passé by some (including some participants). Lowe updated her gown designs to appeal to young women while paying homage to the debutante dress genre. The silhouettes of these gowns followed the 1960s A-line style and, besides the floral embellishment, were simple and structural in keeping with modish fashions. Lowe also included scandalously low backs on her gowns at this time, which did not go unnoticed by mothers.

She joked that it was "To save my beautiful dresses; I want to keep the hands of the boys from getting them so dirty when they dance,"[46] but the low backs also embraced the more body-exposing styles of the decade.

**Bridal Gowns**
Brides were another important customer base for Lowe, and women such as Jacqueline Kennedy and Judith Tabler returned to Lowe for wedding dresses after the success of their debutante gowns. Bridal gowns may be, collectively, the most collaborative of Lowe's work since opinions from the bride, as well as the bride's family and friends, could contribute to the design. While these gowns in Lowe's body of work are traditional—all are white, full length, and recognizable as bridal wear—they also incorporate the changing fashions of the decades and the client's requests, emphasizing Lowe as a dynamic designer. The bridal gowns of Nell Lee and Jane Trimingham both show the distinctive styles of the twenties and forties, respectively. Florance Rumbough's 1951 white satin gown follows a fifties silhouette yet shows nineteenth-century historical inspiration with its off-the shoulder neckline and short, puffed sleeves, as well as an open-front skirt with "a panel of flounces of heirloom, rosepoint lace down the front" that demonstrates eighteenth-century revival. This is one of several examples of Lowe's use of lace—this time the gown incorporated an antique piece from the bride's grandmother, likely requested by Rumbough.[47]

In contrast, Ann Bellah Copeland's 1964 dress was minimal—she had worked in fashion in New York and "felt the days of the big skirted, fussy flowers, ruffles and embroidery were over. I was also bored by the idea of too much lace."[48] Copeland browsed department stores for a dress reflecting her sophisticated style, but only found "fluffy" styles "with lots of flounce and bows." She decided to visit Lowe's atelier on Lexington Avenue and spoke with Lowe. Although Copeland remembers Lowe as fragile with age and her failing eyesight, Lowe "understood the concept that I wanted, and she made it." The silk faille gown features clean lines and

CLOCKWISE FROM TOP LEFT: Bridal portraits: Florance Rumbough, 1951. Collection of the Smithsonian National Museum of African American History and Culture, Gift of the Estate of Florance Rumbough Trevor; Ann Bellah Copeland, 1964. Courtesy, Ann Bellah Copeland. Bridesmaid gown for Elizabeth Mance's wedding by Ann Lowe, 1968. Courtesy, Mrs. Bette Davis Wooden. Ann Bellah Copeland wedding dress by Ann Lowe , 1964. Delaware Historical Society, Gift of Ann Bellah Copeland. 2003.028.

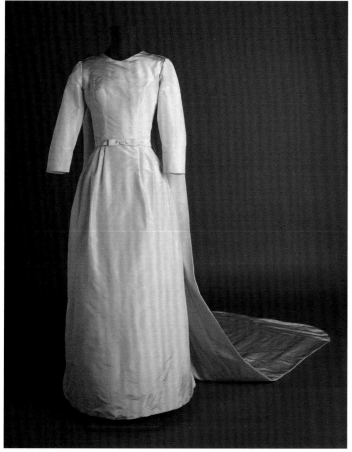
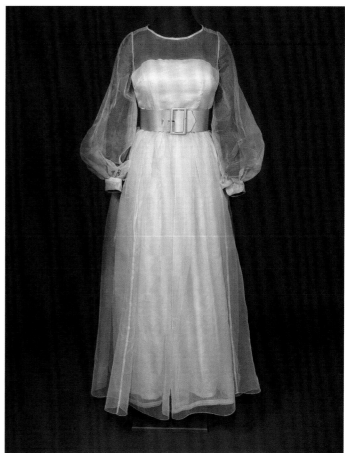

ABOVE: Maid of honor Dianne Mance (left) and bride Elizabeth Mance in Ann Lowe gowns, 1968. OPPOSITE: Elizabeth Mance, wedding photograph, 1968. Ann Lowe can be seen behind the bride and her father being escorted to the church. Photos from the collection of Elizabeth Mance de Jonge. PAGES 118–21: Elizabeth Mance bridal gown by Ann Lowe, 1968. Elizabeth Mance de Jonge Collection.

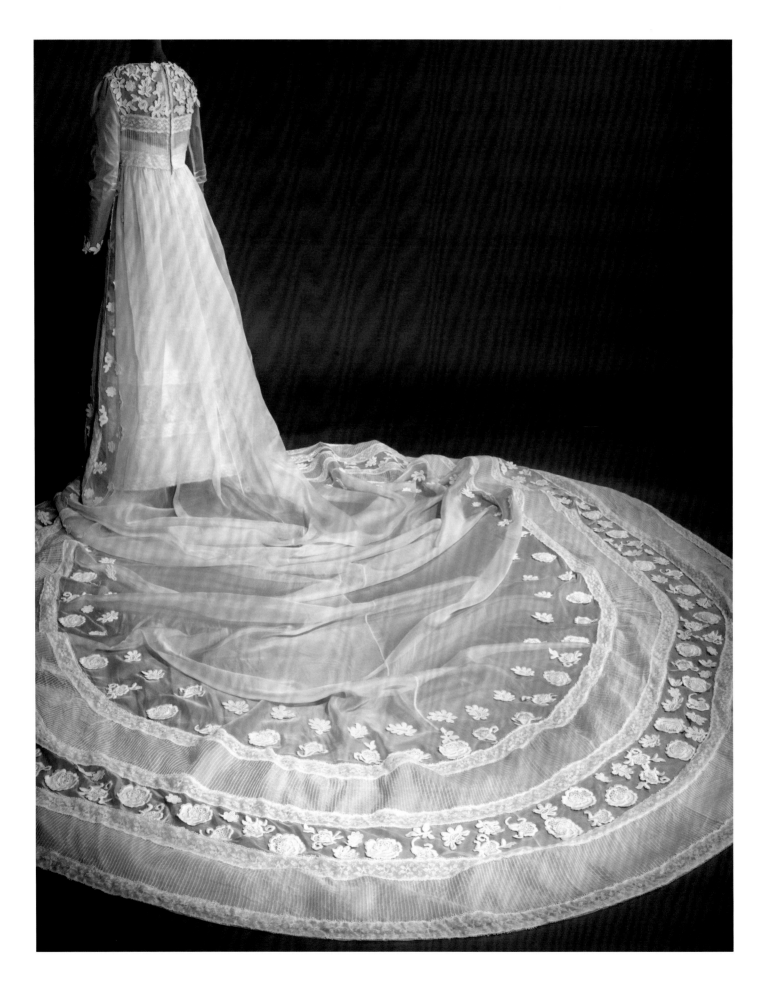

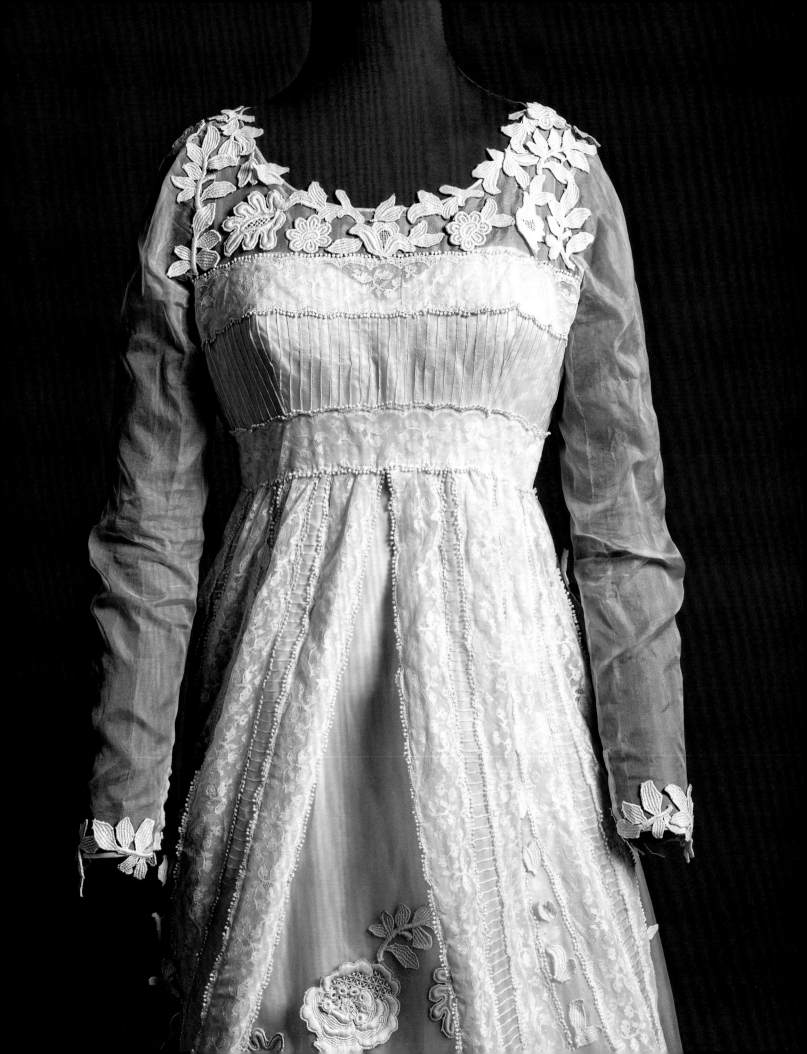

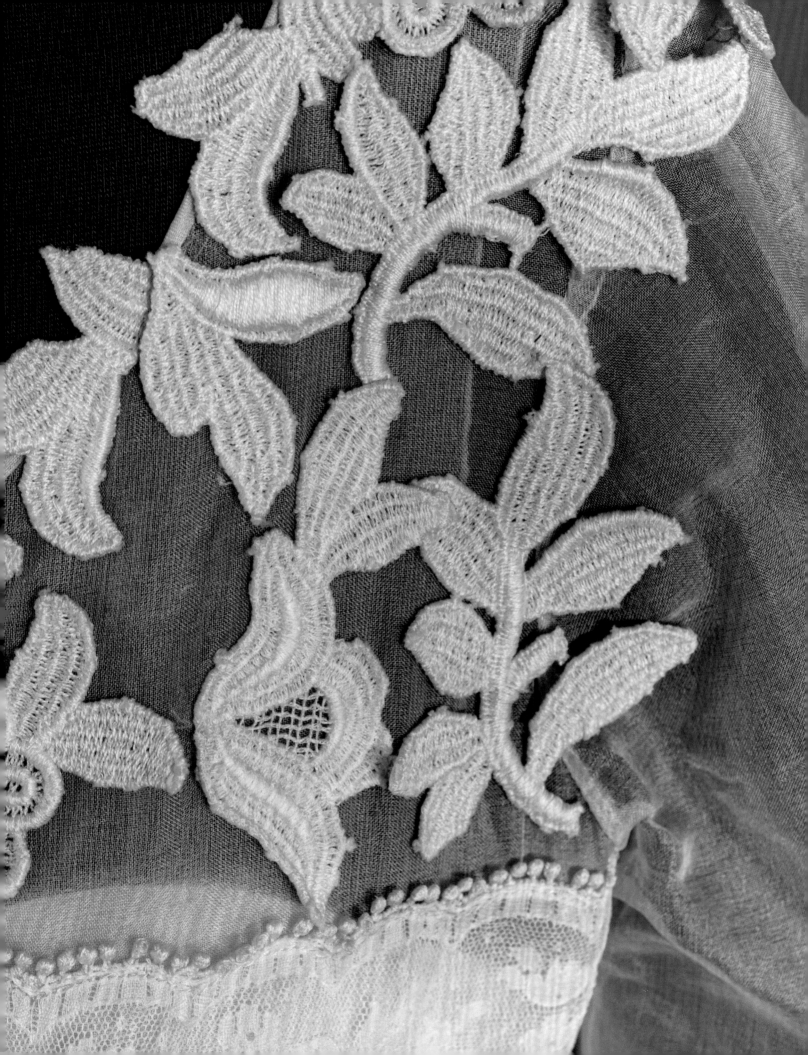

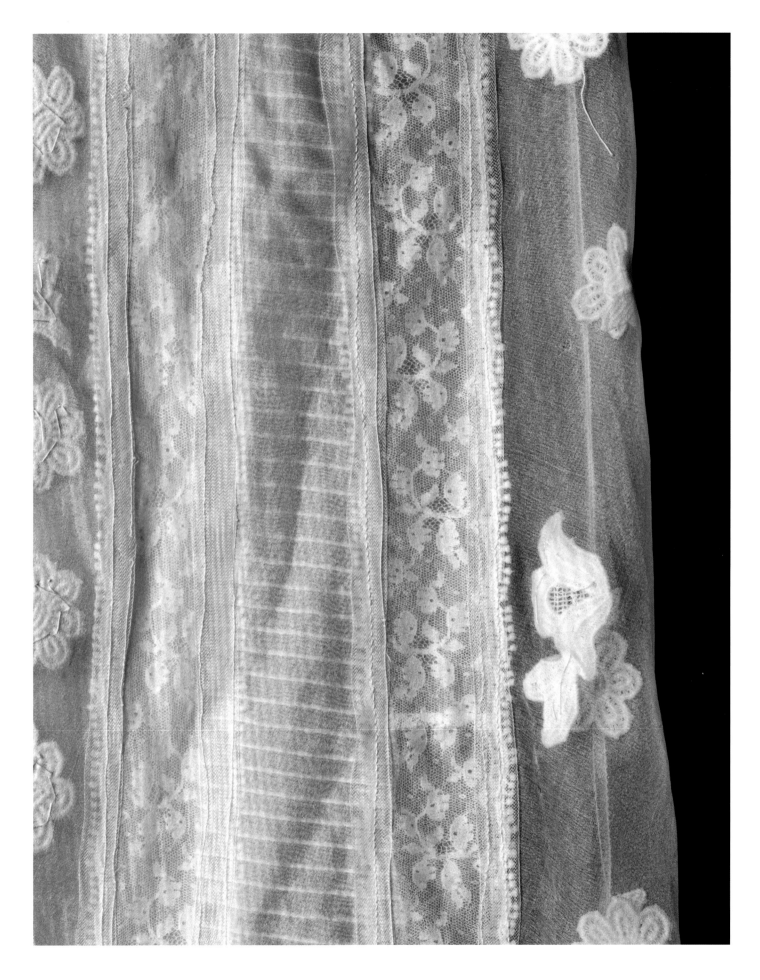

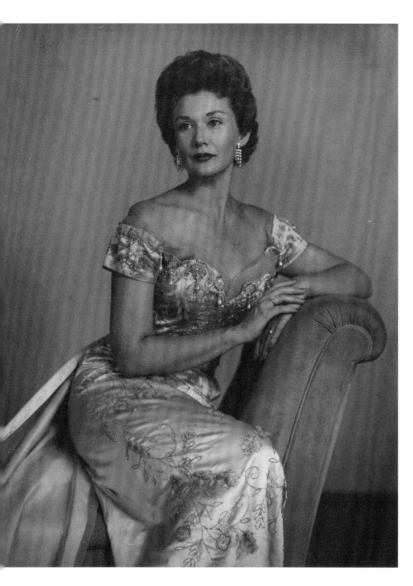

featured bands of lace, pintucking, and appliqué. An open-front overskirt extended into a cathedral-length train and was similarly edged in lace, pintucking, and appliqué. Lowe drew from a sixties countercultural and vintage-inspired style for this gown yet added all the formal elements that the large church wedding required. Lowe also created the bridesmaids' dresses—strapless tight-waisted white gowns with high-necked and long-sleeved sheer overlays, worn with short veils and wide pink satin belts. Maid of honor Dianne Mance's gown was distinguished by a pink under-layer. Bette Wooden, herself a fashion student and later a fashion designer, recalled meeting Lowe in her Madison Avenue studio when she arrived for her fitting. Sibyl Gant, another bridesmaid sent her measurements to Lowe, and the dress was made, sent, and sent back for alterations.[50] A *Tampa Bay Times* article on the Mance wedding party gowns notes the importance they served in Lowe's distinguished career, calling them "the most meaningful," as the Mances were a prominent Black family. The article also noted that the wedding gown served as "an effective closing chapter in Miss Lowe's memoirs, which are currently being written."[51] Unfortunately, no such autobiography was published.

**Fantasy Gowns**

Lowe's designs for festivals and themed balls represented a unique aspect of her work. These occasions gave freer rein to Lowe's imagination. True to the nineteenth-century training she received from her grandmother, Lowe did not experiment wildly with silhouette, but rather turned to embellishments to create the fantasy characteristics of these gowns. As Elaine Nichols, supervisory curator of culture at the Smithsonian National Museum of African American History and Culture, notes, "Lowe was 'helping young, wealthy white women (and their parents) live in a world of fantasy.'"[52] Besides her 1920s and later work for Gasparilla, including a 1957 Jewel Court gown, Lowe designed queen, princess, and countess gowns for the 1961 Ak-Sar-Ben Coronation Ball in Omaha, Nebraska. The ball, dating to 1895, and hosted by the Knights of Ak-Sar-Ben, a civic group

a simple bow belt, as well as a court train emanating from the shoulders, unusual for wedding gowns of this time. Copeland recalls, "I ended up with exactly what I wanted." Copeland also wanted to commission dresses for her eight bridesmaids and her flower girls, but Lowe's assistant subtly signaled that Lowe was not up to such a large order at that time.[49]

One of the latest extant Lowe wedding gowns was made for Elizabeth Mance's 1968 wedding. Lowe was chosen by the bride's father, the distinguished doctor and international church leader Dr. Robert Mance, who is remembered by bridesmaid Bette Wooden as a man with exquisite taste in women's fashion. Lowe attended the wedding and was captured in the day's photographs. The gown was a modern mix of contemporary fashion and traditional wedding dress elements. The bodice was made up of horizontal bands of lace around a band of vertically pintucked organza. The neckline was trimmed in bold floral appliqué, as were the cuffs of the long, sheer sleeves. The high-waisted columnar skirt also

ABOVE: Rebecca Davies Smith wearing Ann Lowe gown in the Jewel Circle at Gasparilla Coronation Ball, 1957.

Courtesy, Collection of Henry B. Plant Museum Society, Inc.
OPPOSITE: Ann Lallman Jessop wearing

Ann Lowe gown at Ak-Sar-Ben Coronation Ball, 1961, Omaha, Neb. Collection of the Durham Museum.

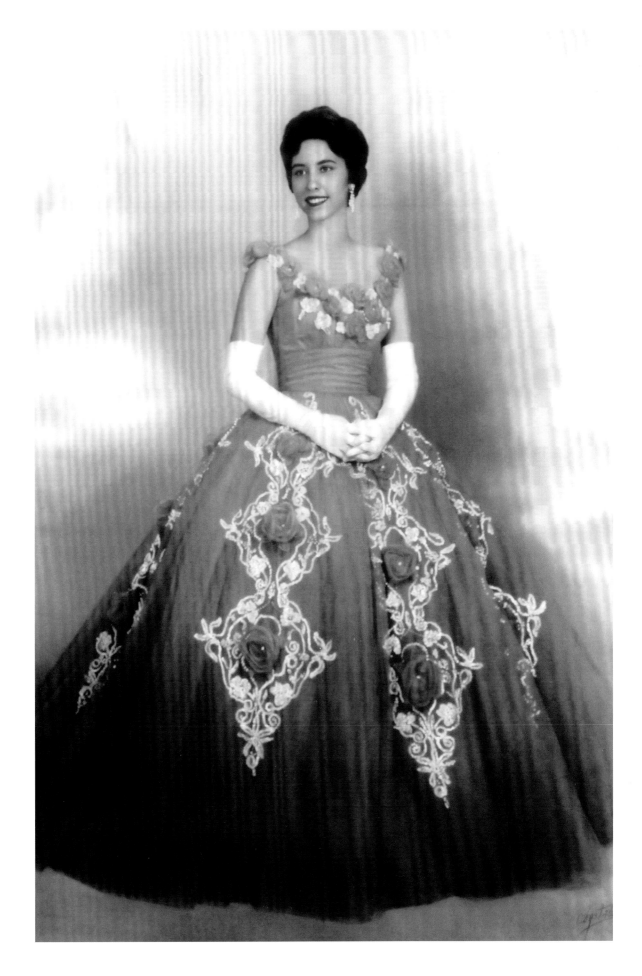

of local businessmen, was held in "celebration of Nebraska's prosperous agricultural industry,"[53] and Lowe was commissioned through Saks Fifth Avenue to make thirty-three extravagant tulle gowns. Each gown contained twelve layers, plus petticoats and hoops, and each was hand beaded. Lowe designed seven over-the-top styles in all: four princess styles, two countess styles, and a queen's gown. The college-aged women selected as the Ak-Sar-Ben Court were transformed; a countess recalled to Powell, "I delighted in my gown. The style was so elegant. I've always referred to it as my Cinderella gown."[54]

Lowe also designed a maid of honor debutante gown for Susan Celeste Peterson for St. Louis's Veiled Prophet Ball in 1963. The Veiled Prophet secret society was formed in 1878 by former Confederate soldier Charles Slayback. Journalist Scott Beauchamp describes its activities as white elites' "response to growing labor unrest in the city, much of it involving cooperation between white and black workers."[55] The group intimidated working-class people, excluded Black and Jewish St. Louisans, and featured a secret Veiled Prophet, whose costume closely resembled a Ku Klux Klan uniform. While Ak-Sar-Ben clearly celebrated Nebraska's industrial leaders and featured women economically privileged enough to attend college in the early 1960s, the Veiled Prophet Ball showcased much more sinister aspects of white elitism. Whether Lowe knew the history of the Veiled Prophet organization when she took Peterson's commission is unknown; however, it is likely that she did not. The ice blue satin dress embellished with grape vines, leaves, and dimensional satin grapes was also sold through Saks Fifth Avenue. Peterson also wore it to a debutante party months later, and she commissioned an additional white debutante gown from Lowe at Saks that was embellished with leaves and rosettes for the Fleur de Lis Ball that season, where she was presented to the local Catholic cardinal.[56] Lowe's design talent drew clients to her for these initiation balls, parades, and debuts that served as markers of elite status for white society around the country. They indicate a class system of exclusion that ironically relied on the creative genius of a Black southern woman. She could provide the "fairy-princess look" that made young women feel special, and each surviving gown shows the extensive range of her design variation and exquisite craftsmanship that significantly contributed to the celebratory atmosphere of these events.[57]

**The Changing Fashion Business: Dressmaker to Designer**
Ann Lowe played varying roles in the American fashion industry over the course of her career, and she witnessed both fashion and cultural evolutions. The United States had been a pioneer in ready-to-wear clothing production since the mid-to-late nineteenth century, and as the garment industry centered in New York City, the strength of American manufacturing only increased. By the 1910s, women could purchase any article of their wardrobe off the rack.[58] And by the 1960s, custom-made clothes were generally a rarity. Ann Lowe worked in a separate sphere of American fashion. When she first began working with her grandmother and mother in Alabama, dressmakers were much more common, especially in locations away from the shopping options of major city centers. Department stores were available—Lowe likely worked in a department store in Dothan, Alabama, in 1916, though she may have worked as a seamstress making alterations or whole garments, as opposed to a salesperson.[59] Yet, for elite women who wanted unique, fashionable, and high-quality clothing that fit them perfectly, going to a trusted local dressmaker was an obvious choice. The clients whom Lowe's family served needed embellished ball gowns in addition to a stylish daily wardrobe, and this seems to have been the Lowe family specialty. As Lowe's earliest training and expertise were in custom dressmaking, she was intimately familiar with the process, which involved orders from clients with a more or less precise idea of what they wanted in the finished product. Therefore, in addition to technical skill, a successful dressmaker needed to know when and how to guide her clients to the best possible outcome and make sure they left happy. The stylish, well-fit dresses would serve as the dressmaker's calling cards and create word-of-mouth advertising, an essential component

PAGES 125–28: Bright coral pink Ak Sar-Ben countess gown by Ann Lowe for Saks Fifth Avenue (bodice, detail, and front), 1961. Collection of the Durham Museum, Gift of Ann Lallman Jessop. PAGES 129–31: Pale pink Ak-Sar-Ben countess gown by Ann Lowe for Saks Fifth Avenue, 1961. Collection of the Durham Museum, Gift of Lynn Robertson Evert.

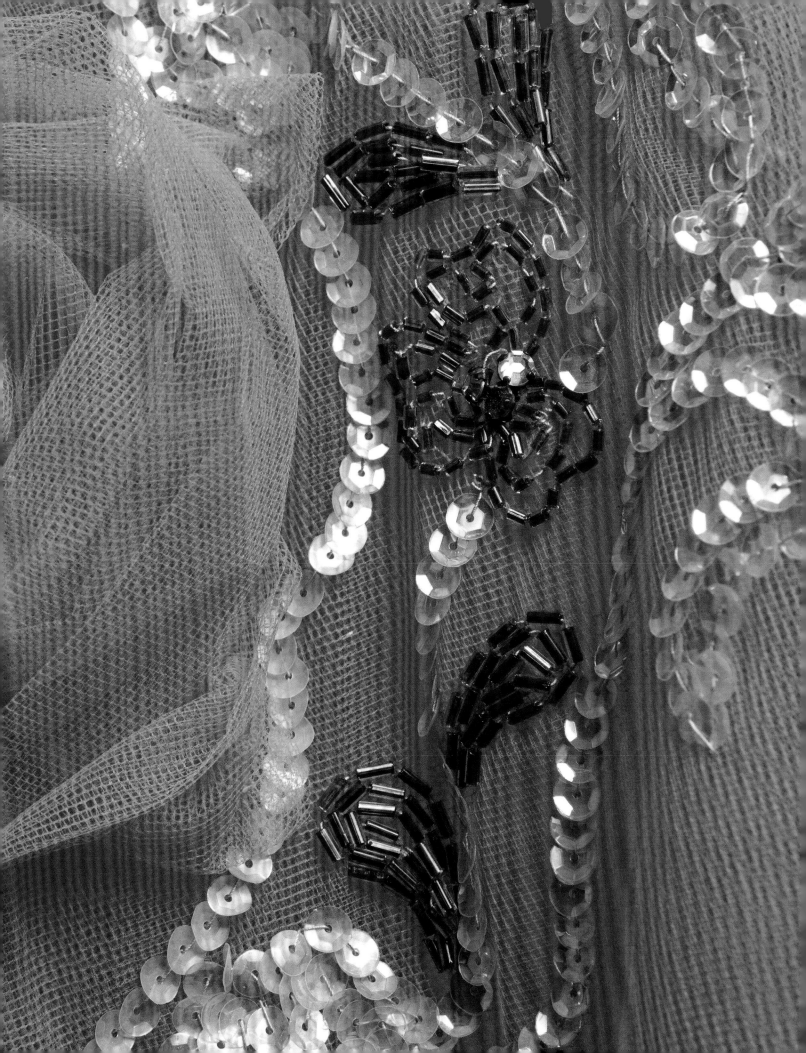

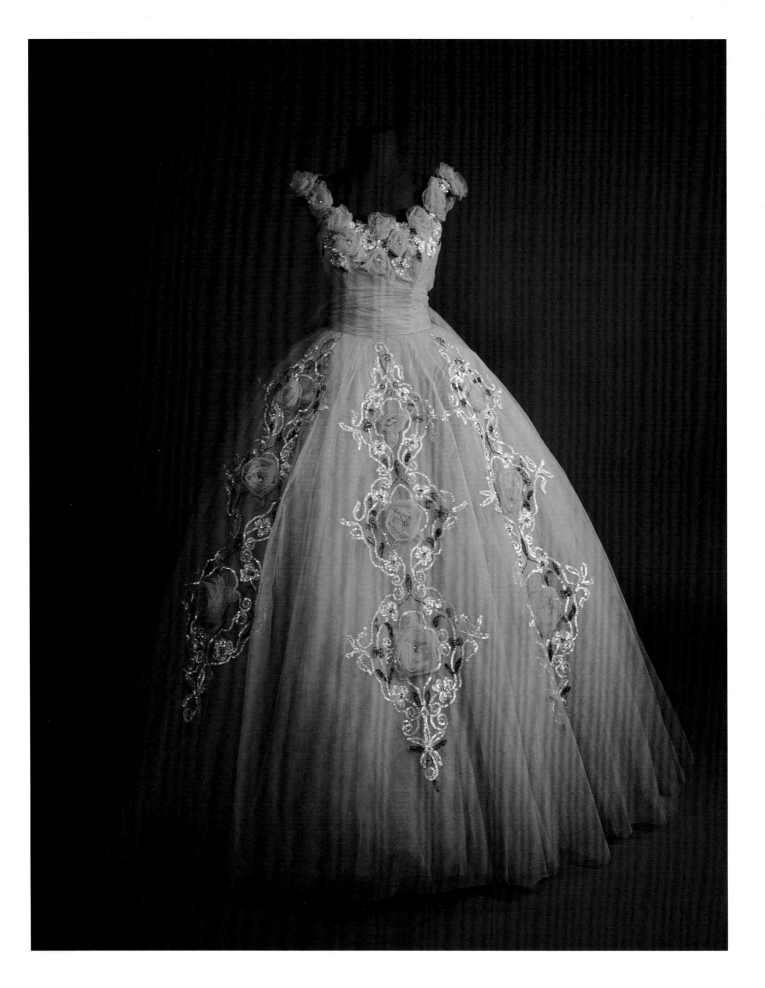

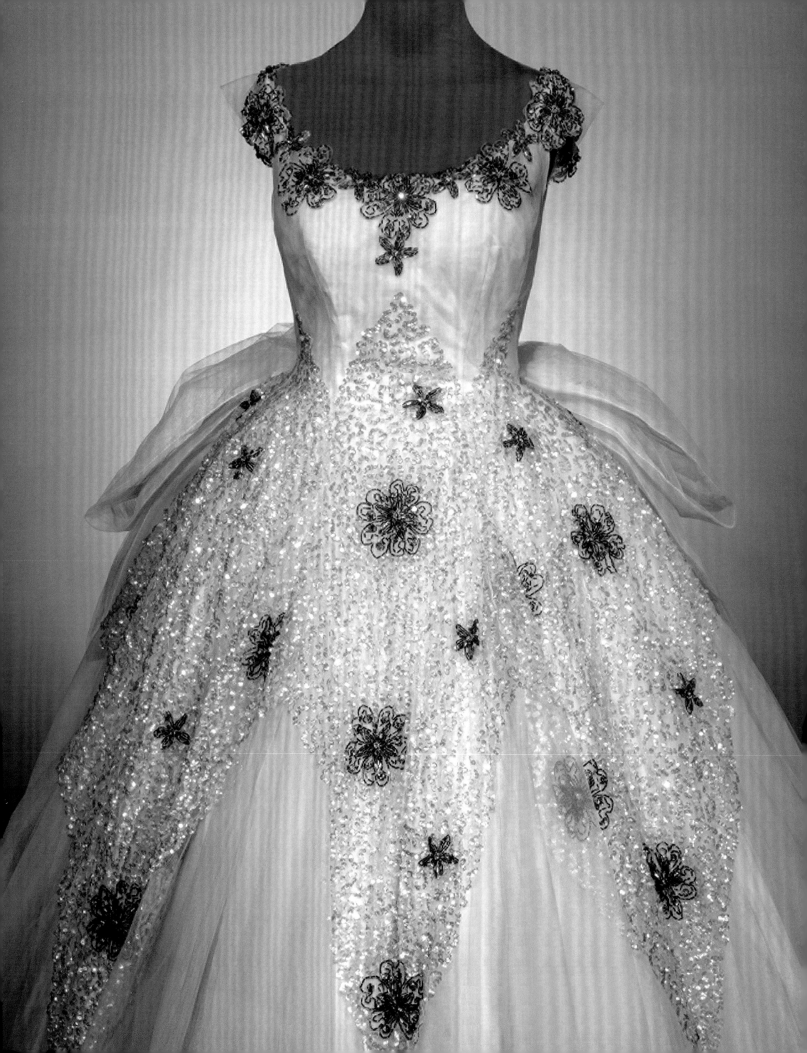

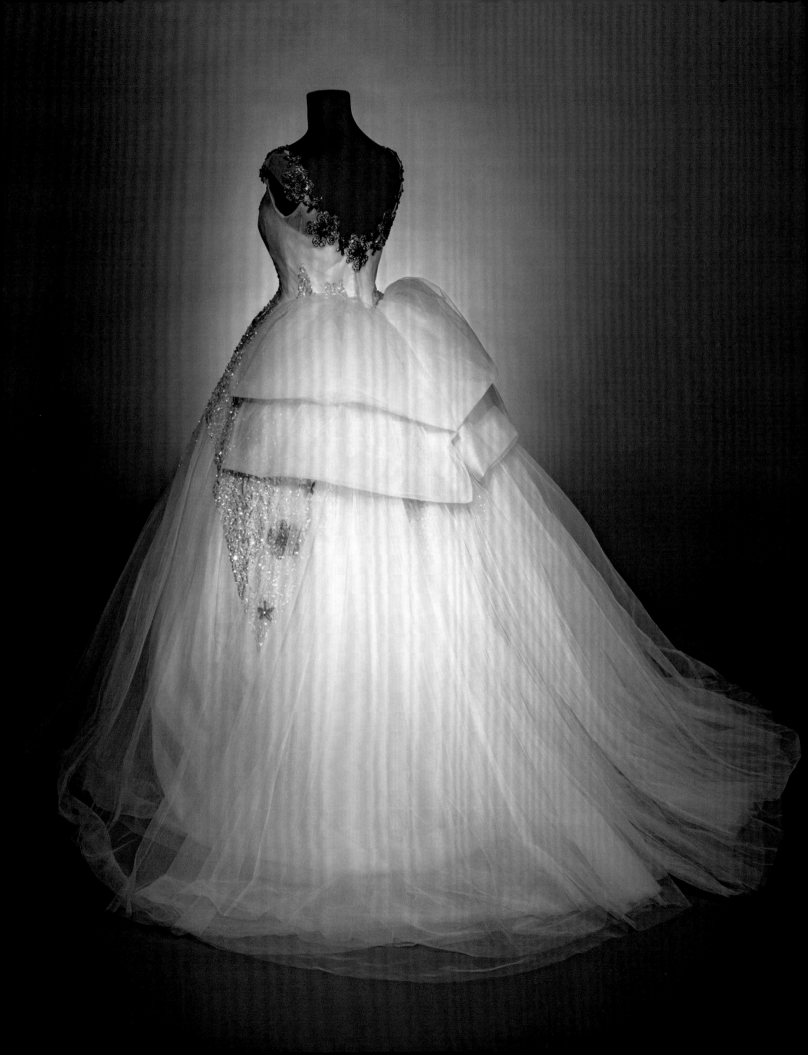

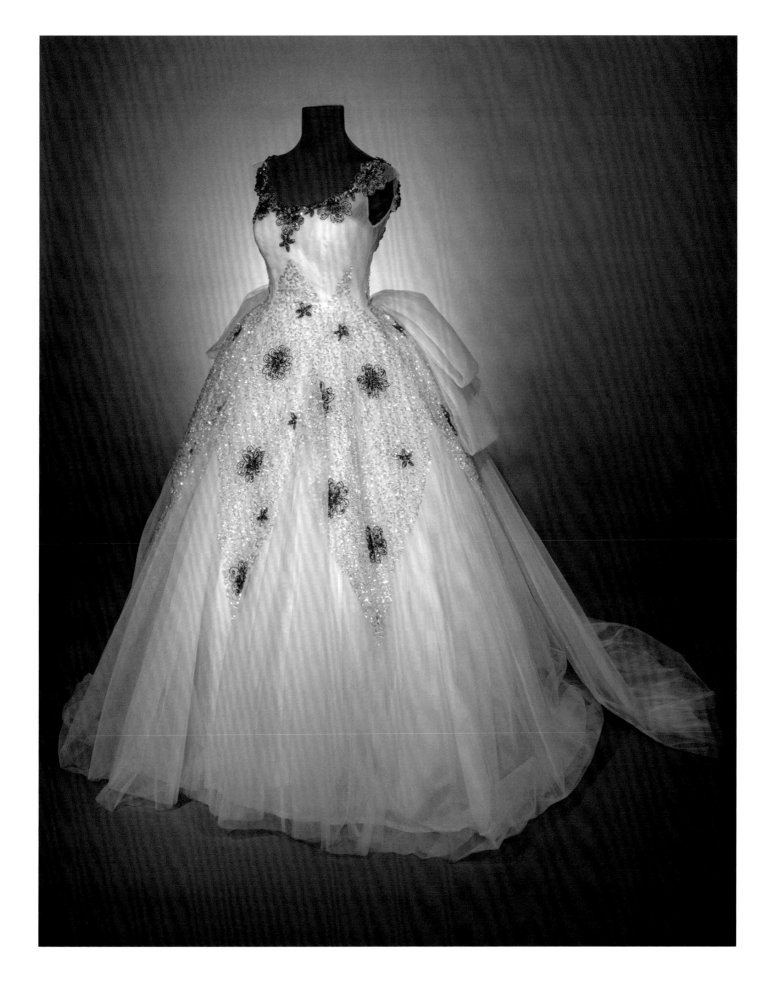

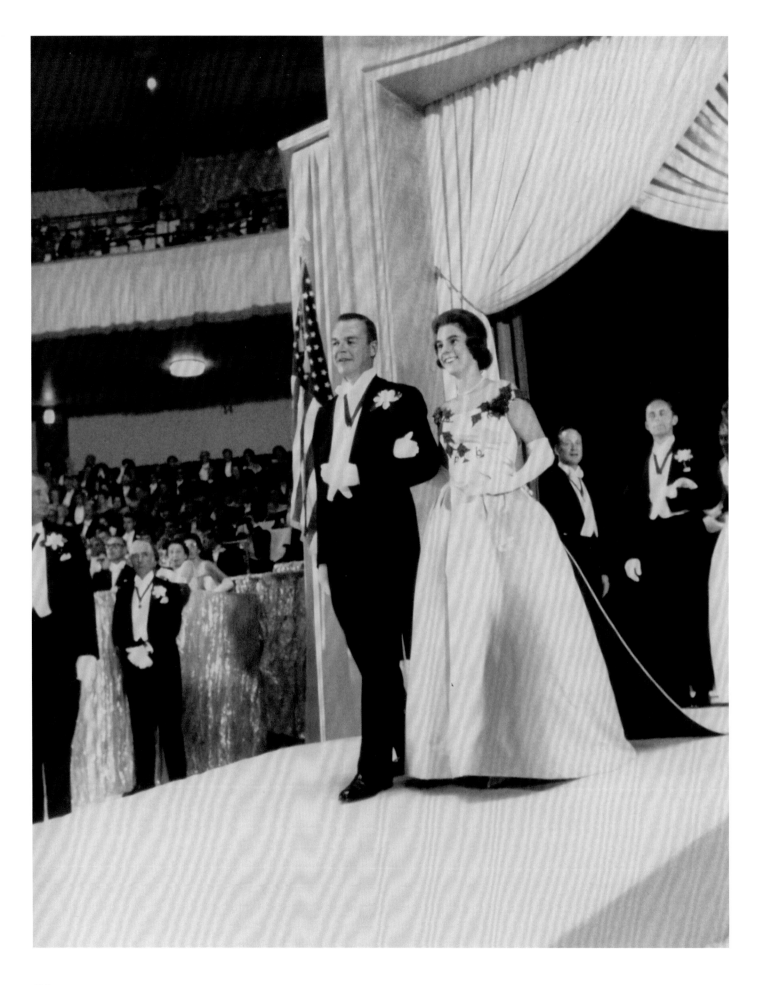

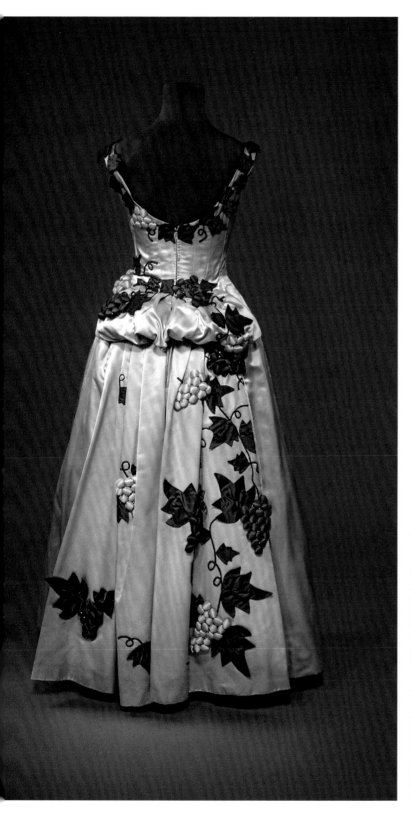

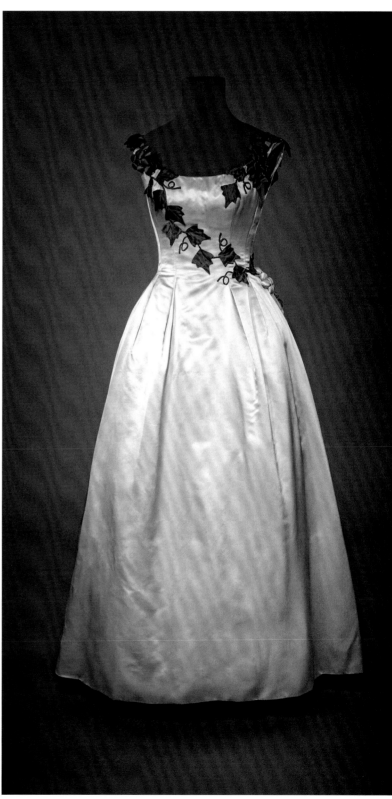

OPPOSITE: Susan Celeste Peterson wearing Ann Lowe gown at Veiled Prophet Ball. Courtesy of the Missouri Historical Society, St. Louis, Mo. ABOVE AND FOLLOWING SPREAD: Veiled Prophet ball gown (back, front, and detail) designed by Ann Lowe for Saks Fifth Avenue and worn by Susan Celeste Petersen, 1963. Courtesy of the Missouri Historical Society, St. Louis, Mo.

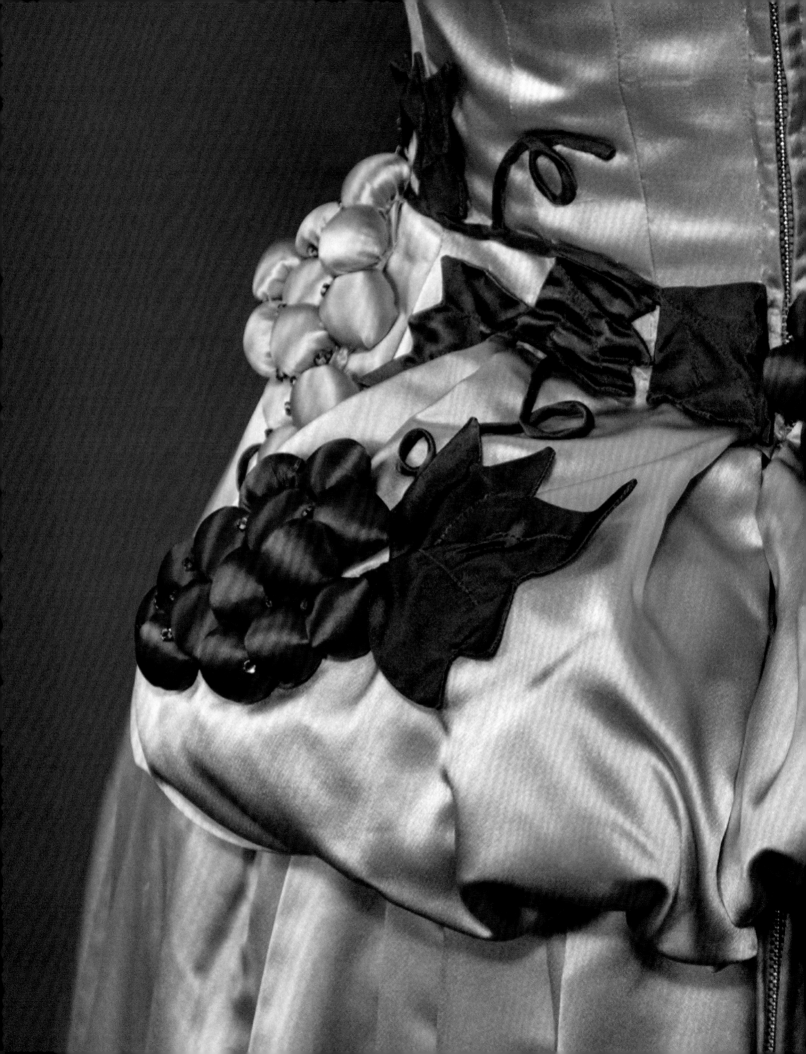

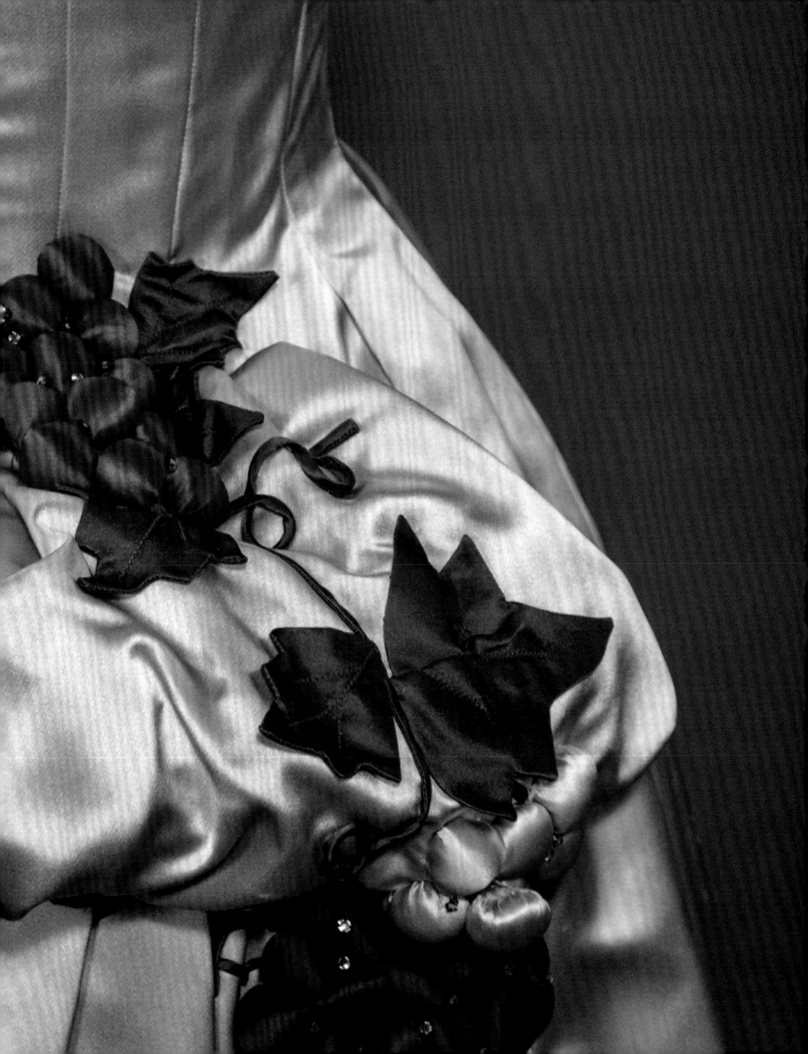

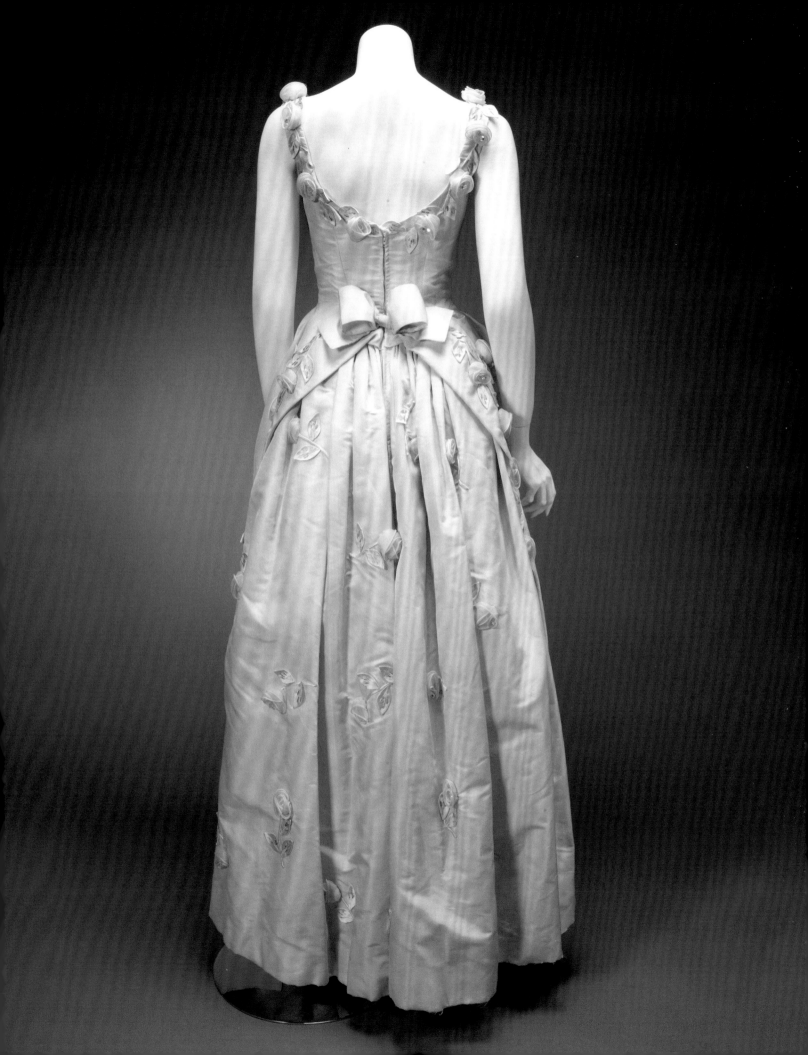

of building a custom business. Lowe's first husband did not support her career, and she stopped working for a time, but enthusiastically resumed when offered a job in Florida. Lowe began as a live-in dressmaker for the Lee family, as mentioned above, and eventually established her own shop, trained her own assistants, and achieved the status of the best dressmaker in Tampa, the go-to for society weddings and the Gasparilla festival. Lowe worked in Tampa for more than a decade and could have easily excelled in her role there for the rest of her life. She seemed to be making a good amount of money through her business, and she was surrounded by clients who valued her and her work. Yet, Lowe might have felt stifled in the small city, and she dreamed of bigger things. Lowe's move to New York signaled the beginning of her transition from a highly skilled dressmaker to a "fashion designer," a perception of her that had more to do with her location and branding than a change in her design work. While Lowe's work in Tampa spoke in dialogue with a wider fashion world, in her decades in New York, she established herself as a creative talent who took an active part in shaping fashion culture on a national scale—though this was not recognized until the end of her career. This transition was made possible by her extraordinary skill and talent, both in design and in connecting with her clients, and through recognition in the press. The latter was due in large part to Ione and Benjamin Stoddard, the owners of Madeleine Couture, where Lowe worked from 1962 to 1965.

The fashion industry that Lowe sought to break into in New York during the late 1920s was dominated by manufacturers who employed designers mostly to copy French couture. A design house like Hattie Carnegie—one of the highest-end labels in New York fashion—employed a stable of designers who worked anonymously under the company's name. American fashion did not value the artistic creativity of individual designers as the French industry did—fashion was, first and foremost, a business. A young Norman Norell, who would later become one of the most prominent mid-century ready-to-wear designers on Seventh Avenue, also worked for Hattie Carnegie during the late 1920s and 1930s. He, like

OPPOSITE: Fleur de Lis ball gown designed by Ann Lowe for Saks Fifth Avenue and worn by Susan Celeste Petersen, 1963.

Courtesy of the Missouri Historical Society.
ABOVE: Idella Kohke in Easter dress designed by Ann Lowe, *New York Age*, April 20, 1957.

137

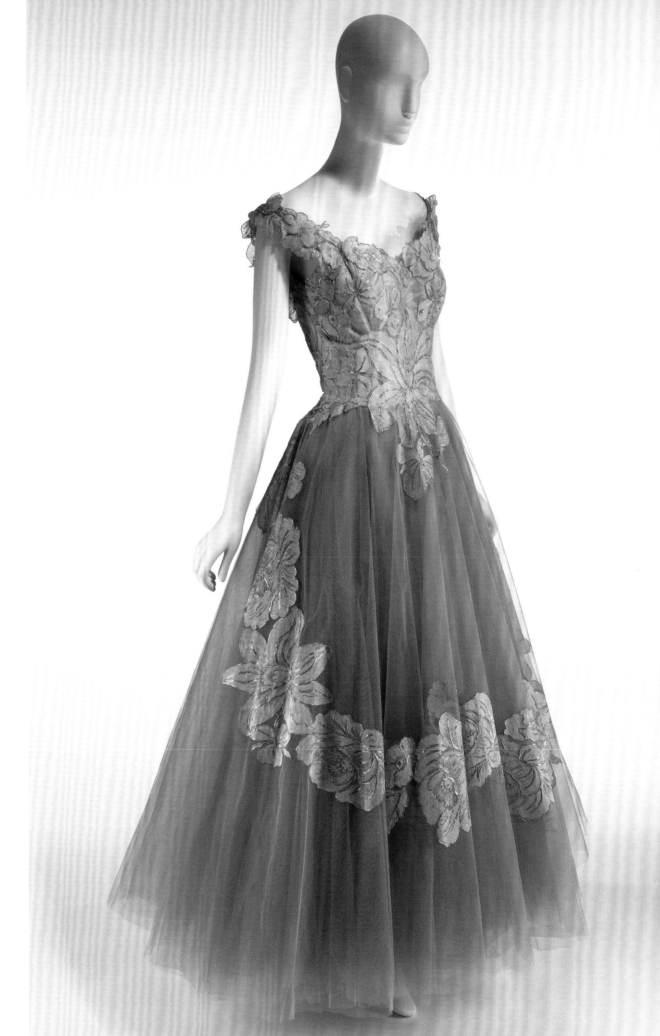

RIGHT: Evening
dress by Ann
Lowe, ca. 1960.
The Metropolitan
Museum of Art,
Gift of Lucy Curley
Joyce-Brennan,
1970 (1979.144).
OPPOSITE: Detail
of label.

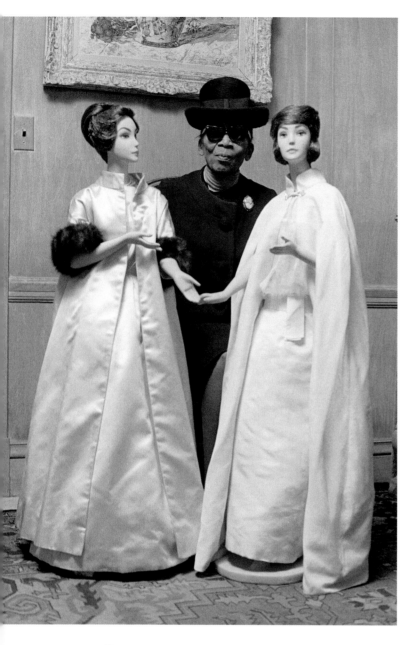

Lowe, offered to work for free to prove his talent, illustrating the position designers held in relation to manufacturers. When offered a partnership with manufacturer Anthony Traina in the early 1940s, Norell negotiated a lower salary in exchange for the clothing label to read "Traina-Norell."[60] Having his name on the label with the manufacturer's name made him an exception, and he paid for it. When Lowe's first shop failed in the wake of the Great Depression, she turned to this same fashion system at a distinct disadvantage as a Black woman. Looking back, she was perhaps bitter at the exploitative nature of the industry. In the context of her 1960s interviews, when American fashion designers garnered much more respect, she stated, "For the 20 years I worked for others, I rode one person after another to glory

on my back."[61] In regard to one of her most photographed designs, Olivia de Havilland's 1947 Oscar dress, she stated, "Its picture was printed in a national magazine, but another designer was credited with its design because my name was not acceptable."[62] Lowe rarely discussed the racism she experienced throughout her career, and this is perhaps a comment on it, though it would have been standard practice for the dress to bear the name Sonia Gowns after her employer, Sonia Rosenberg.[63] Lowe's experience in Tampa as the respected head of her own atelier no doubt left her anxious to reestablish her own company as soon as possible, though she was clearly taking private commissions during her tenure as a designer-for-hire among New York manufacturers.

Powell traces Lowe's various companies and partners from the 1950s to her retirement in 1972. During this period, she slowly built her reputation as a fashion designer through her brand of feminine beauty and exquisite embellishment and through her recognition in the press. Lowe was denied the significant press on Jacqueline Kennedy's 1953 wedding dress, though she was credited in *Vogue* in 1955 for Nina Auchincloss's debutante dress. Lowe also seemed to be well known among Black New Yorkers. In addition to her selection by the *New York Age* for its 1949 couture correspondent, Lowe was the only designer credited among the creators of four Easter ensembles pictured in the paper in 1957. Her beaded dress of black French satin for the Black Harlem socialite Idella Kohke features a large, appliquéd rose on the full skirt in her signature style.[64] Much of Lowe's press focuses on her white clients, but she clearly also designed for fashionable and elite Black clients.

### Creating a Legacy

Ann Lowe spent the majority of her career as "society's best-kept secret," as the *Saturday Evening Post* would dub her in 1964. Yet by the early 1960s, Lowe was more than ready to claim her accomplishments. She participated in promotional events that garnered press, such as the Evyan Perfumes First Ladies miniature doll collection. Lowe reproduced multiple sets of inaugural gowns of more than a

ABOVE: Ann Lowe with Evyan Perfume dolls. From Gerri Major, "Dean of American Designers," *Ebony*, December 1966.

Johnson Publishing Company Archive. Courtesy Ford Foundation, J. Paul Getty Trust, John D. and Catherine T. MacArthur

Foundation, Andrew W. Mellon Foundation, and Smithsonian Institution. OPPOSITE: Ann Lowe fitting dress for fashion show, 1962.

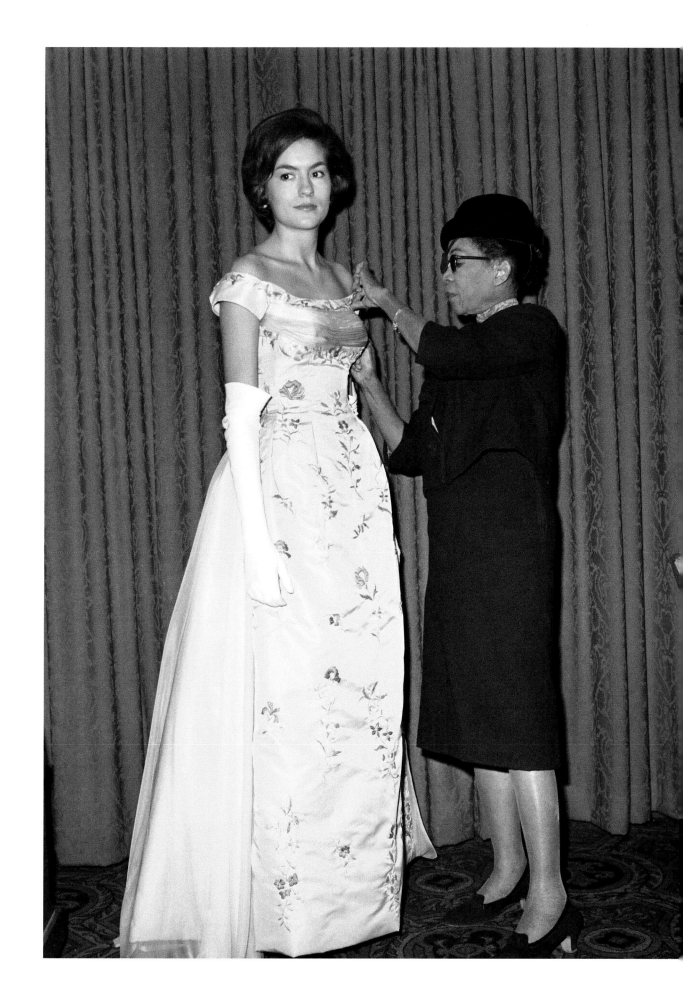

dozen First Ladies beginning with Mary Todd Lincoln. The dolls toured department stores and other venues as a part of a promotional campaign for Evyan Perfumes and were gifted to the Congressional Club in Washington, D.C., in 1961.[65] However, Lowe was largely able to promote her illustrious career through the help of Ione and Benjamin Stoddard. In the fall of 1962, Lowe began working for Madeleine Couture, which had been founded by Benjamin Stoddard's mother, Lillian Stoddard, during the 1920s or 1930s.[66] His wife Ione Stoddard was a registered nurse but attended fashion school and transitioned careers to run the shop in 1961, after Lillian Stoddard's death in 1947 and the retirement of the shop manager. Lowe called Madeleine Couture after her disastrous deal with Saks (see page 48 and 57), telling the Stoddards that she had inquired about a position twenty-five years prior, but at that time, the shop only made suits and daywear. Recognizing Lowe's talent— she was a competitor and shared customers with Madeleine Couture—they hired her and played to her strengths by offering evening, debutante, and wedding gowns.[67] They also decided to promote Lowe widely. By December 1962 the Stoddards organized a society fashion show of Lowe's work at the Berkshire Hotel. Benjamin Stoddard sought help from a friend in advertising, and the Stoddards secured major national press for Lowe, including the *Saturday Evening Post* profile and her appearance on *The Mike Douglas Show*, both in 1964. The Stoddards' daughter, Sharman Peddy, holds a significant personal archive of Lowe's papers collected and preserved by Ione Stoddard, which includes a photograph of Lowe with Ione Stoddard at the airport on their way to Cleveland for Lowe's television appearance. It also includes correspondence between the Stoddards and various newspapers and magazines. The press generated by the Stoddards is one of the most significant resources on Lowe's life and career for contemporary scholars. They hired a press agent in 1963 to write a press release on Lowe's life and secured her appearance in the 1966–67 edition of *Who's Who in America*. Further, Ione Stoddard's experience as a nurse helped her recognize Lowe's painful

eye condition when she was first hired. Stoddard strongly encouraged Lowe to seek treatment, which resulted in glaucoma surgery for Lowe that fall.[68]

Through the Stoddards' efforts, Lowe was gaining a national profile, yet she might have felt stifled in her position at Madeleine Couture. Peddy's archive contains Lowe's 1962 contract with the company. It specified that Lowe would earn a ten percent commission on the dresses she designed that were sold through Madeleine Couture and would work exclusively for the company for five years. Yet on June 13, 1963, a designer named Roberta Reuter received a letter from Madeleine Couture's lawyer informing her that her work with Ann Lowe was in breach of Lowe's contract with Madeleine Couture.[69] Reuter was a designer who worked between Tyler, Texas, and New York and for years had worked with designers and dressmaking shops across the country to create the Queen's Court coronation gowns for the local Texas Rose Festival.[70] Lowe's extravagant gowns for the festival are held in the collection of the Tyler Rose Museum.

In January of that year, Benjamin Stoddard drew up a contract to act as Lowe's "agent, advisor, manager and representative," for which he would receive twenty-five percent of her "gross compensation." This did not apply to Lowe's design work, perhaps at her own insistence.[71] In January 1965, it was reported that Lowe was working at Madeleine Couture in addition to her own shop that was run with a friend named Ida Mitchel, and in June 1965 Lowe was working with two other design firms. Benjamin Stoddard's management would earn proceeds on other projects—a June 1965 article on Lowe in *The Milwaukee Journal* mentioned Stoddard's hope for a book and a motion picture on Lowe.[72] By June 4, 1965, however, Benjamin Stoddard wrote a letter

OPPOSITE: Ione Stoddard and Ann Lowe traveling to *The Mike Douglas Show*, 1964. ABOVE: Sharman Peddy, wearing Ann Lowe confirmation dress, with parents Benjamin and Ione Stoddard. BOTH: Ann Lowe / Madeleine Couture Archives, 1962–67. Courtesy of Sharman S. Peddy in memory of Ione and Benjamin M. Stoddard.

the shop, her eyesight was failing to a significant extent. Her financial situation was dire as well, and she and Florence Cowell experienced financial and legal confrontations. True to Lowe's gracious personality, however, Powell notes that Cowell's son, who was involved in the business, remembered Lowe fondly, a sentiment echoed by Sharman Peddy on behalf of Ione Stoddard.[75]

to Lowe's lawyer in answer to a May 28 letter that attempted to break Lowe's contract—Stoddard told the lawyer that during a press preview at the shop that very day, Lowe responded to her lawyer's May letter by saying, "I never told him to say that."[73] Lowe may be correct or might have simply changed her mind on terminating her contract with Stoddard after the successful press preview, but in any case, Lowe stopped working at Madeleine Couture that year. By July she had established A. F. Chantilly with Florence Cowell. However Judith Guile, a London model who came to New York in 1963 and worked in Lowe's small A. F. Chantilly atelier with five to six other seamstresses for two years around 1966, recalls that Lowe maintained a relationship with Ione Stoddard and Madeleine Couture.[74] Guile sometimes modeled dresses for clients, and she appears with Lowe in the first photograph in *Ebony*'s 1966 article, modeling an evening dress and coat that she helped make. Guile remembers Lowe as "charming . . . she was so elegant and gracious . . . as gracious as her [high society] customers . . . she was so beautifully spoken, very correct, and immaculate in her dress and immaculate in any garment that went out. She was very proud of her work." Guile notes that by the late sixties, though Lowe still sewed and inspected every dress made in

## Conclusion

Looking purely at the material culture, Ann Lowe's legacy is easy to establish. She was an extraordinary designer who was creative, adaptable, and highly skilled. Piecing together the details of Lowe's life is more difficult. Misinformation and contradictions abound in the numerous press articles written during and after her lifetime. In some cases, Lowe herself seems to give conflicting or erroneous information—Lowe's statements of monetary figures are a prime example. In other cases, journalists display sentimental, hyperbolic, or dismissive reportage. Margaret Powell began the meticulous work of sorting out these details. One of the most circulated is the story of Lowe's commission of Jacqueline Kennedy's wedding gown (see "Reproducing Jacqueline Kennedy's Wedding Dress," page 175). In April 1961, the *Ladies' Home Journal* published a story on the new First Lady. The reporter recalled her wedding and generously described Kennedy's bridal gown as a "fairy-princess creation of taffeta faille. . . . Each panel of the swooping skirt was swirled with a rosette of tucked faille. . . . Jacqueline, as a bride, looked adorable." However, any flattery or pride that Lowe might have found in this description was wiped out by her credit from the reported: "The bride's gown and those of her bridesmaids

ANN LOWE ORIGINAL

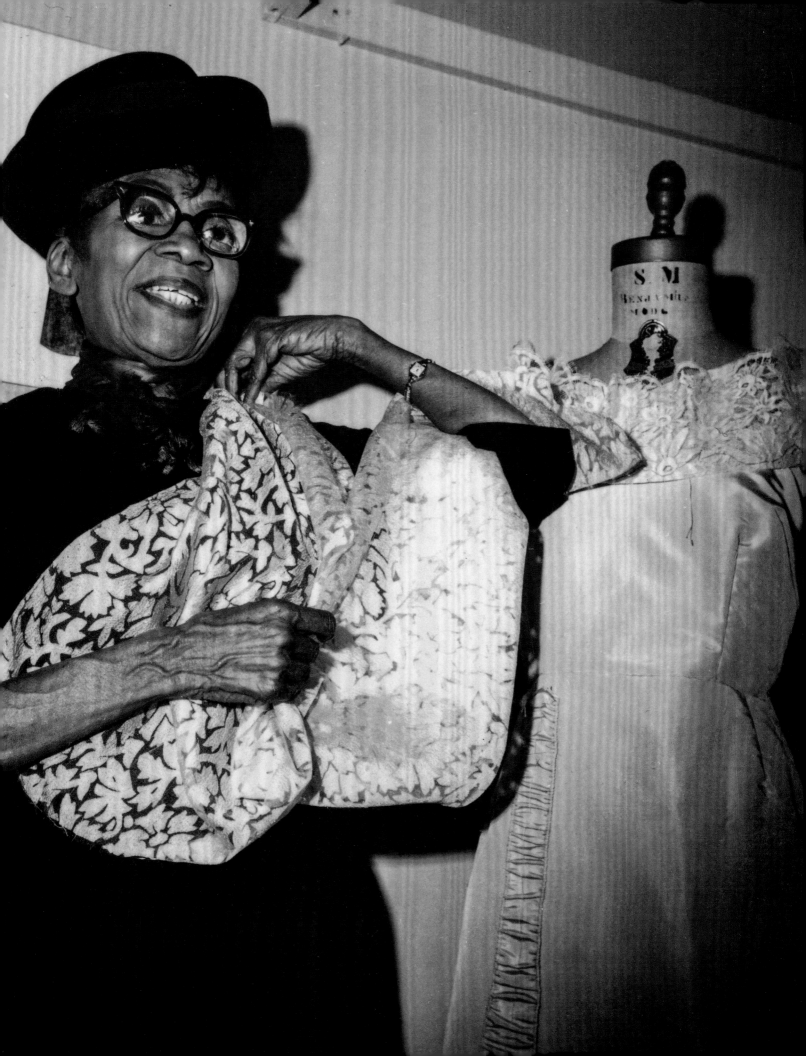

were designed by a colored woman dressmaker, not the *haute couture*."[76] This description of Lowe was and remains dismissive and offensive, and several subsequent articles and essays on Lowe attribute it to Kennedy herself. Powell's careful research into the comment reveals her dedication as a scholar. She dug up letters in the John F. Kennedy Presidential Library and Museum archives that clarify the situation and also reveal Lowe's position as a designer at this time.

Lowe wrote to Kennedy expressing "how hurt I feel as a result of an article. . . . I realize it was not intentional on your part but as you once asked me not to release any publicity without your approval, I assume that the article in question, and others, was passed by you."[77] Lowe wanted to be referred to as "a noted negro designer," adding, "which in every sense I am." She asks Kennedy to try to have the statement corrected, stating, "I have worked hard to achieve a certain position in life which has been considerably more difficult due to my race. At this late point in my career, any reference to the contrary hurts me more deeply than I can perhaps make you realize."[78] In her sixties, Lowe had been sewing for nearly six decades and had made hundreds of gowns to adorn the wealthiest, most privileged women in the country. She had little financial security or acclaim to show for it. Although she made many statements on her love of creating fashion, she was understandably turning her mind to her legacy. Lowe rarely discussed the setbacks she faced as a Black woman—the society and women's column reporters were likely not open to such narratives in any case. Even late in her career, when she was highly sought-after and producing gowns that were shipped all over the country, Guile notes the difficulty she had in securing her A. F. Chantilly salon and workroom on Madison Avenue because of the segregation practiced in the city. Powell points out that Lowe could not operate without white business partners and benefactors.[79] This letter to Kennedy reveals both the pride Lowe took in her accomplishments as a fashion designer and as a Black woman and how quickly that could be stripped away. Besides the unpreferred description of "colored," Lowe took

exception to being labeled "not of the *haute couture*." Rollin Browne, a friend and legal advisor to Lowe, wrote to the Curtis Publishing Company to file a complaint and request a story in *Ladies' Home Journal* on Lowe outlining her accomplishments as a corrective to the injury the first article made to her business. Although Lowe was not named in the article on Kennedy, it was common knowledge among her client circle that she made Kennedy's wedding gown, and Browne stated, "I am sure that you can find out for yourselves, if you do not already know, that Ann Lowe has been for years very much of the *haute couture*" (emphasis original).[80] Further documents in the archive show that Kennedy's press secretary called Lowe on April 10, 1961, to apologize, but also to explain that Kennedy had not reviewed the final version of the *Ladies' Home Journal* story and was not responsible for the reporter's words.[81] Kennedy was not made aware of the situation, and no corrective article was issued by the magazine.[82] It was perhaps this incident that prompted Lowe to partner with the Stoddards to garner more positive publicity and recognition of her life's work. Lowe lived in a complex era of immense change for Black Americans, for women, and for American fashion. That she has been largely forgotten is not surprising (Hattie Carnegie, Elizabeth Hawes, and Norman Norell—American designers mentioned throughout this book—are hardly household names), but it is important that she is remembered for her extraordinary life, significant impact on fashion, and the joy and beauty she channeled through her work.

Lowe holding up fabric. Courtesy of Ann Lowe / Madeleine Couture Archives, 1962–67. Courtesy of Sharman S. Peddy in memory of Ione and Benjamin M. Stoddard.

1. Gerri Major, "Dean of American Designers," *Ebony*, December 1966, 142.

2. Eleanor Coleman, "Deb's Fairy Godmother," *The Milwaukee Journal*, June 27, 1965, 2.

3. Coleman, 2.

4. Margaret Powell, "The Life and Work of Ann Lowe: Rediscovering 'Society's Best-Kept Secret'" (master's thesis, Smithsonian Associates and the Corcoran College of Art and Design, 2012) 2.

5. Saidiya V. Hartman, *Scenes of Subjection: Terror, Slavery, and Self-Making in Nineteenth-Century America* (New York: Oxford University Press, 1997), 151.

6. Judith Thurman, "Ann Lowe's Barrier-Breaking Mid-Century Couture," *The New Yorker*, March 22, 2021, accessed November 19, 2021, www.newyorker.com/magazine/2021/03/29/ann-lowes-barrier-breaking-mid-century-couture; Powell, "The Life and Work of Ann Lowe," 91 n. 53.

7. Thurman, "Ann Lowe's Barrier-Breaking Mid-Century Couture."

8. Thomas B. Congdon Jr., "Ann Lowe: Society's Best-Kept Secret," *Saturday Evening Post*, December 12, 1964, 75.

9. Tanisha C. Ford, "Zelda Wynn Valdes," *New York Times*, January 31, 2019, accessed November 22, 2021, www.nytimes.com/interactive/2019/obituaries/zelda-wynn-valdes-overlooked.html.

10. Ingrid Mida and Alexandra Kim, *The Dress Detective: A Practical Guide to Object-Based Research in Fashion* (London: Bloomsbury Academic, 2015), 175.

11. Congdon, "Ann Lowe: Society's Best-Kept Secret," 76.

12. Congdon, 76.

13. Powell, "The Life and Work of Ann Lowe," 9–10; Daniel James Cole and Nancy Deihl, *The History of Modern Fashion from 1850* (London: Laurence King, 2015), 100, 103.

14. Letty, "Letty Becomes Poetic Between Phone Calls; This One Not So Bad," *Tampa Sunday Tribune*, November 22, 1925, 71.

15. Dorothy Dodd, "Ancient Wedding Formulae Ignored by Modern Bride," *Tampa Daily Times*, March 27, 1926, 7-D.

16. Dodd, "Ancient Wedding Formulae," 7-D.

17. Alexandria Frye, "Fairy Princess Gowns Created by Tampa Designer for Queen in Gasparilla's Golden Era," *Tampa Tribune*, February 7, 1965, 6-E; Cole and Deihl, *The History of Modern Fashion from 1850*, 140.

18. Powell, "The Life and Work of Ann Lowe," 23–24.

19. *Gasparilla Gowns Designed by Ann Lowe*, online exhibition, Henry B. Plant Museum, accessed November 28, 2021, www.plantmuseum.com/exhibits/online-exhibits/gasparilla-gowns.

20. Frye, "Fairy Princess Gowns," 6-E.

21. Dodd, "Ancient Wedding Formulae," 7-D.

22. Coleman, "Deb's Fairy Godmother," 5.

23. Betty Phipps, "Anne [*sic*] Cone Lowe: A Tampa Legacy Is Honored in New York," *Tampa Tribune*, August 7, 1976, 12-D.

24. Powell, "The Life and Work of Ann Lowe," 10–11, 80; Cole and Deihl, *The History of Modern Fashion from 1850*, 165, 177, 179, 184–85.

25. Powell, "The Life and Work of Ann Lowe," 30.

26. Powell, "The Life and Work of Ann Lowe," 80–83.

27. Lizzie Bramlett, "Cincinnati Art Museum—Behind the Scenes in the Costume Collection," *The Vintage Traveler*, October 23, 2017, accessed November 22, 2021, https://thevintagetraveler.wordpress.com/2017/10/23/cincinnati-art-museum-behind-the-scenes-in-the-costume-collection.

28. Cole and Deihl, *The History of Modern Fashion from 1850*, 166.

29. Cynthia Amnéus, "Ann Lowe, African American Fashion Designer," Cincinnati Art Museum blog, November 2, 2020, accessed November 22, 2021, www.cincinnatiartmuseum.org/about/blog/curatorial-blog-1122020.

30. Valerie Mendes and Amy de la Haye, *Fashion Since 1900*, 2nd ed. (London: Thames and Hudson, 2010), 104.

31. Mendes and de la Haye, 128.

32. Congdon, "Ann Lowe: Society's Best-Kept Secret," 76; Powell, "The Life and Work of Ann Lowe," 35.

33. "Miss Lowe Covers Paris Fashion Opening for the New Age," *The New York Age*, September 24, 1949, 13.

34. "Satin, Velvet, Brocade at Consular Ball," *Women's Wear Daily*, October 10, 1955, 4.

35. Nancy Deihl, "Wesley Tann: The Glamour and the Guts," in *Black Designers in American Fashion*, ed. Elizabeth Way, 133–50 (London: Bloomsbury, 2021), 137.

36. Thurman, "Ann Lowe's Barrier-Breaking Mid-Century Couture."

37. Pam Pulley, "For Ann Lowe Finally—Fame Came," *The Tampa Times*, February 16, 1968, 2-C.

38. Pulley, 2-C.

39. "Miss Elizabeth Lillian Mance Wed to Krin de Jong in Capital," *New York Times*, June 23, 1968, 70; author interview with Dianne Mance, Bette Wooden, and Sibyl Gant, June 7, 2021.

40. Conversation with Megan J. Martinelli, assistant curator at Hillwood Estate, Museum & Gardens, August 2, 2021; letter from Marjorie Merriweather Post to David L. Swasey, June 30, 1965, Collection of Hillwood Estate, Museum & Gardens; email correspondence with Martinelli, May 9, 2022.

41. Powell, "The Life and Work of Ann Lowe," 43.

42. Coleman, "Deb's Fairy Godmother," 5.

43. "Barbara Baldwin Is Planning Nuptials in June to John Dowd," *New York Times*, April 8, 1973, 88; Nancy Davis and Amelia Grabowski, "Sewing for Joy: Ann Lowe," *O Say Can You See?* blog, Smithsonian National Museum of American History, March 12, 2018, accessed November 23, 2021, https://americanhistory.si.edu/blog/lowe; Major, "Dean of American Designers," 138.

44. Author interview with Sharman Peddy, May 10, 2021.

45. Coleman, "Deb's Fairy Godmother," 2.

46. Virginia Lee Warren, "For Debutantes: Bare Backs," *New York Times*, November 17, 1967, 42.

47. "Miss Rumbough Is Married to Paul Trevor In the Smithtown Presbyterian Church," *New York Times*, September 23, 1951, 94.

48. Powell, "The Life and Work of Ann Lowe," 67.

49. Author interview with Ann Bellah Copeland, December 6, 2021.

50. Author interview with Dianne Mance, Bette Wooden, and Sibyl Gant, June 7, 2021; author interview with Bette Wooden, March 3, 2022.

51. Maxine Cheshire, "Wedding Gown Is Highlight of Her Career," *Tampa Bay Times*, May 22, 1968, 46.

52. Thurman, "Ann Lowe's Barrier-Breaking Mid-Century Couture."

53. Margaret Powell, "Ann Lowe and the Intriguing Couture Tradition of Ak-Sar-Ben," *Nebraska History* 95 (2014): 137.

54. Powell, 138; Powell, "The Life and Work of Ann Lowe," 57–59.

55.  Scott Beauchamp, "The Mystery of St. Louis's Veiled Prophet," *The Atlantic*, September 2, 2014, accessed November 26, 2021, www.theatlantic.com/politics/archive/2014/09 /fair-st-louis-and-the-veiled-prophet/379460.

56.  Author correspondence with Adam MacPharlain, curator of clothing and textiles, Missouri Historical Society, April 12, 2021.

57.  Frye, "Fairy Princess Gowns," 6-E.

58.  Claudia B. Kidwell and Margaret C. Christman, *Suiting Everyone: The Democratization of Clothing in America* (Washington, D.C.: Smithsonian Institution Press, 1974), 137.

59.  Powell, "The Life and Work of Ann Lowe," 89 n. 33.

60.  Jeffrey Banks and Doria de la Chapelle, *Norell: Master of American Fashion* (New York: Rizzoli Electa, 2018), 104–9.

61.  Sidney Fields, "Golden Fingers," *Daily News*, January 21, 1965, 50.

62.  Pulley, "For Ann Lowe Finally," 2-C.

63.  Powell, "The Life and Work of Ann Lowe," 96 n. 13.

64.  "Easter Preview," *New York Age Defender*, April 20, 1957, 20.

65.  "White House Runway," *The Washington Post*, January 8, 1961, F-17; Marie Smith, "A Doll Dress for $1500," *The Washington Post*, June 10, 1965, D-1.

66.  Priscilla Tucker, "Secret Designer for Society Takes First Public Bow," *The Philadelphia Inquirer*, December 18, 1962, 9.

67.  Coleman, "Deb's Fairy Godmother," 2, 5.

68.  Coleman, 5; author interview with Sharman Peddy, May 10, 2021.

69.  Agreement between Ann Lowe and Madeleine Couture, December 1962, Sharman Peddy private archive; letter to Roberta Reuter from Lee Epstein, June 13, 1963, Sharman Peddy private archive.

70.  "Rose Festival Events To Begin Here Thursday," *The Tyler Courier-Times*, October 13, 1963, 1.

71.  Agreement between Ann Lowe and Benjamin M. Stoddard, January 19, 1965, Sharman Peddy private archive.

72.  Fields, "Golden Fingers," 50; Coleman, "Deb's Fairy Godmother," 2.

73.  Letter to J. M. Fishback from Benjamin Stoddard, June 4, 1965, Sharman Peddy private archive.

74.  "Wholesale-Retail Company Formed," *Women's Wear Daily*, July 27, 1965, 14; author and Margaret Powell interview with Judith Guile, May 17, 2017.

75.  Author and Margaret Powell interview with Judith Guile, May 17, 2017; Author interview with Sharman Peddy, May 10, 2021.

76.  Mary van Rensselaer Thayer, "Jacqueline Kennedy," *Ladies' Home Journal*, April 1961, 130.

77.  Letter to Jacqueline Kennedy from Ann Lowe, April 5, 1961, John F. Kennedy Presidential Library and Museum, accessed by Margaret Powell.

78.  Letter to Jacqueline Kennedy from Ann Lowe, April 5, 1961.

79.  Author and Margaret Powell interview with Judith Guile, May 17, 2017.

80.  Letter to the Curtis Publishing Company from Rollin Browne, April 11, 1961, John F. Kennedy Presidential Library and Museum, accessed by Margaret Powell.

81.  Letitia Baldrige, "Memorandum," April 10, 1961, The White House, Washington, D.C., John F. Kennedy Presidential Library and Museum, accessed by Margaret Powell.

82.  Letter to Clark Clifford from Letitia Baldridge, April 20, 1961, John F. Kennedy Presidential Library and Museum, accessed by Margaret Powell.

# Preserving Ann Lowe's Gowns: Conservation Research and Treatment

LAURA MINA, KATHERINE SAHMEL, AND HEATHER HODGE

The glamorous designs of Ann Lowe's gowns are possible due to her deep understanding of fabrics and her expertise in pattern drafting and draping. From the inside out, her dresses show technical skill that informed and supported her beautiful creations. Conservators are privileged to spend considerable time handling collection materials, such as Ann Lowe's gowns, and engaging in close examination.

The authors of this essay performed conservation work at Winterthur Museum, Garden & Library and the Smithsonian National Museum of African American History and Culture in preparation for the exhibition *Ann Lowe: American Couturier*. Conservation of cultural heritage encompasses a set of practices that aim to understand, preserve, and provide access to materials of cultural heritage that have historical, artistic, and scientific value.[1] We hope this essay will enhance the appreciation of Ann Lowe's artistry, as well as provide information about conservation practices.

## Craft and Construction Research

Ann Lowe's long career, from the 1920s until the early 1970s, was informed by earlier dressmaking techniques she learned from her mother and grandmother. Dressmaking during the mid- to late 1800s relied on a strong corset foundation that supported intricately shaped bodices with many seams and darts. Lowe combined these Victorian construction approaches with changing methods and materials throughout her career. For example, many of the inner bodices in her gowns have shaped, angled horizontal darts at center front that are similar to undergarments from the 1930s–1950s (see photo, opposite). While her designs sometimes show a nostalgic affection for historical styles, they are always fresh and fashionable for their time. Whatever the exterior, the interiors of the dresses show Lowe's familiarity with historical dressmaking practices. This section focuses on gowns from the 1950s and 1960s, since these are the most well-represented in the exhibition.

One characteristic of haute couture is garments made with many shaped panels that not only create the artistic silhouette but also ensure a custom fit. Such garments may have little "hanger appeal" since they are designed for 360-degree viewing and on a three-dimensional body.[2] The quantity and complexity of the shaped panels require expertise both in creating the dress pattern and in stitching the panels together. Mass-produced garments typically have fewer panels with fewer curves to maximize time efficiency in construction and reduce labor costs.

Ann Lowe designs show artistic and technical expertise in their dress patterns. The number of panels, position of seams and darts, and the use of grainline and bias all contribute to Lowe's fabulous designs. Her dresses with asymmetrical patterning are even more complex since pieces cannot be mirrored for left and right and must be individually drafted (see photo, page 99). Many of Lowe's gowns have strategic decorations on the back. This may be a thoughtful consideration for dresses that would be worn at parties with couples dancing, when the back of a woman's dress is on display. Whatever the intention, the dresses are designed to be appreciated from every angle.

Lowe's gowns have a combination of machine and hand stitches that are specifically chosen to create the best effects. For example, most vertical seams are done in a straight (lock) machine stitch that is both time-efficient and strong. Decorative elements and fastenings are secured with a variety of hand stitches that support specific placement and sometimes allow for controlled movement between fabric layers. All of the zippers are hand-stitched. This strategic combination of hand and machine stitching is one of the hallmarks of haute couture and high-end dressmaking.

Some of the garments show evidence of slight alterations with stitch holes near seams that were modified. Lowe worked closely with her clients, and these stitch holes are likely evidence of client fittings to ensure that the dresses fit perfectly for complete comfort and confidence. Some of the seams have wide seam allowances, as Lowe planned ahead for these fittings and potential alterations. Lowe knew that clients would own a variety of undergarments that could create different shapes and silhouettes; however, she built her gowns to have their own integrated undergarments to ensure that the fit and silhouette would always be the same.

Detail of bodice interior of evening dress by Ann Lowe for Barbara Brooke Baldwin, 1966–67. Collection of the Smithsonian National Museum of African American History and Culture, Gift of the Black Fashion Museum, founded by Lois K. Alexander-Lane.

In addition, these structured undergarments would give wearers high confidence that the gowns would move with them while they socialized and danced, with no risk of a wardrobe malfunction.

Artistic excellence can be described as high levels of creative imagination paired with a deep understanding of materials and techniques. Lowe's gowns showcase visual creativity paired with technical sophistication. The hallmarks of haute couture construction are on beautiful display in a close examination of her gowns. In addition to Lowe's own artistry, her work also incorporates the desires, expressions, and hopes of her clients. Haute couture is ultimately a collaboration between the designer and the client, and Ann Lowe's success reflects both her artistry and her ability to make her clients feel like personally idealized versions of themselves.

### Inside Out: Linings and Inner Structures

A typical Ann Lowe dress from the 1950s or 1960s includes a built-in inner bodice and petticoat. These integrated undergarments supported the shapes of both the wearer and the dress to create sculptural silhouettes that could then be decorated. Each gown examined for this exhibition is one of a kind, and Lowe made many small but significant variations to inner bodices and petticoats to suit specific designs and wearers. However, there are some consistent trends in the structure and materials of the inner bodices.

Most inner bodices are made of two layers of ivory synthetic faille. This soft yet strong fabric has a subtle rib pattern in the woven structure. Each layer was seamed separately and the bones were then secured between the layers. The top and bottom edges were finished with white lace hem tape. This construction is very effective and efficient and shows thoughtful attention to detail. Along the bottom edge of the inner bodice, some seams are open in shallow vents (½–¾ inch) to create a better fit at the waist.

A typical inner bodice was constructed with eight panels: four in the front and four in the back (see photos, page 95). The front panels have curved vertical seams at the bust

that contribute to the dimensional shape of the garment. The shape is further enhanced with diagonal horizontal darts radiating from the center front and the side seams toward the bust point. The two back panels join with an angled seam that takes advantage of slight differences in the fabric's grain to balance ease and strength. All of the seams, except for the center back, have bones, and there is an extra channel for boning in the middle of the side front panels. Most of the boning is semi-rigid plastic, except for small pieces of zigzag metal boning that are used for the top portion of the bust seams. The zigzag boning is more flexible and can hold and support the bust curve while the plastic boning is less flexible and vertically stabilizes the inner bodice so that it will not collapse or twist. The combination of curved seams and angled darts, along with boning, creates a very sculptural bodice.

In addition to the shaped seams and boning, the inner bodice includes bands of elastic and petersham ribbon to provide extra shaping and stability. (Petersham is a strong and flexible ribbon with a woven rib structure with small scallops along both edges.) Two different elastic bands provide bust support; a narrow band provides curved support under the breasts, and a wider band provides stability around the rib cage. The narrow band (¼ inch) of elastic is secured to the center front at mid-bust and to the side seams. There are two thread loops on each side between these points to channel the elastic under the bust, so that the elastic forms a V shape on each side. The wide band (1 inch) of elastic is secured to the center front under the bust and has metal hooks and eyes at the ends. This elastic would secure around the rib cage, just below the bust. In addition to these elastic bands, a wide band (1 inch) of petersham ribbon is secured with herringbone stitches along the natural waist and has metal hooks and eyes at the ends. The herringbone stitch combines back and diagonal stitches to create a very strong and decorative pattern. Ann Lowe's label is stitched to the waist tape at or near the center front. This waist tape ensures the gown is well-supported from the waist and cannot slip or twist. The use of a waist tape is one

Details of bust interiors: TOP: wedding dress by Ann Lowe from the Adam Room at Saks Fifth Avenue, early 1960s. Adnan Ege Kutay Collection. BOTTOM: dress by Ann Lowe worn by Susan Celeste Peterson for the Fleur de Lis Ball in 1963. Courtesy of the Missouri Historical Society, St. Louis, Mo. Construction is markedly different despite similar dates and Adam Room labels.

of the characteristics that show how Lowe used more traditional construction techniques in her designs. Her clients undoubtedly appreciated this detail that would help them move with confidence and comfort in strapless dresses.

Some of the more heavily structured bodices have padding in the bust for further shaping, although the materials and construction of the padding is variable (see photos, page 153). Both the Saks Fifth Avenue wedding dress from the collection of Adnan Ege Kutay, made in the early 1960s for the Adam Room, and the Ann Bellah Copeland wedding dress from 1964 (page 153, top, and page 95, top left) have bust pads that appear to be made with a natural fiber stuffing and are finished in a tidy and unfussy manner.[3] These pads are created with a small disk of stuffing, sandwiched between circles of the synthetic faille fabric, machine-stitched in place, and either pinked or whipstitched by hand to finish the edges. The padding in these dresses remains soft and pliable, with only minor issues of shape distortion from storage. In contrast, two dresses from a similar period, both with labels from the Adam Room, have synthetic foam bust pads with lace finishing (page 95, top and bottom right). The ice blue dress embellished with grapevines worn by Susan Celeste Peterson to the Veiled Prophet Ball in 1963[4] has tear-drop-shaped bust pads with material identified as polyurethane foam[5] encased in a gauze fabric and finished with lace around the perimeter. Also worn by Peterson in 1963, the white dress with roses and foliage from the Fleur de Lis Ball appears to have the same bust pads, based on shape and construction, likely with the same polyurethane foam.[6] The only remarkable difference in bodice construction between the former two dresses and the latter two is the bust pads. All four of these dresses were made in a similar window of time in the early 1960s, and three were made during Lowe's short partnership with the Adam Room at Saks Fifth Avenue. Lowe could have simply been using the materials that were available to her, or perhaps she was choosing materials based on more specific qualities, such as the most compatible materials for desired shape and structure of the dress.

Some additional variations on this typical inner bodice are worth noting. For dresses with lower necklines in the back, the inner bodice has fabric loops to guide the wide elastic band and ensure it stays hidden by the dress. Some inner bodices have an outer facing or complete layer of fashion fabric to coordinate with the dress fabric and design. The number and placement of the darts vary from dress to dress and appear to relate to both the wearer's proportions and the shape of the dress bodice.

The skirts also show inner structures with built-in petticoats, linings, and other materials that create silhouettes and contribute to movement. Synthetic horsehair braid, frequently used to shape and stiffen dress hemlines, is found extensively throughout Lowe's gowns. Historically this was made of natural horsehair, but synthetic fibers became typical for horsehair braid in the early twentieth century. Lowe and her studio used the half-inch braid, identified as rayon, as standard trim on all of her hemlines and trains.[7] This trim would serve the purpose of improving the drape and body of the skirt, helping the fabric fall in soft undulations.

## Use and Reuse of Materials

Ann Lowe's dresses make strategic use of a wide variety of materials including silk satin, taffeta, and chiffon; cotton and synthetic laces; and imported and heirloom fabrics. Her deliberate choices show both her artistic vision and her dressmaking expertise.

Two gowns made for Barbara Brooke Baldwin—her debutante dress and an evening gown made from a repurposed sari—beautifully demonstrate Lowe's use and reuse of materials. While the debutante dress shows her masterful use of color, line, and fabric flower decorations, the other gown shows her creative ability to reuse textiles to create new fashionable dresses.

The debutante gown is ivory, as required for this formal event, and is decorated with fabric vines and flowers that cascade over the shoulders and extend asymmetrically on the skirt (see photo, page 111). While the vivid vines and flowers draw the eye, the patterning of the dress is equally impressive and creates a graceful silhouette to frame and support the decorations. The dress has a wide scoop neckline

with narrow straps and a slightly flared skirt. The vertical princess seams extend the lines of the body without any horizontal seams. The graceful, modern simplicity of the exterior is supported by a complex interior bodice that utilizes historical techniques.

The floral decorations are hand-sewn to the dress with no indication of placement marks. This suggests that Lowe determined their placement with the dress on a dressmaker's form, rather than marking flat pattern pieces. Both the dress and floral decoration are silk; the main dress is a matte satin (sometimes referred to as *peau de soie*) while the flowers are lustrous warp-faced satin. The front and back sides of the warp-faced satin are lustrous and matte respectively; Lowe used these contrasting textures for intentional effect with the flowers. The yellow-green and green colors of the vines and leaves are somewhat irregular, which may indicate that Lowe custom dyed the fabric.

The evening dress made from a sari has narrow straps and a scoop neckline on the bodice (see page 90). The skirt has a high empire-style waist and a slight flare toward the hem. On the back, there are self-fabric bows at the base of each strap and a short train that ends at the skirt hem. The center-back zipper closure is mostly hidden by the train.

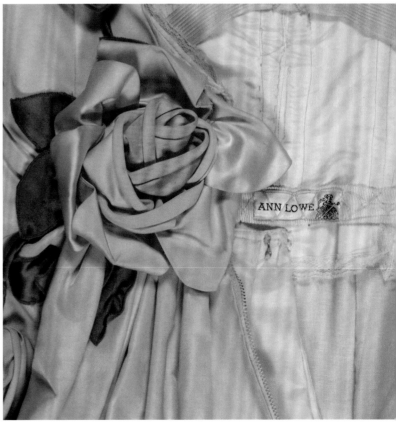

The sari was likely a Banarasi sari, which is a distinctive type named for the historical weaving center Banaras (currently Varanasi) in northern India. These finely woven silk saris are decorated with gold or silver zari (brocade) designs.[8] These are special-occasion saris, and the glamorous evening dress honors that tradition. Many saris, including the one used for this dress, have three areas with different patterning or decorations. The *body*, or main part, of a Banarasi sari has repeating motifs that may be denser or more widely spaced. The *borders* have dense patterning; this adds weight to the hem of the sari and helps stabilize the pleats. The *pallu* is a highly decorated border on the endpiece of the sari that extends from the shoulder down the back of the wearer. Lowe made strategic use of each of these areas in her dress design.

The *pallu* was transformed into the dress bodice with minimal seams and darts so that the patterned fabric appears

Details of bodice for debutante dress by Ann Lowe for Barbara Brooke Baldwin, 1966–67. Collection of the Smithsonian National Museum of African American History and Culture, Gift of the Black Fashion Museum founded by Lois K. Alexander-Lane.

seamless. The bodice straps are cut as part of the front and back pieces so there are no horizontal seams. The body of the sari became the dress skirt, but Lowe made the fabric her own. She cut out motifs from the sari body to create dimensional trim at the base of the bodice. Additional cut-out motifs were appliquéd to the front of the skirt to add variety to the formal pattern (opposite). The borders of the sari decorate the hem of the skirt and the perimeter of the train. While the border on the skirt is part of the woven sari, the border on the train was expertly pieced with mitered corners.

The design and construction of the dress showcase Lowe's knowledge of fashion and fabric. This is one of the few dresses Lowe designed that utilized patterned fabric. However, Lowe was not content to use the fabric as woven, and she made it her own through strategic use of pattern and appliqué. In this way, both dresses designed for Barbara Brooke Baldwin are similar, with fabric appliqués that create design patterns.

**Natural and Synthetic Fibers in Ann Lowe's Designs**
Examination and analysis of Ann Lowe's work reveals that, like many of her contemporaries in the couture world, she used modern synthetic and semi-synthetic fibers in her designs, in addition to natural fibers such as silk.

Prior to World War II, Japan had been the largest supplier of silk to the U.S. clothing and fashion industry. The scarcity of silk during and after the war against Japan, in concert with emerging research and technology, created new opportunities for the burgeoning synthetic fiber industry, and manufacturers such as the DuPont Company seized on these opportunities, during and after the war. Additionally, the United States transitioned to a postwar era, when petroleum products were plentiful including the raw materials needed for the ever-increasing demand for new synthetic fibers. DuPont marketed these fibers as early as 1922 not just as a substitute for silk but as new fibers with unique, attractive qualities.[9]

The use of synthetic and semi-synthetic fibers was also embraced in Europe. Dior, Balmain, Lanvin, Jaques Hein,

and Patou are designers who were incorporating synthetics into their couture designs of the 1950s and 1960s.[10] In one example contemporary to Lowe's work, the evening dress "La Cigale," designed by Christian Dior in 1952–53 in the collection of The Costume Institute at The Metropolitan Museum of Art, uses a moiré-patterned fabric of cotton, rayon, and acetate.[11] The fabric is used to create a sculptural and highly structured dress, with a distinctive silhouette. Lowe met Dior in Paris in 1947, and we know that he admired her work.[12]

Another American designer who used synthetics and semi-synthetics was Charles James, who also took advantage of the particular qualities of these fabrics in his work.[13] Ann Lowe and Charles James were two early adopters of the synthetic material Pellon.[14] Pellon is a nonwoven blend of nylon, acetate, and cotton fibers chemothermally bonded to create a type of felted fabric. First developed and manufactured in Germany during the 1930s, it became available in the United States in the early 1950s.[15] At least two dresses by Lowe have built-in petticoats made of Pellon. One dress from 1956 is a gray silk evening gown with blue lace appliqués.[16] The other dress is an ivory silk evening dress with a dramatic asymmetrical accent of red silk.[17] Both Lowe and James used this lightweight, stiff material to support dramatic structural shapes without adding weight or bulk to their gowns.

A wedding dress from 1941 by Lowe in the collection of The Costume Institute at The Metropolitan Museum of Art is an early example of Lowe's work made with cellulose acetate, known at the time as "artificial silk" (see pages 85–87). Most of Lowe's gowns from the 1950s and 1960s are created with silk fabrics over a synthetic interior lining with a range of both synthetics and natural fibers in the construction and finishing. These fabrics would have been chosen specifically for their inherent qualities, such as drape, sheen, and weight. Semi-synthetics, such as rayon and cellulose acetate, provided fabric options for designers with the sheen of silk but a more structured drape and crisp hand than most silk fabrics. Similarly, a synthetic such as nylon tulle has a lighter feel and stiffer drape than silk

Detail of textile appliqués, evening dress by Ann Lowe for Barbara Brooke Baldwin, 1966–67. Collection of the Smithsonian National Museum of African American History and Culture, Gift of the Black Fashion Museum founded by Lois K. Alexander-Lane.

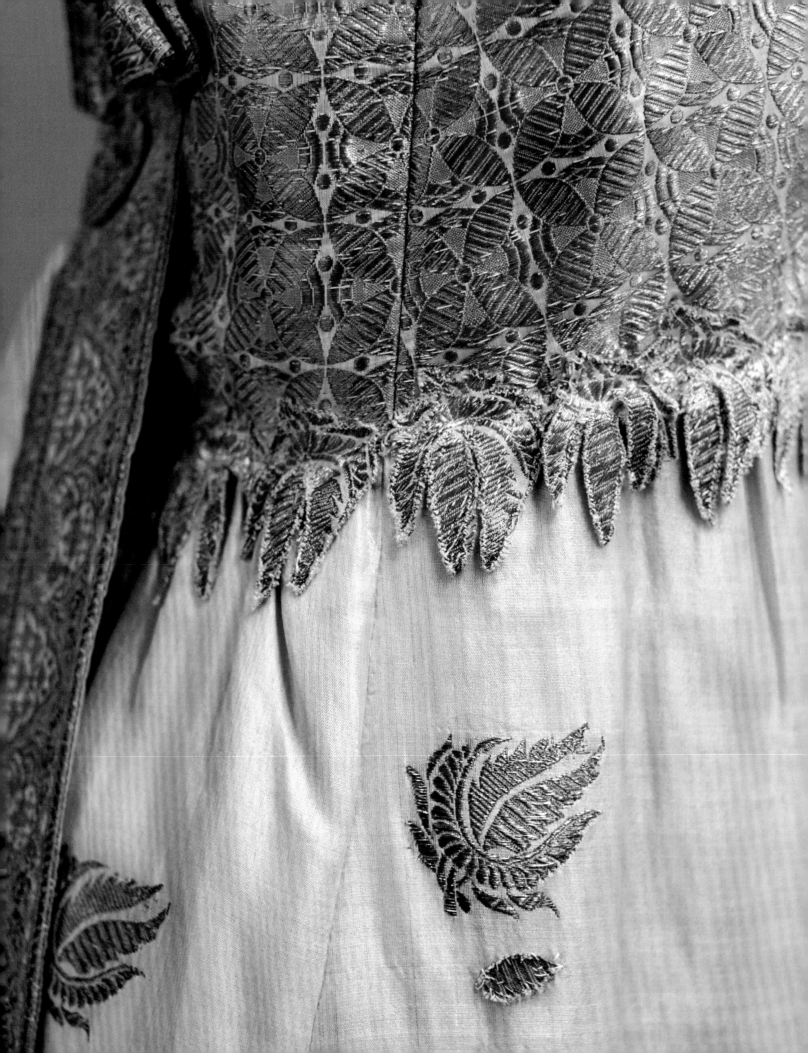

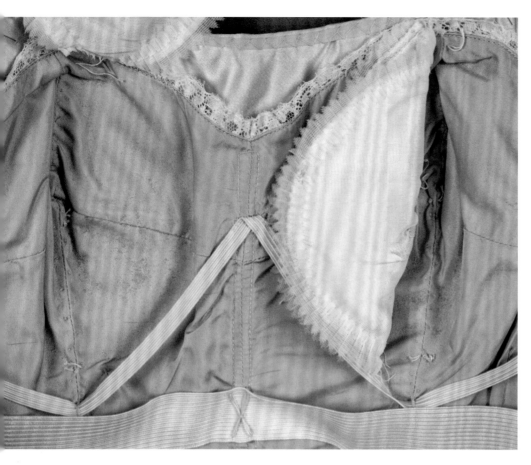

tulle, and could provide structure and lift in a dress skirt in ways that would not have been possible with silk.

The Ak-Sar-Ben countess gown from 1961 is an interesting example when considering Lowe's use of these fabrics, because it is constructed nearly entirely from synthetic fibers and materials.[18] Lowe created thirty-three gowns for the 1961 Ak-Sar-Ben coronation, including this bright coral pink "Cinderella" countess gown from the collection of the Durham Museum in Omaha (see photo, page 160).[19] Margaret Powell writes in her thesis on Lowe that the Ak-Sar-Ben gowns were made from French nylon tulle, and that hundreds of yards of fine-quality French net were used to construct the queen's gown.[20] The bright pink faille lining of this dress was identified as cellulose acetate, a shiny and crisp fabric that would have helped with the structure and shaping of the dress's understructure (see photo, page 161, top left).[21] Rayon horsehair braid along the hem of the interior petticoat skirt creates soft and rounded folds in the drape of the inner skirt. This inner skirt is lined with a white plain woven rayon fabric (see photo, page 161, bottom). There are two types of nylon net in the many yards of fabric that are used in the outer skirt; the first is a stiff, open-structure net fabric underlayer, creating air and volume in the skirt, and the top layers are finer and softer pink tulle that combine desired qualities of both lightness and excellent drape. Silk tulle has

a surprisingly different drape and weight than nylon, and the same dress made with silk would not have the volume and lightness that could be achieved with nylon. The silvery sequins were identified as cellulose acetate, commonly used in the form of a plastic sheet for manufacturing sequins by the middle of the twentieth century.[22] This gown is the only dress so far with evidence of a drawing or design applied to the outer skirt to guide the complex sequin and bugle-bead pattern. In contrast to Lowe's one-of-a-kind gowns, the intensive work required to make the repeating patterns on multiple dresses would likely have necessitated additional planning to ensure that the dresses were consistent in appearance (see photo, page 161, top right).

With few exceptions, the synthetic fibers used in Lowe's work have aged as well as or better than the silk and other natural fibers. The rayon and cellulose acetate linings are in excellent condition in most of the dresses, except for inevitable creasing from storage. One exception to this is the polyurethane foam used in the bust pads of the two dresses made at the Adam Room while Lowe was at Saks Fifth Avenue. As expected for this type of foam, the remaining material is discolored, embrittled, and actively shedding small bits through the gauze exterior of the pads. Textile conservation's approach to this severely degraded material focused on handling the dress with extra care and collecting the polyurethane dust to retain for possible future analysis and research.

### Analytical Fiber Identification

Many natural and synthetic fibers can be identified with basic microscopy techniques, using the shape and visual qualities of the fibers to determine origin or manufacture. For example, unprocessed cotton fibers have a distinctive ribbon-like quality, which is easily seen under

Detail of bust pads with degraded polyurethane foam. Particulate from foam accumulated under the pads. Dress by Ann Lowe, worn by Susan Celeste Peterson for the Veiled Prophet Ball in 1963. Courtesy of the Missouri Historical Society, St. Louis, Mo.

magnification using a microscope, and sheep's wool has easily recognizable scale patterns. Human-made fibers can be more complex to identify, because they are formed mechanically and can appear similar across fiber types. To make synthetic fibers, usually a liquid chemical slurry is extruded through a spinneret, which looks like a showerhead. The liquid is then solidified into fibers using a process that might involve warm or cold air, or a solidifying bath. After more processing steps, these fibers can be spun into thread or yarn, which is then the basis for cloth.[23]

Winterthur Museum is fortunate to have a Scientific Research and Analysis Laboratory (SRAL) that has instruments for analyzing fiber content nondestructively. Winterthur scientists used Fourier-Transform Infrared (FTIR) spectroscopy to look at many of the fabrics in the Lowe gowns on loan to Winterthur for the exhibition, and helped with identification and characterization. In the middle of the twentieth century, when Lowe was at the height of her career, there were several synthetic fabric types available. Some of the most commonly used non-natural fibers at that time were nylon, rayon, and cellulose acetate. Fibers such as rayon and cellulose acetate are considered semi-synthetics, because they are made from regenerated cellulose and have some similar characteristics to natural cellulose fibers such as cotton and linen. Nylon, on the other hand, is considered a fully synthetic fabric, because it is chemically synthesized and produced; therefore, it has quite different properties from natural fibers.

Almost all of Lowe's dresses, regardless of inner structure, are fully lined with a fabric that appears similar to silk faille but has been identified as cellulose acetate and/ or rayon in all of the dresses examined. Rayon had been in use in the clothing industry since the late nineteenth century and by the early twentieth century was a common substitute for silk.[24] Considered a semi-synthetic fiber, rayon is produced with processed cellulose fibers and results in a smooth, filament fiber similar in structure to silk, hence its silk-like sheen and texture.

## Textile Conservation and Ethical Care for Collection Garments

The care of garments is an area of textile conservation that requires additional consideration and training beyond that needed for other types of textiles. Garments often have complex construction and are designed with the intention of being experienced on a body, which creates challenges in terms of preservation, stabilization, and interpretation. Garments are integral to our day-to-day lives but can also hold intense meanings related to memory, ritual, ceremony, community, and individual identity. Ethical considerations when approaching a garment might include historical considerations of the wearer and the maker, as well as cultural context.[25]

As a textile conservator approaches the treatment of any garment, all of these considerations must come into play during decision-making. Often, one of our first considerations when examining a garment involves structural stability and how the current condition of the garment will inform its potential display and interpretation. Structural instabilities that result from age or storage may be approached differently from damage that is the result of how the garment was worn or used. For example, stains or discoloration on a dress might help to tell a story about how that dress was used or serve as important aspects of its unique history. For couture garments such as those that Ann Lowe produced in her studio, high importance is usually placed on the original aesthetic intent of the maker, as well as preservation of original materials, stitching, and construction techniques. Conservators choose materials for their treatments that will be sympathetic to the condition and construction of the object but that can also be easily distinguished as non-original.

Garments are constantly changing—both through human interactions and through natural processes. For example, someone might restitch a hook on a dress, dye it a new color, or alter it for a different style or body shape. A garment might also change in response to physical and chemical forces like sunlight, gravity, or air pollution. Conservators consider all the past changes and make thoughtful decisions

PAGES 160–61: Ak-Sar-Ben countess gown, dress by Ann Lowe for Ann Lallman Jessop, 1961. Collection of the Durham Museum, Gift of Ann Lallman Jessop. RIGHT: Skirt, showing sequins, beads, and fabric. CLOCKWISE FROM TOP LEFT: Detail of interior bodice. Detail of the underside of the outer skirt, showing markings applied to the nylon tulle. Detail of interior of petticoat at the hem.

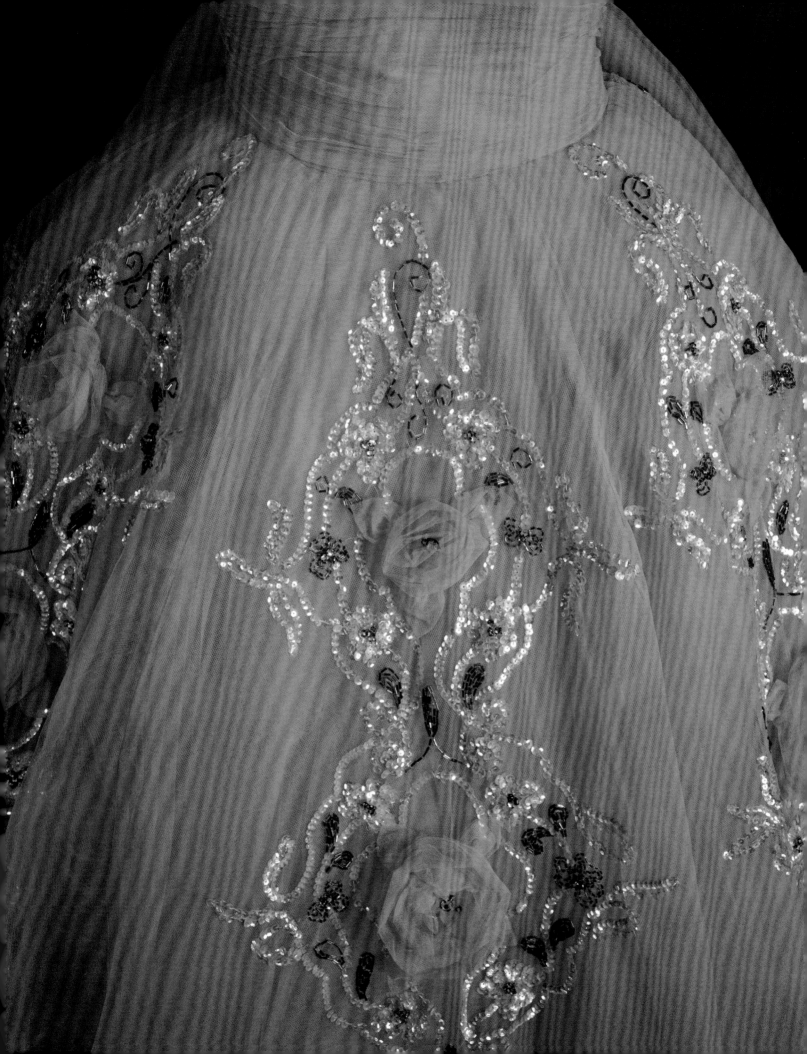

about new changes. We know that garments are never static and unchanging, but we seek to slow the rate of change and thus extend the time for them to be used for research, display, and other purposes.

Conservation work shares some similarities with home care for textiles, but also has some significant differences. The goals for personal garments and institutional collections are different, and the different types of care support these different priorities. Some collection garments are preserved for research purposes, similar to an archive; for other collection garments, the focus is on display and exhibition potential. For this second category of garments in museum collections, preservation and presentation are often very intertwined. Conservators work closely with curators to determine desired presentations of the garments that will not only physically support the garments, but also metaphorically support the exhibition narrative. Often, the display choices inform decisions about treatments.

## Two Case Studies of Ann Lowe Dresses
When asked about the specifics of conservation treatments in practice, a frequent answer given by conservators is: *it depends.* Though the same types of treatments are often performed, the exact manner to which they are executed on an object will vary based on numerous factors. Many of these factors have been discussed throughout this chapter and include the cultural and historical contexts of an object, what materials the object is composed of, and the relevance of condition issues. The following case studies highlight the nuances of two textile conservation treatments on two Ann Lowe dresses completed in preparation for this exhibition: specifically, tear stabilization and stain reduction. The considerations for the care of these garments and their ultimate treatment are discussed.

### Case Study 1
### Afternoon dress worn by Josephine Lee, 1930s
On loan from the Tampa Bay History Center is a diaphanous afternoon dress of white cotton organdy decorated with wide widths of machine-made silk lace insertions.[26] The lace insertions are placed within the sleeves as horizontal bands and within the skirt as zigzags with nearly fifty feet of lace used in total. The dress is believed to have been made in the 1930s for Josephine, matriarch of the Lee family in Tampa, Florida. Organdy is a lightweight, sheer, plain weave fabric, making the dress perfect for hot, southern weather. With a voluminous skirt—created of six bias cut panels, a bodice gathered slightly along the neckline and waist, puff sleeves created from many gathers along the shoulders and sleeve cuffs, and distinctive insertion lace—the dress takes inspiration both from the lingerie dresses of the early 1900s and from the iconic dress created by designer Gilbert Adrian for Joan Crawford worn in the 1932 film *Letty Lynton.*

The type of fabric used for a garment will factor into how that garment is constructed. A lightweight fabric such as the cotton organdy of the afternoon dress is too delicate to fabricate buttonhole closures; rather, the dress closes at the center back with six sets of hooks and eyes and two sets of snaps. Alternatively, the lightweight cotton organdy allowed the dress to be finished with fine, narrow rolled hems and for the large number of delicate gathers within the sleeves, all of which were carefully and precisely hand-stitched. The insertion lace in the sleeves and skirt similarly shows Lowe's handwork and eye for design. There are multiple methods of applying lace to a garment. An appliqué is attached directly on top of a larger piece of fabric, and the fabric under the appliqué is left in place. Insertion lace consists of lengths of trim that are placed either within or between larger pieces of fabric, and there is no fabric beneath the insertion lace. Insertion lace itself can be applied in different ways, and here it is likely Lowe placed the lace on top of the cut-out pattern pieces of organdy, stitched the lace in place along the edges, and then cut away the organdy from underneath. The afternoon dress illustrates Lowe's deep understanding of materials and sewing techniques and her ability to utilize her knowledge and apply it within a single garment.

Understanding of materials and sewing techniques is also integral to the work done by a textile conservator. In the care

The afternoon dress before treatment. Afternoon dress, by Ann Lowe for

Josephine Lee, ca. 1930. Courtesy of Tampa Bay History Center.

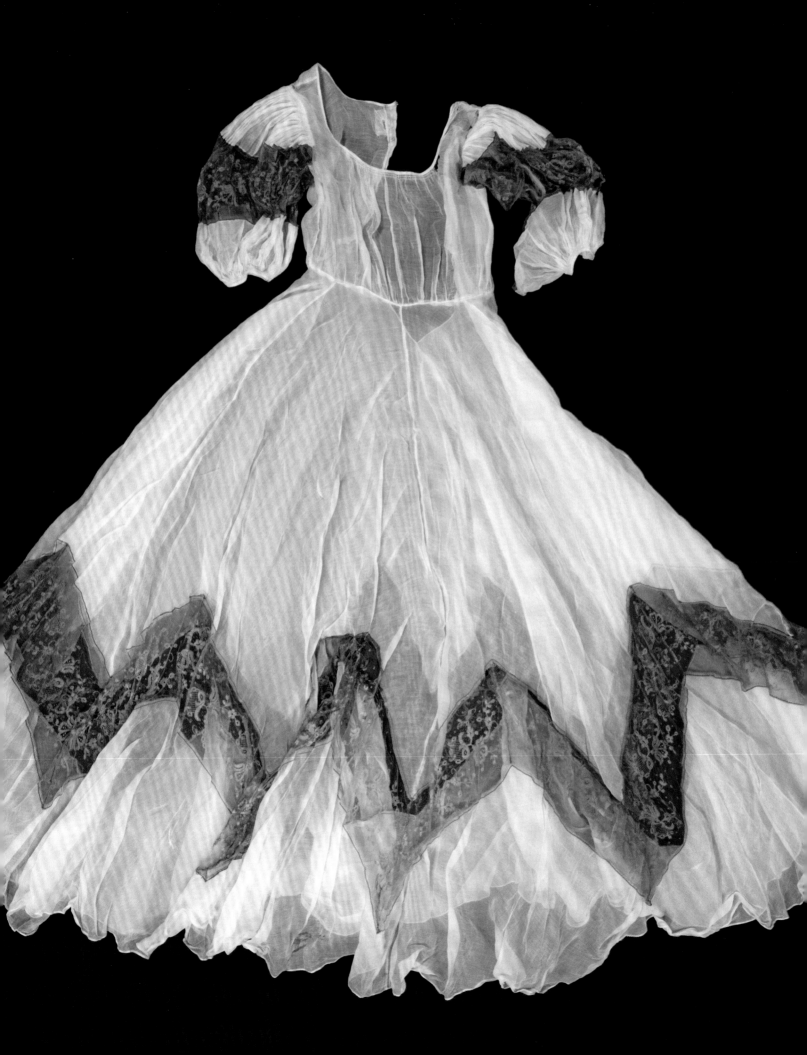

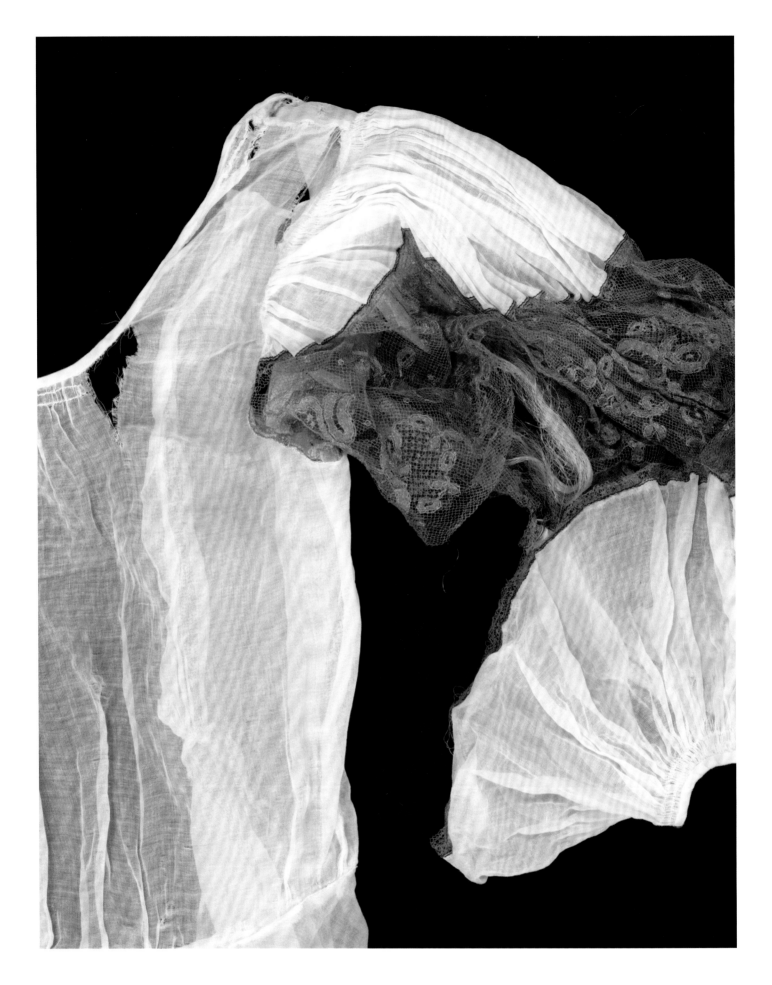

of cultural heritage and in preparation for exhibition, there are many considerations made by conservators, including ensuring the object is structurally sound for handling and mounting and, when appropriate, providing aesthetic compensation necessary for visual continuity. For the afternoon dress, the three major treatment focuses were the stabilization of the cotton organdy, the stabilization and aesthetic compensation of the insertion lace, and fabrication of a reproduction slip dress. Over its lifetime, the organdy of the dress sustained tears in several locations, mostly around the waistline, neckline, and shoulders. These are common locations for damage in a garment, as they are often areas that bear weight when worn and those that are most manipulated during dressing and undressing. Another location with numerous tears was in the insertion lace, within both the sleeves and the skirt. Prior to its acquisition by the Tampa Bay History Center, the dress was wet cleaned and likely bleached during a previous campaign of care. Bleaching agents caused the lace, which was originally black, to turn light brown in color and severely weakened it. For the current exhibition, in addition to the primary goal of stabilization, exhibition curator Elizabeth Way desired visual compensation for the lace, so the dress could be experienced by visitors with its original black appearance. Textile conservators are also occasionally called upon to fabricate a reproduction garment required to complete an ensemble or to create a historically accurate silhouette, both of which also provide necessary physical support to an original garment during exhibition. As a sheer garment, the afternoon dress would have been worn with a slip dress underneath. The original slip dress is no longer extant, and we were tasked with making a reproduction.

Tears are a common type of damage addressed by textile conservators. Tears, fraying, and losses are typically treated with conservation stitching. Performed by hand, many of the conservation stitches employed would be familiar to a dressmaker or an embroiderer, though they are applied with a focus on stabilization. Stabilization of a textile with stitching is often performed with the aid of a fabric underlay for extra support. Considerations must be made when treating garments made with sheer fabrics. Sheer fabrics can be distorted by certain types of stitching, and stabilization techniques utilizing underlays are more easily visible. Therefore, care must be taken to provide the necessary support to weak areas such as tears and to ensure the stabilization is not visually distracting. Several sheer underlay materials were considered for the treatment of the torn organdy, including silk habotai, silk chiffon, cotton gauze, and cotton organdy. Silk crepeline, a lightweight, sheer, plain weave fabric similar in structure to organdy and often used by textile conservators, was ultimately chosen. The silk crepeline provided adequate structural support while being the most visually unobtrusive. For each location, the silk crepeline was cut to size, and the edges were finished to prevent the fabric from fraying. The edges of an underlay can be finished several ways, including pinking using scissors and creating a rolled hem. In this case, the overlay edges were consolidated with a small amount of an archival-grade acrylic adhesive, as it was least noticeable compared to a pinked or rolled hem edge. The tears were secured with these underlays with a type of conservation stitching called laid couching[27] using hair silk, a very fine 100 percent silk thread frequently used by textiles conservators as it can be custom dyed easily and it is visually sympathetic with many fabrics. In addition to the underlays, the proper left and right shoulders of the bodice were each secured with an overlay of nylon bobbinet, a strong, lightweight, hexagonal structured tulle mesh, secured around its perimeter using running stitches with hair silk (see photo, page 166). These overlays provided further protection, as these areas bear much of the weight of the dress and are handled frequently for mounting.

The lace along the sleeves and the skirt hem were similarly stabilized, in this instance using an underlay of nylon bobbinet, dyed black using conservation grade dyes, and which were attached with similarly dyed hair silk. The black color of the bobbinet was chosen to provide some visual compensation akin to the original color of the lace. The underlays were secured around their perimeters and along their

PAGE 164: Proper left sleeve before treatment, showing tears to the organdy and insertion lace.

Afternoon dress by Josephine Lee, ca. 1930. Courtesy of Tampa Bay History Center.

horizontal centers with running stitches. Tears to the lace were secured using darning stitches. The visual compensation to the lace was accomplished by attaching overlays of black silk organza. These overlays were attached in a similar manner as the underlays in these locations (opposite). As the overlays were attached separately from the underlays, the aesthetic overlays can be removed from the dress if desired without disturbing the stabilization of the lace underneath (see photo, page 81).

An underdress, or slip, for the afternoon dress was fabricated by conservation technicians Arianna Gutierrez and Hailey Kremenek. First, similar outfits from the 1930s were researched, from museum collections and fashion

plates available online, to determine what style and silhouette would be appropriate to pair with the afternoon dress. Next, two 1930s sewing patterns of slips were sourced and mock-ups using those patterns were created from cotton muslin. Each mock-up was examined on the mannequin to determine which best suited the dress and to make any adjustments to the size. Another mock-up was made, and the process repeated until a final pattern was established. The reproduction slip was made using this final pattern from a white silk charmeuse.

Ultimately, structural and aesthetic treatment of the afternoon dress allowed for its safe display and for accurate contextual interpretation by audiences to understand the fabrication of the dress and how it would have appeared when worn by its original owner (see photo, page 80 for the afternoon dress after treatment and mounted with the reproduction slip).

### Case Study 2
### Wedding dress worn by Elizabeth Mance de Jonge, 1968

The wedding dress worn by Elizabeth Mance in 1968 (see photos, pages 117–21) is one of Lowe's latest designs included in the *Ann Lowe: American Couturier* exhibition, and it is especially interesting in the context of Lowe's earlier gowns. It would have been made at a time when Lowe's eyesight was in steep decline and therefore may have been sewn in large part by Lowe's staff under her direction. This magnificent dress showcases Lowe's mastery of design and construction, most remarkably through the use of layering fabrics, textures, and stitching details in a dress with otherwise simple color and lines. The dress has a straight silhouette with a slightly raised waistline and a rounded bateau neckline, closing at the center back with a hand-picked metal zipper. The silk organza outer layer of the dress is stunningly embellished around the neckline with hand-stitched floral lace appliqués. Long sleeves made with this sheer ivory organza are finished at the wrists with hand-applied lace foliage encircling the sleeve opening. The simple columnar skirt is constructed with wide horizontal bands of floral appliqués and pintucked organza set between narrower bands of lace, and a cathedral-

Tears to the cotton organdy along the proper left shoulder, before treatment (top); after stabilization with a silk crepeline underlay (middle); and after the addition of the nylon bobbinet, the appearance after treatment (bottom).

Tears to a section of lace insertion along the skirt before treatment and prepped for stabilization with nylon bobbinet underneath (left); after stabilization with a nylon bobbinet underlay (middle); and after the addition of a black organza overlay (right).

length train is stitched into the waist seam as an overskirt. This overskirt with the train opens at the center front to reveal the dress skirt, similar to an eighteenth-century court dress, and the many yards of embellished silk organza trail down the dress back. The edges of the train are finished around the perimeter with rows of inset lace, appliqués, and pintucking details, beginning with narrow bands at the center front and widening down the length of the train.

Many of the elements that have been identified as Lowe's signature details are present in this dress, such as the fussy cut lace flower appliqués and inset lace that embellish the sheer organza, and the bands of inset lace are edged using a cotton trim with small picots. The inner construction of the dress is also familiar: the lining of the dress is made with an ivory synthetic faille, identified as rayon, with lace finishing on the right and left interior seam allowances. The train and skirt hem are edged with bands of synthetic horsehair for shaping, and a petersham ribbon waist tape with Ann Lowe's label is tacked into the bodice. The bust shaping is less complex than many of her designs from the 1950s and early 1960s, with simple darts rather than the padding and elastic band shaping that is present in so many of her other dresses. This shift in construction is most likely a reflection of changing styles in the 1960s, rather than change in Lowe's attention to construction and body shaping. One of the most striking aspects of this dress is the visual impact of the floral appliqués, which start as small leaves and flowers just below the center front waistline, cascading into larger and more complex flowers as they work their way down the length of the more than fourteen-foot train. The sheer fabric at the neckline is covered with floral appliqués front and back, and the inside of this area is lined with a sheer gauze fabric, finished with stitching around the armscyes, or armholes.

Images of the dress from the Mance/de Jonge wedding show the dress was originally close to white in color, which would have made the use of pattern and texture in this dress much more visually impactful. The dress arrived at Winterthur in structurally excellent condition, but many of the elements in the dress were discolored to light brown, particularly the cotton floral appliqués, stitching thread, and picot trim on the edges of the inset lace. This type of discoloration is not uncommon with cellulose-based fibers such as cotton and linen and results from oxidation of the cellulose fibers as they react with light, air, and pollutants. The fabric and materials in the dress span a range of fibers, with a silk outer dress over a rayon lining with nylon lace insets. The ½-inch-wide horsehair braid, found in every one of Lowe's dresses examined at Winterthur, has been identified as rayon. Not only is this trim stitched into the hem of the dress skirt, but seven rows have been applied along the entire perimeter of the train. This range of fiber types creates complications when considering treatment and cleaning options, because each of the fibers will react differently to contact with water.

Extensive testing on all of the fibers of the dress showed most of the fibers reacted well to moisture, with the exception of the rayon and faille lining, where contact with moisture visibly altered the sheen of the fabric. At the same time, testing showed the cotton appliqués reacted well to a custom cleaning system with a surfactant and a chelator (binding agent), dramatically reducing the light brown color to a more ivory tone in most cases. Surfactants, or surface active agents, promote wetting and penetration and act as detergents,[28] while chelating agents help to boost cleaning by chemically grabbing and holding on to certain molecules that can cause staining. In consideration of Lowe and Mance's original intent for the dress, treatment approaches were considered that could help reduce the brown cast on the appliqués without altering the appearance of the water-sensitive fabric. A suction platon worked well to clean areas locally and control moisture, but the sheer size of the train made this option unworkable for the entire dress.[29]

The final treatment plan incorporated a combination of methods. The custom cleaning solution was sponge applied only to the cotton appliqués and picot trim on the train perimeter in a large wash tank. Wide areas of unembellished silk organza in the train were left untreated, with the exception of a stained area in the center. This allowed for a lighter

Wedding dress made by Ann Lowe for Elizabeth Mance in 1968. Elizabeth Mance de Jonge Collection. CLOCKWISE FROM

TOP: Detail of the bodice interior. Detail of the inside of the train, with seven rows of horsehair braid set alongside

seams. Detail of the lace appliqués during localized treatment, on the right side before cleaning and left side after cleaning.

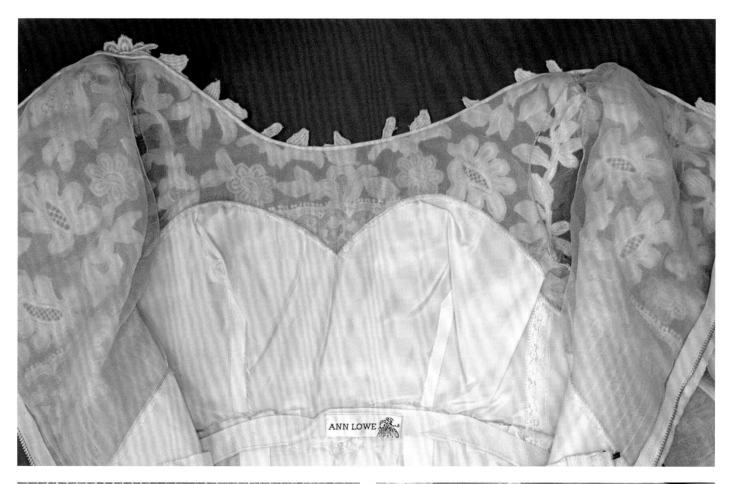

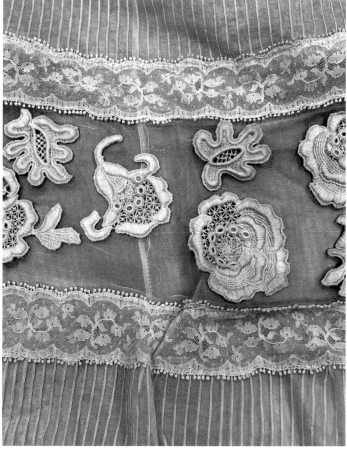

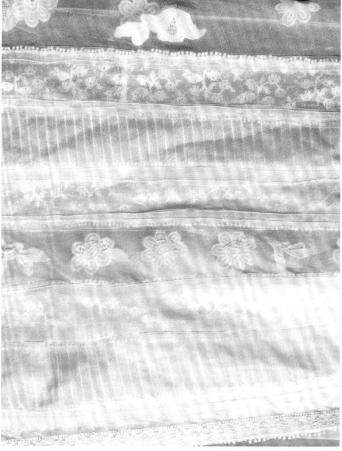

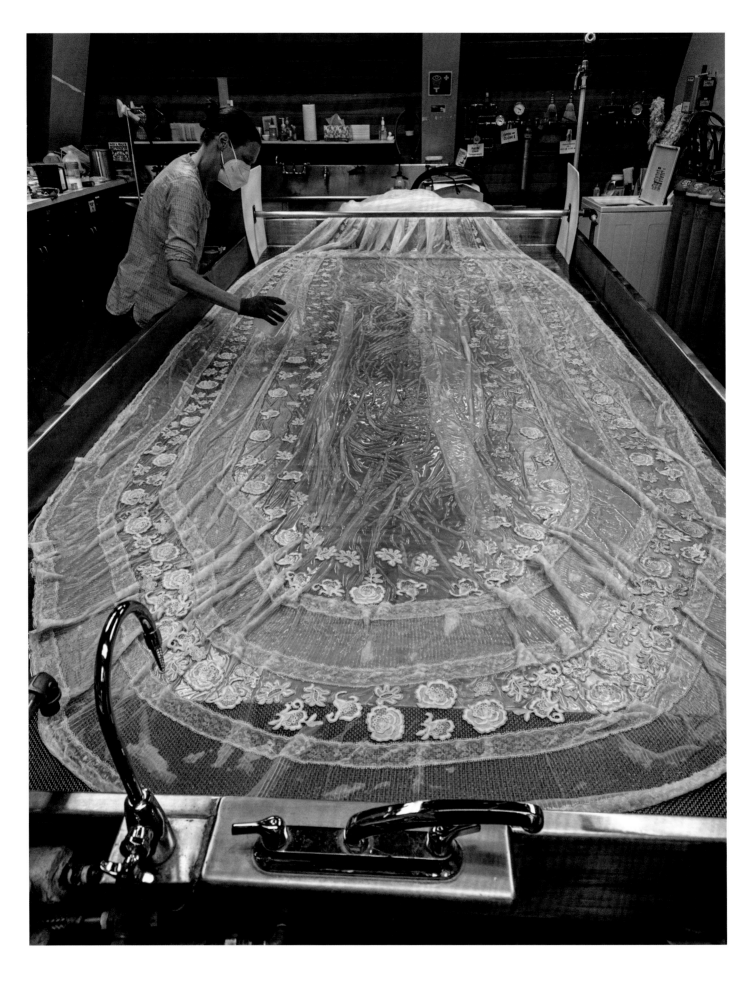

application of the cleaning solution, which would require less subsequent rinsing and manipulation. The train was rinsed thoroughly with running water rather than a full soak, so the water and saturation could be more easily controlled. Afterwards, additional appliqués on the neckline of the dress were treated locally with a suction platon, using Mylar, a transparent polyester film, as a barrier where needed to prevent the water from spreading to the rayon lining. The result of this semi-localized cleaning successfully reduced the overall brown cast of the appliqués, picot trim, and thread in the train, even though the dress has not returned to its original white color. In terms of the other fibers in the dress train, the horsehair braid did visibly swell and expand during this process, but returned to its original texture after drying. The silk organza in the train responded well, maintaining its intended appearance and hand.

Cleaning is not undertaken lightly in the context of textile conservation, because water can be quite damaging in certain circumstances, and cleaning a textile is not reversible. Many considerations come into play, including context and interpretation, present condition, origin of the discoloration and stains, and any damage caused by the discoloration. In this case study, testing demonstrated that the risk of cleaning the appliqués and other cotton elements in this hybrid manner was outweighed by the benefit of significant visual improvement overall. In addition, discoloration of cotton is often the result of buildup of oxidation products, which can acidify fibers over time. When appropriate, cleaning can improve the appearance of textiles, rehydrate fibers, and reduce the buildup of discolored and acidic degradation products in the fibers. This cleaning treatment improved the overall appearance of the dress, bringing the dress's presentation closer to Lowe and Mance's original vision (see page 173).

**Conservation and Collaborative Research**
The treatments, analytic examinations, and contextual research described in this essay represent a small portion of the conservation work done in preparation for the exhibition *Ann Lowe: American Couturier*. The specific choices made

during the treatments were influenced by understanding the garments' pasts, as well as anticipating their present and future uses. While it was a serious responsibility to prepare the dresses for exhibition, it was also a pleasure to spend so much time with such beautiful gowns.

Over the many months of preparation for the exhibition, we had an intimate view of these dresses, similar to that enjoyed by Ann Lowe, her staff, and her clients. This close examination revealed many of the small but significant choices Lowe made in materials and construction techniques to realize her fashionable designs and customize them for each client. Her dresses show that Lowe was a lifelong learner who blended apprentice-style training from her family with formal education, as well as personal creativity and experimentation. Her combination of historical dressmaking practices with modern aesthetics is reflected in her use of both natural and synthetic materials. An understanding of Lowe's technical expertise contributes to knowledge of her artistry by revealing how she was able to achieve such elegant creations.

Conservation work blends a wide range of knowledge from textile mechanics, to organic chemistry, to couture craft practices. Some conservation work is done by trained specialists working with institutional collections, but everyone can contribute through their work with personal, family, and community possessions. Institutional conservators work in close collaboration with curators, scientists, scholars, and others to achieve research and exhibition goals. As we gratefully benefit from others' knowledge, we hope our research can support broader scholarship and enrich an expanding appreciation of Ann Lowe's work.

The train of the wedding dress during cleaning in the large wash tank. Elizabeth Mance de Jonge Collection.

1. UNESCO Institute for Statistics, 2009 *UNESCO Framework for Cultural Statistics*; International Centre for the Study of the Preservation and Restoration of Cultural Property (ICCROM), *Risk Preparedness: A Management Manual for World Cultural Heritage*, 1998; UNESCO, *Traditional Restoration Techniques: A RAMP Study*, 1988; International Council of Museums–Committee for Conservation (ICOM-CC), *Definition of the Profession*, 1984; American Institute for Conservation (AIC), *What Is Conservation?*, 1994.

2. Claire Shaeffer, *Couture Sewing Techniques* (Newton, Conn.: The Taunton Press, 2011), 20.

3. Delaware Historical Society, 2003.028.0002.

4. Missouri Historical Society, 2014.002.0002.

5. Identified with Fourier-Transform Infrared spectroscopy (FTIR) using a Bruker ALPHA portable FTIR instrument.

6. Missouri Historical Society, 2014.002.0001.

7. Identified with Fourier-Transform Infrared spectroscopy (FTIR) using a Bruker ALPHA portable FTIR instrument.

8. Linda Lynton, *The Sari: Styles, Patterns, History, Techniques* (London: Thames and Hudson, 2002), 53–56.

9. George Rocker, "A Wonderful Product Is Fibersilk," *DuPont Magazine*, May/June 1922, 4.

10. Susannah Handley, *Nylon: The Manmade Fashion Revolution* (London: Bloomsbury Publishing, 1999), 82.

11. www.metmuseum.org/art/collection/search/82467.

12. Gerri Major, "Dean of American Designers," *Ebony*, December 1966, 142.

13. Elizabeth-Anne Haldane, "Surreal Semi-Synthetics," *V&A Conservation Journal*, no. 55 (Spring 2007), www.vam.ac.uk/content/journals/conservation-journal/issue-55/surreal-semi-synthetics.

14. Sarah Scaturro and Glenn Petersen, "Inherent Vice: Challenges and Conservation," in *Charles James Beyond Fashion*, ed. Harold Koda and Jan Glier Reeder (New Haven: Yale University Press, 2014), 239.

15. "From Nonwovens Pioneer to Leading Supplier of Technical Textiles," Freudenberg Performance Materials, www.freudenberg-pm.com/Company/the-history; "History," Pellon, https://www.pellonprojects.com/about/about-us/history/#:~:text=In%20the%201930s%2C%20Dr.

16. The Costume Institute at The Metropolitan Museum of Art, 1979.151.2.

17. Smithsonian National Museum of African American History and Culture, 2007.3.25.

18. Durham Museum, Omaha, Nebraska, 2010.35.1.

19. Margaret Powell, "Ann Lowe and the Intriguing Couture Tradition of Ak-Sar-Ben," *Nebraska History* 95 (2014): 134–43.

20. Margaret Powell, "The Life and Work of Ann Lowe: Rediscovering 'Society's Best-Kept Secret,'" (master's thesis, Smithsonian Associates and the Corcoran College of Art and Design, 2012), 58–59.

21. Identified with Fourier-Transform Infrared spectroscopy (FTIR) using a Bruker ALPHA portable FTIR instrument.

22. Chris Paulocik and R. Scott Williams, "The Chemical Composition and Conservation of Late 19th and Early 20th Century Sequins," *Journal of the Canadian Association for Conservation* 35 (2010): 48.

23. Rocker, "A Wonderful Product Is Fibersilk," 12.

24. Rocker, 4, 5, 12.

25. Mary M. Brooks and Dinah D. Eastop, eds., *Refashioning and Redress: Conserving and Displaying Dress* (Los Angeles: Getty Publications, 2016), 7.

26. Courtesy of Tampa Bay History Center, 2020.108.002.

27. Laid couching stitching is used to secure tears and areas with loose warps or wefts. This is done by placing, or laying down, long stitches perpendicular to the tears, which hold them in place, and then securing these laid stitches with short couching stitches spaced at regular intervals across the laid stitch.

28. cameo.mfa.org/wiki/surfactant.

29. A suction platon utilizes a flat, perforated surface configured with a hose to apply vacuum pressure, creating suction through the flat surface. The suction rapidly pulls moisture through the surface, giving the user much more control with wetting and spreading of applied water or solutions.

The wedding dress after cleaning, with the train pulled forward and spread out. Elizabeth Mance de Jonge Collection.

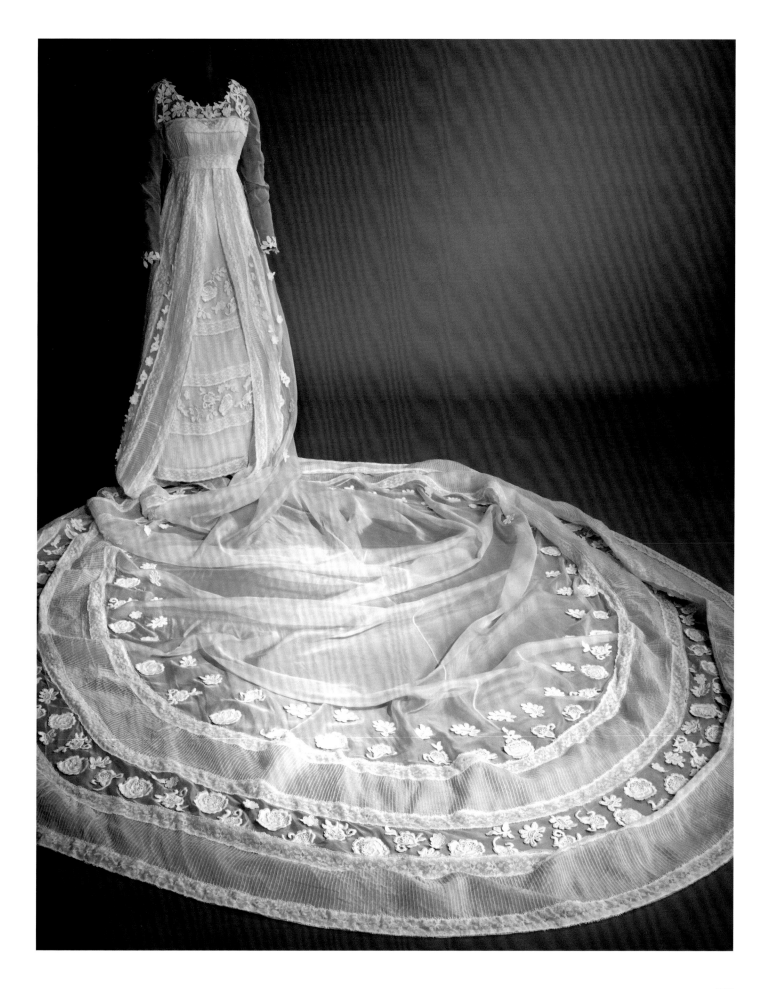

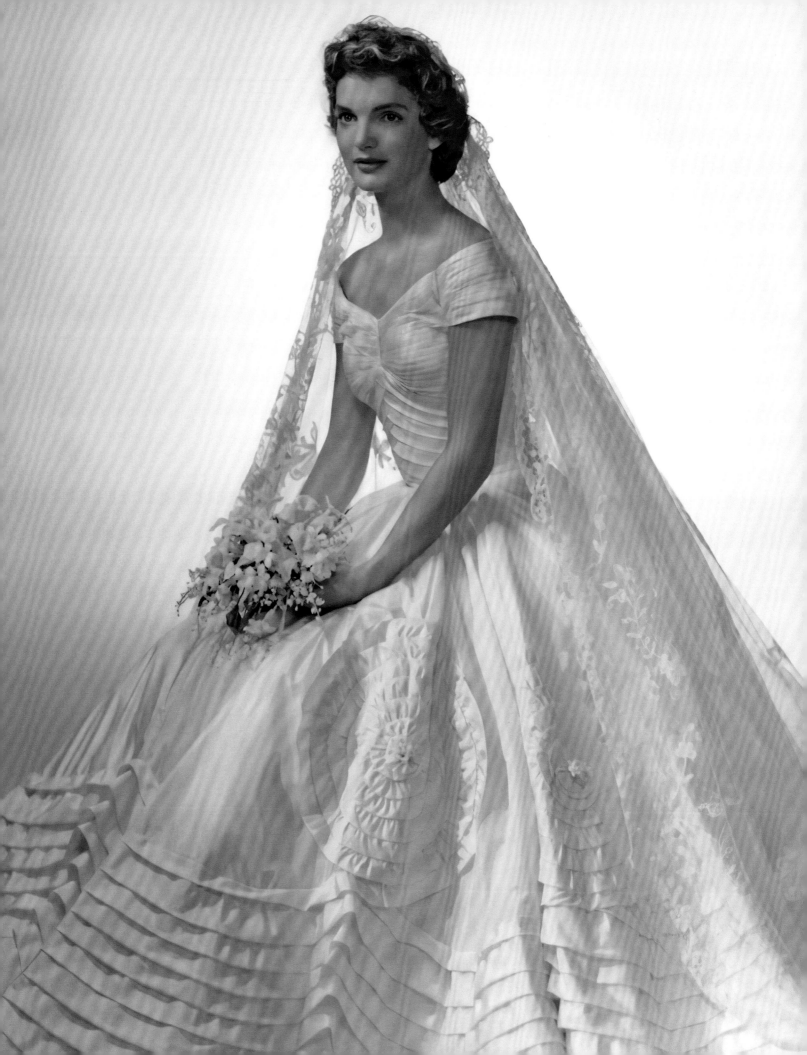

# Reproducing Jacqueline Kennedy's Wedding Dress

KATYA ROELSE

## Context

Ann Lowe had been making dresses for families of the New York Social Register for more than thirty years when she was given the opportunity she had always dreamed about.[1] Janet Auchincloss, the mother of Jacqueline Bouvier, asked Ann to make her daughter's wedding gown for her upcoming marriage to John. F. Kennedy. Mrs. Auchincloss was a longtime client[2] and her daughters made their Newport debut wearing Ann Lowe creations, so it was a natural choice to select Lowe as the designer, and it would also be less expensive.[3]

Fresh off her stint at *Vogue*, Jackie had an eye for fashion and was just beginning to cultivate her "Jackie Look." As a debutante in society culture, it was natural that there would be many people involved in what kind of dress she should walk down the aisle in to marry the freshman senator in the "wedding of the year."[4] Joseph Kennedy certainly saw the wedding as a press opportunity for his son, and his influence was important. Jack Kennedy wanted something "more traditional."[5] However, Jackie remembered asking for a "tremendous dress, a typical Ann Lowe dress."[6] She also requested that the color complement her grandmother's rose-point lace veil that she planned to wear with it. Other accounts say that she had wanted a simpler, more modern dress that would complement her tall, slim figure but that she was overruled by her mother and father-in-law. "Miss Lowe reached into her childhood memories and sketched an old-fashioned ball gown like one her mother had made for a Montgomery belle."[7] Lowe later said, "She [Jackie] was very nice. All the way, I had the feeling that she considered me, and any other people around her 'on her level.' She didn't seem to consider herself as being superior. It was a pleasure working for her."[8] In the end, Lowe designed a dress with a portrait neckline and delicately draped pleats across the bodice, a cinched waist with overlapping bias strips, and a bouffant skirt with ten rows of bias-cut swags that culminate in seven swirling rosettes with mini bouquets of wax orange blossoms nestled into six of them. There is also a three-layer silk faille petticoat with hand-sewn gathered trim. Despite historians reporting that the dress uses *trapunto*,[9] there is no evidence of the stuffing technique anywhere in the dress. It took Lowe and her team two months to create the gown. Cutting it alone took two days. It cost $500.[10]

Despite her discussions with Lowe, Jackie purportedly disliked the dress and felt she "looked like a lampshade."[11] The snug bodice emphasized her modest bust, and the frills and silhouette were far too fancy and complex for her taste. She said, "It was the dress my mother wanted me to wear and I hated it."[12] Mini Rhea, a dressmaker in Georgetown from whom Jackie had commissioned several garments, said that Jackie "did not like to get the effect with side drapes or bunching of material because that would ruin the simple lines she preferred. She did not wear fluffy things—she didn't wear 'buttons and bows' . . . she didn't like ruffles."[13] Rhea continues:

> The wedding dress has tremendous ruffles and circles of ruffles repeated all around the voluminous skirt. These almost endless ruffles were what I most objected to. I counted eleven rows of ruffles around the bottom of the dress and above them were large concentric circles of ruffles which diminished at the center, where there were sprays of flowers. . . . The dress couldn't have been fancier. But I had the feeling that Jackie was trying to please everyone—to dress according to everyone's idea of a bride.[14]

Nevertheless, Lowe understood the assignment and expertly managed the expectations of all the stakeholders, as all haute couturiers know how to do.

## Design and Creation and Signature Details

It is documented that Ann Lowe did not work from patterns but often worked from sketches.[15] She kept detailed information about her clients' measurements and was known to require very few fittings.[16] In the case of the Kennedy gown, Lowe met with Jackie several times the summer before the wedding for fittings and alterations.[17] However, Jackie never disclosed Ann Lowe's name during the process.

Wedding portrait of Jacqueline
Bouvier Kennedy, 1953.

Lowe wanted to be seen as a couturier, and this wedding dress demonstrates her exemplary sewing abilities and showcases many of her signature details. Her designs often featured a flower motif of some kind and in this wedding gown, there are miniature wax orange blossom sprigs, a traditional wedding flower associated with good fortune, nestled inside six rosettes. The rosette sewn on the center back is missing a sprig, presumably to avoid the discomfort of sitting on it and possibly destroying it.

The waistline treatment appears in many of her dresses as well. Although there is a seam in the understructure where the corset meets the petticoat, she eliminated the waistline seam on the outer layer and cut the skirt panels on the bias. This creates length and a more graceful line in the torso and beautiful volume and movement in the skirt.

The petticoat trim is a cleverly constructed signature detail. There is a six-inch-wide strip of gathered fabric at the hem that is hand-sewn in place and creates a sculptural effect. It causes the skirt to push away at the hem and helps achieve the "antebellum" silhouette.

The corset is constructed similarly to those in Lowe's other gowns, with the appearance of the delicate bust pleats, wiggle bones, and the zigzag elastic application across the bustline, which helps to cinch the corset in and create shape in the bust. There is also the familiar catch stitching across the waist stay and elastic at the underbust for further support.

The dress also features Lowe's ingenious "30-15" sleeve where the underarm sleeve seam is eliminated and replaced with a bias gusset that allows for more movement.

She regularly used fabric manipulation on the voluminous gowns to create visual interest and movement. In this case, she added bias pleating across the bodice in the front and back, and overlapping bias strips adorn the rib cage, tapering around to the center back into a V. Similarly there are ten rows of bias strips that are draped, layered, and slightly gathered across the hem of the ten skirt panels. They culminate in seven circular ruffled rosettes swirling in opposing directions throughout.

The main part of the gown is made from what Lowe called "silk chiffon taffeta." The color of the original dress is an off-white ivory meant to complement the veil and the bridesmaids' dresses. There are about thirty-five yards of fabric in the main part of the dress, and twenty of those yards go into making the bias trim for the swags and rosettes. The pleating in the bodice is also made from the same taffeta. The main dress is interfaced with a layer of light 100 percent cotton interlining or lightweight buckram. It is sometimes called "siri."

The understructure of the petticoat and corset is 100 percent white silk faille. The petticoat also has an outer layer of a lightweight beige interlining, and a stiffer, heavyweight interlining sits in between; together they are what help give the dress such volume. In the corset, there is a silk gauze layer that sits on top of the corset onto which the pleating is hand-sewn. There are also a variety of trims, such as petersham and double-satin ribbons, seam and twill tapes, elastics, boning, and hooks and eyes, that all go into the dress.

### Delivery and Reception

As the story goes, ten days before the wedding, a pipe burst in the ceiling of Lowe's workshop and destroyed Jackie's wedding gown as well as most of the fifteen attendants' dresses. Although understandably distraught over the circumstances, Lowe was reported to have said to her staff, "Girls, we've got to stop all this crying and get this place cleaned up."[18]

Lowe paid her dedicated staff time and a half to miraculously re-create the ruined dresses.[19] They remade the wedding gown in five days. When Mrs. Auchincloss called the Tuesday before nervously inquiring where the garments were, Lowe bought herself time and said, "I'm bringing them up to Newport myself. I'm afraid they'll get lost on the way," then escorted them by train to hand-deliver them in time.[20] This exchange was also fraught, for when Lowe arrived at the Auchincloss farm in Newport, Rhode Island, she was told that she must use the service entrance. She refused and said, "I'll take the dresses back,"[21] and was eventually allowed to enter through the front door.

TOP, LEFT TO RIGHT: Details of wax orange blossom bouquet, petticoat treatment, and wiggle bones. CENTER, LEFT TO RIGHT: Details of corset finishing and catch stitching. BOTTOM, LEFT TO RIGHT: Details of "30-15" sleeve, back waist, and color matching.

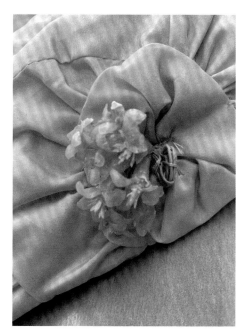

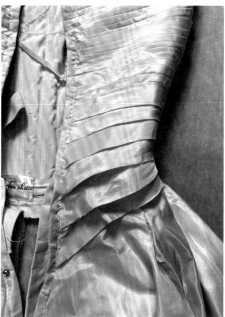

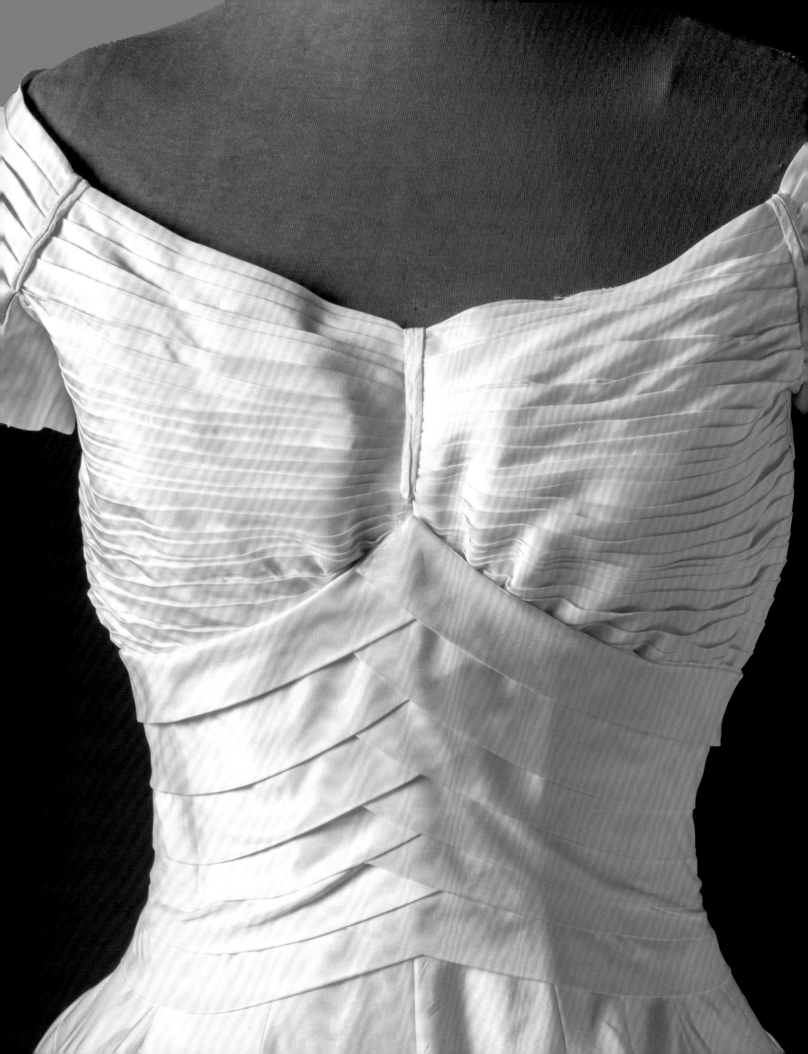

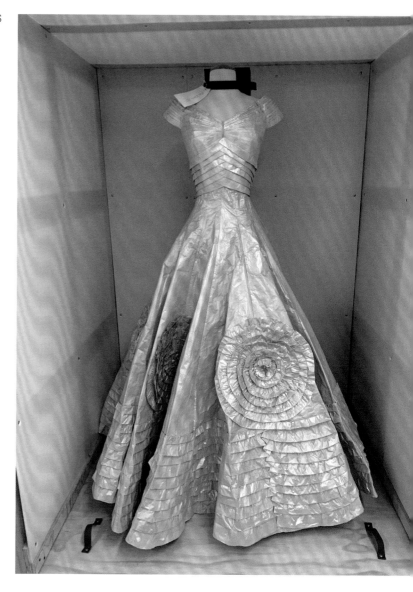

The wedding took place on September 12, 1953, with more than eight hundred invitees. An adoring crowd of no less than two thousand people waited outside. International and domestic press covered the wedding. Ann Lowe was invited to the event as well, but was also there to assist Jacqueline with the dressing. Ann Lowe held the long, antique veil high above the ground so that it would not be trampled.[22] When Jackie walked down the aisle, there was an audible gasp from the invitees.[23] In the receiving line, Senator Kennedy said to Lowe, "Thank you for making my bride so lovely."[24] In more ways than one, the dress was a success, and Ann Lowe hoped this would be a turning point in her career.

Lowe never told the Kennedys or Auchinclosses about the burst pipes and ruined dresses, and she ended up losing $2,200 on what should have been a $700 profit.[25] Those losses could have been recouped had her name actually been shared with the press. Only a *Boston Globe* article reported that the dresses were by "a New York dressmaker who has been her (Jacqueline's) mother's dressmaker for several years."[26] Years later, in a 1961 *Ladies' Home Journal* article about Jackie, Lowe suffered another indignity when she was referred to as "a colored woman dressmaker, not the *haute couture*."[27] As Margaret Powell wrote in her thesis, "thousands of dollars of free advertising for Ann Lowe's Madison Avenue dress salon disappeared into thin air."[28]

Today, Jacqueline Kennedy's dress is considered "the most photographed wedding gown in history"[29] and "one of the most iconic wedding-day looks of all time."[30] It regularly appears on "Best of" lists along with other gowns worn by celebrities, royalty, the politically powerful, and the wealthy. It has inspired designers and collectors for decades, and its likeness is frequently used to promote events and draw in the public.[31] A paper dress version was made by Belgian artist Isabelle de Borchgrave and her collaborator Rita Brown in 2004. Another paper version appeared at a Kennedy exhibit at the Palazzo Belloni in Bologna, Italy, in 2019.[32] The Franklin Mint issued a "Jacqueline Kennedy Heirloom Bride Doll" in 1998.[33] Given the cultural impact, one would hope to see Ann

Lowe's name more prominently associated with the dress, but, most times, her name is missing.

### Re-creation

I was contacted about a dress project in the summer of 2021 by Laura Mina, a textile conservator at Winterthur at the time. I learned then that Jacqueline Kennedy's original wedding dress is not able to be shown and, therefore, could not be part of the planned Ann Lowe exhibition. Having already collaborated with Winterthur on other projects, I was asked if I would be able to make the reproduction. Although this was an incredible opportunity, I initially felt that a BIPOC (Black, Indigenous, Person of Color) designer should take on the project, and I shared a few personal contacts whom I thought would be interested in following in Ann Lowe's footsteps. Ultimately, Winterthur returned to me with the project, and I accepted if I could involve

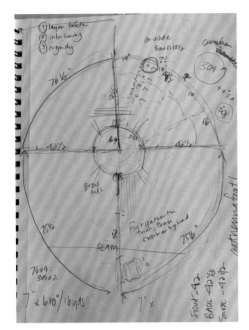

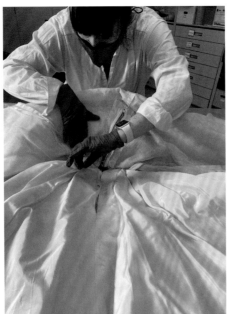

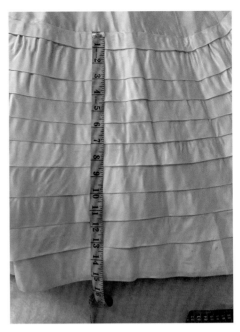

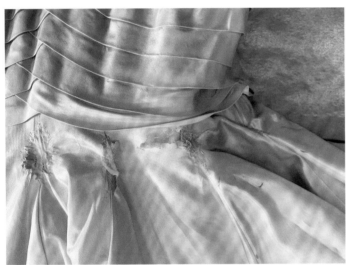

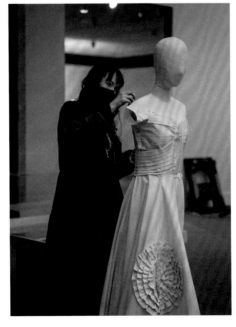

students in the process. As an educator and designer, it was important to me not just to teach the skills but to have students know Ann Lowe's story.

I have a lifetime of experience sewing and creating garments for myself, friends, and family, and many years of experience in the fashion industry. I have designed and created wedding dresses, corsets, and eveningwear garments for private clients. I have also worked as an alteration specialist and tailor's apprentice and have turned many garments inside out to repair and alter. I learned haute couture sewing and embellishment techniques as a graduate student at Drexel University by working for Frank Agostino in Narberth, Pennsylvania, and in Paris, at the Paris American Academy. My time in womenswear taught me the invaluable skill of copying garments by knowing how to take precise and proper measurements and how to draft a pattern without taking a garment apart. As a designer, I have become very familiar with many kinds of fabrics and trims, learned their properties and qualities, and found dependable industry sources.

In January 2022, I spent three days in the archives at the John F. Kennedy Presidential Library and Museum in Boston, evaluating, measuring, photographing, sketching, and taking copious notes on the dress. The last time it was on display was in 2003 for a three-month exhibition celebrating the fiftieth wedding anniversary. Years before it was accessioned in 2009, Caroline Kennedy reportedly found her mother's wedding gown "all crumpled up in a Lord and Taylor's box in the warehouse."[34] It was clear from even an initial survey why the dress could not be displayed. There are many tears at the waistline seams, and the fabric has deteriorated across numerous pleated edges of the bodice. In many places, the hand-tacked stitches had come loose or broken. The elastic in the corset could no longer recover its shape. The disintegration of all these details would only degrade further if displayed, and, although it is the original, it would not showcase Ann Lowe's skills accurately or respectfully.

All the documentation was completed with the dress lying on a large worktable. The skirt was so big that I had to sketch and take the bodice pictures upside down as this was the closest way I could access it, otherwise, the skirt would inevitably pull the gown off the table. It took at least two people to turn it over carefully to avoid any damage the handling might cause. I took hundreds of pictures of the seams, finishings, trims, and construction techniques. When a photograph could not successfully express the shape of a pattern piece or explain the construction or volume, I would sketch and draw diagrams to help better understand the steps Lowe took. There was no measurement too small to document. I took hundreds of specs and either documented them in sketches or took photographs that included a measuring tape or ruler. One small discovery would create a cascade of new questions about the construction and methods Ann Lowe used. My charge was to reproduce, not interpret, so every single part of the dress was investigated in order to be faithfully reproduced, inside and out.

After a comprehensive scan of the entire dress, I organized my documentation into five sections: the petticoat, skirt, swags and rosettes, bodice, and corset. I began with the petticoat because it appeared to be the most straightforward component. I always started by counting the number of pieces in each section and created a list of measurements to take. I measured the length of the center front, center back, the side seams, and then the circumference of the hem. I measured small details like the bow placement, trim dimensions, closure and seam details, and waist pleat depth. I also examined the grain of the fabric and noted if it was cut on the straight grain or on the bias. I repeated this process with the main skirt, taking special note of the waistline placement. In this gown, Ann Lowe eliminated the waistline seam to create an elongated silhouette and cut the ten skirt panels on the bias. This resulted in an elegant effect but is also where the gown gave way to the weight of the swags and began to tear. Next, I examined the swags, counting the number and widths of the ten parallel strips on each skirt hem panel. I took note as to how much gathering she used where the strips fold into one another at the seams and measured the seam allowances and length of the hand stitches. Then I measured the rosettes and documented the diameter, the

TOP, LEFT TO RIGHT: Petticoat diagram; Katya Roelse at work; measuring the swags. CENTER, LEFT TO RIGHT: Detail of waistline deterioration; wax flower experiments. BOTTOM, LEFT TO RIGHT: Annotated photos; Roelse with muslin prototype; tea-dyeing experiments.

width of the exposed bias strip, and counted the number of revolutions the strip makes in each rosette. The bodice was the most difficult to document because it was not created with a pattern and the pleated bias sections were individually draped and finessed in a couture fashion. I could only get precise measurements of the "30-15" sleeve and document the construction techniques and finishings through drawings and photographs. The corset showcases Lowe's engineering skills and how the pieces all work in concert to hold the entire dress together. I made a list of all the pieces and then individually measured each one like a puzzle, making sure that each of the seams would align with the previous one when it was sewn together.

After returning home, I spent a few days organizing my notes and photographs, developing a supply list, a pattern list (cutter's must), and a sewing construction table. I decided to work from the inside out because the foundation of the dress is complicated and supports every other component. I also wanted to execute this part while my memory was still fresh. With every part of the dress, I would begin by conducting a deep review of my sketches and photographs of the specific part, and then check those against my measurements to see if the details aligned and made sense. It was not a linear process, though. Depending on the kind of documentation I used (photograph, drawing, specs), I would cross-reference every detail and look for inaccuracies or confirmation of my choices. This proved difficult if I happened to miss a detail, so I looked to other photographs and information to help me reason out what I had missed. I printed out numerous photographs of my own, and ones I found online, and used them as studies on which to sketch and annotate. I felt that although I was privy to the details of the garment, I was also creating one that was in the public's memory, and I worked to balance these expectations while creating an authentic, functional dress. I sought to meet this goal while photographing, filming, and documenting every step along the way.

I drafted the corset pattern first using basic pattern-making techniques while adhering to the specificities of Ann Lowe's design. Then, following the previously described process, I drafted the petticoat and main dress based on the measurements I took and then draped the gauze bodice layer to which the pleated pieces would be attached.

Along with an assistant, I cut and created a half-muslin prototype to check for proportion and overall pattern accuracy of these three parts (corset, main dress, and gauze layer). It was on this prototype that I tested the swags and rosette construction and figured out how much yardage would be needed. I began the sourcing and ordering of supplies at this time, too, as I anticipated supply chain issues and thought some supplies would be difficult to find. I also did not know the name of the "wiggle bone" wires she used in the bust cups, nor did I have a source for the kind of boning she used in the body of the corset. The silk proved to be the most stressful to obtain, and it took six weeks for the silk faille to arrive and twelve weeks for the taffeta.

I was able to determine and order the appropriate weights for the interlining, and I decided to tea-dye one of the petticoat layers to match the original. The cutting of the petticoat was the quickest part, and although the construction was straightforward, the scale and handling of the garment proved a challenge and much of the work was repetitive. I hand-tacked the three layers together and stitched the seams and skirt perimeter by machine. The silk faille could only be hand-basted to create the ruffle trim; this process took six hours. Placing and pinning took another six hours to distribute the gathers evenly. Hand-sewing the trim took an additional twenty. Adding the "something blue" bow at the hem was a sweet finish.

I constructed the corset next, and after testing different boning applications, I machine-sewed the boning and seams. The wiggle bones, waist stays, and bustline elastic are sewn with a catch stitch and hand tacks.

I researched different ways to re-create the orange blossoms and decided upon a slightly translucent Sculpey clay that was pressed into a silicone mold. The peduncle, or stalk, was shaped by hand, and a florist wire was added. It was then baked to cure. The stamen was painted with a yellow Sharpie pen, and then each individual flower was sealed

OPPOSITE, TOP: Hand-sewing the swags. OPPOSITE, BOTTOM: Re-creating the rosettes.

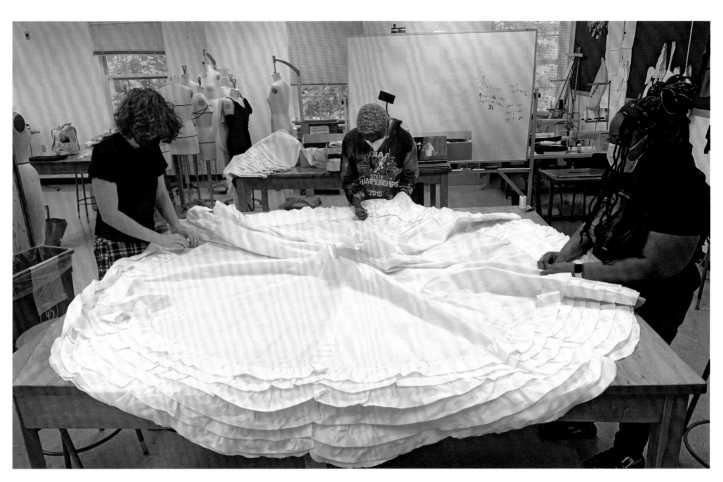

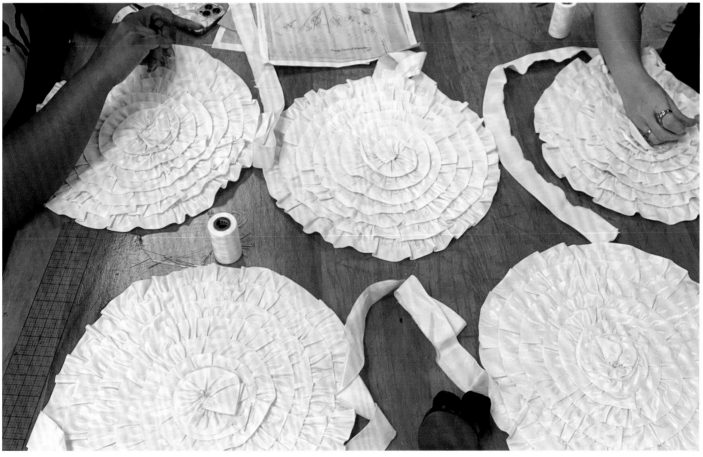

with polyurethane. My assistant made about seventy little flowers for the six bouquets to eventually sit in the rosettes.

The bias-pleated bodice layer was individually pressed in twelve sections and hand-sewn onto a silk gauze layer that is tacked onto the corset. I took meticulous care to count how many pleats there were and the direction they draped across the bodice. Similar to the swags, the width and number are inconsistent, and some of the pleats grow wider and change shape as they cross the bustline. The pleated sections in the back drape continuously to the front and encircle the "30-15" sleeve. There is a catch-stitched elastic around the shoulders that is meant to secure the sleeves slightly off the shoulder. There is also a gauze strip that is hand-sewn around the interior of the neckline to cover the raw edge of the pleated sections.

The vertical seams of the skirt were sewn by machine and quickly came together. I machine-stitched the horsehair hem at this point too. Three students and I spent about six days cutting, gathering, pinning, and hand-sewing the 154 yards of bias trim for the swags and 49 yards for the rosettes. The swags were manipulated and placed "by eye" as there are no calculations explicitly saying when or how much to gather. We worked in an assembly line fashion where I would gather and pin the swags, and then they would hand-sew each row after me. It took approximately a day to hand-sew twenty sections.

The width of the strips varies slightly from panel to panel, and no two are the same. This is also the case with the rosettes as the number of revolutions changes and can vary between ½ inch and 1 inch in diameter. Further, some spiral clockwise and some spiral counterclockwise. They are also not placed consistently, with a few of the rosettes placed slightly off-center and toward the front of the dress, presumably so that they would feature more prominently. The bias ruffles of the rosettes are also manipulated "by eye." I estimated the amount of gathering Lowe used by measuring the continuous folded edge of the bias ruffle and compared that with the number of revolutions it makes.

The final steps in the re-creation were attaching the skirt to the bodice, applying the waistline bias strips, and sewing the handpicked zipper. Admittedly, these steps were the most difficult to complete because the dress was almost completed and a challenge to maneuver due to its weight and size. Further, everything at this point is hand-sewn, so it was important to create strong, consistent stitches to hold the entire dress together. The skirt fits snugly against the bodice, and I had to take care that the correct number of pleats were exposed and that the transition lined up perfectly in the back. There is some crinkling of the pleats under the bust caused by the weight of the skirt, and I sought to imitate this as well by adjusting the tension on my stitching.

The waistline strips cover where the skirt is attached to the bodice. They meet perfectly in center front, alternately overlap, and transition gracefully to the back into a V at center back. It necessitates the stitcher to move from the left to the right, and the back to the front, for each successive strip, which was a painstaking and slow process given the size and scale of the dress. Although the sewing of the handpicked zipper was relatively easy, again, the challenge was working around the enormous dress and ensuring that the strips and pleating all lined up on either side of the zipper. I was honestly confounded at this step and never quite understood how Lowe accomplished it.

I considered if Ann Lowe worked as efficiently as she could have, having to make this garment so quickly. I found that the hand-sewing was not an unnecessary extravagance. The pleating, swags, and rosettes must be sewn and tacked by hand, as there is no way to operationalize the process with a sewing machine. The dress is too big, and the layers too thick to fit into a machine bed. My attempts to hasten the process and gather the silk faille petticoat trim by using a special foot attachment on my machine failed. Except for the handpicked zipper, machine sewing is utilized mainly for straight seams and for points of fortification like in the boning and seam applications. This is testament to Lowe's skill as a couturier and her understanding of fabrics and their inherent potential. The hand-sewn techniques also offer beautiful inconsistencies not seen in machined garments.

Final reproduction of Jacqueline Kennedy's
wedding dress by Katya Roelse, 2022.

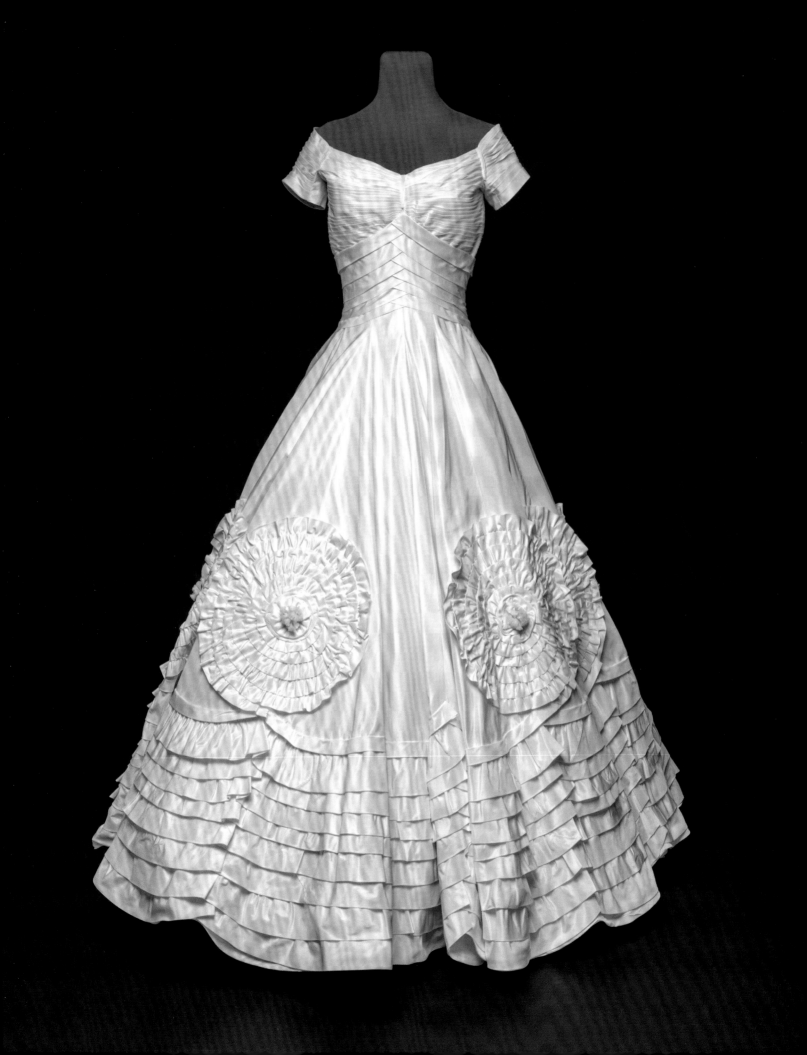

It is perfectly imperfect, providing endless moments where you can see her skill. Unlike ready-to-wear garments that are sewn systematically for speed and ease of production, a haute couture garment is built, so to speak, and not necessarily put together for ease of production.

There were plenty of challenges at every step. The first challenge was not having Jacqueline's actual measurements on which to base the reproduction. Accurate measurements could have provided some idea as to what undergarments were worn with the gown and what kind of ease had been added for comfort. There are plenty of speculative theories, but these assumptions do not account for what her measurements were that day or at that time in her life. The built-in corset offers some structure, but Ann Lowe clients typically wore their own undergarments as support and shape. "When they wear one of my dresses," says Ann Lowe, "they just step in, zip up and they're gone,"[35] suggesting that they came wearing any supplementary garments. In any case, there would be accommodations made in the overall fit of the gown so it would not be too tight or too loose when finally worn. Another challenge was having to account for how much the fabric deterioration had changed the size of the garment over time. The most noticeable tears at the waist could have added an inch or two to the final measurements. Many sections were cut on the bias and could have stretched over time, changing the overall length and proportion. Taking construction cues from the original gown proved to be a challenge as well when deciding what to include in the reproduction. It was difficult to determine what parts of the original gown were salvaged or hastily reconstructed. It is also possible that Ann Lowe, in her wisdom, knew what battles were important and some crooked stitches that were never meant to be seen would not matter. Additionally, the gown has numerous layers, is white, and is of considerable size, and any designer attempting to re-create it has a veritable design conundrum to solve. I relied on the facts of the dress as it is today to guide me, but with every step, I looked for general proportion and checked this against original photographs that the public knows so well. Finally,

although every trim and secondary fabric shipped in a timely fashion, the forty yards of the main taffeta fabric were delayed months due to the ongoing supply chain issues in spring 2022. By resorting to a supplier that had the taffeta in white rather than the original off-white, I was able to complete the reproduction and drop it off at Winterthur on July 1, six months from start to finish.

## Honoring a Master Couturier

The process of re-creating the Jacqueline Kennedy wedding gown only served to further establish Ann Lowe as a consummate dressmaker who is worthy of haute couture status. Successfully executing the numerous details and techniques in such a gown takes many years of experience and a dedicated *metier*. Ann Lowe not only possessed these, but she had the perseverance to weather any storm.

The reproduction is significant because it is an opportunity to document a master couturier's skills and techniques in what is arguably her most important design and a culmination of her life's work. There are so many signature details, and it is important to examine and catalogue them so that her talents and hard work are recognized as much as any other haute couturier's.

The reproduction is also significant because through creating it, we get to know how the dress was made and the specifics of the fabric and trims, and we also become more familiar with what Lowe and her staff experienced as they hurriedly worked to create it after the plumbing accident. We become more appreciative of every stitch, and in a way get to walk in her shoes. By documenting it, we are giving Ann Lowe her voice and the respect she deserves.

The most meaningful characteristic of Ann Lowe's supreme dressmaking abilities was that she had an acute sense of what mattered and what the average person would not detect. With only a few days to re-create the dress, it is evident that she knew what to keep and what to discard. This is another hallmark of a consummate couturier: knowing what to sacrifice while also delivering a beautiful dress on time.

1. Sally Holabird, "Ask Her About Jackie's Bridal Gown," *Oakland Tribune*, August 7, 1966.

2. "26 Attendants to Take Part in Kennedy Ceremony Tomorrow," *Boston Globe*, September 10, 1953.

3. Judith Thurman, "Ann Lowe's Barrier-Breaking Mid-Century Couture," *The New Yorker*, March 22, 2021, www.newyorker.com/magazine /2021/03/29/ann-lowes-barrier-breaking-mid-century-couture.

4. Thomas B. Congdon Jr., "Ann Lowe: Society's Best-Kept Secret," *Saturday Evening Post*, December 12, 1964, 75.

5. Christopher Anderson, *Jack and Jackie: Portrait of an American Marriage* (New York: William Morrow, 1996), 9.

6. Congdon, "Ann Lowe: Society's Best-Kept Secret," 75.

7. Congdon, 75.

8. "Fashion Designer for the Elite," *Sepia*, August 1966, 34.

9. Nancy Davis and Amelia Grabowski, "Sewing for Joy: Ann Lowe," *O Say Can You See?* blog, Smithsonian National Museum of American History, March 12, 2018, accessed August 29, 2019, https://americanhistory.si.edu/blog/lowe.

10. Holabird, "Ask Her About Jackie's Bridal Gown."

11. Jay Mulvaney, *Jackie: The Clothes of Camelot* (Macmillan, 2001), 20.

12. Mulvaney, 20.

13. Mini Rhea, *I Was Jacqueline Kennedy's Dressmaker* (New York: Fleet Publishing Corporation, 1962), 25–28.

14. Mini Rhea, 25–28.

15. Alexandra Frye, "Fairy Princess Gowns Created by Tampa Designer for Queens in Gasparilla's Golden Era," *Tampa Morning Tribune*, February 7, 1965, 6-E.

16. Margaret Powell, "The Life and Work of Ann Lowe: Rediscovering 'Society's Best-Kept Secret'" (master's thesis, Smithsonian Associates and the Corcoran College of Art and Design, 2012), 44.

17. Clemens David Heymann, *A Woman Named Jackie* (Lyle Stuart, 1989), 128.

18. Congdon, "Ann Lowe: Society's Best-Kept Secret," 75.

19. Holabird, "Ask Her About Jackie's Bridal Gown."

20. Congdon, "Ann Lowe: Society's Best-Kept Secret," 75.

21. Davis and Grabowski, "Sewing for Joy."

22. Anderson, *Jack and Jackie*, 11.

23. Anderson, 10.

24. Holabird, "Ask Her About Jackie's Bridal Gown."

25. Congdon, "Ann Lowe: Society's Best-Kept Secret," 75.

26. "26 Attendants to Take Part in Kennedy Ceremony Tomorrow."

27. Mary van Rensselaer Thayer, "Jacqueline Kennedy," *Ladies' Home Journal*, April 1961, 130.

28. Powell, "The Life and Work of Ann Lowe," vii.

29. Penny Carter, "Lewis Chapter DAR Honors Late Fashion Designer," *The Eufaula Tribune*, February 14, 2018, www.dothaneagle.com /eufaula_tribune/lewis-chapter-dar-honors-late-fashion-designer /article_66385548-11a5-11e8-abfe-e7b4585cc687.html.

30. Rose Minutaglio, "Ann Lowe Is the Little-Known Black Couturier Who Designed Jackie Kennedy's Iconic Wedding Dress," *ELLE*, October 24, 2019, www.elle.com/fashion/a29019843 /jackie-kennedy-wedding-dress-designer-ann-lowe.

31. Erica Moody, "Inside Homes: Southern Hospitality," *Washington Life* magazine, accessed on August 16, 2022, https://washingtonlife.com /2018/12/17/inside-homes-southern-hospitality.

32. "The Kennedy Family on Show at Palazzo Belloni," accessed August 16, 2022, www.guidadibologna.com/articles-of-guida-di-bologna /the-kennedy-family-on-show-at-palazzo-belloni/?lang=en&cn-reloaded=1.

33. Summer Lee, "1953—Ann Lowe, Jacqueline Kennedy's Wedding Dress," Fashion History Timeline, accessed August 16, 2022, https:// fashionhistory.fitnyc.edu/1953-lowe-kennedy-wedding-dress.

34. Mulvaney, *Jackie*.

35. Congdon, "Ann Lowe: Society's Best-Kept Secret."

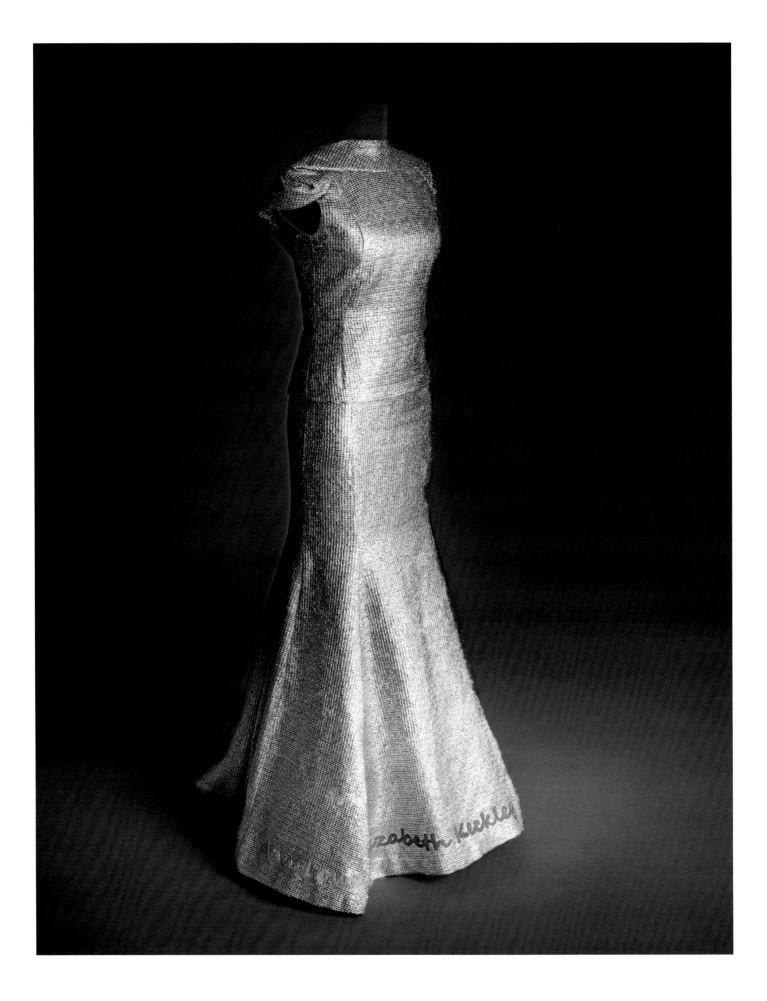

# The Legacy of Ann Lowe

ELIZABETH WAY

In 2021, Dawn Davis, the respected publisher and editor-in-chief of *Bon Appétit* magazine commissioned the American fashion designer B Michael to create a gown for her attendance at The Metropolitan Museum of Art's Costume Institute Gala. Begun in 1948, "the event has gone from an annual fundraiser attended by the fashion industry and New York society to a cultural phenomenon attracting global attention."[1] The red-carpet promenade of the attendees is as much an object of public fascination and comment as any Hollywood awards show, and the fashion is the main attraction. Some guests—celebrities of all fields—use the opportunity to make bold sartorial statements of enormous proportions and over-the-top embellishments inspired by the gala theme, and others use their platform to communicate cultural messages or political beliefs through their clothing—Congresswoman Alexandria Ocasio-Cortez, for example, wore a dress by Brother Vellies that read "Tax the Rich" when she attended the same year as Davis.[2] B Michael recalled that Davis

> wanted her dress to have a narrative that would channel the contributions of "unsung" Black American Designers. Our collaboration led to the embroidery of the names of a few of such designers: *Ann Lowe, Elizabeth Keckley, Arthur McGee, Scott Barrie, Willi Smith, Jay Jaxon and Patrick Kelly*—Dawn Davis said as she ascended the red carpeted steps of the Metropolitan Museum, "I am bringing with me those designers"—with their names colorfully embroidered on the majestic gold paillettes of the hemline, they all attended the Met Gala.[3]

Ann Lowe, whose work is held in the collection of The Metropolitan Museum of Art, sits in good company with the other designers named on Davis's gown. Each has made significant contributions to American fashion, helping to shape its culture and aesthetics both domestically and internationally. With the exception of Keckly (also spelled Keckley) and Lowe, these designers mainly created ready-to-wear fashion in a late twentieth-century tradition—though Jaxon and Kelly

notably contributed to Parisian couture. Keckly (1818–1907), a nineteenth-century modiste, worked in an artisanal tradition that defined high-end (and nearly all other levels of) fashion before its eventual replacement by industrial manufacturing and ready-to-wear garments. Lowe followed in her footsteps, creating made-to-measure couture gowns, much like the B Michael confection that Davis majestically carried into The Met Gala.

Ann Lowe was not the first Black American designer to achieve her level of prominence—Keckly, as First Lady Mary Todd Lincoln's dressmaker, received national press coverage during the 1860s.[4] Yet Lowe's impact—too often unrecognized—was greater than most. She drew on the legacy of Black dressmakers before her, those such as Keckly, but more directly her own grandmother and mother, Georgia Thompkins and Janie Cole, and she left an example for others to follow. As a Black woman born into a poor, rural community in the Jim Crow American South, Lowe did not have an easy life or career, but she was an ingenious designer who garnered respect and admiration from elites in an environment that, at best, undervalued and underestimated Black people and women. Her visibility, at times significant—a 1926 profile in a Tampa newspaper, a 1964 appearance on a national television show—has had an immeasurable effect on fashion designers who came after her, and for people of color who aspired to work in fashion, it was a game-changer. McGee, Barrie, Smith, Jaxon, and Kelly may or may not have known of Lowe, but her career—her attendance at a New York City fashion school, her relationships with suppliers and buyers, her prominent list of clients, and the press she received—all helped normalize the idea that a Black person could be a talented and important fashion designer. Every person she came in contact with personally, professionally, or through her coverage in the media became a little more accepting of that idea.

Margaret Powell's research has shown that Lowe contributed directly to the careers of other dressmakers and designers. She trained her own staff in Tampa, for example, empowering other women with lucrative dressmaking skills,

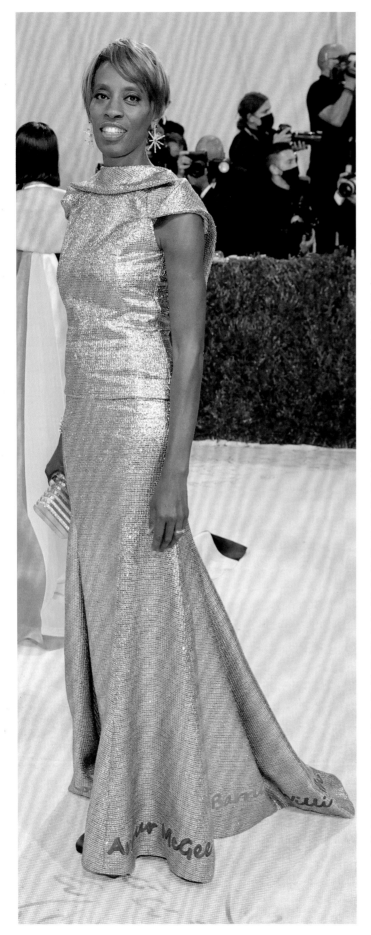

and these women valued their association with Lowe. When Gussie Sheffield placed her 1928 advertisement in the *Tampa Morning Tribune*, she was sure to note that she was "for years associated with Annie Cone West."[5] What is also certainly true but harder to document are the people who read about Lowe in magazines and newspapers or saw her on TV and thought, "I could do that." Television has expanded significantly since Lowe appeared on *The Mike Douglas Show* and has further developed as a medium to expose designers to a public whose interest in and understanding of the profession of fashion design have also expanded. Bishme Cromartie (b. 1991) was introduced to an international audience through the popular fashion design competition show *Project Runway* in 2019. Although his work had been featured in international magazines and he had shown at New York and Los Angeles Fashion Weeks, the program gave him unprecedented exposure to those who would have never known where to find him or his work before. Separated from Lowe by generations, Cromartie grew up in Baltimore, Maryland, and though his urban upbringing contrasts with Lowe's rural childhood, they share the joy and sense of escape each found in design. Cromartie recalls of his home, "It wasn't the best neighborhood, but I think being in a rough environment forces you to develop a great imagination that allows you to escape the world that you're in."[6] Unlike Lowe, Cromartie is self-taught—hard to believe when looking at his draped watercolor-motif silk crepe gown in the collection of the Maryland Center for History and Culture. In terms of elongated proportions and chic asymmetry, the design recalls Lowe's rare 1930s gowns. Also, unlike Lowe, he is harnessing new media, namely social media, to connect directly with customers and to control the narrative of his own story in ways she could not.

B Michael (b. 1957) may be the American designer working today whose fashion practice most closely aligns with Ann Lowe's—he is also a couturier in a land of ready-to-wear designers. Lowe would have surely identified with his description of his position as a couturier: "timeless elegant style, excellence in fabric and workmanship. . . . I dress women with impeccable taste, and who have world class

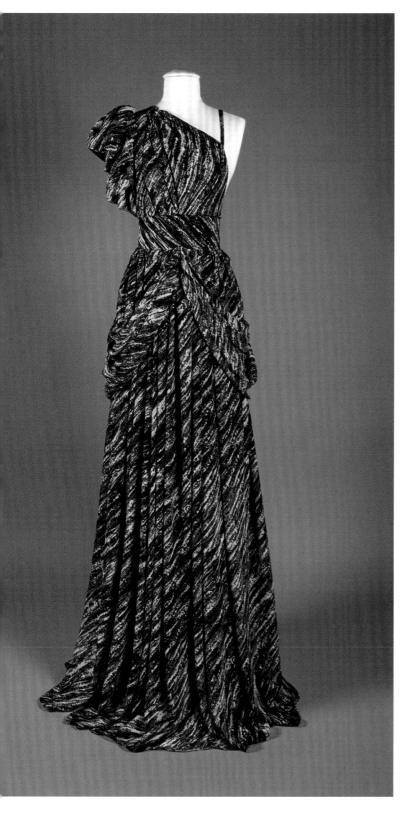

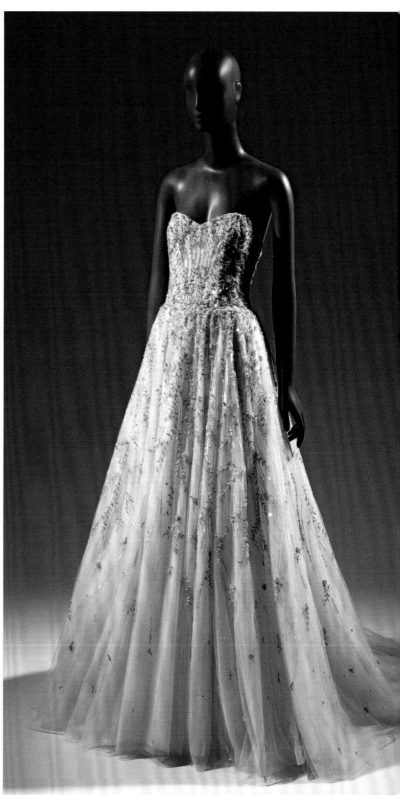

OPPOSITE: Dawn Davis in a B Michael gown at the 2021 Metropolitan Museum of Art's Costume Institute Gala.

ABOVE LEFT: Bishme Cromartie gown. Courtesy of Maryland Center for History and Culture, 2019.11.1.

ABOVE RIGHT: Amsale Aberra beaded silk net wedding dress, 2015. Collection of The Museum at FIT, 2016.107.1.

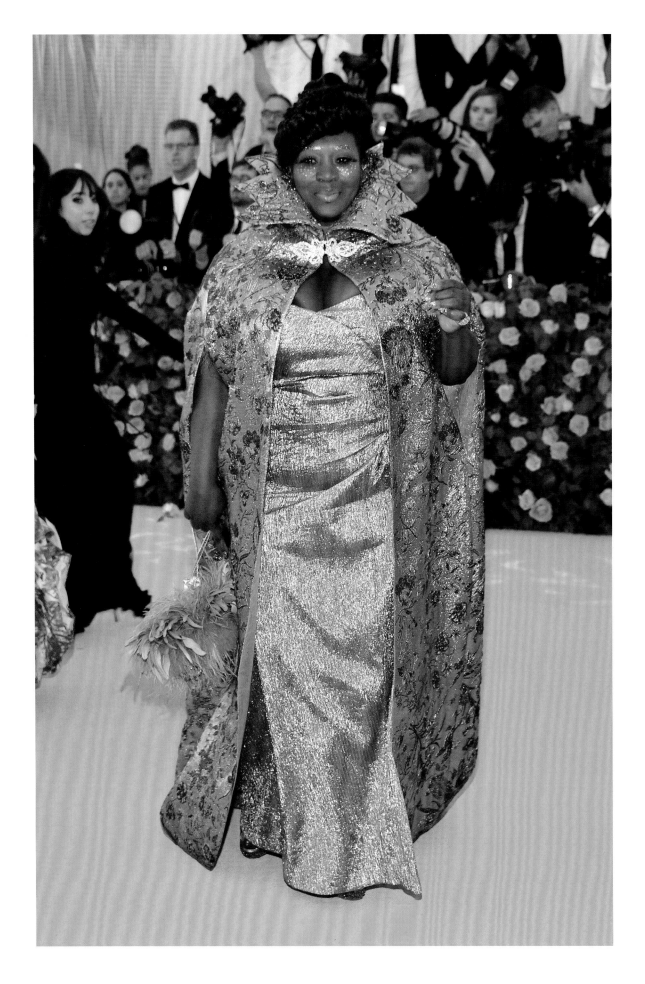

options."[7] In addition to society ladies, his clients reflect the visibility of actors and musicians in contemporary society, including Cicely Tyson, Phylicia Rashad, Valerie Simpson, and Beyoncé, but he also dresses cultural influencers such as writer and producer Susan Fales-Hill and poet laureate Elizabeth Alexander. Fashion was not an inevitable career path for Michael as it seemed to be for Lowe—his parents were professionals in Connecticut, his mother a real estate agent and his father an accountant—and he attended the University of Connecticut and worked on Wall Street before turning to millinery and eventually couture and ready-to-wear fashion. Like Lowe, Michael attended fashion school—the Fashion Institute of Technology—and like her, he worked for other design firms, designing millinery for Oscar de la Renta and Louis Féraud before establishing his own millinery brand in 1989 and his couture collection B Michael America ten years later. While Lowe created fantasy gowns for debutante and costume balls, Michael designed for divas on screen, including hats for *Dynasty* and costumes for Whitney Houston.[8] Michael and Lowe may have found similarities in their fashion practices, but Michael had an asset that would have made all the difference for Lowe: a trusted and highly competent partner in business and life. Mark-Anthony Edwards co-founded B Michael America in 1999 and has steered the business for more than two decades, attracting investors and capital and expanding into ready-to-wear collections. Together, Michael and Edwards helm a fashion business that Lowe could have only dreamed of.

Both B Michael and Ann Lowe have created luxury fashion in a tradition well recognized in Western culture: beautiful fabrics such as ornate silks—velvet, cloqué, and brocade—and laces, and meticulous construction to create well-fit bodices and flowing skirts. These are elite fashions for rarified occasions. Some of the most exceptional gowns Lowe created were for brides, and she was well known early in her career for creating opulent wedding gowns. Her most famous gown is Jacqueline Kennedy's 1953 wedding dress, which is rich in ruffles, pleating, and flowers (see "Reproducing Jacqueline Kennedy's Wedding Dress," page 175). Other

bridal gowns, such as Florance Rumbough's 1951 historically inspired satin and lace dress and Elizabeth Mance's 1968 floral lace and pintucked column with cathedral-length train, show Lowe's love of lavish detail. Yet, as fashion embraced simpler lines, Lowe adapted, as seen in Ann Bellah Copeland's 1964 elegantly simple gown (see photo, page 115, bottom left). Bridal designer Amsale Aberra (1954–2018) would have found affinity in Lowe's design for Copeland. Aberra found her way to bridal design from womenswear while planning her 1985 wedding. She craved minimalism—the opposite of the offerings for a 1980s bride—and designed her own dress. Like Lowe, Aberra was innovative within a narrow set of design parameters. She changed bridal design, "getting away from all the old traditions of lace, beads and everything that really wasn't modern anymore. She created the modern wedding dress."[9] Lowe may have preferred more ornate design, but would have surely appreciated the bridal couture salon Aberra opened on Madison Avenue in 1997, where Lowe herself once kept an atelier. Aberra, like Michael, has expanded on Lowe's couture legacy by building a sound business. All three relied on family, though Lowe's son Arthur tragically died young, denying her a partner she could trust. Aberra partnered with her husband Clarence O'Neill Brown, CEO of the successful Amsale Group. Aberra also died tragically, in 2018, yet she is one of the only Black designers who built a fashion house that has outlived her, a feat Lowe would have also surely admired.

B Michael and Amsale are fashion brands with obvious connections to Lowe's legacy, but a designer like Dapper Dan may be a surprising point of comparison to Ann Lowe's work. Both lived in Harlem in New York City, however, while Daniel Day (b. 1944), better known as Dapper Dan, and his fashion practice are deeply enmeshed in the Black neighborhood, Lowe worked on the Upper East Side, serving mainly white socialites. A client, the Black Harlem socialite Idella Kohke, however, proved that Lowe maintained a presence in her community and designed for her neighbors—the ones who could afford her services.[10] Dapper Dan diverges significantly from Lowe in that he is not a technical practitioner of garment production—he does not sew or pattern, though

Bevy Smith, TV personality and Sirius/XM Radio host, wearing Dapper Dan cape and Kimberly Goldson gown at the 2019 Metropolitan Museum of Art's Costume Institute Gala.

he is a highly skilled and self-taught textile printer. He got his start in fashion by selling luxury styles—furs and leathers—to his Harlem neighbors in the 1970s and 1980s. Like Lowe, who created "fairy princess" gowns to give confidence to nervous debs,[11] Day assessed what his clients needed and dressed them to boost their confidence and help them pro-ject their truest selves. These were not elite white women, but the hustlers, gangsters, and later rappers of Harlem and other Black urban centers. While Lowe is known for her dimensional flowers, Day is inextricably associated with the logo-covered streetwear designs he pioneered during the late 1980s. Lowe's work speaks in conversation with mid-century Parisian haute couture with its meticulous construction and overtly feminine silhou-ettes, fabrications, and embellishments. Day started a new conversation, taking European luxury logos—Louis Vuitton, Gucci, and MCM—and incorporating them into athletic, military-inspired, and classic menswear staples in new sil-houettes that were changing the way both men and women dressed during the late twentieth century. Daniel Day's use of these logos was not strictly legal, and he was forced underground by raids from these brands' lawyers, yet for more than thirty years, his influence has been seen on fashion at every level, from couture runways to street corner clothing vendors. In 2017, Dapper Dan re-emerged. The fashion industry was forced to recognize his innova-tive influence on American and international fashion when Gucci was criticized on social media for copying his original designs. Dapper Dan partnered with Gucci on a series of collections that emphasized his undeniably cool and current streetwear.[12] These designs also showed Day's flexibility as a designer. The 2019 Met Gala was filled with celebrities wearing Day's designs in collaboration with Gucci, and the piece he created for his guest, fellow Harlemite and television personality Bevy Smith, shown on page 192, was not only stunning but a surprising departure from his usual style.[13] The full-length floral metallic cape with a medieval collar was paired with a delicate pink gown designed by Kimberly Goldson—a Brooklyn-based designer who, like Cromartie,

gained international exposure through *Project Runway*. The ensemble is right at home with Ann Lowe gowns, but the feminine cape is not as divergent from Dapper Dan's styles as a first glance might suggest. Day's oeuvre is luxury, and as much as Lowe, he has always outfitted his clients to present the best version of themselves to fit the occasion.

Ann Lowe did not often discuss race in the press or the prejudice she faced as both a Black person and a woman, though it inevitably came up in her 1960s interviews, when the civil rights movement demanded national attention. At the beginning of her career, "dressmaker" was the common term for fashion makers, and these artisans were mostly women. However, few Black woman created high-end fashion at the level that her grandmother, mother, and she worked. By the end of her career, Lowe witnessed a transi-tion that favored male designers for womenswear, as ready-to-wear became an industry and fashion design became recognized in America as a creative and artistic pursuit. When a callous journalist at the *Ladies' Home Journal* referred to Lowe as a "colored woman dressmaker" in 1961, she was deeply offended. She wrote to Jacqueline Kennedy, the subject of the article, that she preferred to be referred to as a "noted Negro designer."[14] The moniker may jar with twenty-first-century identifications with Blackness, but what is important to note is that Lowe had thought deeply about how she positioned herself in the fashion industry and the image she wanted to project. This is seen as clearly in the portraits that show her immaculate and chic dresses and hats. Tracy Reese (b. 1964) may be the most prominent and respected Black female designer working in American fashion at this time, and like Lowe, she has given thought to her position in the industry: "I consider myself a designer of women's sportswear and dresses. . . . I never say, oh I'm a Black designer or I'm a woman designer. I design for women, but I don't think I have to be identified as anything other than a clothing designer."[15] Reese's statement is telling of the progress that the design industry has undergone over six decades, though racial discrimination and sexism are far from absent.

White cutwork dress from the Hope for
Flowers collection by Tracy Reese.

Reese, a native of Detroit and alumna of Parsons School of Design, was first exposed to fashion by her mother, but unlike Lowe, who joined the family business to help support their livelihoods, both Reese and her mother were home sewers who enjoyed the pleasure of fashion outside of the latter's professional career. Reese was surrounded by both creatives and entrepreneurs in her own family, setting an example she could latter draw on to form a fashion business. Like Lowe, and countless other fashion designers, Reese has experienced business ebbs and flows. Unlike Lowe, Reese has been savvy in her business practices, although she did learn through trial and error. After gaining experience by designing under other labels, Reese launched her own brand in 1987, supported by her family.[16] Although her sportswear label received accolades and orders from prominent department stores, the business did not have the capital to survive. The 1987 stock market crash was not as devastating as the 1929 crash that killed Lowe's first New York business, but it did claim Reese's first brand after two years.[17] Reese was able to learn from the incident. She grew her reputation as a designer of flattering, functional womenswear creating under other labels, and she relaunched in 1995.[18] After nearly twenty years, Reese is now a mainstay of American fashion, and like Lowe, her most famous client is a First Lady with a well-noted sense of style: Michelle Obama.

In terms of design, Tracy Reese creates for a very different woman than Ann Lowe did. Reese's ready-to-wear is designed not for once-in-a-lifetime events such as weddings or debutante balls but for modern women who fulfill multiple roles. Still, their design philosophies seem remarkably similar. Reese has studied the work of female designers, including couturiers like Lowe and Callot Soeurs as well as ready-to-wear designers like Claire McCardell, and she notes:

I always felt that they ended up with a more useful product that took into account the wearer. This person had someplace to go and something to do and needed to look beautiful and be comfortable and be flattered by the

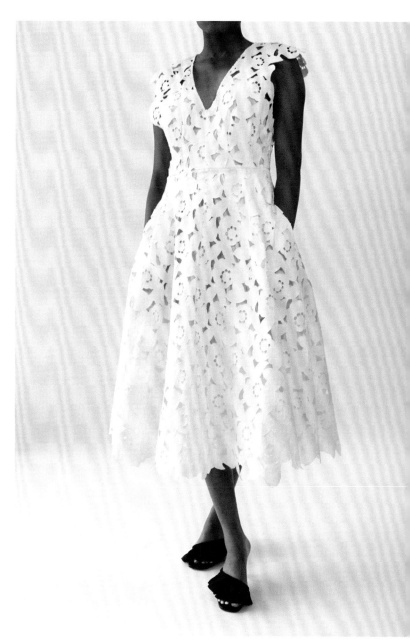

clothing. . . . For me that's job one. Whoever is wearing my clothes should be flattered by them and look good in them and they should have a use for the pieces.[19]

Reese's work translates some of the dressmaker's details that she associates with Lowe's work into modern fashion. Appliqué and cutwork dresses in fit-and-flare silhouettes, for example, embody the same delicate femininity of Lowe's designs in versatile and modern pieces. Floral elements—a signature design element for Lowe—are also important to Reese, though in a very different way. Reese's "Hope for Flowers" collection focuses on sustainable materials and bringing production back to the United States, specifically, her hometown of Detroit.[20] Reese explains,

> I've always been drawn to flowers and to nature as a source of inspiration. When we see something growing and we see flowers in bloom, there's a spirit of optimism in that . . . all of those things are continually inspiring . . . but for Hope for Flowers I was really thinking beyond the obvious. . . . For me it's that flower or seed in each person that deserves to be nurtured and expressed. I wanted Hope for Flowers to stand for being a hub and an ecosystem here in Detroit where we are nurturing the creative talent in young people and grown-ups alike. It's more than just the thing itself, it's the greater meaning. It would definitely outlast the life of any flower.[21]

Lowe's legacy in contemporary fashion can be seen in countless ways. The designers explored here represent only a handful of those who have consciously or unconsciously built on Lowe's example, in ways both similar and completely divergent from Lowe. Through their design philosophies and business practices, American fashion culture is continuing to evolve and maintain its relevance in an international industry. As a new generation of designers emerges, they will implement even newer practices and adjust to contemporary realties. Anifa Mvuemba (b. 1990), for example, has created opportunities for herself outside of the traditional

fashion gatekeepers. She is self-taught and established her brand in Maryland in 2011, away from the New York City hub. Mvuemba's label, Hanifa, drew international attention during the COVID-19 pandemic for her three-dimensional animated Instagram fashion show. In May 2020, when the world was locked down, Mvuemba accomplished what so many established brands were struggling to do—create a compelling and entertaining digital fashion presentation. The collection, Pink Label Congo, celebrated her family's roots in the Democratic Republic of the Congo. "She wanted to convey the beauty and hope of the Congolese spirit while shedding light on the African country's problems, including the use of child labor in local mines."[22] Harnessing digital technology and social media, Hanifa is a modern brand for fashion's future. Body inclusivity is baked into her design philosophy, as is social activism.

Ann Lowe acted as a bridge between a nineteenth-century dressmaking tradition and modern fashion in a twentieth-century context over her six-decade career, from the 1910s through the 1960s. The Amsale brand, Bishme Cromartie, Dapper Dan, B Michael, Anifa Mvuemba, and Tracy Reese are all carrying American fashion into the twenty-first century—each building on the past and innovating for the future, sometimes in ways that Lowe would have recognized and sometimes in ways she might never have imagined.

1.  Elizabeth Stamp, "The Met Gala's History and Decor Throughout the Years," *Architectural Digest*, September 10, 2021, www.architecturaldigest.com/gallery/the-met-galas-history-and-decor-throughout-the-years/amp.

2.  Sarah Spellings, "Alexandria Ocasio-Cortez Sent a Message with Her First Met Gala Appearance," *Vogue*, September 16, 2021, www.vogue.com/article/alexandria-ocasio-cortez-met-gala-2021.

3.  Author's email correspondence with B Michael, May 9, 2022.

4.  Mary Clemmer Ames, "Emancipation in the District—Stories of the Late Slaves," *New York Evening Post*, April 18, 1862.

5.  "Advertisement," *Tampa Morning Tribune*, October 10, 1928, 12.

6.  Lauren Bell, "A Rose That Grew from Concrete: From Greenmount to Bravo, Bishme Cromartie Is Taking Over the Fashion Industry," *Baltimore Magazine*, undated (2019), www.baltimoremagazine.com/section/styleshopping/baltimore-native-bishme-cromartie-project-runway-taking-over-fashion-industry.

7.  Author's email correspondence with B Michael, May 9, 2022.

8.  "B Michael Biography," *The HistoryMakers*, May 10, 2014, www.thehistorymakers.org/biography/b-michael; Bridget Foley, "B Michael: Tired of Platitudes," *Women's Wear Daily*, August 3, 2020, 7; David Moin, "B Michael on Whitney Houston and Macy's," *Women's Wear Daily*, June 12, 2012, 6.

9.  Rosemary Feitelberg, "Bridal Designer, Amsale Group Founder, Amsale Aberra, 64," *Women's Wear Daily*, April 3, 2018, 7.

10. "Easter Preview," *New York Age Defender*, April 20, 1957, 20.

11. "New York Negro Designer Fashions Debutant Gowns," *Calgary Herald*, November 20, 1967, 31.

12. Ariele Elia, "Dapper Dan: The Original Streetwear Designer and Influencer," in *Black Designers in American Fashion*, ed. Elizabeth Way (London: Bloomsbury, 2021): 167–92.

13. "Every Aspect of Bevy Smith's Met Gala Look Is a Tribute to Black Excellence—and Camp, of Course," *Allure*, May 6, 2019, www.allure.com/story/bevy-smith-2019-met-gala-black-designers-beauty-team.

14. Mary van Rensselaer Thayer, "Jacqueline Kennedy," *Ladies' Home Journal*, April 1961, 130; Letter to Jacqueline Kennedy from Ann Lowe, April 5, 1961, John F. Kennedy Presidential Library and Museum, accessed by Margaret Powell.

15. Author interview with Tracy Reese, January 20, 2022.

16. Lawrence Chua, "Tracy Reese." *Women's Wear Daily*, September 8, 1987, 5.

17. Constance C. R. White, "Designers on Designing: Tracy Reese: Coming of Age at Magaschoni," Supplement: WWD Best of New York, *Women's Wear Daily*, April 1, 1992, 11; A. R., "Three Strike Out," *Women's Wear Daily*, November 30, 1988, 8.

18. Lisa Lockwood, "Reese Returns with Her Own Sportswear Line," *Women's Wear Daily*, August 29, 1995, 2.

19. Author interview with Tracy Reese, January 20, 2022.

20. Jenna Birch, "Tracy Reese on Why Domestic Supply Chains Are Key to Sustainability," *The Helm*, June 25, 2020, https://thehelm.co/tracy-reese-hope-for-flowers-interview.

21. Author interview with Tracy Reese, January 20, 2022.

22. Dhani Mau, "Hanifa's Anifa Mvuemba Couldn't Get the Fashion Industry's Support. Turns Out She Didn't Need It," *Fashionista*, September 8, 2020, https://fashionista.com/2020/09/anifa-mvuemba-hanifa-clothing-3d-fashion-show; Emily Farra, "Hanifa's Anifa Mvuemba Celebrates 10 Years in Business with Her First Show at the National Portrait Gallery," *Vogue*, November 17, 2021, https://vogue.com/fashion-shows/fall-2021-ready-to-wear/hanifa.

# Exhibition Checklist

The following dresses, ensembles, and accoutrements, accompanied by ephemera and photographs both seen and unseen in this catalogue, appear in the exhibition *Ann Lowe: American Couturier*, on view at Winterthur Museum, Garden & Library, September 9, 2023–January 7, 2024.

1. Ak-Sar-Ben countess gown
Ann Lowe, Omaha, Nebraska; 1961
Silk, tulle, synthetic fabric, synthetic
horsehair braid, elastic, lace trim, sequins,
beads, boning, and metal zipper, hooks and
eyes, and snaps
Courtesy of The Durham Museum, Lynn
Robertson Evert
Cat. pp. 129–31

2. Organdy and lace afternoon dress
Ann Lowe, Lake Thonotosassa, Florida;
ca. 1930
Cotton organdy, lace, buttons, synthetic
horsehair, metal closures
Courtesy of Tampa Bay History Center
Cat. p. 80, detail p. 81

3. Dress and belt
Ann Lowe, New York, New York; 1935–38
Silk
Cincinnati Art Museum, Anonymous Gift,
1999.811a-b
Cat. p. 83, left

4. Wedding dress
Ann Lowe, 1941
Synthetic
Lent by The Metropolitan Museum of Art,
Gift of Mrs. K. Fenton Trimingham Jr., 1975
(1975.349a, b)
Cat. pp. 85–87

5. Dress designed by Ann Lowe and worn by
Nora Francke Cammann
Ann Lowe, 1950
Silk taffeta, silk faille, and metal fasteners
Collection of the Smithsonian National
Museum of African American History and
Culture, Gift of the Black Fashion Museum
founded by Lois K. Alexander-Lane

6. Evening ensemble
Ann Lowe for A. F. Chantilly Inc.
ca. 1966
Silk, cotton
Lent by The Metropolitan Museum of Art,
Gift of Florence I. Cowell, 1980 (1980.433.2a, b)
Cat. p. 73

7. Gasparilla court gown
Ann Lowe, 1926
Silk, silver threads, glass beads, rhinestones,
diamante
Collection of Henry B. Plant Museum
Society, Inc., Tampa, Florida
Cat. p. 79

8. Ak-Sar-Ben countess gown
Ann Lowe, 1961
Silk, tulle, synthetic fabric, synthetic horsehair
braid, elastic; lace trim, sequins, beads, metal
zipper, hooks and eyes, and snaps, and various
bonings, potentially wood on the hoop skirt
Courtesy of The Durham Museum, Ann
Lallman Jessop
Cat. p. 128; details pp. 125–27, 160–61

9. Veiled Prophet ball gown worn by Susan
Celeste Petersen
Ann Lowe, for Saks Fifth Avenue, 1963
Silk, tulle, synthetic horsehair braid, elastic,
lace trim, rhinestones, boning, metal zipper,
hooks and eyes, and snaps
Courtesy of the Missouri Historical Society,
St. Louis
Cat. p. 133, detail pp. 134–35

10. Fleur-de-Lis ball gown worn by Susan
Celeste Petersen
Ann Lowe for the Adam Room, Saks Fifth
Avenue, 1963
Silk, tulle, synthetic horsehair braid, elastic,
lace trim, tear drop and bugle beads, boning,
metal zipper, hooks and eyes, and snaps
Courtesy of the Missouri Historical Society,
St. Louis
Cat. p. 136

11. Dress designed by Ann Lowe and worn by
Jennifer Peabody Marks
Ann Lowe for A. F. Chantilly, 1966
Silk taffeta, silk organdy, passementerie,
synthetic fiber, metal fasteners
Collection of the Smithsonian National
Museum of African American History and
Culture, Gift of the Black Fashion Museum
founded by Lois K. Alexander-Lane

12. Evening dress
Ann Lowe for A. F. Chantilly, 1965
Rayon
Lent by The Museum at the Fashion Institute
of Technology, Gift of Judith A. Tabler

13. Ann Lowe debutante dress for A. F. Chantilly
pictured on the cover of *Park Avenue Social
Review*, January 1966
Cat. p. 37

14. Ann Lowe debutante dress for A. F. Chantilly
pictured on the cover of *Park Avenue Social
Review*, November 1965
Cat. p. 65

15. Flier for debutante gowns, 1965
Collection of Ms. Margaret E. Powell
Cat. p. 64

16. Wedding dress designed by Ann Lowe and worn by Florance Trevor
Ann Lowe, 1951
Silk satin, lace, gauze, buckram, tulle, and metal fasteners
Collection of the Smithsonian National Museum of African American History and Culture, Gift of the Estate of Florance Rumbough Trevor

17. Wedding gown of Ann Bellah Copeland
Ann Lowe, 1964
Silk faille, satin lining, silk, synthetic fabric, cotton, tarlatan, lace trim, elastic, metal closures, and boning
On loan from the Delaware Historical Society (#2003.028; Gift of Ann Bellah Copeland)
Cat. p. 115, bottom left

18. Wedding dress of Elizabeth Mance
Ann Lowe, 1968
Synthetic fabric, cotton, lace, tulle, synthetic horsehair, elastic, metal zipper and closures
From the collection of Elizabeth Mance de Jonge
Cat. pp. 118–19, 173; details pp. 120–21, 170

19. Bridesmaid's dress
Ann Lowe, 1968
Silk, tulle, synthetic horsehair, metal zipper, snaps
Private collection

20. Bridesmaid's dress worn by Bette Wooden
Ann Lowe, 1968
Silk, tulle, synthetic horsehair, metal zipper, snaps
Mrs. Bette Davis Wooden
Cat. p. 115, bottom right

21. Reproduction of Jacqueline Bouvier Kennedy's wedding dress
Katya Roelse
Assistants: Maya Bordrick, Kayla Brown, Alex Culley
Newark, Delaware; 2022, based on original by Ann Lowe, 1953
Cat. p. 185, detail p. 178

22. Dress worn by Barbara Baldwin Dowd
Ann Lowe, 1966–67
Silk, tulle, linen, metal, elastic
Collection of the Smithsonian National Museum of African American History and Culture, Gift of the Black Fashion Museum founded by Lois K. Alexander-Lane
Cat. pp. 110–11

23. Ann Lowe workshop (group):

Samples, paper patterns, paper records, ca. 1965, Courtesy of Sharman S. Peddy in memory of Ione and Benjamin M. Stoddard

Patterns for flowers and trim and fabric sample, undated, Collection of Ms. Margaret E. Powell
Cat. p. 109

24. Floating Cloud debutante gown in white peau d'ange
Ann Lowe, 1964
Crepe, silk, synthetic fiber
Museum of the City of New York
Cat. p. 57

25. Dress
Ann Lowe for the Adam Room, Saks Fifth Avenue, early 1960s
Silk, cotton, lace, tulle, elastic, synthetic horsehair, beads, metal zipper, hooks and eyes, snaps
Adnan Ege Kutay Collection
Cat. pp. 102–3

26. Evening dress worn by Marjorie Merriweather Post
Unknown designer, attributed to Ann Lowe, 1952
Silk, synthetic horsehair braid, tarlatan, ribbon, boning, metal zippers, hook and eyes
Hillwood Estate, Museum & Gardens, Washington, D.C., Bequest of Marjorie Merriweather Post, 1973 (48.106)
Cat. p. 104, details pp. 106–7

27. Concert dress
Ann Lowe, ca. 1966–67
Silk, synthetic fabric, bobbinet, lace, beads, synthetic horsehair, metal zipper and hook and eye
From the collection of Elizabeth Mance de Jonge
Cat. pp. 98–99, details pp. 100–1

28. Cotillion gown
Ann Lowe, 1956
Silk, taffeta, horsehair, appliques, sequins, glass beads, rhinestones
Chicago History Museum, Gift of Mrs. Charles Chaplin, 1976.241.170
Cat. pp. 50–51; detail pp. 52–53

29. Evening dress
Ann Lowe, ca. 1955
Silk, velvet
Lent by The Museum at the Fashion Institute of Technology, Gift of Eleanor Cates
Cat. p. 88

30. Dress and belt
Ann Lowe, 1930–34
Silk
Cincinnati Art Museum, Anonymous Gift, 1999.810a-b
Cat. p. 82

31. Dress and cropped jacket designed by Ann Lowe and worn by Florance Trevor
Ann Lowe, 1950s
Silk satin, silk faille, gauze, buckram, and metal fasteners; jacket: silk satin, gauze, and metal fasteners
Collection of the Smithsonian National Museum of African American History and Culture, Gift of the Estate of Florance Rumbough Trevor
Cat. pp. 92–93

32. Dress worn by Barbara Baldwin Dowd
Ann Lowe, 1966–67
Brocaded silk taffeta, silk chiffon, synthetic fiber, buckram, elastic and metal fasteners
Collection of the Smithsonian National Museum of African American History and Culture, Gift of the Black Fashion Museum founded by Lois K. Alexander-Lane
Cat. p. 90, detail p. 157

33. Beaded coat
Ann Lowe, early 1960s
Silk satin with glass and pearl beads
Collection of the Smithsonian National Museum of African American History and Culture, In memory of Benjamin and Ione Stoddard of Madeleine Couture, Inc., New York, New York

34. Jacket, dress, and belt
Ann Lowe, 1930s, remodeled in 1950s
Silk, leather, metal
Cincinnati Art Museum, Gift of Fashion Design Department, University of Cincinnati, 2016.83a-c
Cat. p. 83, right

35. Dress designed by Ann Lowe and worn by
Nora Francke Cammann
Ann Lowe, 1950, altered 1951
Tulle, lace, acetate, plastic buckram, elastic,
and metal fasteners
Collection of the Smithsonian National
Museum of African American History and
Culture, Gift of the Black Fashion Museum
founded by Lois K. Alexander-Lane

36. Gasparilla queen's gown worn by Sara Lykes
Keller (Mrs. W. Frank Hobbs)
Ann Lowe, 1924
Silk faille, glass beads
Collection of Henry B. Plant Museum
Society, Inc., Tampa, Florida
Cat. p. 78

37. Dress designed by Ann Lowe
Ann Lowe, mid-1950s
Silk taffeta, silk faille, buckram, elastic, and
metal fasteners
Collection of the Smithsonian National
Museum of African American History and
Culture, Gift of the Black Fashion Museum
founded by Lois K. Alexander-Lane

38. Evening dress
Ann Lowe, ca. 1960
Nylon, metallic thread, silk
Lent by The Metropolitan Museum of Art,
Gift of Lucy Curley Joyce Brennen, 1979
(1979.144)
Cat. p. 139, label p. 138

39. Evening dress
Ann Lowe, sold by Saks Fifth Avenue,
1962–64
Silk
Lent by The Metropolitan Museum of
Art, Gift of Mrs. Carll Tucker Jr., 1979
(1979.260.2)
Cat. p. 55, label p. 54

40. Dress
Ann Lowe for Madeline Couture, 1964
Silk, cotton, ostrich feathers
Private collection of Sharman Stoddard
Peddy
Cat. pp. 60–63

41. Dress designed by Ann Lowe
Ann Lowe, late 1960s
Silk satin, silk faille, lace, tulle, cotton, plastic
trimming, elastic, and metal fasteners
Collection of the Smithsonian National
Museum of African American History and
Culture
Gift of the Black Fashion Museum founded
by Lois K. Alexander-Lane

42. A. F. Chantilly brochure
Courtesy of Sharman S. Peddy in memory of
Ione and Benjamin M. Stoddard
Cat., p. 145

43. Ann Lowe announcement from
A. F. Chantilly
Collection of Ms. Margaret E. Powell
Cat. p. 66

44. Jacqueline Bouvier Kennedy miniature
in inaugural ball gown
Ann Lowe, 1967
Silk, taupe bugle beads, silk chiffon,
ecru cape with silk
The Congressional Club Museum
and Foundation

45. Mary Todd Lincoln miniature in inaugural
ball gown
Ann Lowe, 1967
Navy velveteen, silk taffeta, pelon, silk
piping, black lace, gold thread, satin ribbon
The Congressional Club Museum and
Foundation

46. *Saturday Evening Post*, December 12, 1964,
"Ann Lowe: Society's Best-Kept Secret," by
Thomas B. Congdon Jr., pp. 74–76.
Courtesy of Sharman S. Peddy in memory
of Ione and Benjamin M. Stoddard
Photos on p. 56 (top) and p. 144 appear in
article

47. Photograph of Ione Stoddard and Ann Lowe,
1964
Courtesy of Sharman S. Peddy in memory
of Ione and Benjamin M. Stoddard
Cat. p. 142

48. Airline tickets for Ione Stoddard and
Ann Lowe, 1964
Courtesy of Sharman S. Peddy in memory
of Ione and Benjamin M. Stoddard

49. Dress bearing names of Black fashion
designers, worn by Dawn Davis
B Michael, 2021
Collection of Dawn Davis
Cat. p. 188

50. Dress
B Michael. 2015
Silk cloqué, lace
On loan from the collection of B Michael

51. Dress
B Michael, 2015
Black-red silk brocade
On loan from the collection of B Michael

52. White embroidered fit and flare dress
Tracy Reese, 2021
Organic cotton, spandex twill
Hope for Flowers by Tracy Reese
Cat. p. 195

53. Green halter dress with lace applique
Tracy Reese, 2021
Linen, cotton lace
Hope for Flowers by Tracy Reese

54. Dress
Bishme Cromartie, 2009
Silk crepe
The Barbara P. Katz Fashion Archives at the
Maryland Center for History and Culture
Cat. p. 191, left

55. Wedding gown
Amsale, 2015
Silk net, sequins, beads, and bugle beads
Lent by The Museum at the Fashion Institute
of Technology, Gift of Amsale
Cat. p. 191, right

*Checklist as of February 20, 2023.*

# Selected Bibliography

The following is a selection of sources that informed this work. It is not an exhaustive list, which can be found in the notes of each chapter. Instead, the following provides general fashion historical context to the study of Ann Lowe, points to the key contemporary newspaper articles and secondary resources on Lowe's life and career, and identifies the technical conservation texts used to examine her existing material culture.

## Fashion History Sources

Cole, Daniel James, and Nancy Deihl. *The History of Modern Fashion from 1850*. London: Laurence King, 2015.

Kidwell, Claudia B., and Margaret C. Christman. *Suiting Everyone: The Democratization of Clothing in America*. Washington, D.C.: Smithsonian Institution Press, 1974.

Mendes, Valerie, and Amy de la Haye. *Fashion Since 1900*, 2nd ed. London: Thames and Hudson, 2010.

Mida, Ingrid, and Alexandra Kim. *The Dress Detective: A Practical Guide to Object-Based Research in Fashion*. London: Bloomsbury Academic, 2015.

Shaeffer, Claire. *Couture Sewing Techniques*. Newton, Conn.: The Taunton Press, 2011.

Way, Elizabeth, ed. *Black Designers in American Fashion*. London: Bloomsbury, 2021.

## Key Sources on Ann Lowe

Cheshire, Maxine. "Wedding Gown Is Highlight of Her Career." *Tampa Bay Times*, May 22, 1968, 46.

Coleman, Eleanor. "Deb's Fairy Godmother." *The Milwaukee Journal*, June 27, 1965, 2, 5.

Congdon Jr., Thomas B. "Ann Lowe: Society's Best-Kept Secret." *Saturday Evening Post*, December 12, 1964, 74–76.

Dodd, Dorothy. "Ancient Wedding Formulae Ignored by Modern Bride." *Tampa Daily Times*, March 27, 1926, 7-D.

"Fashion Designer for the Elite." *Sepia*, August 1966, 32–36.

Frye, Alexandra. "Fairy Princess Gowns Created by Tampa Designer for Queens in Gasparilla's Golden Era." *Tampa Tribune*, February 7, 1965, 6-E.

Holabird, Sally. "Ask Her About Jackie's Bridal Gown." *Oakland Tribune*, August 7, 1966, 87.

Major, Geri. "Dean of American Designers." *Ebony*, December 1966, 133–42.

"Miss Lowe Covers Paris Fashion Opening for the New Age." *New York Age*, September 24, 1949, 13.

Phipps, Betty. "Anne [sic] Cone Lowe: A Tampa Legacy Is Honored in New York." *Tampa Tribune*, August 7, 1976, 12-D.

Polk, Anita. "Anne [sic] Lowe . . . Designs 'One of a Kind.'" *Call and Post*, February 20, 1965.

Powell, Margaret. "Ann Lowe and the Intriguing Couture Tradition of Ak-Sar-Ben." *Nebraska History* 95 (2014): 134–43.

Powell, Margaret. "The Life and Work of Ann Lowe: Rediscovering 'Society's Best-Kept Secret.'" Master's thesis, Smithsonian Associates and the Corcoran College of Art and Design, 2012.

Pulley, Pam. "For Ann Lowe Finally—Fame Came." *Tampa Daily Times*, February 16, 1968, 2-C.

Robertson, Nan. "A Debutante Assembles Herself with Care." *New York Times*, October 30, 1957, 22.

Thurman, Judith. "Ann Lowe's Barrier-Breaking Mid-Century Couture," *New Yorker*, March 22, 2021, www.newyorker.com /magazine/2021/03/29/ann-lowes -barrier-breaking-mid-century-couture.

Tucker, Priscilla. "Secret Designer for Society Takes First Public Bow." *Philadelphia Inquirer*, December 18, 1962, 9.

Warren, Virginia Lee. "For Debutantes: Bare Backs," *New York Times*, November 17, 1967, 42.

## Conservation Sources

Brooks, Mary M., and Dinah D. Eastop. *Refashioning and Redress: Conserving and Displaying Dress*. Los Angeles: Getty Publications, 2016.

"From Nonwovens Pioneer to Leading Supplier of Technical Textiles." Freudenberg Performance Materials. www.freudenberg-pm.com/ Company/the-history.

Haldane, Elizabeth-Anne. "Surreal Semi-Synthetics." *V&A Conservation Journal* 55 (Spring 2007), www.vam.ac.uk /content/journals/conservation-journal /issue-55/surreal-semi-synthetics.

Handley, Susannah. *Nylon: The Manmade Fashion Revolution*. London: Bloomsbury Publishing, 1999.

Paulocik, Chris, and R. Scott Williams. "The Chemical Composition and Conservation of Late 19th and Early 20th Century Sequins." *Journal of the Canadian Association for Conservation* 35 (2010): 46–61.

Rocker, George. "A Wonderful Product Is Fibersilk." *DuPont Magazine*, May/June 1922, 4–5, 12.

Scaturro, Sarah, and Glenn Petersen. "Inherent Vice: Challenges and Conservation." In *Charles James Beyond Fashion*, edited by Harold Koda and Jan Glier Reeder, 233–50. New Haven: Yale University Press, 2014.

# Photography Credits

Individual images and works that appear in this publication may be protected by copyright in the United States of America, or elsewhere, and may not be reproduced in any form without the permission of the rights holders. Winterthur Museum obtained the permission of the rights holders whenever possible. Should the museum have been unable to locate a rights holder, notwithstanding good-faith and due diligence efforts, it requests that any contact information concerning such rights holders be forwarded to its digital asset manager so that they may be contacted for future editions. Unless otherwise noted, all loaned ephemera and objects were photographed courtesy of Winterthur.

Bachrach/Getty Images: 10.

Bettman/Contributor via Getty Images: 141, 174.

Cecil Beaton: Cecil Beaton Archive © Condé Nast, 43

Cincinnati Art Museum: © Cincinnati Art Museum/ Bridgeman Images, 82, 83 (left and right).

Chicago History Museum: 50, 51, 52–53.

Dia Dipasupil/Staff via Getty Images: 192.

*Ebony*: front cover, 2, 33, 34, 70, 140.

Henry B. Plant Museum Society, Inc.: 78–79; photo courtesy of A. Frank Smith and Patricia Smith Walkup, 122.

Hillwood Estate, Museum & Gardens: Photographed by Edward Owen, 104; photographed by Renee Comet, 105.

Maryland Center for History and Culture: 191 (left).

Metropolitan Museum of Art, image © The Metropolitan Museum of Art; image source: Art Resource, NY: 16–17, 54, 55 (left and right), 73, 85–87, 138–39.

Mike Coppola/Staff via Getty Images: 190.

*Milwaukee Journal*: 6, 62.

Missouri Historical Society: 136.

Museum at the Fashion Institute of Technology: © The Museum at FIT, 88, 108, 191 (right).

Museum of the City of New York:  38–39, 40, 57, 89.

*New York Age*: 137.

*Oakland Tribune*: 13.

*Park Avenue Social Review*: 37, 65.

*Saturday Evening Post*: 56 (top), 144.

Smithsonian National Museum of African American History and Culture: 18–21, 90, 92–93, 110–11, 150, 157.

Smithsonian National Museum of American History, Division of Cultural and Community Life: 112–13.

*Tampa Daily Times*: 14, 26, 75.

*Town & Country*: © Hearst Magazines, a unit of Hearst Communications, Inc., 47; photo by Francesco Scavullo © Hearst Magazines, a unit of Hearst Communications, Inc., 59.

Tracy Reese: 195.

*Vogue*: 44–45.

Winterthur Museum: Photographed by Jim Schneck: 9, 23, 60–61, 63, 80–81, 95 (all four photos), 98–99, 100–1, 102 (all four photos), 103, 106–7, 109 (all five photos), 115 (bottom two), 118–19, 120–21, 125–28, 129–31, 133 (left and right), 134–35, 153 (top and bottom), 158, 160–61 (all four photos), 163–64, 169 (top), 170, 173, 178, 185, 188, and back cover. Other photos courtesy of Winterthur: 155 (top and bottom), 166–67, 169 (bottom two), 177 (all eight photos), 179, 180 (all eight photos), 183 (top and bottom).

# About the Authors

**Elizabeth Way** is associate curator of costume at The Museum at the Fashion Institute of Technology. Her past exhibitions include *Global Fashion Capitals* (2015), *Black Fashion Designers* (2016), *Fabric in Fashion* (2018), and *Head to Toe* (2021). Way's personal research focuses on the intersection of Black American culture and fashion. She holds a master of arts in costume studies from New York University, where she wrote her thesis on the work of Ann Lowe and Elizabeth Keckly. She edited and authored chapters in the book *Black Designers in American Fashion* (2021) and is co-author of *Fresh Fly Fabulous: 50 Years of Hip Hop Style* (2023).

**Heather Hodge** is a postgraduate fellow in textile conservation at the Winterthur Museum, Garden & Library. She graduated from Juniata College in Huntingdon, Pennsylvania, with a bachelor of arts degree in art history. She received her master of arts and certificate of advanced study in art conservation from the SUNY Buffalo State Garman Art Conservation Department in 2021, where she specialized in textiles. Hodge spent her graduate internships at the Indianapolis Museum of Art at Newfields, Zephyr Preservation Studio, Trupin Conservation Services, and The Colonial Williamsburg Foundation.

**Laura Mina** is conservator of textiles with the Smithsonian National Museum of African American History and Culture. She previously served as head of the Textile Conservation Lab with Winterthur Museum, Garden & Library, affiliated assistant professor of the Winterthur/University of Delaware Program in Art Conservation, and associate conservator with The Costume Institute at The Metropolitan Museum of Art. Mina is endlessly fascinated by the human capacity for creative self-expression and self-exploration through clothing. Her research interests include conservation ethics, the cultural contexts of textiles, and the chemistry of textile cleaning.

**Margaret Powell** (1975–2019) was the first scholar to take a rigorous academic interest in Ann Lowe and her work. She first came across Lowe's work in 2011 while interning at the Hillwood Estate, Museum & Gardens in Washington, D.C., and she pursued her exploration at the suggestion of the chief curator, Liana Paredes. Intrigued by her initial research, Powell went on to complete a meticulous study of Lowe's life and work for her 2012 master's thesis in the history of decorative arts at the Smithsonian Associates and the Corcoran College of Art and Design (now Corcoran School of the Arts and Design). She carried on her Lowe research well after her graduate degree, tirelessly piecing together documents, personal accounts, and material culture to fill in the details of Lowe's life and design work. Margaret Powell was lost much too early, and the field of fashion studies, as well as a larger public fascinated by Lowe's story, feels this tremendous loss.

**Katya Roelse** is an instructor in the fashion and apparel program at the University of Delaware. She has worked in the fashion and apparel industry as a creative and technical designer for womenswear, menswear, childrenswear, uniforms, and wearable medical devices. She teaches CAD, illustration, and product development. Her scholarship integrates design, pedagogy, and technology, and she recently co-authored *The Book of Pockets: A Practical Guide for Fashion Designers* (Bloomsbury Visual Arts, 2019).

**Katherine Sahmel** is conservator of textiles at Winterthur Museum, Garden & Library and affiliated assistant professor of the Winterthur/University of Delaware Program in Art Conservation (WUDPAC). Previously, she worked with many local Delaware and Philadelphia museums and institutions on textile care and treatment through her private conservation practice. She also spent time as a conservation fellow in the Costume and Textiles Department at the Philadelphia Museum of Art. She holds a master of science in Art Conservation from the WUDPAC program and continues to be inspired by the stories and significance held within textile material culture. She is active in the American Institute for Conservation (AIC) and served as the program chair and chair of the Textiles Specialty Group for AIC from 2014 to 2016, and on the TSG Scholarship Committee from 2017 to the present.

# Index

*Note: Page numbers in italic type indicate illustrations.*

# Acknowledgments

I would like to extend my gratitude to the entire Winterthur Museum, Garden & Library team, including Charles F. Montgomery Director and CEO Chris Strand, John L. and Marjorie P. McGraw Director of Collections Alexandra Deutsch, Curator of Exhibitions Kim Collison, and Manager of Publications Teresa Vivolo. I would like to thank my fellow authors for their important contributions to fashion scholarship and the study of American history in this work. Big thank-yous to Jim Schneck for his beautiful photography and to Corinne Brandt for her tireless work in securing the other images. I am grateful to all the private individuals and institutions who allowed their images to be reproduced in this book. Additionally, I would like to thank the following people for contributing their voices through formal interviews and informal conversations and generally sharing their memories, insights, and research, as well as objects from their institutional and private collections. This book would not have been possible without them.

**Private Collectors and Researchers:**

Joan Apthorp
Elinor Boushall
Ann Copeland
Dawn Davis
Mark-Anthony Edwards
Charlene Fossum
Sibyl Gant
Judith Guile
Adnan Ege Kutay

Dianne Mance
B Michael
Sharman Peddy
William and Sarah Powell
Tracy Reese
Rebecca Sowers
Judith Thurman
Bette Wooden

**Institutions:**

Cynthia Amnéus of the Cincinnati Art Museum
Emma Sundberg and Becky Putzer of the Durham Museum
Kate Markert and Megan Martinelli of the Hillwood Estate, Museum & Gardens
Adam MacPharlain of the Missouri Historical Society
Elaine Nichols and Candace Oubre of the Smithsonian National Museum of African American History and Culture
Heather Culligan and Mallory Dorman of the Tampa Bay History Center

—*Elizabeth Way*

Many thanks to Elizabeth Way and Elaine Nichols for the invitation to include conservators' perspectives in this publication and their support throughout this project. Additional thanks to Dr. Rosie Grayburn and Catherine Matsen in the Winterthur Scientific Research and Analysis Laboratory for their assistance with materials identification for our essay on the preservation of Ann Lowe's gowns, and to Winterthur and the University of Delaware Department of Art Conservation for funding to purchase the analytic instruments. Further appreciation goes to Heather Hansen, Arianna Gutierrez, and Hailey Kremenek for their assistance with the treatment of the wedding dress from the collection of Elizabeth Mance de Jonge. Thanks to Antje Neumann and Joy Gardiner for their support.

—*Laura Mina, Katherine Sahmel, and Heather Hodge*

I would like to thank everyone at Winterthur for giving me the opportunity to work on this incredible project. Specific thanks go to Laura Mina (now at the Smithsonian National Museum of African American History and Culture) for inviting me to take part, Kim Collison for her constant support in the face of supply chain issues, Katherine Sahmel for her attention to detail and collaboration, and Heather Hansen for making the reproduction of Jacqueline Kennedy's wedding gown shine. I'm grateful to Elizabeth Way from The Museum at the Fashion Institute of Technology for sharing so many helpful resources for my essay. I also want to thank Alan Price, Janice Hodson, and Jim Wagner of the John F. Kennedy Presidential Library and Museum for their time and support that allowed me to accurately document the original gown. I would like to thank Ainsley Rutherford for her assistance in organizing the resources for this chapter. Further thanks go to my talented students, Alex Culley, Maya Bordrick, and Kayla Brown, for their help in the gown creation. Finally, I would like to thank the many folks over the decades who have taught me how to sew.

—*Katya Roelse*